Edited by Talia Esnard and Melanie Knight

Mothering and Entrepreneurship

Global Perspectives, Identities, and Complexities

DEMETER

Mothering and Entrepreneurship

Global Perspectives, Identities, and Complexities

Edited by Talia Esnard and Melanie Knight

Copyright © 2020 Demeter Press

Demeter Press
2546 10th Line
Bradford, Ontario
Canada, L3Z 3L3
Tel: 289-383-0134
Email: info@demeterpress.org
Website: www.demeterpress.org

Demeter Press logo based on the sculpture "Demeter" by Maria-Luise Bodirsky www.keramik-atelier.bodirsky.de

Printed and Bound in Canada

Cover design and typesetting: Michelle Pirovich

Library and Archives Canada Cataloguing in Publication
Title: Mothering and entrepreneurship: global perspectives, identities and complexities / edited by Talia Esnard and Melanie Knight.
Names: Esnard, Talia, editor. | Knight, Melanie, 1976- editor.
Description: Includes bibliographical references.
Identifiers: Canadiana 2020025832X | ISBN 9781772582413 (softcover)
Subjects: LCSH: Working mothers. | LCSH: Businesswomen. | LCSH: Motherhood. | LCSH: Work and family. | LCSH: Entrepreneurship—Social aspects.
Classification: LCC HQ759.48. M68 2020 | DDC 306.874/3—dc23

Acknowledgments

The scholarly examination of mothers as entrepreneurs, the challenge of their context, the precarious nature of their engagement, and their contributions to the entrepreneurial space form the basis of this collaborative work. Although this is an emerging field of social investigation, it remains generally untapped and undertheorized with many possibilities for deeper analyses and more pointed interventions, which can better their experiences within the field. As coeditors of this volume, we are, therefore, immensely grateful to our contributors who took this two-year journey with us, to the entrepreneurial mothers who were part of this process, and to Andrea O'Reilly of Demeter Press for creating avenues that centre the voices and experiences of mothers.

Talia R. Esnard

I would like to express my gratitude to Melanie Knight for embarking on this journey with me. Our conversations around this work through emails, virtual meets and over lunch in downtown Toronto remain etched in my memory. Thank you as well Melanie the opportunity to serve as a visiting scholar at Ryerson University in October 2018. Both this project and the time away working on this would not be possible without the understanding of my family (Roy, Tiffany, Misti, and Michael) and the support that we continue to receive from in-laws on both sides. To you all, I remain indebted.

Melanie Knight

This collaborative effort would not have been possible without my colleague Talia Esnard, whose kindness and persistence pushed this project to completion. Our discussions were lively and always engaging. We had a common goal, which was to create a contribution that would

be a critical voice in the field of gender and entrepreneurship. A sincere thank you to you, Talia, for your friendship and collaboration in this project. I would also like to thank my family (Adélaida, Tony, Vicky, and Rocky) for their continued support and for always believing in me. You are my heart.

Contents

Mothers as Entrepreneurs: Negotiating Work and Life Complexities in the Global Economy

Talia Esnard and Melanie Knight

T his book examines the complexities of mothers who are entrepreneurs in different parts of the world. Research on women entrepreneurship presents many new questions and issues that ultimately serve to further inform and expand the field. One must historicize context and focus on sociopolitical realms and on lived realities, which is a challenging endeavour when looking at mothering and entrepreneurship in different global contexts. What about the workers in these contexts? More specifically, what about the female workers within these contexts? How have women negotiated gendered roles within old and new structures? What complexities have preconfigured the diverse realities and positionalities of maternal workers? How have these intricacies shifted the boundaries of the work-family interface? This book focuses on a specific subset of work and the economy—mothers who are entrepreneurs in different parts of the world. Three key components anchor this edited collection.

First, many chapters examine how mothers negotiate their entrepreneurial endeavours within the contexts of local and global economic shifts. Chapters in the book detail experiences of mothers who are entrepreneurs in Canada, the United States, the Caribbean (specifically Trinidad and Tobago, Jamaica), and the Czech Republic.

Some of the questions this collection addresses include the following. How has the shift from social welfare states to more neoliberal, neoconservative ones affected the lived realities of women workers? How have global governing bodies, such as the International Monetary Fund (IMF) and World Bank (WB), affected life and work for women in the Global South? Lastly, how have women entrepreneurs operated within postsocialist nations with relatively new economic regimes and possible remnants of older ones? Such attention to the multidimensionality and complexity of context is increasingly critical, given the changing nature of global and social hierarchical relations of power that unfold at varying levels and degrees of intensity.

Second, this edited collection examines the sociocultural, economic, and national contexts that (re)structure and (re)frame multiple nodes of power, difference, and realities for mothers as workers across diverse contexts. This type of contextual analysis allows for new lines of inquiry and questions that move beyond the descriptive profiling and gendered assessment of women entrepreneurs. In fact, in their attempt to respond to the prevalence of research on male entrepreneurs, however, these researchers have created a "female model of entrepreneurship," which essentializes and homogenizes women's entrepreneurship (Mirchandani). The focus is primarily on a single axis of oppression, largely, gender. Patricia Hill Collins remains us that "varying placement in systems of privilege, whether race, class, sexuality or age, generate divergent experiences with motherhood; therefore, examination of motherhood and mother-as-subject from multiple perspectives should uncover rich textures of difference" (326). Although attention to the situated nature of women's entrepreneurial experiences has been increasing (see Brush et al., "Women Entrepreneurship and Growth"; Hughes and Jennings), there is little comparative work that makes visible the intersectional nature of oppression and the contextual facets of identity, self-employment, and family for mothers. The sociocultural and economic contextualization of racialized histories is particularly important to understand the many issues that women and mothers face in the market and the outcomes of that process (Steyart and Katz).

Lastly, the work-life balance of the mother entrepreneur frames our discussion. We set the work-life discourse within many points of contention related to how researchers have conceptualized the work-life interface, the specific assumptions embedded within these investigations,

and the implications of these for how we (re)present the dynamics related to mothering and entrepreneurship. Thus, although we start with a broad reference to the centrality of the work-family interface for mothers as entrepreneurs, we deliberate more deeply into the many conjectures related to notions of the embedded or embodied worker and/or mother as well as of the presumed freedoms with which mothers think through their identity and practices. We particularly use these controversies to trouble the inherent incongruities and simplicities within existing constructions of mothers as workers, the problems associated with placing mothers within the boundaries associated within each domain, and the lack of attention to the fluidity and diversity of their engagement across contexts. We also explore the complex perspectives of mothers on matters related to the understandings, experiences, and effects of working within and between these two domains. Given the lack of nuanced research on these issues, we use this edited volume to strengthen existing lines of investigations while, potentially, framing new lines of inquiry within the area of work-life interface for mothers as entrepreneurs.

Globalization and the New Economy

Context remains central to entrepreneurial thinking and practice (Mair et al.; Welter). Shaker Zahra contends that "contextualizing entrepreneurship means the linking of theory, research, and sites where researchers build on the innate qualities of the phenomena they examine" (445). Contextualization then requires focusing on the spatial, historical, social, and institutional dynamics of a given space (Welter; Di Domenico et al.; Ramírez-Pasillas, Brundin, and Markowska). Exploring the use these contextual lenses to interrogate the structures and processes related to women and mothers in the new global economy allows for greater specificity, depth, and scope within entrepreneurship research. This approach is particularly useful for capturing how the contexts or environments in which one exists can yield multiple structures, constructions, complexities, and contra-dictions that affect the thinking and practices of mothers within the entrepreneurial space. To some extent, this contextual relevance has been scrutinized in the work of some scholars (see Bjørnskov and Foss; Foss, Lyngsie, and Zahra; Ucbasaran, Westhead, and Wright). However, whereas the vast majority of entrepreneurial research has

been within the context of Europe and North America (Bruton et al.; Jaim and Islam), scholarly knowledge about the peculiar conditions and processes that affect the maternal worker across diverse contexts remains limited. In advancing the entrepreneurial field, it is, therefore, important that we comparatively treat and appreciate the variability, intricacy, and fluidity inherent within the mothering-entrepreneurship nexus. Although we acknowledge the metaphorical and political meanings embedded within categorizations that differentiate between countries (McEwan), we use the geographical distinctions of the Global North and South (i) to underscore the relative complexities within and between nations that differently configure the connection between the market and home and/or between mothers and economic agents; (ii) to trouble the effects of neoliberal market mechanisms on relations of power, both at the macro and micro levels; and (iii) to advance understandings of how such restructuring continues to erode workers and institutions, particularly in the case of mothers who work as entrepreneurs.

Global North

Corporate globalism has redistributed the balance of power across the globe. Today, the world economy revolves around three supraregional economies; Western Europe, East Asia, and North America. Through this triadization of the world economy, global capitalists increasingly own a substantive share of investment and patterns of trade within the triad. What we see, therefore, is that wealthy Northern countries in particular have increased their efforts to establish a single inter-dependent global market through regional and international trade-liberalization agreements, such as, the North American Free Trade Agreement (NAFTA) and World Trade Organization (formerly GATT). Narratives of the Global North, therefore, draw on the relevance of transnational capital flow, advance economic development, and diverse expressions of power related to wealthy countries and continents. These structural changes (notably in the types of goods, services, sectors, and applied technologies) have given rise to a knowledge-information-service-based economy or what some have referred to as the "new economy" (Pupo and Thomas) as well as to the application of "micro-technologies to a wide variety of production processes and the computerization of work processes" (Pupo, et al.).

The hollowing out of mass production industries in North America, such as automotive, steel, and electronics, is the result of entire industries moving offshore to lower wage destinations. Canada also experienced soaring growth in corporate profits, with a growing threat of wage cuts, in the 1990s (Rapley). Former centrally planned economies in Europe and the former Soviet Union have now transitioned to market economies, with a growing tendency for outward investments and entrepreneurial activities. There, the size of the market, available infrastructure, existing trade policies, and available funding from the WB serve as critical factors that have supported the transition (Caccia and Milgrim).

Despite the promises and assurances of free trade proponents for consumers and producers in the market, patterns of deindustrialization and deunionization continue to create immense challenges for many global communities. Closer examinations of the global pressures and changes for instance in the 1970s bring attention to the dark periods of recession for Western democracies, such as the United States (US) and Canada, when the promotion of the liberal economy and principle markets also supported a strong shift away from the welfare state and its policies (Larner; Rapley). This deregulation process inadvertently produced a crisis of the state and for civil society. In some cases, the crisis unfolded when countries began "freeing themselves of some of the responsibilities they acquired throughout the twentieth century" (Ilcan 214) by deregulating the economy, privatizing state-owned enterprises and state-provided services, using market proxies in the public sector, and rolling back state interventions (Jessop 2002). The US, for instance, witnessed a drastic shift in employment, away from the standard employment relationship (largely for white men) to more precarious nonstandard forms of work, such as contract or part-time employment, just to name a few (Drache et al.). This shift has been a cause for concern, since nonstandard work provides limited or no social benefits, little job insecurity, low wages, and high risks of occupational injury.

These structural patterns emerge as key indicators of how neoliberal principles and practices have radically restructured social realities and relations across the globe. Thus, on the one hand, we see broad patterns of work and employment opportunities (e.g., telework, flexible initiatives, new management and monitoring practices, and new contractual arrangements) that continue to unfold within the global economy. On

the other hand, we also see growing narratives of inequality that emerge to challenge the broader representations of the neoliberal economy. Thus, despite the regime's increasing emphasis on investment in human capital and integration of people into the market, this sense of market embeddedness negates how employment security is being steadily eroded through changes to labour laws and employment policies, serving to dislocate analysis from the social onto the individual. As such, over the last few decades, there has been a general weakening of labour's institutional voice (Fudge and Vosko; Cranford and Vosko) and eroding global citizenry (McEwan). Norene Pupo et al. argue that global trade patterns have had a "profound impacts on social interaction and institutional relationships, and, as a result, altered production processes and employment practices, transformed local landscapes, and touched various aspects of social life at local, regional, national and global levels" (9-10). Thus, while individuals are defined as "rational, calculating creatures whose moral autonomy is measured by their capacity to for self-care, the ability to provide for their own needs and service their own ambitions" (Brown, 42), the equity of the context in which these individuals live remains in question. These inequalities raise several questions around women, work, and the economy. What then of the workers within what Ruth Lister defines as a "social investment state" or a "hybrid welfare regime" that combines "elements of liberal and social-democratic welfare regimes" (Lister 4)? How then do we create what Doug Porter and David Craig refer to as "inclusive neoliberalism," which focuses on the specific concerns and realities of marginalized groups that participate within the market economy? How do we bring into existence a moral economy that includes issues of justice and freedoms?

The volatility of economies is felt across the globe. It is important to recognize that the marketization and corporatization of Western democracies do not exist as insular national entities but function and benefit from transnational and imperialist practices imbued with notions of femininity and masculinity. The global assembly line, the marketing of goods and the creation of consumers, and the patters of migration within and across national borders all rely upon ideologies and practices of gender and race. These global patterns have increased the opportunities in the market and facilitated the rise of entrepreneurship as a liberating avenue for profit maximization and self-actualization. We follow in the

tradition of many feminist scholars who have deromanticized these ideals. We cannot, therefore, ignore the growing volatility of the market and of the engagement of vulnerable groups, such as women and mothers. We examine how mothers negotiate discourses of enterprise and motherhood within current neoliberal economic narratives. We specifically address the many social and economic inequalities that intensify the vulnerabilities of women while deteriorating the wellbeing of women in the Global North. Despite the promise of shared prosperity under a neoliberal market economy, conditions have worsened for certain nations, largely (but not exclusively) those in the Global South.

Global South

Globalization has also encouraged a dual process of integration and fragmentation. The emergence of this new neoliberal economic world order has its origins at an economic conference held at the end of WWII in Bretton Woods. At the meeting, participants agreed to expand international trade and establish binding rules on international economic activities, which laid the foundation for the new political order. On a deeper level, the Bretton Woods conference, and later the Washington Consensus, set the foundation for the establishment of three new international financial institutions (IFIs): the IMF, WB, and World Trade Organization (WTO, formally the General Agreement on Tariffs and Trade). In addition to financing projects, such as roads, power plants, and schools, the WB also facilitated the disbursement of loans and structural adjustment programs (SAPs) to reform, reintegrate, and realign economies of the Global South. As such, the use of SAPs emerged as a neoliberal strategy through which loan conditionality often forced developing countries to centralize market principles, promote private investments, liberalize trade, and reduce state sovereignty markets. Such agendas are closely tied for instance to the central mission of the IMF—to reduce foreign exchange restrictions and use its reserve of funds to lend to countries. For many, these IFIs have led to greater debt and have exacerbated the unequal distribution of wealth, social inequalities, and the marginalization of many people and countries in the Global South.

Most studies show that the gap between rich and poor countries is widening, with an unequal concentration of sellers within the markets of the Global North as compared to the Global South (Hoogevelt; Rapley).

Even so, some nuances exist. We see for instance that certain Asian economies, such as Malaysia, Thailand, Philippines, and China, have attracted foreign investment from the United States and Canada. Moreover, other countries, such as Brazil, Mexico, Argentina, South Africa, Barbados, Antigua, and Barbuda, and Trinidad and Tobago (among others) are now categorized as high-income countries. Other patterns of South-South trade continue to grow based on economies with increasing economic heterogeneity and volatility, including oil-producing countries (e.g., Trinidad and Tobago and Venezuela), industrial (e.g., Puerto Rico and Dominican Republic), and service economies (e.g., Cayman Islands and Bahamas). Other middle- and low-income countries within the Global South, however, continue to experience growing levels of economic fragmentation, including increased debt, reduced global demands for exports, fluctuating export commodity prices, and poor fiscal performance. Such variability within the domestic debt and service ratio also raises concerns for the viability of regional economies. These concerns are particularly relevant given the continued effects of the 2008 global crisis and the potential economic consequences of Brexit.

One cannot dismiss the structural and geopolitical challenges facing developing societies and the implications for how vulnerable groups experience and cope with the growing effects of neoliberal economies. Of note, therefore, are the growing claims that in the Global South, workers face horrendous working conditions, lack of safety standards, increasing wage gaps, and sustained poverty levels (Pupo et al.). We also see reports related to the negative effects of global economic restructuring on the labour market position of workers in Latin America and the Caribbean (Korzeniewicz and Smith). In *Globalization and Neoliberalism*, Thomas Klak speaks to the economic and political marginalization of Caribbean countries, the increasing internationalization of labour, the pressure of Caribbean governments to respond to neoliberal reforms, and the increasing effects on working-class citizens. Policies such as deregulation, privatization, and antiwelfare movements are also transferred within these global shifts. What emerges is an inherent focus on the impact of historical relations between countries in the Global North and South, the level of exploitation that ensues from these processes, and its impact on the people of the region (Klak; McElroy and Sanborn). Although wage work in exported-oriented factories, offshore banking , migration, and entrepreneurial ventures have emerged as ways

of coping with the pressures of global capitalism, these do not mitigate the precarious nature of these activities and the potential vulnerabilities facing those who engage in them. This vulnerability is certainly evident in the various indicators of the Human Development Index for many Global South countries, and the growing attention to areas of politics, the economy, health, and the environment (UNDP).

These ongoing uneven and contradictory effects of global capitalism also raise pertinent questions related to changing economic systems, the expression of power on a global scale, the position of women within the labour market and their experiences within it. In speaking to this issue, Valentine Moghadam suggests that although "women have been gaining increasing share of many kinds of jobs ... [but] in the context of a decline in the social power of labour and growing unemployment, their labour market participation has not been accompanied by a redistribution of domestic, household, and child-care responsibilities (139)." Women are increasingly disadvantaged in the market and made vulnerable through their need for other forms of employment to maximize their economic power. This phenomenon is made clear in women's increased participation in informal labour markets within developing countries, particularly in terms of small enterprises, self-employment, and home-based enterprises.

Women and Entrepreneurship

Across the globe, women are increasingly entering and participating within the entrepreneurial sphere. Empirical research on this growing phenomenon highlights a central concern for the ways in which women exploit new business opportunities (Richomme-Huet et al.). In many of these cases, researchers centre on how, why, and under what circumstances women are pulled or pushed into entrepreneurship (see, for instance, the work of Hughes et al.; Lashley and Smith). No doubt such insights continue to provide important starting points and baseline data from which scholars can continue to map women's movement and mobility across various sectors of the market. However, although this push-pull framework does have merit, it only has relative applicability to understanding of women entrepreneurs; it has a tendency to homogenize as well as to decontextualize the motivations of entrepreneurial mothers (Bruni et al; Rodríguez and Santos), and to depoliticize the entrepreneurial space (Das Gupta; Galabuzi; O'Neil

and Bilimoria; Ekinsmyth, "Family Friendly Entrepreneurs") as well as the fluidity of that process (Hytti).

It is against these theoretical and conceptual limitations that ongoing calls for new lines of inquiry surface across the globe. Central to this call is the push for more critical analyses that underscore the importance of environmental (e.g., institutional and regulatory) factors and social constituted (e.g., race, gender, class, and ethnicity) ones for understanding the experiences and challenges related to the prospects for women who enter into the neoliberal market at a collective level. In building on the theorization of women's entrepreneurship, therefore, it is imperative that researchers also examine the structures and relations of power that continue to affect women's choices to enter and to stay within that sector (Kirkwood; Sangha, Jasjit, and Gonsalves). At a broader level, various metasyntheses of the literature suggest a collective push towards analysing the motivations, experiences, and challenges for women entrepreneurs (see Bruni et al.; De Bruin et al). In "Why Research on Women Entrepreneurs Need New Directions," Helene Ahl, for instance, calls for comparative studies that expand our understanding of how external factors (such as social norms, family policy, and labour market participation) order the participation and practices of women entrepreneurs. Some scholars use a gender-awareness framework that goes beyond analyzing the market to explore the potential significance of societal influencers, such as cultural norms and practices. Others call for greater theorization that captures the heterogeneity of the thinking and behaviour of women entrepreneurs, both within and across various sectors and\or contexts (Brown, et al.; Verheul et al.).

A point of convergence within the literature on women's entrepreneurship is the relative importance of environmental factors in shaping the underrepresentation and vulnerability of women entrepreneurs. Much of this research primarily comes from the Global North. Such is the case for researchers in the Canadian context, who focus on the experiences of marginalized groups, such as immigrant self-employed women (Khosla; Rooney, et al.) or those with relatively low earnings and/or without protection from risks (Delage; Hughes). In treating with the latter, key environmental concerns are those of the lack of access to resources, training, and support structures (in both the public and private sectors) (Baxter and Raw; Josephides; Carrington; Orser et al.). Other researchers stress on the relevance of socially constituting

categories—such as gender (Mirchandani; Rooney et al.; Carrington; Hughes), class, and race—in understanding women's experiences and outcomes (related to growth and success) within the entrepreneurial space (Knight, "Race-ing, Classing"; "For Us by Us"). Similar calls for contextual analyses emerge from US-based researchers who examine the experiences of women entrepreneurs (Allen et al.; Brush et al., *The Diana Project*). Global Entrepreneurship Monitor (GEM) reports, for instance, specifically emphasize the underrepresentation of women in business (Allen et al.), in which they suffer from a lack of equity as well as limited investment opportunities (Brush et al., "Advancing Theory Development"). Even within the analysis of the performance and success of women entrepreneurs, the lack of gender sensitive measures and conceptualizations remains a core contention for researchers within that space (Ahl, *Scientific Production of Knowledge*; Bruni et al.).

In Europe, researchers also stress the importance of cultural and social constraints faced by women. Such cultural predispositions and presuppositions about gender roles were clearly evident in Elizabeth Chell and Susan Baines's early study of 104 micro-service-oriented businesses in the United Kingdom. Based on the use of 2002 GEM data for 29 countries (in Europe and developing countries in Southern Africa and Asia), Ingrid Verheul et al. also focus on the family-embedded nature of women-owned businesses. Similarly, in Turkey, Delik Cetindamar et al. use the 2006 GEM Turkish dataset of 2,417 participants from the adult population survey to show that family capital remains a strong predictor for women entrepreneurs. Similarly, using data on women entrepreneurs in India, V. Kanti Prasad et al. highlight the importance of social relations, support networks, and resources for women entrepreneurs. However, fewer studies explore the contextual factors related to women entrepreneurs in emerging economies, such as in Czech Republic, where concerns remain over growing inequalities, the rise of the informal economy, and the predominance of women within necessity-driven entrepreneurial activities (Dell'Anno). As a response to this lacuna, researchers have advocated for more contextual research that captures the institutional, social, and historical dynamics that affect the roles and experiences of women entrepreneurs (see, for example, Smallbone and Welter; Verheul et al.).

Few studies exist on women entrepreneurs in the Global South. However, some of the emerging findings are worthy of mention, such

as the research stressing the negative impact of structural and cultural constraints on the representation of entrepreneurial women in Latin America and the Caribbean (Ferdinand; World Bank). In a comparative analysis of time-series data (2001–2008) on female entrepreneurship across thirteen countries in Latin America and the Caribbean, Verheul et al. contend that gender inequality remains pervasive but diverse, with varying effects on equity in terms of the distribution of and access to both resources and institutional support. Such is the case of women entrepreneurs in highly stratified societies, such as those in the Caribbean (Browne; Allahar; Verheul et al.; Hossein), where gendered constructions of women as mothers and as workers noticeably constrain their entrepreneurial undertakings (Lashley and Smith; Terjesen and Amorós; Esnard, "The Personal Plan"; "Centering Entrepreneurial Mothers"). Key gaps, however, remain within existing analyses of women and mothers within the entrepreneurial sector of the Caribbean. These make a credible case for further contextualization of the spatial and situational realities these women confront and negotiate (Esnard, "Entrepreneurial Engagement"; Frederick and Esnard, "Women, Mothers, and Entrepreneurial Engagement"). Although these research sites in the Caribbean, Czech Republic, United States and Canada cannot provide comparative points of analyses, they make visible the situated nature of their entrepreneurial thinking and practices.

Entrepreneurial Mothers

Mothers are increasing structured within the market economy. Anne Demo et al. demonstrate, for instance, how activities related to consumption and production reframe the notions and dynamics surrounding motherhood and the market. Melinda Vandenbeld Giles underscores the presence of dualistic structures and expectations related to neoliberalism and patriarchy that "lead to massive structures of inequality that benefit neither mothers nor children" (7). This is particularly the case when neoliberal ideologies push mothers to use their individualistic strengths while still operating within a landscape in which they are tied to the social and cultural expectations of motherhood as an institution. Thus, "mothering in the market realm only further entrenches dualistic conceptualizations of motherhood by creating an exclusive working mother categorization that does not

incorporate [the weight of] reproduction or caregiving (Vandenbeld Giles 3-4). Vandenbeld Giles asserts that mothers must be neoliberal self-optimizing economic agents in the public realm and maternalist self-sacrificing mothers in the private realm. Such a reality does not speak to how mothers make sense of, experience, and respond to these conflicting messages. It is particularly important to capture the multiple subjectivities and material lives that circulate around patriarchal economies and societies. Investigations of the mother-entrepreneurship nexus, however, remain relatively absent within the empirical literature.

New lines of questioning are necessary that speak to the being and becoming of mothers as entrepreneurs, how these processes are complicated by intersecting axes of power (e.g., race, gender, class, and sexuality) and how these affect their identities, perspectives, and experiences. These questions are especially important given that eentrepreneurship "constitutes a primary site and central practice of neo-liberal self-creation and labour in today's global economy; a dual project in which economic livelihoods and new subjectivities are being forced in tandem" (Freeman, 2). New research must examine the complexities within the entrepreneurship-motherhood nexus and explore both the meanings and experiences of motherhood within the contexts of "consumption and market activity as building blocks for their [mothers] identities and empowerment" (Demo et al. 15). More research is also needed on the specific realities and challenges for mothers who work within the entrepreneurial sector (Barriteau; Esnard, "The Personal Plan"; "Centering Caribbean Women's Gendered Experiences"; "Mothering and Entrepreneurship"), on the complexities that underlie notions of choice and agency within their negotiations of these structures (Esnard, *Mothering and Entrepreneurship*; O'Brien Hallstein; Esser et al.), as well as on the fluidity of their entrepreneurial thinking and action (Korsgaard; Ekinsmyth, "Challenging the Boundaries"; "Managing the Business"). The perspectives, identities, and complexities that emerge from these webs of influence cannot remain secondary within these discourses.

At a comparative level, therefore, research should centre the work-family experiences of women entrepreneurs, the ideologies and cultural expectations that underpin that interconnection, and the ways in which such thinking both perpetuates and silences the economic and political

volatility of their contributions (Josephides; Westwood and Bachu). The vulnerability of women entrepreneurs is further entrenched given the lack of investment and support within patriarchal capitalism. Moving beyond these empirical limitations requires capturing the relative ways in which the participation and/or experiences of maternal entrepreneurs are shaped by contextual embeddedness or by the specific realities embedded within their localized contexts. Advancing research on maternal entrepreneurs also require that researchers tease through the emerging literature on women entrepreneurs and the heterogeneity of those who operate within that entrepreneurial and maternal space. Research must bring together interrogations of the social, economic, political, and cultural realities associated with the entrepreneurial engagement of mothers. As the topic of entrepreneurial mothers remains highly undertheorized, the spatial and temporal relevance and ambivalent nature of these realities must be examined (Haynes; Ekinsmyth, "Challenging the Boundaries"; "Family Friendly Entrepreneurship"; "Managing the Business"). This edited volume serves as a response to this gap in the literature. At the core of the volume, therefore, is an examination of the motherhood-entrepreneurship nexus, the relational and contextual factors that underpin the dynamics surrounding that connection (however constructed), and the paradoxical effects that these (re)produce or engender, both within and across contexts.

Reframing Work-Life Interface

The incompatibility between work and family roles for women entrepreneurs remains a major contestation within the literature (Clark; Reynolds and Renzulli; Whitehead et al.; Damaske and Gersen). Here, issues of gender, work, and the family emerge as contested issues. Entrepreneurship is often presented as something positive for women, as they are empowered to make their own choices around work and family balance (Voyandoff) or to better negotiate the boundaries that define each domain (Ibarra; Aldrich and Cliff; Bruni et al.; Brush et al. "A Gender-Aware Framework"). Thus, whether because of a desire for autonomy or a sense of achievement (as expressions of intrinsic needs or as manifestations of a push factor), the prospects for worker flexibility and agility remain at the core of this discussion. Yet others discussions on work and family are pitted against

competing discourses related to the ideal mother or worker—blurring of the boundaries and the inherent contradictions within these roles (Ekinsmyth, "Challenging the Boundaries"; Duberley and Carrigan). Where these competing discourses create multiple demands for time and resources (Voydanoff), scholarly work has examined the conflicting experiences and psychosocial effects of work-family interface (Gupta et al.; Eddleston and Powell; Desrochers and Sargent; Reynolds and Renzulli; Shelton) or the effect of these on the wellbeing of women (Parasuraman and Simmers; Malenfant et al.). Important points of references within these discussions relate to normative gender roles, role identity, gender specific motives (Gupta et al.; Porter and Nagarajan; Ergeneli et al.) and the restrictive effects of gendered spaces within the entrepreneurial field (Mirchandandi; Lewis; Hamilton).

Other scholars call for more critical theorizations on the varied forms and degrees of embeddedness that preconfigure the choices of women within the entrepreneurial sector (Salmenniemi et al.; Eddleston and Powell). Patrice DiQuinzio cautions against the essentialization of motherhood and, instead, advances critiquing the ideological and moral discourses underpinning the choices and practices of mothers. Sharon Hays also questions the extent to which empirical investigations of the work-life interface take into consideration the competing ideologies of the two domains and the significance of these underlying tensions for understanding notions of choice and agency. In many ways, the attention is on the multiple ways in which competing logics of the market and of the home complicate the lived realities for the women who attempt to (re)produce and\or resist the embodied mother worker. For Lynn O'Brien Hallstein, these theoretical rigidities inherent within the understanding of macro-micro processes for women entrepreneurs raise many questions around how neotraditional families experience and cope with conflicting principles of privatization, responsibility, and choice. She warns, however, of the risks inherent in framing work-life decisions within the framework of maternal choices—a point of view that renders "invisible... the problems of motherhood from the public sphere" (308).

Two related points here are the contradictions within the interconnections of motherhood-entrepreneurship and the complexities around how mothers think about and through their responses. Alena Krizkova et al. underscore the importance of traditional gender roles and stereotypes for how men and women differently experience the

entrepreneurial sphere within post-Soviet societies. Joanne Duberley and Marylyn Carrigan reference the ways in which mothers navigate the "tensions between [notions of] intensive mothering and entrepreneurship through self-exploitation and limiting business size" (16). From this perspective, the contradictory nature of these discourses presupposes some ambivalence around the liberating and marginalizing experiences of mothers who operate as entrepreneurs. Ekinsmyth argues that mothers continuously face spatiotemporal restrictions that affect the extent to which their entrepreneurial engagement are nested within family-friendly time space routines. In *Negotiating Identities*, Talia Esnard demonstrates the diverse ways in which these intricacies of the entrepreneurial space affect how mothers in Trinidad and Tobago consciously move between acceptance to resistance in their negotiation of the time-space demands and conflicts of working between the maternal entrepreneurial domains. It is against this background that other researchers call for more a thorough examination about whether the work-family experiences of female entrepreneurs change across their life course (Sharifian et al.; Jayawarna et al.). In all cases, the push is for (re)conceptualizations of mothers, motherhood, and mothering within the context of entrepreneurship. More specifically, what appear within these discussions are constructions of identities and praxes that both conform to and resist dominant ideologies associated with patriarchal economies and societies.

In many ways, the (non)reconciliation of these tensions challenges the notion of promise within the growth economy (Korsgaard) while further muddling the discursive divide within discussions of contextual and relational dynamics of motherhood with that of the entrepreneurial realm (Mair et al.; Shaw and De Bruin; De Bruin and Lewis). Thus, whether women make integral connections between worker flexibility and their structured realities (be it around race or gender, for instance), it is clear that they continue to face particular challenges that call for them to (re)negotiate their work-life strategies (Jean and Forbes; Ekinsmyth, "Challenging the Boundaries"). The embeddedness of these lived realities and the complexities that these create for mothers within the entrepreneurial sphere remain obscured. This "public discourse ... on ...work and family life ... [is therefore] hard to ignore" (Whitehead et al. 3). Such silences call for new research that speaks to the importance of these contextual or situational realities for the positionalities,

perspectives, wellbeing, and identities of mothers. What is needed at this point are (re)imaginings of this work-life interface that pushes and reframes the thinking and practices of mothers working as entrepreneurs (Nel et al; Ekinsmyth, "Managing the Business"; Lewin; Duberley and Carrigan).

The Chapters of this Collection

The authors in the first section of this book—"Negotiating Neo-liberalism and Autonomy"—explore how mothers who are entrepreneurs negotiate capitalist and other economic models of domination including the problematic aspects of global entrepreneurial identities.

The first chapter, "Reproducing Precarity: Representations of Mompreneurship, Family, and Work in a British Columbian Parenting Magazine" by Joseph Moore and Gillian Anderson focuses on the representation of women entrepreneurs in *West Coast Families*—a Canadian parenting magazine published in Vancouver, British Columbia. The authors argue that the narratives of "mompreneurship" and that of the possibility related to having it all mask the hardships, struggles, and precarity of being entrepreneurs. A key insight from their work is how the magazine communicates a neoliberal discourse that shifts responsibility, decision making, and debt onto individuals. This emerges through how the authors position the centring of enterprise culture and the entrepreneurial self within a broader process that normalizes the value of competition and situates the market as the dominant organizing mechanism of social life. In this sense, entrepreneurship is presented as a process that promises and celebrates worker flexibility. This chapter, though, emphasizes how these market processes and principles impose certain values, expectations, and constraints on women, whose lives are continuously commodified and differently structured by an enterprising culture. The authors argue for the continued interrogation of the processes through which women and mothers both experience and respond to dominant narratives and politics related to family, work, culture, market, and identity.

In chapter two, "Mompreneur: Is This a Real Job," Allison Weidhaas confronts questions about the legitimacy and intricacy of mothers who are entrepreneurs. This chapter addresses the dangers within competing

discourses of motherhood and entrepreneurship for women and mothers who move between the maternal and entrepreneurial spheres. Using a relational perspective of work, the author demonstrates the extent to which cultural contexts, relationships, and gender roles remain at the centre of the tensions, uncertainty, and trepidations that emerge for mothers who are entrepreneurs. The challenge that emerges therefore is one of delineating the specific characteristics and dynamics for mothers as entrepreneurs. The question of a "real job," therefore, makes visible not only the social cultural and economic constructions around the two domains but also the relational ways in which entrepreneurial mothers experience and respond to these constructions. By so doing, the author calls attention to the complexities around these discursive contexts, the ways in which these are sustained and internalized, as well as the difficulties associated with reconfiguring the narratives around such structured contexts. How entrepreneurial mothers justify and speak to the notion of a "real job," therefore, presents instructive points of interrogation.

In chapter three, "Structured Agency and Motherhood among Copreneurs in the Czech Republic," Nancy Jurik, Gray Cavender, Alena Křížková, and Marie Pospíšilová explore entrepreneurial mothers within the Czech Republic. Using a structured agency perspective, the authors reflect on the narratives of twelve female entrepreneurs to highlight the complexities related to motivations their family relationships as well as the entrepreneurial practices they have adopted. The authors present "copreneurship" as a strategy for coping with the degree to which institutional and cultural environments structure the agentic expressions of these women. The chapter shows the importance of these contextual factors on the contradictions of working within and between regulative frameworks, patriarchal norms, and the market economy. Thus, by centring familial relationships and environmental factors, the study allows us to locate women's gendered experiences, their choice for copreneurial arrangements, and the intricate ways in which they navigate such contextual dynamics within the Czech Republic.

In the second section of this book—"Race, Culture, and Market Activity"—the authors examine how the gendering and classing of entrepreneurship is informed by histories of migration and the politics of race. In chapter four, "Reclaiming Motherhood and Family: How Black Mothers Use Entrepreneurship to Nurture Family and

Community," Melanie Knight explores how Black women in Canada understand their role as mothers, business women, and their ties to community. Thus, although Knight recognizes the dominant narratives and stereotypical images associated with the super-strong Black mother, her chapter allows readers to think through alternative scripts and representations of the Black mother. Knight argues that Black mothers use entrepreneurship as a mechanism through to acquire more time and resources to nurture their children, to safeguard them against economic hardships, and to (re)educate them on social, cultural, and economic matters. Black women challenge individualistic models of economic practice and caregiving for more collective communal approaches. Ultimately, they challenge dominant gendered and racialized discourses of motherhood and entrepreneurship.

In chapter five, "Autohistoria-teoría: Lessons from a Deviant Bar Owner," Marissa Cisneros reflects on her deviant grandmother and discusses how social history, power structures, and culture worked to name and frame her grandma's maternal and entrepreneurial experience. In fact, the naming of her grandmother as a deviant bar owner compels the reader to see through the ways in which colonialism can structure and oppress ethnic minorities as well as the possibilities related to the use of culture, familial relations, and communities to defy these systems of power. The chapter, therefore, critically reflects on the stories of a Mexican American woman, whose entrepreneurial activities challenged and resisted the status quo of the 1940s in the U.S. and provided instructive lessons that resonated with the psychosocial and cultural dispositions of her granddaughter—the chapter's author. These counternarratives, therefore, highlight acts of resistance (being and becoming an entrepreneur), moments of struggles, and messages of strength. The story underscores the complex entanglement related to migration, power, representation, culture, entrepreneurship, and activism.

In the final section of the book—"Reframing the Work-Life Interface"—the authors deepen and reframe debates on work-life balance. The chapters focus on how these tensions associated with the work-life interface have negatively affected the position, wellbeing, and psychosocial orientations of mothers. In chapter six, "Social Positioning, Work-Family Interface, and Early-Careet Engagement: The Case of Entrepreneurial Mothers in Jamaica," Esnard demonstrates the extent

to which the structures and relations of power position the thinking and practices of entrepreneurial mothers in Jamaica. This chapter shows how positionality becomes a critical lens through which entrepreneurial mothers think through their subjectivity and strategize around the intricacies of that nexus. It also highlights how intersubjectivities and entrepreneurial engagement reflect practices of embodiment and performance that unfold differently based on how positionality is evaluated. These findings are used to make a case for the contextual and intersectional layers of mothering as an entrepreneur and the implications of these for how we begin to theorize about the positionalities, work-life interface, and engagement of entrepreneurial mothers.

In chapter seven, "Mompreneurship and Quality of Life in Trinidad and Tobago: Capabilities and Constraints," Ayanna Frederick looks at the work-life conflict and quality of life of entrepreneurial mothers within Trinidad and Tobago. Frederick uses Sen's notion of "capacity" to underscore the convergence and divergence of experiences related to the two domains, the concerns that mothers share for the realities of engaging between the two, and the ways in which they navigate these domains to improve their overall sense of wellbeing. By so doing, Frederick makes a case for the theoretical utility of social capacity theory for understanding the motherhood-entrepreneurship nexus. By shifting theoretical lenses, this chapter shows how an evaluative approach can help the reader delve further into the real and imagined possibilities of entrepreneurs who are mothers within this space.

In chapter eight, "Doing All That Matters: A Relational Career Psychology Perspective on Mother-Entrepreneurship Career Success," Rebecca Hudson Breen and Silvia Vilches employ the use of a relational career psychology perspective to examine the career-life development of women entrepreneurs. The chapter explores how well the business meets the needs of the women, how these needs are affected by their multiple life roles, and the changing nature of their relationships affects their experiences overtime. This relational analysis supports a women-centric approach, which sheds light on the contextually embedded and mutually constitutive effects of motherhood and entrepreneurship on the women's career-life trajectories. Such a shift in analysis allows for an appreciation of how mothers construct their own career paths, how mothers sustain their maternal and entrepreneurial worlds, how they to balance these competing demands.

Contributions of This Edited Collection

Despite the growing attention to women entrepreneurs, two core limitations remain. The first is the limited critique of contextual embeddedness that treats with the structures of power, which frame the realities, identities and practices of entrepreneurial mothers. The second is tendency for much of the research on women, mothers, and entrepreneurship to be concentrated in the Global North. The edited volume, therefore, examines the complexities for maternal entrepreneurs within specific contexts (namely, Canada, United States Caribbean, and Europe), and the nuanced ways in which these shape identities, perspectives, and positionalities across countries. The unique contributions of the volume are threefold.

First, the volume expands and deepens the understanding of entrepreneurial mothers beyond the social geographies for which the field is becoming increasingly recognized. This is achieved through examining mothers as entrepreneurs across global contexts, including mothers in the US (chapters three and nine), in Canada (chapters two and five), within transitional economies, such as the Czech Republic (chapter four), and within the Anglophone Caribbean (chapters seven and eight). Although the chapters do not cover the vast majority of the countries across these regions in the Global North and South, it presents useful starting points from which readers can begin to situate the specific social and economic constituencies that frame the thinking and practices of entrepreneurial mothers. These chapters also provide strong empirical support for the relevance of contextual explorations of mothering and entrepreneurship on a broad level and for comparative structures and differences in the realities of mothers across contexts.

Second, the chapters in this edited volume offer empirical insights that transcend existing divides between the local and the global, the material and the relational, the maternal and the entrepreneurial as well as the discursive and the lived. To a large extent, such analyses serve as instructive litmus tests through which the authors push new perspectives or theoretical lenses, which all take into consideration the multiplicities and complexities within the entrepreneurial engagement of women and mothers. Although these frameworks remain exploratory, they offer critical social and psychological perspectives, through which we can begin to scrutinize or problematize how mothers make sense of or respond to structural forms of marginalization within the entrepreneurial sphere.

Collectively, these theoretical and methodological insights present important lenses through which we can begin to shift interrogations of maternal and entrepreneurial realms. These chapters also centre the comparative as well as the sociocultural and economic realities of mothers and discus how mothers are discursively and materially constructed as well as how they reproduce or resist the tensions embedded within the everyday complexities of working through these matrices of power. In some ways, the volume helps readers to contextualize and politicize the thinking and practice of entrepreneurial mothers. By examining this mothering-entrepreneurship nexus, we take the position that the realities of entrepreneurial mothers are contextually situated, structured, and constructed in multiple and complex ways, which produce diverse yet shifting perspectives, experiences, and responses. With such a focus, this edited collection enables readers to comprehend the changing patterns and conditions of work as well as the deep-seated sociocultural and ideological frameworks that shape existing expectations surrounding women, mothers, and work. Collectively, such theorizations help shift understandings of the complexity, specificity and tractability of entrepreneurial mothers who are continuously entangled within the mechanics of the market.

Works Cited

Ahl, Helene. *The Scientific Reproduction of Gender Inequality: A Discourse Analysis of Research Texts on Women's Entrepreneurship.* Copenhagen Business School Press, 2004.

Ahl, Helene. "Why Research on Women Entrepreneurs Need New Directions." *Entrepreneurship Theory and Practice*, vol. 30, no. 5, 2006, pp. 595-622.

Aldrich, Howard E., and Jennifer E. Cliff. "The Pervasive Effects of Family on Entrepreneurship: Towards a Family Embeddedness Perspective." *Journal of Business Venturing*, vol. 18, no. 5, 2003, pp. 573–596.

Allahar, Anton. "Ethnic Entrepreneurship and Nationalism in Trinidad: Afrocentrism and Hindutva." *Social and Economic Studies*, vol. 53, no. 2, 2004, pp. 117-54.

Allen, I. Elaine, et al. *Global Entrepreneurship Monitor 2007 Report on Women and Entrepreneurship.* The Centre for Women's Leadership &

Global Entrepreneurship Research Association, 2008.

Barriteau, Eudine. "Women Entrepreneurs and Economic Marginality: Rethinking Caribbean Women's Economic Relations." *Gendered Realities: Essays in Caribbean Feminist Thought*, edited by Patricia Mohammed, University of the West Indies Press, 2002, pp. 221-48.

Baxter, S., and G. Raw. "Fast Food, Fettered Work: Chinese Women in the Ethnic Catering Industry." *Enterprising Women*, edited by Sallie Westwood and Parminder Bhachu, Routledge and Kegan Paul, 1988, pp. 58-76.

Bjørnskov, Christian, and Nicolai Foss. "How Strategic Entrepreneurship and the Institutional Context Drive Economic Growth." *Strategic Entrepreneurship Journal*, vol. 7, no. 1, 2013, pp. 50-69.

Brown, Doyle, et al. *Women Entrepreneurs in Canada in the '90s*. Business Development Bank of Canada, 2002.

Brown, Wendy. "Neoliberalism and the End of Liberal Democracy." *Edgework: Critical Essays on Knowledge and Politics*, edited by Wendy Brown, Princeton University Press, 2009, pp. 37-59.

Browne, Katherine E. "Female Entrepreneurship in the Caribbean: A Multisite, Pilot Investigation of Gender and Work." *Human Organization*, vol. 60, no. 4, 2001, pp. 326-42.

Bruni, Attila, et al. "Doing Gender, Doing Entrepreneurship: An Ethnographic Account of Intertwined Practices." *Gender, Work and Organization*, vol. 11, no. 4, 2004, pp. 406-29.

Brush, Candida, et al. *The Diana Project, Women Business Owners and Equity Capital: The Myths Dispelled*. Kauffman Center for Entrepreneurial Leadership, 2001.

Brush, Candida G., et al. "A Gender-Aware Framework for Women's Entrepreneurship." *International Journal of Gender and Entrepreneurship*, vol. 1, no. 1, 2009, pp. 8-24.

Brush, Candida G., et al. "Introduction: Women Entrepreneurs and Growth." *Women Entrepreneurs and the Global Environment for Growth: A Research Perspective*, edited by Candida G. Brush, et al., Edward Elgar Publishing, 2010, pp. 1-16.

Brush, Candida G., et al. "Advancing Theory Development in Venture Creation: Signposts for Understanding Gender." *Women's Entrepreneurship in the 21st Century: An International Multi-Level Research*

Analysis, edited by Kate V. Lewis, et al., Edward Elgar Publishing, 2014, pp. 11-26.

Bruton, Gary D., et al. "Entrepreneurship and Strategy in Emerging Economies." *Strategic Entrepreneurship Journal*, vol. 7, no. 3, 2013, pp. 169-180.

Caccia, Federico C., and Juliette M. Baleix. "Foreign Direct Investment from Emerging Countries: Motivations and Impacts." *Revista de Economia Mundial*, vol. 50, 2018, pp. 65-82.

Carrington, Christine. "Women Entrepreneurs." *Journal of Small Business and Entrepreneurship*, vol. 19, no. 2, 2006, pp. 83-93.

Cetindamar, Delik, et al. "What the Numbers Tell: The Impact of Human, Family and Financial Capital on Women and Men's Entry into Entrepreneurship in Turkey." *Entrepreneurship & Regional Development*, vol. 24, no. 1-2, 2012, pp. 29-51.

Chell, Elizabeth, and Susan Baines. "Does Gender Affect Business 'Performance'? A Study of Microbusinesses in Business Services in the United Kingdom" *Entrepreneurship and Regional Development*, vol. 10, no. 2, 1998, pp. 117-35.

Clark, Sue C. "Work/Family Border Theory: A New Theory of Work/Family Balance." *Human Relations*, vol. 53, no. 6, 2000, pp. 747-70.

Collins, Patricia Hill. *Black Feminist Thought: Knowledge, Consciousness, and the Politics of Empowerment*. Routledge, 2000.

Cranford, Cynthia J., and Leah F. Vosko. "Conceptualizing Precarious Employment: Mapping Wage Work across Social Location and Occupational Context." *Precarious Employment: Understanding Labour Market Insecurity in Canada*, edited by Leah F. Vosko, McGill-Queen's University Press, 2006, pp. 43-66.

Damaske, Sarah, and Kathleen Gerson. "Viewing 21st Century Motherhood through a Work-Family Lens." *Handbook of Family Work Integration: Research, Theory and Best Practices*, edited by Karen Korabik, Donna S. Lero and Denise L. Whiteheah, Academic Press, 2008, pp. 233-48.

Das Gupta, T. "Racism/Anti-Racism, Precarious Employment, and Unions." *Race and Racialization: Essential Readings*, edited by Tania D. Gupta et al., Canadian Scholars' Press Inc., 2007, pp. 350-55.

De Bruin, Anne, and Kate V. Lewis. "Traversing the Terrain of Con-

text in Social Entrepreneurship." *Journal of Social Entrepreneurship*, vol. 6, no. 2, 2015, pp. 127-36.

Dechant, Kathleen, and Asya A. Lamky. "Toward an Understanding of Arab Women Entrepreneurs in Bahrain and Oman." *Journal of Developmental Entrepreneurship*, vol. 10, no. 2, 2005, pp. 123-40.

Delage, Benoit. *Results from the Survey of Self-employment in Canada*. Human Resource Development Canada, 2002.

Dell'Anno, Robert. "Inequality and Informality in Transition and Emerging Countries." *IZA World of Labour*, 2016, pp. 1-11.

Demo, Anne T. et al. *The Motherhood Business: Consumption, Communication, and Privilege*. University of Alabama Press, 2015.

Desrochers, Stephan, and Leisa D. Sargent. "Boundary/Border Theory and Work-Life Family Integration." *Organizational Management Journal*, vol. 1, no. 1, 2004, pp. 40-48.

Di Domenico, MariaLaura, et al. "Social Bricolage: Theorizing Social Value Creation in Social Enterprises." *Entrepreneurship Theory and Practice*, vol. 34, no. 4, 2010, pp. 681-703.

DiQuinzio, Patrice. "Mothering and Feminism: Essential Mothering and the Dilemma of Difference." *Maternal Theory: Essential Readings*, edited by Andrea O'Reilly, Demeter Press, 2007, pp. 542-55.

Drache, Daniel, et al. "Non-Standard Employment, the Jobs Crisis and Precarity: A Report on the Structural Transformation of the World of Work." *SSRN*, 2015, http://dx.doi.org/10.2139/ssrn.2581041. Accessed 13 Oct. 2019.

Duberley, Joanne, and Marylyn Carrigan. "The Career Identities of Mumpreneurs' Work-Life Balance: A Gendered Perspective." *Entrepreneurship Theory and Practice*, vol. 36, no. 3, 2013, pp. 513-41.

Eddleston, Kimberly A., and Gary N. Powell. "Nurturing Entrepreneurs' Work-Life Balance: A Gendered Perspective." *Entrepreneurship Theory and Practice*, vol. 36, no. 3, 2012, pp. 513-41.

Ekinsmyth, Carol. "Challenging the Boundaries of Entrepreneurship: The Spatialities and Practices of UK 'Mumpreneurs.'" *Geoforum*, vol. 42, no. 1, 2011, pp. 104-14.

Ekinsmyth, Carol. "Family Friendly Entrepreneurship: New Business Formation in Family Spaces." *Urbani izziv*, vol. 23, no. 1, 2012, pp. 115-25.

Ekinsmyth, Carol. "Managing the Business of Everyday Life: The Roles of Space and Place in 'Mumpreneurship.'" *International Journal of Entrepreneurial Behaviour & Research*, vol. 19, no. 5, 2013, pp. 525-46.

Ergeneli, Azize, et al. "Work-Family Conflict and Job Satisfaction Relationship: The Roles of Gender and Interpretive Habits." *Gender, Work and Organization*, vol. 17, no. 6, 2010, pp. 679-95.

Esnard, Talia. "The Personal Plan Is Just as Important as the Business Plan: A Feminist Social Constructivist-Rationalist Choice Approach to Female Entrepreneurship." *The Journal of the Motherhood Initiative for Research and Community Involvement,* vol. 3, no. 1, 2012, pp. 163-81.

Esnard, Talia. "Centering Caribbean Women's Gendered Experiences and Identities: A Comparative Analysis of Female Entrepreneurs in St Lucia and Trinidad and Tobago." *Women's Entrepreneurship in the 21st Century: An International Multi-Level Research Analysis*, edited by Kate V. Lewis et al., Edward Elgar Publishing, 2014, pp. 278-93.

Esnard, Talia. "Negotiating Identities: The Case of Mompreneurs in Trinidad and Tobago." *Mothering in the Age of Neoliberalism*, edited by Melinda Vandenbeld Giles, Demeter Press, 2014, pp. 133-47.

Esnard, Talia. "Entrepreneurial Engagement and Wellbeing in the Caribbean: A Meta-Synthesis." *Wellbeing of Women in Entrepreneurship: A Global Perspective*, edited by Maria Teresa Lepeley et al., Routledge, 2019, pp. 179-96.

Essers, Caroline, et al. *Critical Perspectives on Entrepreneurship: Challenging Dominant Narratives*. Routledge, 2017.

Ferdinand, Carol. *Jobs, Gender and Small Enterprises in the Caribbean: Lessons from Barbados, Suriname and Trinidad and Tobago*. International Labor Organization, 2001.

Foss, Nicolai J., et al. "The Role of External Knowledge Sources and Organizational Design in the Process of Opportunity Exploitation." *Strategic Management Journal*, vol. 34, no. 12, 2013, pp. 1453-71.

Frederick, Ayanna, and Talia Esnard. "Women, Mothers, and Entrepreneurial Engagement in the Caribbean: The Challenge of Context." *Go to Market Strategies for Women Entrepreneurship Creating and Exploring Success*, edited by Victoria Crittenden, Emerald Publishing, 2019, pp. 109-24.

Freeman, Carla. *Entrepreneurial Selves: Neoliberal Respectability and the Making of a Caribbean Middle Class.* Duke University Press, 2014.

Fudge, Judy, and Leah F. Vosko. "Gender, Segmentation and the Standard Employment Relationship in Canadian Labour Law, Legislation and Policy." *Economic and Industrial Democracy,* vol. 22, no. 2, 2001, pp. 271-310.

Giles, Melinda V. "An Alternative Mother-Centric Economic Paradigm." *Mothering in the Age of Neoliberalism,* edited by Melinda Vandenbeld Giles, Demeter Press, 2014, pp. 1-30.

Gupta, Vishal K., et al. "The Role of Gender Stereotypes in Perceptions of Entrepreneurs and Intentions to Become an Entrepreneur." *Entrepreneurship Theory and Practice,* vol. 33, no. 2, 2009, pp. 397-417.

Hamilton, Eleanor. "The Discourse of Entrepreneurial Masculinities (and Femininities)." *Entrepreneurship and Regional Development,* vol. 25, no. 1-2, 2013, pp. 90-99.

Haynes, Kathryn. "Moving the Gender Agenda or Stirring Chicken's Entrails?" *Accounting, Auditing & Accountability Journal,* vol. 21, no. 4, 2008, pp. 539-55.

Hays, Sharon. "Why Can't a Mother Be More like a Businessman?" *Maternal Theory: Essential Readings,* edited by Andrea O'Reilly, Demeter Press, 2007, pp. 408-30.

Hoogevelt, Angie. *Globalization and the Post-Colonial World: The New Political Economy of Development.* 2nd ed. John Hopkins University Press, 2000.

Hossein, Caroline S. "Using a Black Feminist Framework: A Study Comparing Bias against Female Entrepreneurs in Caribbean Microbanking." *Intersectionalities: A Global Journal of Social Work Analysis, Research, Policy, and Practice,* vol. 2, 2013, pp. 52-70.

Hughes, Karen D. *Gender and Self-employment in Canada: Assessing Trends and Policy Implications.* Canadian Policy Research Networks, 1999.

Hughes, Karen D., and Jennifer E. Jennings. "Introduction: Showcasing the Diversity of Women's Entrepreneurship Research." *Global Women's Entrepreneurship Research: Diverse Settings, Questions and Approaches,* edited by Karen D. Hughes and Jennifer E. Jennings, Edward Elgar Publishing, 2012, pp. 1-11.

Hughes, Karen D., et al. "Extending Women's Entrepreneurship Research in New Directions." *Entrepreneurship Theory and Practice*, vol. 36, no. 3, 2012, pp. 429-42.

Hytti, Ulla. "Contextualizing Entrepreneurship in the Boundaryless Career." *Gender in Management: An International Journal*, vol. 25, no. 1, 2010, pp. 64-81.

Ibarra, Herminia. *Working Identity: Unconventional Strategies for Reinventing Your Career*. Harvard Business School Press, 2003.

Ilcan, Suzan. "Privatizing Responsibility: Public Sector Reform Under Neoliberal Government." *Canadian Review of Sociology*, vol. 46, no. 3, 2009, pp. 207-34.

Jaim, Jahangirnagar, and Nazmul Islam. "Context Specificities in Entrepreneurship Research." *Journal of Entrepreneurship, Business and Economics*, vol. 6, no. 1, 2018, pp. 59-77.

Jayawarna, Dilani, et al. "Entrepreneur Motivations and Life Course." *International Small Business Journal*, vol. 31, no. 1, 2013, pp. 34–56.

Jean, Melissa, and Caroline Forbes. "An Exploration of the Motivations and Expectations Gaps of Mompreneurs." *The Journal of Business Diversity*, vol. 12, no. 2, 2012, pp. 113-30.

Jessop, Bob. "Liberalism, Neoliberalism and Urban Governance: A State-Theoretical Perspective." *Antipode*, vol. 34, no. 3, 2002, pp. 452-72.

Josephides, Sasha. "Honour, Family and Work: Greek Cypriot Women Before and After Migration." *Enterprising Women*, edited by Sallie Westwood and Parminder Bhachu, Routledge, 1988, pp. 34-58.

Kanti Prasad, V., et al. "Exploring Entrepreneurial Fulfilment for Women in India: An Empirical Study." *Journal of Enterprising Culture*, vol. 19, no. 3, 2011, pp. 287-314.

Khosla, Punam. *If Low Income Women of Colour Counted in Toronto*. The Community Social Planning Council of Toronto, 2003.

Kirkwood, Jodyanne. "Motivational Factors in a Push-Pull Theory of Entrepreneurship." *Gender in Management: An International Journal*, vol. 24, no. 5, 2009, pp. 346-364.

Klak, Thomas. *Globalization and Neo-liberalism: The Caribbean Context*. Littlefield Publishers, 1998.

Knight, Melaine. "For Us by Us (FUBU): The Politicized Space of Black Women's Entrepreneurship in Canada." *Southern Journal of Canadian Studies,* vol. 5, no. 1-2, 2012, pp. 162-83.

Knight, Melanie. "Raceing, Classing and Gendering Racialized Women's Participation in Entrepreneurship." *Gender, Work & Organization,* vol. 23, no. 3, 2014, pp. 310-17.

Korsgaard, Steffen. "Mompreneurship as a Challenge to the Growth Ideology of Entrepreneurship." *Kontur,* vol. 16, no. 1, 2007, pp. 42-45.

Korzeniewicz, Roberto P., and William C. Smith. "Poverty, Inequality, and Growth in Latin America: Searching for the High Road to Globalization." *Latin American Research Review,* vol. 35, no. 3, 2000, pp. 7-54.

Krizkova, Alena, et al. "The Division of Labour and Responsibilities in Business and Home among Women and Men Copreneurs in the Czech Republic." *Women's Entrepreneurship in the 21st Century: An International Multi-Level Research Analysis,* edited by Kate A. Lewis et al., Edward Elgar, 2014, pp. 258-77.

Larner, Wendy. "Neo-liberalism: Policy, Ideology, Governmentality." *Studies in Political Economy,* vol. 63, no. 1, 2000, pp. 5-25.

Lashley, Jonathan, and Katrine Smith. *Profiling Caribbean Women Entrepreneurs: Business Environment, Sectoral Constraints and Programming Lessons.* International Bank for Reconstruction and Development/ The World Bank, 2015.

Lewis, Patricia. "'Mumpreneurs': Revealing the Post-Feminist Entrepreneur." *Revealing and Concealing Gender: Issues of Visibility in Organizations,* edited by P. Lewis and R. Simpson, Palgrave Macmillan, 2010, pp. 124-38.

Lister, Ruth. "Women and Public Policy, Post-neoliberalism? A UK Perspective." Canadian Political Association Annual Conference, May 2006, Toronto. Conference Presentation.

Mair, Johanna, et al. "Building Inclusive Markets in Rural Bangladesh: How Intermediaries Work Institutional Voids." *Academy of Management Journal,* vol. 55, no. 4, 2012, pp. 819-50.

Malenfant, Romaine, et al. "Intermittent Work and Wellbeing: One Foot in the Door, One Foot Out." *Current Sociology,* vol. 55, no. 6, 2007, pp. 814-35.

McElroy, Jerome L., and Katherine Sanborn. "The Propensity for Dependence in Small Caribbean and Specific Islands." *Bank of Valletta Review*, Spring, no. 31, 2005, pp. 1-16.

McEwan, Cheryl. *Post Colonialism, Decoloniality and Development*. 2nd ed. Routledge, 2019.

Mirchandani, Kiran. "A Special Kind of Exclusion: Race, Gender and Self-employment." *Atlantis*, vol. 27, no. 1, 2002, pp. 25-38.

Moghadam, Valentine M. "Gender and the Global Economy." *The Globalization and Development Reader: Perspectives on Development and Global Change*, edited by J. Timmons Roberts and Amy Bellone Hite, Blackwell Publishing, 1999, pp. 135-51.

Nel, P., et al. "Motherhood and Entrepreneurship: The Mumpreneur Phenomenon." *The International Journal of Organizational Innovation*, vol. 3, no. 1, 2010, pp. 6-34.

O'Brien Hallstein, Lynn. "When Neoliberalism Intersects with Post-Second Wave Mothering: Reinforcing Neo-traditional American Family Configurations and Exacerbating the Post-Second Wave Crisis in Femininity." *Mothering in the Age of Neoliberalism*, edited by Melinda Vandenbeld Giles, Demeter Press, 2014, pp. 297-314.

Orser, Barbara J., et al. "Women Entrepreneurs and Financial Capital." *Entrepreneurship Theory and Practice*, vol. 30, no. 5, 2006, pp. 643-65.

Parasuraman, Saroj, and Claire A. Simmers. "Type of Employment, Work-Family Conflict and Wellbeing: A Comparative Study." *Journal of Organizational Behaviour*, vol. 22, no. 5, 2001, pp. 551-68.

Porter, Doug, and David Craig. "The Third Way and the Third World: Poverty Reduction and Social Inclusion in the Rise of 'Inclusive' Liberalism." *Review of International Political Economy*, vol. 11, no. 2, 2004, pp. 387-423.

Porter, Elaine G., and K. V. Nagarajan. "Successful Women Entrepreneurs as Pioneers: Results from a Study Conducted in Karaikudi, Tamil Nadu, India." *Journal of Small Business and Entrepreneurship*, vol. 18, no. 1, 2005, pp. 39-52.

Pupo, Norene, and Mark Thomas. *Interrogating the New Economy: Restructuring Work in the 21st Century*. University of Toronto Press, 2010.

Pupo, Norene, et al. *Crises in Canadian Work: A Sociological Perspective.* Oxford University Press, 2017.

Ramirez-Pasillas, et al. "Contextualizing Entrepreneurship In-Between." *Contextualizing Entrepreneurship in Emerging Economies and Developing Countries*, edited by Marcela Ramirez-Pasillas, Ethel Brundin and Magdalena Markowska, Edward Elgar, 2017, pp. 1-17.

Rapley, John. *Globalization and Inequality: Neoliberalism's Downward Spiral.* Lynne Rienner Publishers, 2004.

Reynolds, Jeremy, and Linda A. Renzulli. "Economic Freedom or Self-Imposed Strife: Work-Life Conflict, Gender and Self-Employment." *Entrepreneurship: Research in the Sociology of Work (Vol. 15)*, edited by L. Keister, Elsevier Limited, 2005, pp. 33-60.

Richomme-Huet, Katia, et al. "Mompreneurship: A New Concept or an Old Phenomenon?" *International Journal of Entrepreneurship and Small Business,* vol. 19, no. 2, 2013, pp. 251-75.

Rodríguez, M. J., and F. J. Santos. "The Activity Emprendedorade the Women and the Process of Creation of Companies." *Commercial Information*, vol. 841, 2008, pp. 117-34.

Rooney, Jennifer, et al. *Self-Employment for Women: Policy Options That Promote Equality and Economic Opportunities.* Status of Women Canada, 2003.

Salmenniemi, Suvi, et al. "Between Business and Byt: Experiences of Women Entrepreneurs in Contemporary Russia." *Europe-Asia Studies*, vol. 63, no. 1, 2011, pp. 77-98.

Sangha, Jasjit, and Tahira Gonsalves. *South Asian Mothering: Negotiating Culture, Family and Selfhood.* Demeter Press, 2013.

Sharifian, Manely, et al. "Should Women Go into Business with their Family Partner?" *Global Women's Entrepreneurship Research: Diverse Settings, Questions and Approaches*, edited by Karen D. Hughes and Jennifer E. Jennings, Edward Elgar, 2012, pp. 114-34.

Shaw, Eleanor, and Anne De Bruin. "Reconsidering Capitalism: The Promise of Social Innovation and Social Entrepreneurship?" *International Small Business Journal,* vol. 31, no. 7, 2013, pp. 737-46.

Shelton, Lois M. "Female Entrepreneurs, Work-Family Conflict and Venture Performance: New Insights into Work-Family Interface." *Journal of Small Business Management,* vol. 44, no. 2, 2006, pp. 285-97.

Smallbone, David, and Friederike Welter. "The Distinctiveness of Entrepreneurship in Transition Economies." *Small Business Economics,* vol. 16, no. 4, 2001, pp. 249-62.

Steyaert, Chris, and Jerome Katz. "Reclaiming the Space of Entrepreneurship in Society: Geographical, Discursive and Social Dimensions." *Entrepreneurship & Regional Development,* vol. 16, no. 3, 2004, pp. 179-96.

Terjesen, Siri, and Jose E. Amoros. "Female Entrepreneurship in Latin America and the Caribbean: Characteristics, Drivers and Relationship to Economic Development." *European Journal of Development Research,* vol. 22, no. 3, 2010, pp. 1-18.

Ucbasaran, Deniz, et al. "The Focus of Entrepreneurial Research: Contextual and Process Issues." *Entrepreneurship: Theory and Practice,* vol. 25, no. 4, 2001, pp. 57-80.

United Nations Development Programme. *Caribbean Human Development Report: Human Resilience Beyond Income.* UNDP, 2016.

Verheul, Ingrid, et al. "Explaining Female and Male Entrepreneurship at the Country Level." *Entrepreneurship and Regional Development,* vol. 18, no. 2, 2006, pp. 151-83.

Voydanoff, Patricia. "Towards a Conceptualization of Perceived Work-Family Fit and Balance: A Demand and Resource Approach." *Journal of Marriage and Family,* vol. 67, no. 4, 2005, pp. 822-36.

Welter, Friederike. "Contextualizing Entrepreneurship: Conceptual Challenges and Ways Forward." *Entrepreneurship Theory and Practice,* vol. 35, no. 1, 2011, pp. 165-184.

Westwood, Sallie, and Parminder Bhachu. "Introduction." *Enterprising Women,* edited by Sallie Westwood and Parminder Bhachu, Routledge, 1988, pp. 1-20.

Whitehead, Denise L., et al. "Work-Family Integration: Introduction and Overview." *Handbook of Work-Family Integration: Research, Theory and Best Practices,* edited by Denise L. Whitehead, Donna S. Lero, and Denise L. Whitehead, Academic Press, 2008, pp. 3-11.

World Bank. *The Environment for Women's Entrepreneurship in the Middle East and North Africa Region.* World Bank, 2007.

Zahra, Shaker A. "Contextualizing Theory Building in Entrepreneurship Research." *Journal of Business Venturing,* vol. 22, no. 3, 2007, pp. 443-52.

SECTION I

Negotiating Neoliberalisms and Autonomy

Chapter One

Reproducing Precarity: Representations of Mompreneurship, Family, and Work in a British Columbian Parenting Magazine

Joseph Moore and Gillian Anderson

In this chapter, we reflect on the representation of women entrepreneurs in the magazine *West Coast Families*. Our intent is to critically engage with these representations to tease out what they might tell us about family, work, and gender in late capitalism. This moment, we argue, is one in which precarity has come to define not only labour markets but also politics, culture, and family life. In short, we argue that the narratives of mompreneurship offered in this popular magazine are something of a bait and switch, in which the possibility of having it all masks the ever more distinct possibility of losing it all. Grounded in real-world examples of determination, creativity, and conscience, these stories forget, overlook, and, in the end, help mask the boring, futile, and desperate struggles of many others. However, we also want to suggest the possibility that in refusing to be fully captured by the logic of neoliberalism, mompreneurship opens up possibilities for rethinking gender roles and identities as well as capitalist economic and cultural forms.

The Context of Precarity

Social theorists and political economists have historically named the particular sociocultural environment they find themselves in, and if they were fortunate, these labels would cross over from academic journals to popular culture. Over the last several decades, such terms as postmodernity, liquid modernity, globalization, post-Fordism, the risk society, and enterprise culture have each, to a greater or lesser extent, had their moment in the sun (Harvey; Bauman; Robertson; Beck; Peters). Although these terms are often intensely debated and sometimes positioned as competitors with one another, each centres the notions of heightened insecurity, risk, reflexivity, and uncertainty. If there is agreement to be had among this disparate group it is that the material, cultural, and psychological precarity that has marked the lives of marginalized peoples (Olofsson et. al.) has come now to be more generalized.

For the moment, it appears that neoliberalism has captured the naming rights for our tumultuous times, and with the acknowledgment that this term is contested (Whelan), we tend to argue for its usefulness. On the one hand, neoliberalism's more recent history in critical political economy dovetails with our materialist sensibilities, and, on the other, its adoption by a wide range of feminists, critical geographers, and cultural theorists has broadened its reach. As noted by Jennifer Lawn and Chris Prentice, neoliberalism "directly names a particular mode of political economy, and governance that is inextricable from cultural life, from intra-subjective through to collective levels" (1).

A recent research paper published by the International Monetary Fund concisely defines the neoliberal agenda as consisting of two main planks: the deregulation and opening of markets fostering competition and the shrinking of the state through privatization and limits on government spending (Ostry et al.). As David Harvey has pointed out, what could be cast as a straight forward change in economic policy has in fact entailed, indeed demanded, the "creative destruction" of not only economic policy but also "ways of life and thought, reproductive activities, attachments to the land and habits of the heart" (2). Here, we only wish to highlight the well repeated acknowledgement that more and more of our lives, our families, and our psyches have been subjugated to economic cycles and the zero-sum games of marketplace dynamics.

The neoliberal turn is most directly encountered through paid work.

Unleashed from international and domestic barriers, capital has flowed quicker and less predictably around the globe. At home, governments have deregulated labour markets. Union density, especially in the private sector, has fallen. In North America at least, workers' long march for shorter-working hours has been stopped in its tracks. Not without controversy, Canada's former finance minister Bill Morneau, suggested that "job churn" is inevitable and that the most governments might do is to "think about, 'How do we train and retrain people as they move from job to job to job?' Because it's going to happen. We have to accept that" ("Get Used To"). The so-called gig economy has extended to a broader number of private and now public job markets and has created more part-time, contract, intern, and low-wage work—a situation summed up in a 2015 CIBC report that describes a decade long decline in "job quality" attributable to the weak bargaining power of those in what is now "the fastest growing segment of the labour market" (Tal).

Precarity in neoliberal times extends beyond the job market. As Sanford Schram and others have described, a heavily financialized economy combined with neoliberal public policy has shifted responsibility, decision making, and debt onto individuals. While governments scale back the use of debt to spur economies and maintain social welfare supports, neoliberal citizens are encouraged and compelled to take on student loans, mortgage, and consumer debt—and the incumbent risks. The poor, who have always faced precarity, are now joined by the self-identified middle class, whose formal education and professional status produce ever thinner buffers from uncertainty. Though felt throughout Canada, Vancouver has become something of a posterchild for this broadening of precarity, where a potent mix of high housing costs, renovictions, and mortgage debt have extended precarity well into the ranks of the relatively privileged middle class (Catherall).

Although precarity has become generalized, the class effects have intensified. Neoliberal economic policies have created a redistributive effect much more effective than those accomplished by Keynesian and welfare states; only in this case, the redistribution has been directed upwards toward the wealthiest. The attendant growing income and wealth inequality creates not only insecurity for those at the bottom but also precarity in the form of anemic growth and more dramatic economic fluctuations. Here too, however, there is a link to not only deeper but also broader precarity. Though underdeveloped, there exists a growing

scholarship on the social psychology of inequality that suggests a link to lower levels of trust, status competition, and happiness at the societal level (Wilkinson and Pickett). Speculation is rife on the connection mechanisms, but it seems probable that as the stakes of inequality grow, so do the generalized fears and anxieties of others. As Richard Wilkinson and Kate Pickett aptly describe, alongside the threat of material deprivation comes a more generalized "threat to the social self" (37).

It is, however, a mistake to homogenize the experience of precarity. Neoliberal policies have had a greater impact on those with fewer market resources and marginalized communities faced with discrimination and exclusion. There exists a substantial and growing literature on the intersectional effects of neoliberal policy on the poor, racialized minorities, women, youth, LGBT2Q+ and persons with disabilities. Speaking to the experience of mothers facing the policy shift from Unemployment to Employment Insurance in Canada, Leslie Nichols concludes that "women with intersecting underprivileged identities, characterized by low income, immigration, and having children to care for, are left without the supports enjoyed by a select group of privileged women who are assumed to represent the entire feminine condition" (16). Nicole Bernhardt, meanwhile, reminds us that "while neoliberalism has intensified the experience of precariousness and exclusion for racialized Canadians" a return to a welfare state that in itself was "built around the norm of a White male-breadwinner model" is hardly a solution (1).

Precarity, the Enterprise Society, and Entrepreneurship

The ascendancy of neoliberal policy is not an inevitable consequence of the contradictions of welfare states but rather an ongoing accomplishment grounded in political, cultural, and personal struggle. The creative destruction of economic and social policies, longstanding political arrangements, and of those "habits of the heart" has required winning elections, garnering consent, and crushing of the opposition. Other scholars have aptly traced the overt political struggles (Stedman Jones; Monbiot; Metcalf), and we agree with many that neoliberal economic policies have been both a cause and consequence of a neoliberal cultural turn and have become new common sense. Stephen Metcalf captures

this nicely arguing that neoliberalism is

> a way of reordering social reality, and of rethinking our status as individuals. … we are now urged to think of ourselves as proprietors of our own talents and initiative … a language formerly confined to chalkboard simplifications describing commodity markets (competition, perfect information, rational behaviour) has been applied to all of society, until it has invaded the grit of our personal lives … the attitude of the salesman has become enmeshed in all modes of self-expression. (www.theguardian.com/news/2017/aug/18/neoliberalism-the-idea-that-changed-the-world)

Metcalf sharply identifies with what others have referred to as the new "enterprise culture," which celebrates self-reliance, risk taking, and competition (Wee and Brooks 1). In this culture, the figure of the entrepreneur looms large or, perhaps, small. What we mean by "small" is that whereas earlier forms of capitalism might have given special place to the entrepreneur as a heroic figure worthy of both admiration and outsized rewards, neoliberal culture democratizes entrepreneurship— voices from a surprising range of political vantages tell us that "we are all entrepreneurs" (Cosic; De Carolis).

Those making such claims not only stretch the definition of entrepreneur to the point of breaking but also "necessarily bypass the reality and balance of real working lives" (Nicholson and Anderson qtd. in Bowman 385). The resonance of the entrepreneur, however, comes not from its accurate representation of material circumstances but from the fact that it holds out hope that we may find meaning and prosperity in an increasingly precarious environment. For the champions of neoliberalism, and those simply trying to just get by, creativity, flexibility, and fearlessness will allow us to surf the increasing uncertainty of our times. In the best case, tossing aside the ties of Fordist bureaucratic work arrangements and state welfare systems will provide the freedoms of entrepreneurial work to the masses; the "boundaryless career" will supersede the organizational career and its constraints (Lewis).

More sinisterly, this cultural figure, this idealized entrepreneurial self, also helps make sense of winners, whose increasingly disproportionate wealth can be attributed to their equally disproportionate merit, and of losers, whose hardship reflects a lack of initiative, creativity, and forward

thinking. The centring of enterprise culture and the entrepreneurial self is part of the normalizing of competition and market logic as the dominant organizing mechanisms of social life. As in the new economy, the new culture entails winners and losers and the losses here include but are not limited to values of embeddedness, (inter)dependency, and cooperation. As Dardot and Laval argue, "neoliberalism is not merely destructive of rules, institutions and rights. It is also *productive* of certain subjectivities ... at stake in neoliberalism is nothing more, nor less than the *form of our existence*" (8).

A critical feminist and intersectional lens is necessary, however, if we are to understand the gender politics that underlie this broader cultural shift. As others have noted "the archetypical entrepreneur is male" (Bowman 2), that "existing definitions of entrepreneurship are premised on a particular heroic masculine norm" (Luckman 149), and that the "entrepreneurial self is normed white" (Gill and Ganesh 272). Long after women's struggles to join the "organizational man" in steady paid work had born significant fruit, both the myth and practice of entrepreneurship remained staunchly male, and there is evidence that this continues to be the case. Across the Organization for Economic Co-operation and Development, which includes Canada, women are less likely to be owners of businesses and are less inclined to do so ("Women Entrepreneurship").

The cultural centring of the entrepreneur in neoliberalism can, however, be read in many, sometimes contradictory ways. Although we remain skeptical, a point to which we will later turn, some have argued that an increasingly entrepreneurial culture and economy can lead to "alternative models" of entrepreneurship (Ekinsmyth), which may be more inclusive of women. The hope for an inclusive, degendered entrepreneurship can be understood as particularly inviting to women who struggle with persistent gender discrimination and harassment in traditional workplaces, which trap women in more ways than men. In any case, recent data suggest that the lure of entrepreneurship is particularly strong for Canadian women. There remains a gender gap in the different measures of entrepreneurial activity. However, this is narrowing more rapidly in Canada than in similar countries, and Canadian women report similar positive attitudes towards entrepreneurship (Hughes).

There is reason, however, to question the appropriation of neoliberal

enterprise culture by women. The preeminent scholar on mompreneurship, Carol Ekinsmyth, cautions that even the most optimistic accounts must be aware of the "the darker side of mumpreneur working practices, the potential for self-exploitation, workaholism, hidden labour (emotional and affective) and the newly enabled practices ... that bring capitalism firmly (and potentially damagingly) into the realm of the family" (1244). It is a distinct possibility that in celebrating some white and economically privileged women's pursuit of seemingly "boundaryless" entrepreneurial careers, we may also be reinforcing a cultural ideal and an economic and political form that is harmful to the vast majority of women (and men). Richard Sennett, who has cast one of sharpest eyes and sympathetic ears to the women and men working in the precarious workplaces of enterprise culture, summarizes this as follows: "Here I had the chance to see the cultural ideal of the new capitalism at its most robust, the boom suggesting that this new man/woman would get rich by thinking short term, developing his or her potential and regretting nothing. What I found instead were a group of middle-class individuals who felt that their lives were cast adrift" (7).

Precarity, Gender, and the Family

If the neoliberal turn has made precarity the central feature of the landscape of paid work, it has also disrupted families and communities bringing austerity and precarity into the most intimate spaces of our lives. This transformation, however, has been curious and contradictory. Simultaneous processes of defamilialization, which under neoliberal regimes takes the form of the commodification of care work and household maintenance, and refamilialization, where families are encouraged/forced to make up for services no longer provided by the state (see for example, Fudge and Cossman). Alternately, the processes of commodification and decommodification (Pupo and Dufy) have pushed and pulled in different directions (for a discussion of the gendered effects, see Mathieu). Neoliberal regimes have reversed the expansion of state support for families, privatized public facilities, and aggressively pushed the commodification of reproductive work while arguing that individuals and families can make the best decisions about how and when to provide these services and that they can best do so through purchasing them in the market. Everything from meals,

cleaning, homework support, yard work, and caregiving are increasingly outsourced in a neoliberal, market version of defamilialization.

The commodification of family life feeds into the precarity of gender and familial relations in several ways. Perhaps the most contradictory is that as state supports often using unionized labour have been replaced with market goods relying on low-wage, part-time work, union density has dropped, labour market regulations and protections have been lost, and job polarization has gained speed. An increasing number of workers, often racialized women, rely on precarious work, typically providing gendered caring labour or family services so that economically advantaged women and men may spend more time in (better) paid work (Tungohan et al.). These women, in turn, face the gendered burden of unpaid care work in their own homes (Premji et al).

At the same time, the commodification of reproductive work—from meal provision, pet care, cleaning to education and cleaning services—is intensely marketed and has become a middle-class norm (Livingston). The purchasing of these services is made possible by increasing consumer debt, which is itself marketed relentlessly, leaving even relatively more affluent families both deeply embedded in markets and at economic risk (Montgomerie). Across class divides, longer hours of work are needed to address the precarity of low wages, high costs, and debts, time impoverishment accentuates the precarity of not only low-income families, many headed by lone mothers, but also the more relatively privileged (Schor).

In many respects, defamilialization through the commodification of daily life is consistent with the market fetishism and individualism of neoliberal economics. More curious is the extent to which, across a wide spectrum of countries, there has been a parallel form of refamilialization rooted in more socially conservative politics. Here, feminist political economists have argued that the triumph of neoliberalism owes as much to the moral romanticizing of traditional family bonds, as it does to the fetishizing of market solutions. In the face of dwindling support from the state, it is families that are expected to pick up the burden, and in heterosexual nuclear families, it is mothers who continue to undertake an unfair burden of unpaid work. Feminist scholars refer to these twin processes as the "simultaneous intensification and erosion of gender" (Haraway; Brodie; Harder) and, by extension, the intensification and erosion of the family (Fudge and Cossman).

West Coast Families Magazine and the Celebration of Mompreneurs

It is in this context of neoliberal precarity, precarity of work, income, debt, and time that we read the narratives of mothers working as entrepreneurs featured in *West Coast Families,* a parenting magazine published in Vancouver, British Columbia. In several regards, the province is an ideal locale in which to study the economic and cultural implications of mompreneurship. Between 2001 and 2016, the province was ruled by the centre-right Liberal Party that enacted policies of business-friendly deregulation, attacked public sector employees, and provided tax cuts for both corporations and wealthy individuals. By the time that the social democratic NDP, in an alliance with the Green Party, formed a minority government in 2017, British Columbia had Canada's highest rates of income and wealth inequality. British Columbia has also been identified by the Business Development Bank of Canada as having the highest rate of small and medium size start-ups (Edwards) and, when self-employment is counted, the province has the highest rate of women-owned small businesses in Canada.

Since 2007, *West Coast Families,* which produces roughly nine editions each year, has published glossy profiles of mothers, typically a one or two page spread that highlights the work and family life of a woman in British Columbia, most of whom reside in Metro Vancouver. Initially, these profiles were featured as part of a magazine insert titled "Yummy Mummy, This Time It's All About You!" However, in 2010, the format changed with a rebranding and launch of *West Coast Mom.* Eventually, the *West Coast Mom* profile continued as a feature of a singular, broader *West Coast Families* publication. The feature is a prominent part of the *West Coast Families* brand and is highlighted in the "About Us" section of the website. On (rare) seasonal occasions, the feature is turned over to a "West Coast Dad," typically in the June edition to coincide with Father's Day, or to "West Coast Grandparents" in the September edition. The magazine's webpage notes how they wish to include "all family members" in their publications.

Previously, we have interrogated these profiles for what they have to say about ideologies of motherhood (Anderson and Moore), but here we focus more specifically on the profiles that highlight mompreneurs. The "mompreneur" label is contentious and has been taken to mean everything from a generic title for combining mothering and widely

defined entrepreneurial work to the more specific that involves the "configuring of a business around the spatio-temporal routines of childcare work" (Ekinsmyth 1235). Here, we apply a narrow definition and have considered only profiles of women who own or co-own their own business. We recognize the debate over the use of the term and the fact that many reject it. Our use does not discount the argument that mompreneur discourse can serve to reproduce traditional gender roles or that it has the potential for creating new understandings of gender and work. As will become apparent, we argue alongside Ekinsmyth that it just might be capable of both. A total of thirty-seven profiles were included in this analysis.

Mompreneurship: Success, Entrepreneurship, and Motherhood

Above all, these narratives embody an entrepreneurial spirit; they exude stories of courage, strength, and success. The women profiled have made a choice to start a business, and through their commitment and talents, they have succeeded. These are not stories of unfortunate decisions, mistakes, or regrets. Other than the acknowledgment of difficulties, such as juggling work and family commitments (see below), there are few hints of hardship. An owner of a baby store described the process as follows: "We worked on putting all our ideas together and created a business plan—and, then, just jumped in without looking back. It was scary but we realized that it was better to try and fail than never to try at all" (April 2008). Exemplifying this theme, a mompreneur said that "my life just seems to flow ... I think I take it all in stride and try to stay organized and focused. I've always had a gift for managing stress" (July/August 2010). These silences are telling.

As we have earlier noted about the representation of contemporary motherhood more broadly, these women entrepreneurs are "doing it all ... and making it look easy" (Anderson and Moore 95). Almost all the women featured are described as building successful businesses, spending quality time with their children and family, and enjoying a blissful family life. One representative mompreneur, a woman who owns a children's furniture, accessory, and clothing store, is described as having a charmed life; with her real estate agent husband, she has "managed to create an example of the life they hope for their daughter; one that includes success,

love and family." It is a life that combines a successful business, skiing in the local mountains, an off-the-grid cabin for relaxing, and evenings at restaurants and dancing (May/June 2016).

It should be noted that many of these women attribute their success in business to motherhood, arguing that their mothering provides skills and strengths useful in entrepreneurship. The owner of a children's party planning business contended that "I really feel that being a mom has made me a better woman.... Motherhood has given me the power and the strength to achieve my goals" (July/August 2010). Another woman who started her own business after several years of unpaid work in the home described her experience in the following way: "When I was a stay-at-home mom, I lost some of my confidence and didn't give myself credit for being a productive part of my family. But, looking back, I realize how important my role has been, and I owe a lot of credit to my children for helping me become a much stronger, capable woman" (April 2009).

Motherhood is also the impetus for these women's entrepreneurship. Although there are rare examples of women whose entrepreneurial activities predate their becoming a mother, almost all of the profiles imply, if not explicitly state, that these women started their businesses because of their desire to find a way to combine an intense commitment to parenting with paid employment. Often, the rationale for this choice is not elaborated in any detail. One mompreneur bluntly stated: "I was one of those women who requested part time work of my employer after the birth of my son and was shown the door. It was a hard time in my life. I felt like I didn't have any options" (October 2009). Another mompreneur, working from a home-based business, described the following situation: "As a woman working in the corporate world, I felt I wasn't able to commit enough energy towards raising my children ... by deciding to stay home, I've realized that so many mothers feel exactly the same way and are crying out for a better solution" (May 2008). These narratives reflect the earlier empirical work of Bruce Arai, who found that women in Canada turn to entrepreneurial work to cope with what Canadian sociologist, Meg Luxton has termed the "double day."

In a world in which the freedom to engage in paid work is threatened by precarious economies and the freedom to have less paid work is stymied by patriarchal workplace cultures, these narratives celebrate entrepreneurship as a way out for women. However (un)representative

such success stories may be of the real-world experience of most women, these stories hail entrepreneurship as a form of taking control over the pace, place and content of work. The material trappings of success are on occasion noted. That said, the definition of success at the forefront of these profiles centres the ability of mompreneurs to combine their entrepreneurial career with mothering work.

Entrepreneurship and the Family

Two major themes concerning the intersection of family and entrepreneurship emerge in these profiles: the struggle to balance time demands of work and family obligations as well as the desire and ability to prioritize family. In almost every instance, the mompreneur profiles address the question of how these women deal with the demands of both running their business and finding time for family and themselves. Indeed, the profiles almost invariably direct attention to the strategies women use and to the possibility of a work-life fit.

In rare examples, a profile will suggest that the mompreneur works part time or has a stay-at-home partner. For instance, a pregnant mother of a two-year-old and owner of a children's clothing and toy store described how she spent her mornings with her child and afternoons at the store: "I couldn't be in a better workplace for being pregnant" (April 2008). In another case, a (heterosexual) couple, both business owners, each worked partial weeks (he worked four days and her three) so that "one of us is always home" (June 2014). The partner of the owner of a children's store meanwhile decided to step aside from his real estate business until their child began school (May/June 2016).

Mostly though mompreneurs are said to use the aforementioned flexibility of entrepreneurship to reconcile the demands of family and paid work. Three strategies are most common: bringing children to work, working while parenting away from the workplace, and working around parenting times. In each case, these solutions are presented, uncritically, as effective. Articulating the most direct form of this blending of paid work and childcare, one mompreneur described how when taking business calls during the day, "the person on the other end may hear one of my children in the background—that's just the reality of it" (October 2009). Another explained that her key solution for balancing work and childcare was to "have as many art and craft supplies in my

office as I do files!" (July/August 2010). Strategic multitasking was common, especially among the many profiles of retail businesses focused around children, where one suspects children are less likely to seem out of place.

What struck us, however, was the extent to which many profiles underscored that the presence and integration of children and the workplace was more than a useful form of childcare; it was also understood to be a self-reflective form of engaged parenting. A craft centre owner said the following about her son: "[He] can't help but be engaged at the store because of how much time we spend there. His love of books and interest in what we do there makes me thankful to have pursued my ambitions" (May 2012). Similarly, the owner of a tea company and farm where ingredients are grown described that her three children are all part of the business: "Kalea often helps with events while the younger kids like to help forage for herbs and fungi" (May 2014). Children's work on family farms has a long tradition. For these parents, such inclusion was both a way to simultaneously parent and engage in paid work. This mother remarked: "We involve the kids in steps as an educative experience about initiative, creative problem solving and accountability, using time wisely" (May 2014).

Other women brought work to their childcare. It was not uncommon for these women to list their mobile phones as a must have more often than not so that they might "be at the park with my kids and still feel in touch with my work" (December/January 2010). It was acknowledged that this was not always a viable solution and that sometimes one had to simply work after the children were in bed or when other care was possible. One mompreneur lamented she found it hard to get paid work done "in the summer when Sam and Jane needed [her] most" (April 2009).

Most of the profiles, at one point or another, emphasize that these women prioritize family. One profile begins rather bluntly: "What gets you out of bed in the morning? Like most of us, Jem Terra rises in the morning to do what is necessary to financially support her family. But that is only a small portion of what motivates Jem. Like most of us moms, her biggest passion is her children" (April 2010). An owner of a web domain registry company shared the following: "You never feel like you are spending enough time on the business but your first priority is the children" (May 2008). The founder of an online home décor store assured

readers that "my priority will always be my children, but I'm happy to be spreading my wings a bit, too" (April 2009). In another instance, a mompreneur who owns a travel company and works as a television and radio host reminded readers that "it is the all-encompassing role of 'Mom' that is [her] number one priority." This mompreneur said, "I would drop everything that I'm doing right now if they needed me ... being a mom is the most important thing that I do" (December 2007/2008).

In a similar vein, the owner of a small chain of umbrella shops and an umbrella manufacturing company is described as passionate about her trade, but this is then qualified: "Although her business is important to her, Cory truly shines in her most important role as mother to her three children." The article goes on to quote this mompreneur's rule of thumb: "Motherhood is always primary. In saying that, any working mom will tell you that there is always stress between being a good mom and being there for your business" (Nov/Dec 2014).

It is only very rarely and always obliquely that a profile alludes to the fact that a woman may have prioritized her paid work. A former United Nations lawyer who runs an organization advising companies of social and environmental responsibility issues and an offshoot that runs educational workshops for children described herself as "once a serious 'workaholic'" but now tries to take one day off a week to spend with her four-year-old daughter. A little more directly, a chemical engineer who fled Iran following the revolution and is now an owner of a skin care product company admitted that her biggest challenge in life has been balancing family and work: "I adore my family and always feel they have been neglected through my work" (November/December 2010).

This last profile also stands out as one of only a few cases in which there is more than a passing reference to husbands, partners, or other family members helping with domestic tasks and childcare. This woman—whose profile makes it clear that she was a pioneer having broken into male-dominated domains—credited the support of her "true partner in life who shares everything and believes in equality and respect. "I have been blessed to have been loved and respected and helped throughout my marriage" (November/December 2010). In another example, the two female co-owners of a publishing business relied on family members and paid care providers to "cobble together a network of support." But they emphasized their "supportive partners, both at

work and home, [who] are the glue that holds the business together" (January/February 2017). Yet such passages are the exception, and in no instances are male partners described as fathers first.

The profiles are also relatively silent on the subject of childcare outside of the privatized realm and the de facto care provided by schools for older children. Though one mompreneur was the owner of a private daycare, such care was mostly performed by the women themselves. One mompreneur was quoted as saying: "The biggest reward of my work is that I get to spend a lot of time with my girl. I've never needed daycare or a nanny—not to imply it wouldn't have been handy here and there—but we always made it work" (September 2011).

In short, these profiles place their subjects firmly within the gendered definition of "mompreneur" favoured by Ekinsmyth. These are women who have challenged masculine definitions of entrepreneurship, not the least by their mere presence as women entrepreneurs. However, in simultaneously maintaining their position as primary caregiver, these women have insisted that "doing business differently" does not mean "doing gender differently" (Luckman 156)—or family, for that matter. There is a real risk here that the celebration of motherhood reinscribes neoliberal divisions of labour that paradoxically erode and intensify gender and family relations in the face of economic precarity.

Motherhood and the Quest for Good Work

If these narratives place motherhood as the prime reason for women's entrepreneurship and balancing the demands of motherhood with entrepreneurial work as the most significant challenge, they also suggest that motherhood has shaped the sorts of businesses that the women build and how they go about this.

In fact, many of the profiles are of businesses that grew directly out of the women's caregiving and mothering experiences. The women are described as looking for a particular product for their child; they are concerned about the quality of preschool education available, or they are concerned about bullying at school, and they decide that what they do for their own children they can do for others through building a business.

Sometimes, it is just about recognizing an individual talent or opportunity to commodify an aspect of parenting that a mother may already be doing for their own child. A party organizer, for instance, suggested that "being a parent myself, I know first-hand how much work

it can be to plan your child's party ... I think we all want to give our child the party they deserve but parents simply don't have the time to do it" (May 2008). Often, however, there is the suggestion that the mompreneurs want to provide for the greater good and to provide for the greater community. The founder of a private school was motivated by a worry for her own boys that "with the technology driven world ... her children needed a different kind of learning experience" (May/June 2017). In each case, these mothers spin their good mothering into commodities that buy time for others, who have the resources to do so.

The profiles take pains to underscore the social, environmental and ethical values that the women bring to their business ventures, often blurring the lines between reproductive and productive work. One of the clearest examples of this blurring is reflected in the concerns of the owner of an organic bedding company. Her search to find non-toxic bedding for her child and to then market it is held up as "just one great example of a mother who has proposed to make the world a better place for her children and that passion has become something beneficial to us all" (April 2010). In another profile, the owner of a wooden toy store explained that the blurring of such lines is deeply rooted in her experience of motherhood: "As with many other mompreneurs my priorities shifted when I had children and while I still very much wanted to work in some capacity my decision was that in order to spend time away from the kids, the work needed to be meaningful and not something where I just went through the motions and collected a paycheque" (May 2010).

These profiles also highlight the importance of entrepreneurial activity as community building. At the broadest level, they speak to how the women's businesses are tied to volunteer activities, such as when the organic bedding company owner is highlighted for making "charity a large part of her business" (April 2010). The owner of a retail store that sold the work of local artists and craftspeople (all within 100 kilometres of the store) described her "lifelong goal ... to support the growth and well-being of the arts community" (May 2012).

Two of the profiles are of women who started businesses that cater to women entrepreneurs. One woman, for instance, cofounded Momcafé Network Inc. which produces events and is an online hub, "to support the dialogue between educated, savvy women who are striving to balance their lives." The owner explained that "with so many options available, these women needed a forum to come together to share ideas and

opportunities" (December 2009/January 2010). Another echoed this sentiment, saying I think the biggest reward for me with my work has got be when a mom comes up to me and tells me EMN [Enterprising Moms Network] helped them and contributed to their growth. That makes it all worthwhile because that's exactly why I started it—to support women" (October 2009). An owner of a small chain of paediatric physiotherapy centres was quoted as relying on such a service and coming to the recognition that "I can be a business owner and a mom. I just had to tap into the community. I call them mompreneurs" (Jan/Feb 2015). A woman who has her own line of spices, hosts a cooking show, and authors cookbooks declared "I love women and I think we need to support each other, mentor each other, make each other strong" (March 2012).

In these narratives, mompreneurship is positioned as an effective response to the desire of women to be fully committed mothers and to have paid work. Motherhood, however, offers not just a reason for becoming an entrepreneur; it, in turn, shapes of the sort of entrepreneur women become. The experience of motherhood is said to provide skills and aptitudes that support entrepreneurship, and mompreneurs are said to bring values of cooperation, community, and social responsibility to their entrepreneurship. The narratives describe women who first identify as mothers but who also through entrepreneurship create good work that they can reconcile with parenting.

The profile of one mompreneur named Erin had this to say: "Much of the workforce craves the kind of opportunity that Erin has created for herself. She is able to work in a field she cares deeply about, can bring her child to work with her while honing a love for art in others" (July/August 2014). This quote captures the dominant theme and hope of these profiles. Questions remain, which we will explore in a moment, whether this represents a viable strategy for less advantaged women or, for that matter, for most advantaged women. Moreover, even if such mompreneurship became more widely possible, the political implications are unclear.

Framing the Good Life and Good Mother in a Precarious World

It is not difficult to find fault with the narratives of mompreneurship displayed in these profiles. Indeed, they echo what Susan Luckman has called the 'magical solution" of micro-entrepreneurial homework. These stories repeatedly and emphatically insist that through entrepreneurship, women can find economic stability and nonalienated work while also completely engaging in the joys of motherhood and caregiving. As in much magic, the illusion rests on both what is revealed and what is concealed.

Certainly, there is much hidden in respect to the financial stability of entrepreneurship. Although the numbers vary depending on where we are in economic cycles, each year in Canada, thousands of small and medium sized businesses are created, and a similar number also fail ("Archived—Key Small Business Statistics"). Whereas these profiles show us the births, the deaths are left unaccounted for. The precarity of this work will only exacerbate if, as the "churn" of jobs continues, more are drawn to entrepreneurship as an alternative. Only once among all of these profiles was the worry of business failure directly addressed and that was when a woman described herself as "inherently risk adverse" and admitted that the pursuit of entrepreneurship made "leaving a secure and stable income difficult." Avoiding almost any hint of financial difficulty, of cash flow problems, of troubles raising capital and getting loans, these profiles distance us from the material struggles of most entrepreneurs and especially women. Mompreneurship may, indeed, represent a "cruel optimism" that "exists when something you desire is actually an obstacle to your flourishing" (Berlant in Luckman 156).

If the precarity of such businesses is hidden, so are the working conditions. The reality of long hours is raised, but usually just in passing. It is hardly a focus and is almost always dismissed. These mompreneurs make it work. What Ekinsmyth refers to as part of the "darker side of mumpreneur working practices"—the self-exploitation, workaholism, and hidden labour—remains largely in the shadows. The profiles do acknowledge the struggle to find balance, but this is typically and magically resolved through the flexibility of entrepreneurial work, including working from home, bringing children into the workplace, having nonstandard working hours, using technology, and multitasking paid work with caregiving.

Meanwhile, many of these mompreneurs are running businesses that employ staff (or sell retail products created by other, often women labourers), and it is entirely unclear how these workers similarly juggle paid and unpaid work. While our attention focuses on the impressive acrobatics of women who successfully build businesses while caring for children and families, we risk losing sight of the vast majority of women (and men) whose precarious work is not balanced by the rewards of unalienated work and whose economic situation precludes the purchasing of commodified reproductive services of which they often produce. In the narratives, the privilege of buying one's way out of the double day is usually reserved for modest splurges, such as spa services or restaurants, and none of the profiles explicitly mention paid caregivers. Though not part of our sample, in an early article about an upcoming workshop on mompreneurship, there is but one mention of an owner of a web domain name registry company for whom "choosing to hire a live-in nanny cleaning help and to work from home has allowed her to focus what little free time she has on her children" (May 2008). We expect however that this is another silence not necessarily reflective of at least some of the more economically privileged mompreneurs.

Finally, in fetishizing the centrality of women's unpaid caregiving and the relentless message that with proper time management, hard work, and ingenuity caregiving is made compatible with the precarity of entrepreneurial work, these narratives risk reproducing traditional gender roles in a political economy in which such gender roles are even more harmful. Our attention is drawn away from the harm of extended work hours, from burnout, and from family conflict. On their own, these omissions are enough to condemn the mompreneur narratives of this magazine as just another neoliberal fantasy—a bright and shiny distraction from the everyday struggles of women and men to find meaning and livelihoods in labour markets where precarity is the norm. The solution to the contradictions and inconsistencies of neoliberal political economy turns out, to no surprise, to be individual struggle, creativity, and hard work rather than political struggles for either stable work or the sort of robust, stable social supports that women and men need if they are to successfully navigate precarious labour markets.

The Mompreneur and Resistance

It is then of significant political import that we not veer away from the critique of cultural narratives that hold out unrealistic expectations for women trapped between imperatives to participate in increasingly precarious job markets and to continue to take on the majority of unpaid reproductive work. At the best, some relatively privileged women manage—only through self-exploitation, the purchasing of time, luck, and skill—to adjust to this precarious world. The risks, however, are many and those with fewer economic, cultural, and social resources find themselves particularly vulnerable.

Indeed, the uncritical celebration of mompreneurship poses significant political risk for those of us who hold hope for a cross-class, intersectional alliance to provide alternatives to neoliberalism. Encouraging privileged women's retreat to the home or business could harbour a neo-traditionalism that reinforces neoliberal-conservative alliances in North America (Brown). Moreover, the entrepreneurial work of these women is made possible by, and reinforces, the commodification of everyday life. Many of these businesses—the party planners, home décor companies, hipster baby shops, landscapers, life coaches etc.—are fuelling a cycle of consumer spending and economic growth built on privatized debt that binds workers tighter to capitalist work (Schor). Such critiques, however, must not lose sight of the contradictions in neoliberalism that these mompreneur narratives have revealed. These narratives, however compromised by the silences around women's real, messy everyday struggles, do speak to women's struggles to do business differently and to challenge patriarchal norms of entrepreneurship.

The "creative destruction" of neoliberalism, which strips away the stability of both Fordist-era jobs and the supports of welfare states, demands as Sennett tells us, a new ideal woman or man—"a self oriented to the short term, focused on potential ability, willing to abandon past experience." Perhaps it need not be said, but we tend to agree with Sennett that "most people are not like this, they need a sustaining life narrative, they take pride in being good at something specific, and they value the experiences they've lived through" (5).

We read into these stories a counternarrative—a resistance to the demands of neoliberal ideals of limitless flexibility, of ruthless market rationality, and of the celebration of uncertainty. The nostalgia for the

family, however much as it may help reproduce an unequal gender division of labour in the home, also reflects an attachment to a space, the home, that market rationality can never quite capture. In a brilliant piece of rhetoric and pedagogy, A.G. Cohen invokes a camping trip to suggest that at least in certain contexts, even the most antiegalitarian among us accept that norms of reciprocity and cooperation are both appropriate and effective. We acknowledge that actual existing homes— shaped by intersections of capitalism, patriarchy, racism, and homophobia—often resemble hell more than a haven, homes freely chosen, as these narratives describe, are stubbornly resistant to the hyperrationalization of neoliberalism (Anderson et al. 9).

An alternative reading of these narratives, one centring more contradictory aspects, draws our attention to women who refuse to subjugate their lives to markets. They choose to maintain a proximity to a space that is organized, at least partially, through cooperation and reciprocity, principles that in the current moment are surfeit with radical possibility. Moreover, in their practice as entrepreneurs, they smuggle these values back into their business practices, where values of collaboration, cooperation, and doing good in the world come to challenge those of competition and limitless growth.

In many cases, these narratives underscore what Barbara Orser et al. refer to as the enaction of feminist values through "opportunity recognition and governance," which they identified in their interviews with "entrepreneurial feminists" (Orser et al. 249-51). A sympathetic reading, such as that of these authors, would speak to the way that these entrepreneurs are able to enact their feminist values within and through entrepreneurial activity. The challenge for feminism, and for the left more broadly, is not only to deconstruct the magic of mompreneur narratives and reveal the hidden costs of having it all but also to suggest alternative economic, political, and cultural structures that in a world of plenitude (Schor) would allow women and men to have meaningful work and lives. These narratives mask the messy, real-world experiences of the majority of women and men for whom late capitalism brings precarious work, family, and gender relations, they reveal the central human need for a coherent narrative identity as well as the importance of cooperation, reciprocity, and the reproductive work.

As Arlie Hochschild warns, when home becomes organized like work, both women and men flee. Without discounting the extent to

which neoliberalism has restructured the home through the business of commodified sport and entertainment, concerted cultivation, and the like, we believe that a feminist, class-conscious politics of the home is both needed and possible. Celebrating the importance of reproductive work over productive work for exchange value and embedding productive work within the needs of caring for others is only problematic when this work is undervalued, unequally distributed, and imposed. The task for a progressive politics, one that is ecologically and socially sustainable, is to render imaginable a broader economy that centres reproduction and meaningful work freely chosen. In a fashion highly compromised by the precarity of neoliberal economies, mompreneurs seek privatized ways of accomplishing just this. The task is to spread these successes widely.

Further research should aim to inform this political action. Insofar as neoliberalism is a cultural, political and, material project, there is a continued need to interrogate both the material realities of women's entrepreneurship and the attendant cultural imagery. The heterogeneity of women and of entrepreneurship calls for intersectional approaches that trace the contours of the different and unequal experiences of contemporary discourses on entrepreneurship. There is a continued need for the uncovering and celebrating the entrepreneurship of women, of racialized women, and of the economically disadvantaged, which is obscured by the dominant imagery of entrepreneurs as white, male, and economically privileged. And there is a need to interrogate if and when such entrepreneurship challenges dominant entrepreneurial practices (Orser et al.).

However, there also remains a need to continue to critically evaluate the material and cultural effects of entrepreneurship and entrepreneurial discourses as central to neoliberal regimes. The emancipatory impetus central to feminisms must continue to interrogate the means by which everyday entrepreneurial practices and discourses, which are performed by relatively privileged and marginalized women and men, reproduce neoliberal conditions (Luckman). The practice of entrepreneurial feminism (Orser et al.) must be interrogated within this context.

Works Cited

"Archived—Key Small Business Statistics – June 2016." *Government of Canada,* www.ic.gc.ca/eic/site/061.nsf/eng/h_03018.html#point 2-3, Accessed Feb. 16 2019.

Anderson, Gillian, et al. "Introduction: For a Sociology of Home in Canada." *Sociology of Home: Belonging, Community, and Place in the Canadian Context*, edited by Gillian Anderson, Joseph G. Moore, and Laura Suski, Canadian Scholars' Press, 2016.

Anderson, Gillian, and Joseph Moore. 2. "'Doing It All and Making It Look Easy': Yummy Mummies, Mompreneurs and Neoliberal Crises of Home." *Mothering and Neoliberalism*, edited by Melinda Vandenbed Giles, Demeter Press, 2014.

Arai, Bruce. "Self Employment as a Response to the Double Day for Women and Men in Canada." *Canadian Review of Sociology*, vol. 37, no. 2, 2000, pp. 125-42.

Bauman, Zygmunt. *Liquid Modernity*. Polity Press, 2000.

Beck, Ulrich. *Risk Society: Towards a New Modernity*. Sage, 1992.

Bernhardt, Nicole S. "Racialized Precarious Employment and the Inadequacies of the Canadian Welfare State." *Journal of Workplace Rights*, vol. 5, no. 2, 2015, pp. 1-13.

Bowman, Nina. "Men's business: Negotiating Entrepreneurial Business and Family Life." *Journal of Sociology*, vol. 43, no. 4, 2007, pp. 385-400.

Brodie, Janine. *Politics on the Margins: Restructuring and the Canadian Women's Movement*. Fernwood Publishing, 1995.

Brown, Wendy. "American Nightmare." *Political Theory*, vol. 34, no. 6, 2006, pp. 690-714.

Catherall, Robert. "Living on the Edge: Delineating the Political Economy of Precarity in Vancouver, Canada." *Queen's Policy Review*, vol. 8, issue 1, 2017, pp. 39-55.

Cohen, A. Gerald. *Why Not Socialism?* Princeton University Press, 2009.

Cosic, Miriam. "'We are All Entrepreneurs': Muhammad Yunus on Changing the World, One Microloan at a Time." *The Guardian: International Edition*, 29 Mar. 2017, www.theguardian.com/sustainable-business/2017/mar/29/we-are-all-entrepreneurs-muhammad-yunus-on-changing-the-world-one-microloan-at-a-time. Accessed 10 Apr. 2018.

Dardot, Pierre, and Christian Laval. *The New Way of the World: On Neoliberal Society*. Translated by Gregory Elliott, Brooklyn, Verso, 2014.

De Carolis, Donna M. "We Are All Entrepreneurs: It's A Mindset, Not A Business Model." *Forbes*, 9 Jan. 2014, www.forbes.com/sites/forbeswomanfiles/2014/01/09/we-are-all-entrepreneurs-its-a-mindset-not-a-business-model/#6fda7a3d84fd. Accessed 10 Apr. 2018.

Edwards, Glen. "Startup Fever: B.C. Becomes Hot Spot for Entrepreneurs." *Business in Vancouver,* 3 Apr. 2018, biv.com/article/2018/04/startup-fever-bc-becomes-hot-spot-entrepreneurs. Accessed 15 May 2018.

Ekinsmyth, Carol. "Mothers' Business, Work/Life and the Politics of 'Mumpreneurship.'" *Gender, Place & Culture*, vol. 21, no. 10, 2014, pp. 1230-48.

Fudge, Judy, and Brenda Cossman. "Introduction: Privatization, Law, and the Challenge to Feminism." *Privatization, Law, and the Challenge to Feminism*, edited by Brenda Cossman and Judy Fudge, University of Toronto Press, 2002, pp. 3-40.

"Get Used to Multiple Careers, Finance Minister Says." *Toronto Star,* 22 Oct. 2016, www.thestar.com/news/canada/2016/10/22/finance-minister-says-canadians-should-get-used-to-short-term-employment.html. Accessed 16 May 2018.

Gill, Rebecca, and Shiv Ganesh. "Empowerment, Constraint, and the Entrepreneurial Self: A Study of White Women Entrepreneurs." *Journal of Applied Communication Research*, vol. 35, no. 3, 2007, pp. 268-93.

Haraway, Donna. *Simians, Cyborgs and Women: The Reinvention of Nature.* Routledge, 1991.

Harder, Lois. *State of Struggle: Feminism and Politics in Alberta.* The University of Alberta Press, 2003.

Harvey, David. *The Condition of Postmodernity: An Enquiry into the Origins of Cultural Change.* Blackwell, 1990.

Hochschild, Arlie Russell. *The Time Bind: When Work Becomes Home and Home Becomes Work.* Henry Holt and Company, 1997.

Hughes, Karen D. "GEM Canada 2015/16 Report on Women's Entrepreneurship." *Global Entrepreneurship Monitor,* 14 Nov. 2017, www.thecis.ca/wp-content/uploads/2016/04/GEM-2015-16-Womens-Report-FINAL-Nov-14-2017.pdf. Accessed 10 April 2018.

Lawn, Jennifer, and Chris Prentice. "Neoliberal Culture/The Cultures of Neoliberalism." *Sites*, vol. 12, no. 1, 2015, pp. 1-29.

Lewis, Kate V., et al. "The Entrepreneurship-Motherhood Nexus: A Longitudinal Investigation from a Boundaryless Career Perspective." *Career Development International*, vol. 20, no. 1, 2015, pp. 21-37.

Livingston, Eve. "Middle-Class Feminism Has a Blind Spot Over Female Cleaners." *The Guardian: International Edition*, 1 April 2016, www.theguardian.com/commentisfree/2016/apr/01/middle-class-feminism-female-cleaners-domestic-low-paid. Accessed 8 Aug. 2018.

Luckman, Susan. "Women's Micro-Entrepreneurial Homeworking." *Australian Feminist Studies*, vol. 30, no. 84, 2015, pp. 146-60.

Mathieu, Sophie. "From the Defamilialization to the 'Demotherization' of Care Work." *Social Politics: International Studies in Gender, State & Society*, vol. 23, no. 4, 2016, pp. 576-91.

Metcalf, Stephen. "Neoliberalism: The Idea that Swallowed the World." *The Guardian: International Edition*, 18 Aug. 2017, www.theguardian.com/news/2017/aug/18/neoliberalism-the-idea-that-changed-the-world. Accessed 12 Apr. 2018.

Monbiot, George. "Neoliberalism—the Ideology at the Root of all our Problems." *The Guardian: International Edition*, 15 Apr. 2016, www.theguardian.com/books/2016/apr/15/neoliberalism-ideology-problem-george-monbiot. Accessed 12 Apr. 2018.

Montgomerie, Johnna. "Giving Credit where it's Due: Public Policy and Household Debt in the United States, the United Kingdom and Canada." *Policy and Society*, vol. 25, no. 3, 2006, pp. 109-41.

Nichols, Leslie. "Motherhood and Unemployment: Intersectional Experiences from Canada." *Canadian Review of Social Policy*, vol. 76, 2016, pp. 1-24.

Orser, Barbara, et al. "Entrepreneurial Feminists: Perspectives about Opportunity Recognition and Governance." *Journal of Business Ethics*, vol. 115, no. 2, 2013, pp. 241-57.

Ostry, Jonathan D., et al."Neoliberalism: Oversold." *Finance & Development*, vol. 53, no. 2, 2016, www.imf.org/external/pubs/ft/fandd/2016/06/ostry.htm. Accessed 2 May 2018.

Olofsson, Anna, et al. "The Mutual Constitution of Risk and Inequalities: Intersectional Risk Theory." *Health, Risk & Society,* vol. 16, no. 5, 2014, pp. 417-30.

Peters, Michael. "Education, Enterprise Culture and the Entrepreneurial Self: A Foucauldian Perspective." *Journal of Education Inquiry,* vol. 2, no. 2, 2001, pp. 58-71.

Premji, Stephanie, et al. "Precarious Work Experiences of Racialized Immigrant Women in Toronto: A Community Based Study." *Just Labour: A Canadian Journal of Work and Society,* vol. 22, 2014, pp. 122-43.

Pupo, Norene, and Ann Duffy. "Blurring the Distinction between Public and Private Spheres: The Commodification of Household Work – Gender, Class, Community, and Global Dimensions." *Work in Tumultuous Times: Critical Perspectives,* edited by Vivian Shalla and Wallace Clement, McGill-Queen's University Press, 2007, pp. 289-325.

Robertson, Roland. *Globalization: Social Theory and Global Culture.* Sage, 1992.

Sennett, Richard. *The Culture of the New Capitalism.* Yale University Press, 2006.

Schor, Juliet. *The Overspent American: Why We Want What We Don't Need.* Media Education Foundation, 2003.

Schram, Sanford. *The Return of Ordinary Capitalism: Neoliberalism, Precarity, Occupy.* Oxford University Press, 2015.

Stedman Jones, Daniel. *Masters of the Universe Hayek, Friedman, and the Birth of Neoliberal Politics.* Princeton University Press, 2012.

Tal, Benjamin. "Employment Quality, Trending Down." *CIBC,* 5 Mar. 2015, www.research.cibcwm.com/economic_public/download/eqi_20150305.pdf. Accessed 6 Sept. 2018.

Tungohan, Ethel, et al. "After the Live-In Caregiver Program: Filipina Caregivers' Experiences of Graduated and Uneven Citizenship." *Canadian Ethnic Studies,* vol. 47, no. 1, 2015, pp. 87-105.

Wee, Lionel and Ann Brooks. "Negotiating Gendered Subjectivity in the Enterprise Culture: Metaphor and Entrepreneurial Discourses." *Gender, Work & Organization,* vol. 19, no. 6, 2012, pp. 573-91.

Whelan, Andrew. "Academic Critique of Neoliberal Academia." *Sites: A Journal of Social Anthropology and Cultural Studies*, vol. 12, no. 1, 2015, pp. 1-25.

Wilkinson, Richard, and Kate Pickett. *The Spirit Level: Why Equality is Better for Everyone*. Penguin, 2010.

"Women Entrepreneurship: Key Findings: Canada." *OECD*, Mar. 2016, www.oecd.org/sdd/business-stats/EaG-Canada-Eng.pdf. Accessed 25 Mar. 2018.

Chapter Two

Mompreneur:
Is This a Real Job?

Allison Weidhaas

Connecting the Roles of Business Owner and Mother

Female business owners who are also mothers must contend with two different and frequently competing discourses—one related to motherhood and another related to business ownership—as they attempt to frame their identities in a dynamic and challenging landscape. This chapter explores how female business owners make sense of their experiences and if, at times, they question the legitimacy of their roles as "mompreneurs," a term intended to denote the combination of motherhood and entrepreneurship or business owner- ship. The term prioritizes motherhood by placing "mom" before the business role, and this chapter seeks to understand how women conceptualize this. Do they really prioritize motherhood over their business endeavours? How do they make sense of their mothering experiences while attending to the needs of a growing business?

In exploring these questions, it is important to recognize the complexity imbued in this chapter because identity roles are multifaceted. Identity is defined as how one answers the question "Who am I in a given context?" (Ladge et al.). Today, many scholars recognize that identity roles, the role one plays in a specific setting, are affected not only by social influences but also by the constraints of many intersecting identities (Helene and Gyger Gaspoz; Golombisky; Essers and Benschop). Research shows gender and work identities intersect in ways that enable

and constrain women as they construct their professional identities and simultaneously account for many contrasting and, at times, conflicting identities, including those related to culture, ethnicity, gender, and profession (Golombisky; Essers and Benschop).

This chapter specifically explores mompreneurs working in public relations, a service-oriented industry dominated by women (Cline; Grunig; Daugherty-Phillingane; Aldoory, "Feminist Criticism in Public Relations"; Place and Vardeman-Winter) and an industry that often lacks a clear definition (Sebastian; Tsetsura). This highly feminized industry has garnered criticism for practices perceived as limiting women's advancement (Wrigley; Cline et al.; Place and Vardeman-Winter; Dozier; Dozier et al.), which, along with definitional ambiguity, can make framing one's identity particularly challenging. One public relations study found female Russian public relations practitioners legitimized their roles as "real jobs" by employing gender in socially constructed ways that often limited their career advancement (Tsetsura). This finding could suggest that women in the United States (U.S.) also experience challenges framing their jobs as real, especially when adding motherhood to an already complicated identity.

Scholars continually recognize work as an important part of identity construction for most Americans. This may explain why Robin Clair's 1996 study of how individuals' perceive a real job attracted so much scholarly interest and follow up research (O'Connor and Raile; Clair et al.; Tsetsura). Amy O'Connor and Amber Raile, as well as Clair, draw attention to the need for increased scholarly attention on colloquial phrases because social implications are often embedded in these utterances.

To address the lack of scholarly attention to real jobs, Clair asked college students to provide their interpretations of a real job. Clair's participants identified a real job as one that earned them money—which was of primary importance to them—used their education, allowed them to live up to their potential, included the standard 40-hour work week, and offered opportunities for advancement. The students also listed factors that could undermine the job's status as real, including whether it was too easy or too low skilled, whether it was temporary or unstable, and whether it constituted a primary means of income (Clair).

This list provides some challenges when it's applied to mompreneurs. For example, Clair indicates a real job should occur during regular business hours, pay a salary, and include benefits. Business owners

frequently work odd hours, reinvest their income into their businesses, and pay their own benefits. The ability for women to characterize their mompreneur status as a real job may be further hampered by the time-consuming and often underappreciated mother role, which also fails to align with many of the constructs defined for a real job. Clair's study illuminates the problems for those who do not hold real jobs by indicating these individuals typically get marginalized or ignored. This chapter explores this concept as it exists in our neoliberal, capitalist economy with its often shifting work environment.

Using the frame of Clair's real job study, this chapter explores if the dual roles of mompreneur can be constructed as a real job and what this framing could mean for the women's identities. In examining this concept, it is important to consider the evolving expectations for career and gender roles while exploring how women narratively construct their interpretation of themselves. The chapter begins by exploring the literature on the roles of female business owners and mothers within the U.S., addresses the concept of a "real job," provides an overview of the methodology used, and concludes by embedding several narrative examples to reveal how women communicate their experiences. In many sections, the chapter explores the historical context of the role because I argue our social systems and expectations come from prior norms that continue to get reified in subtle and not so subtle ways. Often these expectations include gender, especially as it relates to organizational life. Although scholars have addressed how gender manifests in organizations (Ashcraft; Ashcraft and Mumby; Buzzanell and Liu; Gill et al.), more limited research exists on how systematic means of oppression follow people when they create their own organizations and what this means for individuals who must forge identities while aligning with social discourses.

Female Business Owners

This chapter examines female business owners and argues that traces of masculine associations with entrepreneurship still exist. This assertion aligns with other scholars' research, which has recognized the link between masculinity and business ownership (P. Lewis, "The Quest for Invisibility"; Lewis et al.; Hytti; Ahl; Kanze et al.; Know-ledge@Wharton).

Scholars, such as Anthony Giddens, recognize that social systems exist before we are born and often survive unabated throughout our lives. When changes occur, they typically unfold incrementally instead of the sweeping changes one often envisions, since social norms are so deeply engrained that people fail to question their underlying values and assumptions. For example, in 1939, a minimum wage was introduced in the U.S. to equalize pay between men and women; this was perceived as an enormous social change (McGee and Moore), most likely because the country's capitalistic value system frequently links pay and prestige. However, it did not have the monumental impact many people predicted. In 1939, one assumption was women only wanted minimum wage jobs, so it was assumed this would create equality. Although raising a minimum wage may increase the lowest salaries, it does not affect all jobs. Furthermore, even when the Equal Pay Act of 1963 was passed, little attention was given to how this law, and subsequent laws were enacted. For example, companies skirted issues of pay inequality by simply changing the job titles for male employees or they did not publicize salaries, making it nearly impossible to know if a pay difference existed (McGee and Moore). In 2018, PEW Research released a study of 2017 financial data, which revealed that women still only earned 82 per cent of a man's salary. In 2017, it would have taken an American woman an extra forty seven days per year to make the same annual median income of a man (Graf et al.); thus, gender-biased social systems still exist with minimal changes eighty years after the 1939 minimum wage act passed.

Not only do wages affect individuals employed in traditional organizational settings, but ideas about wages and value in a capitalist economy also impact women's perception of what they can charge for their services as well as their access to capital. Research shows women still experience challenges gaining access to venture capital and bank loans (Yohn, "You Can't Share Babies with Bonds"; "Crippled Capitalists"; Kanze et al.). Furthermore, on average, women-owned businesses earn less money (McManus), which aligns with women's lower median income. According to the U.S. Small Business Association, for every dollar generated by a female-owned business, a male-owned business earns $2.30 (McManus).

Negative perceptions about women and their ability to manage money and businesses have existed for centuries. In early American history, women were considered too irresponsible to handle money—a

misconception furthered by government requirements in the 1800s that women relinquish all property and financial rights to their husbands when they married (McGee and Moore). Negative associations of women and money continued for centuries; American women could not borrow money without a cosigner until the 1974 Equal Credit Opportunity Act. The inability to access funding or seed capital to start a business likely inhibited many fledging female entrepreneurs. Only 4 per cent of women were business owners by 1972 (Linard).

Historically, women were also harassed and judged as immoral for their interest in business. For example, Hetty Green, a business woman reportedly worth $100 million when she died in 1916, was villainized for her focus on business and wealth (Yohn, "Crippled Capitalists"). She was known as the "witch of Wall Street" for her reported focus on business over family, but some scholars question whether she was inappropriately judged based on society's long-standing view that honourable women stayed home (Yohn, "Crippled Capitalists"). Some argue these expectations still exist today (Yohn, "Crippled Capitalists"). They are borne out in conversations about good mothers staying home to raise children, inequalities in pay and benefits for women, and the smaller number of female-owned businesses.

Money and family caregiving frequently emerge as important conversations for business owners. Many mothers lament the lack of affordable childcare options or inflexible schedules that inhibit their ability to care for their families. Although there are stories of large companies offering daycare options and providing people in management-level positions flexible schedules so they can meet their children at the bus stop or nurse their infants during the workday, these practices do not exist unilaterally or in variety of workplaces. When American companies offer benefits, such as onsite daycare or extended maternity leave, they do so at their own expense; these are not government funded, and, thus, managing childcare is a significant concern for most American families. Childcare costs leave many U.S. families financially strapped (Pao); a recent survey indicates that childcare is not affordable for seven in ten U.S. families and that one in three families spend 20 per cent or more of their annual income on childcare ("This Is How Much Child Care"). When one considers women's lower salaries and lack of affordable childcare, it often creates challenges that make leaving the workplace appear as the only viable option. Women often report that they leave the

formal workplace because they are pushed out by these factors (Shelton; Williams), making self-employment or business ownership appear as a more viable option. Women in countries with less institutional support for family care—which could mean limited access to programs, such as affordable childcare, family-friendly scheduling, and longer maternity leaves—tend to have larger numbers of female business owners, but this "Plan B" approach often means these female business owners opt for smaller, less-growth-oriented endeavours (Thebaud). This finding is consistent with research that suggests women make conscious choices about their business size, often based on their family obligations (Morris et al.).

Although the U.S. is seen as the land of opportunity, research from the Small Business Association of America has found that there are still more male-owned businesses (McManus). Additionally, statistics show women own a greater number of small businesses, categorized as having five or fewer employees (McManus). Men are typically associated with large, growth-oriented businesses (McManus), and research indicates that business ownership or entrepreneurship is perceived as a masculine endeavour (P. Lewis, "The Quest for Invisibility"; Yohn, "Crippled Capitalists"; Knowledge@Wharton). Historically, women in the late eighteenth and nineteenth centuries employed men to masquerade as business owners to avoid ridicule and shame, potentially setting the stage for generations of women to experience business ownership as a mascu-line form of organizing (Yohn, "Crippled Capitalists"). In fact, recent studies show women still perceive the term "entrepreneur" as gendered (Gupta and Fernandez; Gill and Ganesh), which is particularly interest-ing given the focus in many cultures, including in the U.S., on entre-preneurship. It is a term used in political commentary, often touted in elections, and in the media on popular American shows, such as *Shark Tank, The Entrepreneurs, How I Made My Millions,* and *Mongrels, Mavericks and Empires.* These American television shows focus on entrepreneurship and, in many cases, frame it in predominately masculine terms. Instead, women often describe their business success as a team effort or share the credit for their success with others (Weidhaas; K. V. Lewis, "Public Narratives of Female Entrepreneurship"); men are often cited as more aggressive (Bartoš et al.), which is often reflected in the ways they com-municate (P. Lewis, "The Search for an Authentic Entrepreneurial Iden-tity"). America's pop culture, exemplified in the media, communicates

ideas about entrepreneurship in aggressive language, including such terms as "shark" and "mongrel." Entrepreneurship as a solo pursuit is emphasized in the media through use of the word "I." Discourse scholars show how gender often exists in language in ways we fail to question, yet it can still undermine one's experiences (Fairhurst). If a woman questions whether she belongs in a certain type of work, words can consciously or unconsciously affect her perception of her own work as a real job.

It has long been argued that work is gendered in many ways, from individual roles to job duties and expectations (Ashcraft). To visualize the gendered assumptions about job roles, one only has to ask: What gender pronoun is more likely to be used for an aggressive growth-oriented Fortune 500-level CEO and that person's secretary? Even the tasks within an organization are often assigned based on gendered expectations (Ashcraft); if an organization hosts an event, it is more common for women to handle food and decorations, whereas men move the tables and perform the heavy lifting. Examining the gendered nature of work in organizations is important because women typically work in organizations before starting their own businesses. Thus, an initial focus on organizational life helps us to understand how these practices continue to get reinforced, validated, and remain largely unabated, even though, in some cases, technology would permit a more flexible work-life arrangement.

Some scholars argue that gender inequalities manifest in the very structures that repeatedly go unacknowledged in the workplace. Research shows women frequently accept the misguided idea that business is a masculine enterprise by conceding that is just the way it is (Gill et al.) Rosalind Gill et al. offer examples of accepted inequalities in the business world, such as business case studies that primarily highlight the achievements of male CEOs, women getting hired for a job based on their attractiveness, and fewer females in management positions based on women taking time off for family. These examples serve as reminders that gender inequalities frequently remain because hegemonic practices are accepted by those who enact them, those who receive them, and even those who merely observe the practices.

Public Relations

The gendered nature of work is particularly prominent when scholars and practitioners examine feminized professions, such as nursing, teaching, and caregiver roles, which today rely heavily on women's labour (Tronto; Crittenden). Public relations is also a field dominated by women (Daugherty-Phillingane), and because of the highly concentrated number of American women within this industry, it has been classified as a "velvet ghetto" or as a "pink ghetto" because of the inequalities in pay and limited advancement opportunities for women (Toth et al.; Friedman). Early studies of public relations in the U.S. primarily focused on pay differentials, pointing out that industries that experienced a shift from predominantly male to female workers also on average showed a substantial decline in salary and social recognition (Toth et al.; Cline et al.). However, later studies of public relations have shifted to examine gender difference in more nuanced ways, which account for the intersectionality of identities, avoid binary categories, and recognize systematic and organizational means of oppression (Golombisky).

Today, women still experience gender-based discrimination. The importance of increasing the number of women in leadership roles is well articulated (Place and Vardeman-Winter; Golombisky; Aldoory, "A (Re)Conceived Feminist Paradigm"; Dozier; Grunig; Wrigley); however, while women represent 75 per cent of practitioners, they occupy a meagre 20 per cent of public relations leadership positions (Fitzpatrick). The earnings of women and men in the field also represent a significant disparity; the median income of a woman is calculated at $84,000, whereas the male median income is $125,000 (Marx et al.). Business ownership has been proposed as a way to circumvent the glass ceiling and better manage family issues (Grunig), but the assertion that business ownership can assist with family and gender inequalities fails to recognize the structural limitations and may suggest a simplistic view of business ownership as devoid of effort and challenges.

Many public relations business owners work as consultants or, as public relations practitioners call it, solo practitioners. While the exact number of women who work as consultants in public relations is not available, given the statistics about women owning a larger number of small businesses (McManus), it is likely that many of these independent practitioners are women. The number of independent public relations

practitioners continues to rise, and in the last few years, the Public Relations Society of America (PRSA), the nation's leading association for public relations practitioners, has started an interest group for independent practitioners based on their concentrated growth. Not only do some of the independents, also known as indies, lack external brick and mortar locations ("Independent Practitioners Alliance Section"), but they also lack organizational members who can support their efforts and, as it relates to this chapter, legitimize their roles as business owners. Studies show that organizational connections and affiliations can help support and sustain professional identities (Alvesson and Willmott; Dutton and Dukerich).

The phenomenon of sole proprietorship raises interesting questions about the way individuals create and sustain work identities. Some scholars (McPhee and Iverson; Hytti; Ahrne; Giddens) report that affiliations with organizations, particularly workplaces, help individuals to articulate their identities and develop connections with coworkers to support those identities, but few scholars address how those not part of an organization manage identity challenges. This may become more important with the growth of the gig economy—temporary employment often associated with the sharing economy and embodied in companies such as Uber and Airbnb (Shade). Whereas owning a public relations business lacks the sharing aspects, such as the ability to reconceptualize and capitalize on underutilized possessions or services, it does share some of the feminist concerns about neoliberal capitalism and a precarious workforce. In a gig economy, workers can be exploited for the benefit of the company, and although these individuals are often enticed by the seemingly fast and nonbinding work arrangements, criticism can justly be aimed at these corporations' lack of responsibility towards their workers, including safety, a living wage, and access to needed benefits (Shade). In comparison, independent practitioners, though not necessarily part of the virtual, sharing economy, can still face challenges related to earning a living wage, paying benefits, and feeling the stress of only having temporary work, which could require practitioners to continually seek new employment and build new relationships. This instability creates hardships and could threaten an already precarious identity.

Mothering

To deepen this conversation, we must also consider the other aspect of the term "mompreneur": the role of mother. In Western society, a mother is considered an important role but not necessarily one that raises a woman's social status. American scholars and popular press both recognize the mother as an important caregiving role but also one that gets marginalized in society (Tronto; Crittenden). Mothers are frequently expected to care for children and other family members, attend to domestic duties and, in some cases, work outside the home to supplement the household income.

As we examine the construct of mother, it is helpful to recognize the dominant discourse on mothering in Western society, which defines the ideal mother as one who is readily available for her children (Weidhaas; Gorman and Fritzsche). Americans idealize mothering, unlike any other role (Hays; Crittenden; Gorman and Fritzsche). Such terms as "intensive mothering" underscore the importance placed on this role as well as the focused enactment. Intensive mothering includes a child-focused world in which the mother is perceived as the most capable or essential caregiver (Rizzo et al.). Furthermore, this worldview includes the belief that mothers should be completely fulfilled by this experience; they should be primarily responsible for the intellectual stimulation of the child, and their role should be both intense and challenging. These social ideals can setup some monumental goals and create added stress, especially if these women are attempting to start a business and raise children. Paradoxically, whereas some people believe that parenthood will make them happier and more fulfilled, intense mothering has been linked to negative mental health outcomes, including stress, depression, and decreased satisfaction with life (Rizzo et al.). Interestingly, intensive mothering has been specifically associated with women in middle- to higher-income families (Rizzo et al.), which suggests that working mothers, who likely increase the household income with their contributions, may be particularly prone to intense mothering, even while trying to balance a demanding career.

Ideations about women's role in the home extend beyond childcare. In the U.S., the ideal mother cooks, cleans, and attends to her children's emotional and educational needs. Studies suggest these expectations are widely accepted for stay-at-home mothers, who are often considered as the ideal mother, as well as for working mothers (Gorman and Fritzsche; Willmott). Working mothers experience tension as they navigate two

intense roles. Such terms as "the second shift" have emphasized that for decades, women, regardless of their work outside of the home, are primarily responsible for domestic life (Hochschild and Machung). Regardless of how hard a woman works outside of the home, when friends and relatives visit, women are typically the ones judged for messy houses or dishevelled children.

In many cases, mompreneurs juggle the demands of domestic life with paid work. Studies indicate women experience a significant mental burden as they try to balance family planning with their work obligations (Offer). "Mommy guilt," a phrase used by both scholars and journalists in the popular press (Borelli et al.; Guendouzi; White), refers to the guilt mothers face when they do something unrelated to childrearing or when they do not feel as if they are living up to an ideal mother role. Articles in popular magazines and mommy blogs try and relieve this guilt, particularly for working mothers. Tips and suggestions range from a relaxing bubble bath or enjoying a good book to more elaborate plans, such as treating mothers to spa weekends or mommy-only retreats. Oftentimes, these relaxation suggestions only further underscore the intensity of mothering—a job that is viewed as so demanding that women need time off. Yet social discourse about mothering often frames motherhood as the job that never ends.

Combining paid employment and motherhood only intensifies the stress. Women often experience working and mothering as a double bind (Sharpiro et al.), which means there is no right answer for how to combine both mothering and work. Those who select work as their leading role risk being portrayed as bad mothers, and those who stay home with kids can also experience negative stereotypes. Research on stereotypes reveals these constructs can limit personal perceptions of value, diminish confidence, and affect work (Steele). Individuals build their self-image in concert with the world around them, and this is particularly true for roles that hold great social significance, such as mothering, which is one of the oldest gender models available to females and perhaps why it is so deeply rooted in society.

Interestingly, as more women opt for paid work either in the home or outside the home, expectations continue to increase, due in large part to the Internet. A recent study of first-time working mothers' Facebook usage reveals women use Facebook as a means of validating their experience as mothers (Schoppe-Sullivan et al.). The study shows that

women who are especially influenced by external validation seek feedback from the Facebook community and are more prone to depression if they do not receive the anticipated likes and comments for the photos they post of their children as well as for the parenting experiences they recount (Schoppe-Sullivan et al.). Not only does this study reveal the social pressures of doing motherhood in the U.S. (Schoppe-Sullivan et al.), but it also provides us with insight into how performing the role of mother can change in the Internet era and, in some cases, add more pressure as mothers use these as platforms to compare themselves to others.

Social media sites, such as Pinterest and Facebook, show mothers embarking in creative acts, such as the perfect after-school snack or adorable nursery décor, which often get equated with their mothering skills. These platforms provide opportunities to see what domestic and maternal endeavours should look like in Western society, but those who critique these sites indicate that women, in particular mothers, often feel challenged to live up to unrealistic expectations (Harding). This added social exhibitionism can affect mompreneurs' identities because these women may initially start businesses at times when they could be organizing a theme-oriented birthday party, developing creative healthy snacks for their child's classroom, or creating the ideal holiday decor. In a social media world fed by likes and shared photos, can a mompreneur navigate this difficult terrain to legitimize her roles as both mother and business owner using the lens of a real job?

Real Jobs

Americans, as well as others in many different societies, view their work identities as an important part of their lives (Whyte; Gini), and many desire work identities that provide social value. In fact, even in professions considered dirty work, workers find ways to mitigate the stigma through expressing their gender (Mavin and Grandy)multiple enactments of femininity and masculinity. In considering the experiences of 21 exotic dancers working in a chain of UK exotic dancing clubs and conclude that in order to be good at their job, exotic dancers are expected to do gender well, that is, perform exaggerated expressions of femininity. However, we also theorize that for some dirty workers, specifically exotic dancers as sex workers, doing gender well

will not be enough to reposition bad girls (bad, dirty work, gaining organizational member support (Ashforth and Kreiner), and distancing themselves from the stigma by situating it elsewhere (Grandy). These identity-management strategies underscore the importance of creating a socially legitimate identity that is linked to work, which may further sub-stantiate why the colloquialism of "a real job" has gained acceptance and importance in American discourse.

Methodology

This study stems from a larger project, which explores the many complex identity issues of female public relations business owners. In speaking with these women, an important sub-segment of the population emerged—female business owners who juggle the dual role of practitioner and mother. Whereas the original study included eighteen women, this chapter specifically explores how nine of these women understand their experiences as business owners and mothers. With an emphasis on mothering, I specifically reviewed the narrative accounts of the nine mothers in my study. Six of these women were solo practitioners. The women in the original study ranged in age from their late twenties to their fifties. Each individual mentioned that she maintained a leadership role in the business; the majority ran their own businesses, only one of the mothers shared ownership with a nonfamilial partner. Three of the mothers in this study worked in an office and managed employees, whereas the six independent practitioners worked in virtual offices, which included a mix of homes, coffee shops, client locations and, in one instance, a space within a larger public relations agency.

I chose a narrative methodology because the women could share their experiences as reflexive detailed stories (Lindlof and Taylor). To gain access to these narratives, I employed qualitative interviewing because it creates a co-constructed conversation that provides women with agency in how they describe their lives (Lindlof and Taylor). I recruited participants using snowball sampling, making initial contact through a referral from a university colleague. I relied on the following criteria: (a) the participants owned and worked in their businesses; (b) they created the business and did not inherit or buy into an existing entity; and (c) they were willing to meet with me for a face-to-face interview. Each

interview ranged from forty-five minutes to nearly two hours.

Interviewees selected the location, and we met in coffee shops, an office at a local university, restaurants, homes, and their office space. I spoke to individuals until I reached theoretical saturation—the point when the narratives began to overlap and clear similarities emerged between their stories. Each interview was recorded and later transcribed, and then I analyzed the transcripts for themes using the general inductive approach, which is guided by an evaluation objective and entails careful analysis of the data (Thomas). In this methodology, the researcher does not develop a hypothesis but rather lets the findings emerge from the data (Thomas). However, while grounded theory allows anything to emerge (Charmaz), this type of analysis allows the researcher to investigate select topics for a focused analysis (Thomas). I chose this because I could focus on parenting, work, and motherhood.

Results

Several challenges emerged for these women as they struggled to constitute identities, and I experienced significant challenges as I attempted to apply the frame of a real job to mompreneurs' lives. First, women did not frame both jobs equally, so it became challenging to consider both aspects at the same time. Instead, this section considers both aspects separately to account for their different perceptions and notes some areas of overlap.

All of the women, with the exception of one woman, prioritized motherhood over business ownership. These women repeatedly stressed the ways in which they placed their children's needs over their business commitments, even though one might question how effective this prioritization was. For example, the women who discussed sharing an office with children minimized the distraction of responding to children's requests while trying to concentrate on work. Additionally, although women talked about working in off hours, such as while children slept, they attempted to frame these alternative schedules as part of their day. One woman explained:

> When my son is awake, I am with him when we are home. When my son is awake, I'm with him. When he's asleep, I go back in the office, which is hard when you have your own business

because it's hard to differentiate between work time and home time.... So, I don't really balance it very well, and I will admit this—I probably don't utilize work time to its best advantage. Like I should be working my tail off from eight to five, but my son doesn't go to school until 9:40 a.m., so the morning is kind of just wasted.

In explaining her daily schedule, this mother maintains a focus on her child, not her work. She repeats that when her son is awake, she is with him; her workday doesn't start until after her son leaves for school at almost 10:00 am. In this excerpt, she does not complain about focusing on her son while he is in her presence; instead, she accepts the onus for limiting her workday by not "working her tail off." Working around their children's schedules, even if late at night, is framed as part of their day with little attention to the gendered nature of work and social perceptions related to mothering. For example, women do not discuss how their husbands go back to work at night after caring for their children.

The only interviewee who specifically commented on the social expectations of mothering as a female role was the fifty-two-year-old mother, who indicated her husband was the primary caregiver for her daughter. She framed this father-daughter relationship as a close one, but one that, at times, leaves her feeling guilty based on social expectations:

Sometimes I want to know, and sometimes I want to belong, and other times I'm like, "You know what, that's what they have." And it's not big stuff; it's just things that I would normally feel— that's been a little interesting, you know, as ... a female being brought up by a trad—my mother worked too, but not ... for all the years I was at home. And and, um, she was absolutely in that role. So I would find myself sometimes being, "Well, I should be doing that."

In the excerpt above, she tries to reconcile with her choice to run a growth-oriented business instead of being the primary caregiver for her daughter. She references the model of her mother, which she almost indicated was traditional. This articulate woman stumbles in this excerpt, as she compares herself to her mother who was home during her childhood. She expresses some guilt in this comparison through the

phrase "Well, I should be doing that." Although she made different choices about how to balance mothering and business ownership, she still acknowledges the tug of social expectations for motherhood in the U.S. To further address some aspects of the framing of a real job, the following sections examine motherhood and business ownership in more detail.

Motherhood

Most women, especially those with young children, communicated the desire to be home with their children. One mompreneur explained, "Well, for Elizabeth, I took a year off. My first. Didn't work. At all. For a year. And ... with Kelly it was much shorter. Like maybe three months. But still, for three months, I got to be mom to the new baby, so that was super important to me." The interviews were setup as opportunities to talk about their experiences as business owners, but, in many cases, the mothers wanted to talk about their experiences of childrearing and the importance of this role to them. The woman above could have said she needed to get back to work quickly to satisfy her clients' needs or generate income for her family; instead, she stressed the time commitment, which was entirely focused on the new baby. She punctuated this in short phrases that stopped and started to underscore the focused commitment. Women continually highlighted the importance of being there for their children, even if it meant lower salaries.

In some cases, this role entailed aspects of intense mothering and provided less money, as this mother of two young kids explained, "And the world is so full of like just maladjusted people that I think a large part of it is just nobody really let them [children] know that they're important and I'm investing time in you and this is—you know." She embodies aspects of intense mothering by "investing time" in the children so they know they are important. This mother further explained she has to be home with her children because they need her; in her words, the children are "important" and with her child-caring duties, she is only left with about twenty-five hours a week to work from her home office. Throughout the interview, she was steadfast in her commitment to prioritize her children over money: "I know that I have sacrificed some earning opportunities, um but that's just my priority." She acknowledges this as an important choice, exemplified in the word

"priority;" also, this is not something that merely happened to her, such as lower income during an economic downturn. She expresses agency in her choice. Additionally, the word "sacrifice" in this context can relate to her role as mother, a role that often involves the perception of personal sacrifice. Ultimately, this woman takes ownership of her choice and compares her decisions to other women: "I have friends that I know— you know, they have the house on the water and like a car and a boat, and they consider those necessities so they have to go to work." This comparison is offered not only as a means of justifying her limited income; it also critiques other women's choices. She frames her decision as a "sacrifice" for her kids and compares it other women seeking more material goods, which could suggest they are lesser mothers in her eyes.

The mothers in this study did not easily fit Clair's criteria for a real job, especially when one examines potential detractors (Clair 253). First, Americans idealize motherhood as being something enjoyable (Rizzo et al.). Although the women in this study attempted to frame their experiences balancing motherhood and business ownership as enjoyable, they often unintentionally revealed challenges, such as the mother above who discussed the social expectations of the mother as the primary caregiver. In another example, a mother with five grown children said, "I mean when my children were young, after they did their homework and got their stuff and went to bed, a lot of people just pass out on the couch. Not me." This woman might have framed her boundless energy as a personal accomplishment, but her description also reveals a sense of the commitment and time required to attend to children's needs, which require so much energy that people "just pass out on the couch" from exertion. Instead, she focuses on the children's chores and then returns to work.

In terms of the second criteria, although it is not an easy job, it does not require a college degree to be a mother. Third, it is a temporary role because the child will grow up, and many women talk about the change in time required for school-age children versus infants and babies. Fourth, Americans typically associate regular income as stable, and since being a mother does not generate income for the family, this could affect Clair's third and eighth indicators, which discuss temporality and the job as a primary source of income. Kids do not pay their parents; instead, parents frequently lament the immense cost of raising children. Estimates indicate raising one child born in 2015, from birth to age 17, excluding

college costs, will total over a quarter million dollars, or $12,350 to nearly $14,000 per year (Vasel). These figures certainly detract from motherhood's association as a real job when one employs salary as a primary criterion. Thus, the role of mother includes four of the seven detractors delineated by Clair's students.

Business Owners

In the late 1990s, Clair introduced the phrase "a real job" to an academic audience when she asked college students to provide their interpretations of a real job. College students identified a real job as one that earned them money, which was of primary importance to them, used their education or allowed them to live up to their potential, included the standard forty-hour work week, and offered opportunities for advancement. Factors that could undermine a job's status as real included: "1) enjoyable, 2) easy or nonskilled, 3) temporary or unstable, 4) have low probability of success, 5) require little trust, 6) are not conducted in their natural time (e.g., a soldier in war time versus a soldier in peace time), 7) underutilize the worker in terms of duration and intensity, and 8) are not primary means of support" (Clair 253).

Using the same criteria provided by Clair's students, female business owners also experience some challenges in their abilities to frame their work as real jobs. First, this may not be the primary means of support for the family, especially given that a number of women mentioned working fewer hours when they had young children. With one exception, the women intended to place their children over their business needs, which limited their income and business growth. Some women with young children talked about potentially growing the business as their kids got older, and others talked about the inability to predict one's income. One woman said, "If my husband didn't have a good job [in which] he got a paycheck every two weeks, I could not be doing what I'm doing. And I tell people that when they ask me about it." One could also argue that the instability of regular income, especially during challenging economic times, and the focus on caregiving over business could suggest a temporality of a business. Although the women were at different stages of business growth, at least one woman spoke about the flexibility of her role: "I mean, once the girls are older, I don't know what's going to happen. We might just shut it down and get jobs, you

know, I don't—it depends on the economy and all kinds of variables of which I have no control over, so. Just kind of have to wait and see." This mother of a six-year-old and a six-month-old worked with her husband, and she indicated they started the business to allow them to spend more time with their kids, but they might get jobs when their children got older or other factors interceded. Clair's criteria also mentioned the number of hours worked, and most mompreneurs work odd hours, not a normal nine-to-five workday as indicated in some of the previous excerpts. Again, female business owners have at least four of the factors Clair indicated could challenge a job's credibility. Although Clair's participants focused primarily on pay and benefits, she also acknowledged the importance of organizational assimilation and socialization, which can be particularly challenging for those who work from home. Six of the women were solo practitioners, and the majority of women discussed working from home full or part time. Women initially mentioned the benefits of working from home, such as the ability to do a load of washing between conference calls. Perceptions about people who can work from home while balancing domestic chores can increase rather than decrease the pressure. Furthermore, working from home can isolate individuals from social networks that help legitimize their work as a real job and provide social support, including the ability to brainstorm ideas on the fly, share challenges as they happen, and celebrate workplace successes.

Women who worked from home said they looked for ways to achieve social interaction. Some joined industry associations so that they could attend networking events; others organized semiformal meetings to discuss business ideas and challenges, and still others confessed to working in sandwich and coffee shops to get out of the house (Weidhaas). One woman said that "I don't want to spend money on an office when I've got a perfectly good office here at Starbucks or Panera or any number of places that offer free Wi-Fi." Another joked that a family member bought her a gift certificate for coffee at her virtual office. Although these comments appear lighthearted, they reveal a longing for connection that they lack in their secluded home offices. One woman discussed the importance of interactions with her children's caregiver as a means of support: "She'd [the caregiver] say, 'How was your day?' And I'm like the husband that comes home, I'd, you know, download on her." This quote reifies gendered notions of men working outside the home with the use of the word "husband" as the person coming home to share his

work experiences. This quote also serves as a reminder of the need for social interaction to validate our work and work identities because this woman needed to "download" or unload on someone.

Several women in my study discussed some challenges of legitimizing their various roles and one woman used the concept of a real job. One mompreneur explained, "So I don't believe in having your child home when you're working if it's a real job that you need to talk to people." This quote emphasizes how women, in particular a female business owner, can struggle with how to construct the phenomenon of a real job while balancing their children's needs. In this case, she set her own parameters of a real job that was defined by the presence of children, but others discussed working at home with children present.

Discussion

While there is no singular script for how to simultaneously enact motherhood and business ownership, the women in my study, with one exception, prioritized motherhood over business ownership. In doing so, they made sense of their experiences by using the frame of a good working mother, which uses traditional gender roles of prioritizing motherhood and enacts it by accepting primary responsibility for the children (Buzzanell et al.). Women communicated the importance of motherhood by using words, such as priority, and emphasizing their ability to alter their work schedules to meet family obligations (Weidhaas). Although they mentioned sacrifices and limiting their incomes, they also framed these as choices they made, which shifts the frame from one that emphasizes paid employment, described by Clair's participants as a real job, to one that prioritizes motherhood. Thus, applying the colloquialism of "a real job," inappropriately uses a neoliberal frame for mothering, an endeavour that has existed for centuries outside of the paid economy.

Today's modern entrepreneurial women also express agency in their choice to limit business growth and personal income, particularly when their children are young. Women frame this as an acceptable choice because of their perceived agency, even as one may question their ability to select an alternative that contradicts the social norms of motherhood.

Research not only shows that motherhood in the U.S. is highly scrutinized but also that middle-class women can isolate themselves from

support based on an idea that mothers are the best caregivers (Buzzanell et al.; Sperling). Maternal bias, the idea that women should desire primary responsibility for their children, undermines other individuals' ability to provide support and perpetuates the long-held belief that good mothers belong at home (Sperling). In selecting the role of mother as primary, women conceptualize it as a choice, which frees them from discourses that suggest the ideal worker lives to work, but they often fail to recognize the limitations imposed by romanticized notions of motherhood, which may be more inhibiting than any associated with a real job.

These women tout motherhood as an ideal, not income or business ownership, but in doing so, they fail to address the limitations. These limitations include creating categories of motherhood (Buzzanell et al.), as in the mother who touts her limited income as a sacrifice and presents herself as superior to working mothers with many material trappings. Instead, discourses that compare so-called good working mothers as those who limit their income serves as a divisive means of validating their own identities in this intensely judged role. As for the colloquialism of a real job, it may be a good time to reevaluate this phrase. The women described here do not meet the criteria Clair's students developed more than twenty years ago. However, colloquial phrases often evolve. A recent study on millennials' perceptions of a real job indicates that social ideas have shifted, which may provide future generations with a more inclusive view of work (O'Connor and Raile). Clair's students prioritized salary as an important marker of a real job; however, millennials rank benefits over salary and reject salary as a signal of social acumen (O'Connor and Raile). Interestingly, almost half of the participants in a study of millennials completely reject the term "real job," suggesting it might be "stressful" or "life sucking" (O'Connor and Raile 14). The study reminds us that the social backdrop, including conversations about expectations for employment, can influence colloquiums and the underlying assumptions they embody. Although the mompreneurs in this study are not millennials, changing social values that emphasize personal fulfillment over high income may provide a more suitable narrative for future generations.

Future Research

Scholars who continue to examine the construct of a real job could expand our understanding of work by speaking with other generations in the workforce to better understand their perceptions. As it relates to female business owners who are also mothers, scholars should continue to question whether to apply the colloquialism of a real job to women's experiences because it may further marginalize them by reducing their experiences to a phrase primarily associated with paid employment and which may hold limited social value for future generations of workers. Additionally, future scholars should consider adding other aspects to their studies, such as using a less binary gender framework. Most published studies ask people to identify as either male or female, a reflection of a society that has long held to these two categories. Such a limiting and binary approach can influence and skew research results. All of the women I spoke to identified as female, and no one mentioned gender fluidity. Additionally, by chance, not by selection, the women in this study were in heterosexual relationships, and the study included only a limited number of single parents. Future studies could examine these specific populations. Finally, colloquialisms and social expectations are embedded in our social ideas. An exploration of other cultures' colloquialisms and interpretations of gender roles could deepen our understanding of how they operate.

Conclusion

As individuals in society, we are bound in particular ways by social values and expectations. Mompreneurs who chose the role of mother as their primary role did not escape social expectations; many still held ideas relating to intense mothering, as indicated in some of the excerpts of women who needed to continually be there for their children. This creates complications for women who enact the roles of mother and business owner, but in selecting a primary role, it explains how women can prioritize their actions in an otherwise overwhelming existence. Yet it limits women who want to pursue growth-oriented businesses or those who seek to make more than a modest income because the dominant mothering discourse relegates these individuals into less admirable categories and undermines their ability to seek support from other women.

As with any role identity, individuals can make a variety of choices in how they construct and communicate about their lives. The idea of agency and the powerful gender role of the mother in American society allow women to rationalize their choice, even with its limitations, and express their satisfaction with it. This choice affects the way they structure their businesses, their relationships with other mothers, and their view of the gendered nature of work. Undoubtedly, motherhood will remain an important role in American society, but it is important to consider that women can make other choices about how they enact this role if they can recognize limiting discourses. In promoting discourses that situate mothering as a noncompetitive and shared role, we can begin to create discourses that recognize more inclusive networks of mothers who wish to support one another.

Works Cited

Ahl, Helene. "Why Research on Women Entrepreneurs Needs New Directions." *Entrepreneurship Theory and Practice*, vol. 30, no. 5, 2006, pp. 595-621.

Ahrne, Goran. *Agency and Organization: Towards an Organizational Theory of Society.* Sage Publications, 1990.

Aldoory, Linda. "A (Re)Conceived Feminist Paradigm for Public Relations: A Case for Substantial Improvement." *Journal of Communication*, vol. 55, no. 4, 2005, pp. 668-84.

Aldoory, Linda. "Feminist Criticism in Public Relations: How Gender Can Impact Public Relations Texts and Contexts." *Rhetorical and Critical Approaches to Public Relations II,* edited by Robert Heath, Elizabeth L. Toth, and Damoin Waymer. *Routledge,* 2009, pp. 110-123. Print.

Alvesson, Mats, and Hugh Willmott. "Identity Regulation as Organizational Control: Producing the Appropriate Individual." *Journal of Management Studies*, vol. 39, no. 5, 2002, pp. 619-44.

Ashcraft, Karen Lee. *Reframing Difference in Organizational Communication Studies: Research, Pedagogy, Practice.* Sage Publications, 2011.

Ashcraft, Karen Lee, and Dennis K. Mumby. *Reworking Gender: A Feminist Communicology of Organization.* Sage, 2004. Print.

Ashforth, Blake E., and Glen E. Kreiner. "'How Can You Do It?':
Dirty Work and the Challenge of Constructing a Positive Identity."
The Academy of Management Review, vol. 24, no. 3, 1999, pp. 413-34.

Bartoš, Přemysl, et al. "Are Men More Innovative and Aggressive in
Business? Case Study from the Czech Republic." *International
Journal of Entrepreneurial Knowledge*, vol. 3, no. 2, 2015, pp. 29-39.

Borelli, Jessica L., et al. "Gender Differences in Work-Family Guilt in
Parents of Young Children." *Sex Roles*, vol. 76, no. 5-6, 2017, pp.
356-68.

Buzzanell, Patrice M., et al. "The Good Working Mother: Managerial
Women's Sensemaking and Feelings about Work—Family Issues."
Communication Studies, vol. 56, no. 3, 2005, pp. 261-85.

Buzzanell, Patrice M., and Meina Liu. "Struggling with Maternity
Leave Policies and Practices: A Poststructuralist Feminist Analysis
of Gendered Organizing." *Journal of Applied Communication Research*,
vol. 33, no. 1, 2005, pp. 1-25.

"This Is How Much Child Care Costs in 2018." *Care*, 17 July 2018,
www.care.com/c/stories/2423/how-much-does-child-care-cost/.
Accessed 24 July 2018.

Charmaz, Kathy. "Shifting the Grounds. Constructivist Grounded
Theory Methods." *Developing Grounded Theory: The Second Generation*,
edited by Janice Morse et al., Left Coast Press, 2009, pp. 127-19.

Clair, Robin Patric. "The Political Nature of the Colloquialism, 'a Real
Job': Implications for Organizational Socialization." *Communication
Monographs*, vol. 63, no. 3, 1996, pp. 249-67.

Clair, Robin Patric, et al. *Why Work?: The Perceptions of a "Real Job" and
the Rhetoric of Work Through the Ages*. Purdue University Press, 2008.

Cline, Carolyn Garrett, et al. *The Velvet Ghetto: The Impact of the
Increasing Percentage of Women in Public Relations and Business
Communication*. IABC Foundation, 1986.

Crittenden, Ann. *The Price of Motherhood: Why the Most Important Job in
the World Is Still the Least Valued*. Metropolitan Books, 2001.

Daugherty-Phillingane, E. *The Pathways of Successful Entrepreneurial
Women in Public Relations: Ethics, Theoretical Models of Practice, and
Motivating Factors*. 2010. The Claremont Graduate University, PhD
dissertation. *ProQuest Dissertations Publishing*. proquest.umi.com/

pqdweb?did=1976882931&Fmt=7&clientId=20178&RQT =309&V
Name=PQD. Accessed 3 Feb. 2019.

Dozier, D. M. "Breaking Public Relations' Glass Ceiling." *Public Relations Review*, vol. 14, no. 3, 1988, pp. 6-14.

Dozier, Davis, et al. "Why Women Earn Less Than Men: The Cost of Gender Discrimination in U.S. Public Relations." *62nd Annual Conference of the International Communication Association,* 14 May – 8 June 2012 Arizona, pp. 1-31.

Dutton, Jane E., and Janet M. Dukerich. "Keeping an Eye on the Mirror: Image and Identity in Organizational Adaptation." *Academy of Management Journal*, vol. 34, no. 3, 1991, pp. 517-54.

Essers, Caroline, and Yvonne Benschop. "Muslim Businesswomen Doing Boundary Work: The Negotiation of Islam, Gender and Ethnicity within Entrepreneurial Contexts." *Human Relations,* vol. 62, no. 3, 2009, pp. 403-23.

Fairhurst, Gail Theus. *Discursive Leadership: In Conversation with Leadership Psychology.* SAGE Publications, 2007.

Fitzpatrick, Maggie. "A Strong Case for Female Inclusion at the Top Level." *PRweek*, vol. 16, no. 2, 2013, p. 25.

Friedman, Ann. "Why Do We Treat PR Like a Pink Ghetto?" *The Cut*, 18 July 2015, www.thecut.com/2014/07/why-do-we-treat-pr-like-a-pink-ghetto.html. Accessed 26 July 2018.

Giddens, Anthony. *The Constitution of Society: Outline of the Theory of Structuration.* University of California Press, 1984.

Gill, Rebecca, and Shiv Ganesh. "Empowerment, Constraint, and the Entrepreneurial Self: A Study of White Women Entrepreneurs." *Journal of Applied Communication Research*, vol. 35, no. 3, 2007, pp. 268-93.

Gill, Rosalind, et al. "A Postfeminist Sensibility at Work." *Gender, Work & Organization,* vol. 24, no. 3, 2017, pp. 226-45.

Gini, Al. "Work, Identity and Self: How We Are Formed by the Work We Do." *Journal of Business Ethics,* vol. 17, no. 7, 1998, pp. 707-14.

Golombisky, Kim. "Renewing the Commitments of Feminist Public Relations Theory from Velvet Ghetto to Social Justice." *Journal of Public Relations Research*, vol. 27, no. 5, 2015, pp. 389-415.

Gorman, Kristin A., and Barbara A. Fritzsche. "The Good-Mother Stereotype: Stay at Home (or Wish That You Did!)." *Journal of Applied*

Social Psychology, vol. 32, no. 10, 2002, pp. 2190-2201.

Graf, Nikki, et al. "The Narrowing, but Persistent, Gender Gap in Pay." *Pew Research Center*, 9 Apr. 2018, www.pewresearch.org/fact-tank/2018/04/09/gender-pay-gap-facts/. Accessed 3 Feb. 2019.

Grandy, Gina. "Managing Spoiled Identities: Dirty Workers' Struggles for a Favourable Sense of Self." *Qualitative Research in Organizations and Management*, vol. 3, no. 3, 2008, pp. 176–198.

Grunig, Larissa A. "Feminist Phase Analysis in Public Relations: Where Have We Been? Where Do We Need to Be?" *Journal of Public Relations Research*, vol. 18, no. 2, 2006, pp. 114-40.

Guendouzi, Jackie. "'The Guilt Thing': Balancing Domestic and Professional Roles." *Journal of Marriage and Family*, vol. 68, no. 4, 2006, pp. 901-09.

Gupta, Vishal, and Cheryl Fernandez. "Cross-Cultural Similarities and Differences in Characteristics Attributed to Entrepreneurs: A Three-Nation Study." *Journal of Leadership & Organizational Studies*, vol. 15, no. 3, 2009, pp. 304-18.

Harding, Lindsey. "Super Mom in a Box." *Harlot: A Revealing Look at the Arts of Persuasion*, vol. 1, no. 12, 2014, harlotofthearts.com/index.php/harlot/article/view/197. Accessed 3 Feb. 2019.

Hays, Sharon. *Cultural Contradictions of Motherhood*. Yale University Press, 1998.

Helene, Langinier, and Deniz Gyger Gaspoz. "Expatriates' and Teenagers' Nomadic Identities: An Intersectional Analysis." *Equality, Diversity and Inclusion: An International Journal*, vol. 34, no. 4, 2015, pp. 308-24.

Hochschild, Arlie Russell, and Anne Machung. *The Second Shift: Working Parents and the Revolution at Home*. Viking, 1989.

Hytti, Ulla. "New Meanings for Entrepreneurs: From Risk-Taking Heroes to Safe-Seeking Professionals." *Journal of Organizational Change Management*, vol. 18, no. 6, 2005, pp. 594-611.

"Independent Practitioners Alliance Section." *Public Relations Society of America*, www.prsa.org/independent-practitioners-section/. Accessed 26 July 2018.

Kanze, Dana, et al. "Male and Female Entrepreneurs Get Asked Different Questions by VCs—and It Affects How Much Funding

They Get." *Harvard Business Review*, 27 June 2017, hbr.org/2017/06/male-and-female-entrepreneurs-get-asked-different-questions-by-vcs-and-it-affects-how-much-funding-they-get. Accessed 3 Feb. 2019.

Ladge, Jamie J., et al. "Cross-Domain Identity Transition during Liminal Periods: Constructing Multiple Selves as Professional and Mother during Pregnancy." *Academy of Management Journal*, vol. 55, no. 6, 2012, pp. 1449-71.

Lewis, Kate V. "Public Narratives of Female Entrepreneurship: Fairy Tale or Fact?" *Labour & Industry*, vol. 24, no. 4, 2014, pp. 331-44.

Lewis, Kate V., et al. "The Entrepreneurship-Motherhood Nexus: A Longitudinal Investigation from a Boundaryless Career Perspective." *Career Development International*, vol. 20, no. 1, 2015, pp. 37-21.

Lewis, Patricia. "The Quest for Invisibility: Female Entrepreneurs and the Masculine Norm of Entrepreneurship." *Gender, Work & Organization*, vol. 13, no. 5, 2006, pp. 453-69.

Lewis, Patricia. "The Search for an Authentic Entrepreneurial Identity: Difference and Professionalism among Women Business Owners." *Gender, Work & Organization*, vol. 20, no. 3, 2013, pp. 252-66.

Linard, Laura. "Enterprising Women—a History." *Harvard Business School Working Knowledge*, 18 Nov. 2002, www.hbswk.hbs.edu/item/enterprising-womena-history. Accessed 3 Feb. 2019.

Lindolf, Thomas R., and Bryan C. Taylor. *Qualitative Communication Research Methods*. 2nd ed. Sage Publications, 2002.

Marx, Wendy, et al. "The Surprising Gender Wage Gap in PR." *Fast Company*, 23 Dec. 2014, www.fastcompany.com/3040253/the-surprising-gender-wage-gap-in-pr. Accessed 3 Feb. 2019.

Mavin, Sharon, and Gina Grandy. "Doing Gender Well and Differently in Dirty Work: The Case of Exotic Dancing." *Gender, Work & Organization*, vol. 20, no. 3, 2013, pp. 232-51. Accessed 3 Feb. 2019.

McGee, Suzanne, and Heidi Moore. "Women's Rights and Their Money: A Timeline from Cleopatra to Lilly Ledbetter." *The Guardian*, 11 Aug. 2014, www.theguardian.com/money/us-money-blog/2014/aug/11/women-rights-money-timeline-history. Accessed 3 Feb. 2019.

McManus, Michael J. *Women's Business Ownership: Data from the 2012*

Survey of Business Owners. U.S. Small Business Administration, 2017. www.sba.gov/sites/default/files/advocacy/Womens-Business-Owner ship-in-the-US.pdf. Accessed 3 Feb. 2019.

McPhee, R., and J. Iverson. "Agents of Constitution in Communidad." *Building Theories of Organization: The Constitutive Role of Comm- unication,* edited by Linda L. Putnam and Anne M. Nicotera, Routledge, 2009, pp. 49-87.

Morris, Michael H., et al. "The Dilemma of Growth: Understanding Venture Size Choices of Women Entrepreneurs." *Journal of Small Business Management,* vol. 44, no. 2, 2006, pp. 221-44.

O'Connor, Amy, and Amber N. W. Raile. "Millennials' 'Get a "Real Job"': Exploring Generational Shifts in the Colloquialism's Charac- teristics and Meanings." *Management Communication Quarterly,* vol. 29, no. 2, 2015, pp. 276-90.

Offer, Shira. "Time with Children and Employed Parents' Emotional Well-Being." *Social Science Research,* vol. 47, 2014, pp. 192-203.

Pao, Maureen. "U.S. Parents Are Sweating and Hustling To Pay For Child Care." *NPR,* 22 Oct. 2016, www.npr.org/2016/10/22/4985 90650/u-s-parents-are-sweating-and-hustling-to-pay-for-child- care. Accessed 3 Feb. 2019.

Place, Katie R., and Jennifer Vardeman-Winter. "Where Are the Women? An Examination of Research on Women and Leadership in Public Relations." *Public Relations Review,* vol. 44, no. 1, 2018, pp. 165-73.

Knowledge@Wharton. "Why Are There More Male Entrepreneurs Than Female Ones?" *Wharton School,* University of Pennsylvania, www.knowledge.wharton.upenn.edu/article/why-are-there-more- male-entrepreneurs-than-female-ones/. Accessed 6 June 2018.

Rizzo, Kathryn, et al. "Insight into the Parenthood Paradox: Mental Health Outcomes of Intensive Mothering." *Journal of Child & Family Studies,* vol. 22, no. 5, 2013, pp. 614-20.

Schoppe-Sullivan, Sarah, et al. "Doing Gender Online: New Mothers' Psychological Characteristics, Facebook Use, and Depressive Symptoms." *Sex Roles,* vol. 76, no. 5-6, 2017, pp. 276-289.

Sebastian, Michael. "PRSA Announces the Final Definition of 'Public Relations.'" *Ragan's PR Daily,* 2 Mar. 2012, www.prdaily.com/

Main/Articles/10993.aspx. Accessed 16 Jan. 2016.

Shade, Leslie Regan. "Hop to It in the Gig Economy: The Sharing Economy and Neo-Liberal Feminism." *International Journal of Media & Cultural Politics*, vol. 14, no. 1, 2018, doi.org/10.1386/macp. 14.1.35_1. Accessed 3 Feb. 2019.

Sharpiro, Mary, et al. "Confronting Career Double Binds: Implications for Women, Organizations, and Career Practitioners." *Journal of Career Development*, vol. 34, no. 3, 2008, pp. 309-33.

Shelton, Lois M. "Female Entrepreneurs, Work-Family Conflict, and Venture Performance: New Insights into the Work-Family Interface." *Journal of Small Business Management*, vol. 44, no. 2, 2006, pp. 285-97.

Sperling, Jennifer H. "Reframing the Work-Family Conflict Debate by Rejecting the Ideal Parent Norm." *Social Policy*, vol. 22, 2013, pp. 47-90.

Steele, Claude M. *Whistling Vivaldi: How Stereotypes Affect Us and What We Can Do.* Reprint ed., W. W. Norton & Company, 2011.

Thebaud, Sarah. "Gender and Entrepreneurship as a Career Choice: Do Self-Assessments of Ability Matter?" *Social Psychology Quarterly*, vol. 73, no. 3, 2010, pp. 288-304.

Thomas, David R. "A General Inductive Approach for Analyzing Qualitative Evaluation Data." *American Journal of Evaluation*, vol. 27, no. 2, 2006, pp. 237-46.

Toth, E. L., et al. *Beyond the Velvet Ghetto.* IABC Research Foundation, 1989.

Tronto, Joan C. *Moral Boundaries: A Political Argument for an Ethic of Care.* Routledge, 1993.

Tsetsura, Katerina. "Is Public Relations a Real Job? How Female Practitioners Construct the Profession." *Journal of Public Relations Research*, vol. 23, no. 1, 2010, pp. 1-23. *Taylor and Francis+NEJM,* doi:10.1080/1062726X.2010.504763. Accessed 3 Feb. 2019.

Vasel, Kathryn. "It Costs $233,610 to Raise a Child." *CNN Money*, 9 Jan. 2017, money.cnn.com/2017/01/09/pf/cost-of-raising-a-child-2015/index.html. Accessed 3 Feb. 2019.

Weidhaas, Allison. *Female Business Owners in Public Relations: Constructing Identity at Home and at Work.* Lexington Books, 2016.

White, Jennifer S. "Why All of This 'Mom Guilt'?" *Huffington Post*, 21 Oct. 2016, www.huffingtonpost.com/entry/mom-guilt_us_58069713e4b08ddf9ece119b. Accessed 3 Feb. 2019.

Whyte, David. *Crossing the Unknown Sea: Work as a Pilgrimage of Identity.* Riverhead Books, 2001.

Williams, Joan C. "The Opt-out Revolution Revisited: Women Aren't Foresaking Careers for Domestic Life. The Ground Rules Just Make It Impossible to Have Both." *The American Prospect,* vol. 18, no. 3, 2007, www.questia.com/magazine/1G1-160164845/the-opt-out-revolution-revisited-women-aren-t-foresaking. Accessed 3 Feb. 2019.

Willmott, Hugh C. "Images and Ideals of Managerial Work: A Critical Examination of Conceptual and Empirical Accounts." *Journal of Management Studies*, vol. 21, no. 3, 1984, pp. 349-68.

Wrigley, B. J. "Glass Ceiling? What Glass Ceiling? A Qualitative Study of How Women View the Glass Ceiling in Public Relations and Communications Management." *Journal of Public Relations Research,* vol. 14, no. 1, 2002, pp. 27-55.

Yohn, Susan M. "Crippled Capitalists: The Inscription of Economic Dependence and the Challenge of Female Entrepreneurship in Nineteenth-Century America." *Feminist Economics*, vol. 12, no. 1, 2006, pp. 85-109.

Yohn, Susan M. "You Can't Share Babies with Bonds: How Americans Think About Women Making Money." *Iris,* vol. 20, no. 40, 2000, www.athena.rider.edu:2278/genderwatch/docview/ 214671495/9A9E2CB01C24AEAPQ/1?accountid=37385. Accessed 3 Feb. 2019.

Chapter Three

Structured Agency and Motherhood among Copreneurs in the Czech Republic

Nancy Jurik, Gray Cavender, Alena Křížková,
and Marie Pospíšilová

Introduction

The number of women-owned business start-ups around the world is increasing (Kelley et al.), and motherhood is credited as the motivation for this trend. The Czech Republic (CR) is experiencing such growth. This trend is especially interesting because business ownership was banned in the CR during its four decades of state socialism, and only since 1989 has the nation been transitioning to a market economy. According to Czech Radio, "The number of female entrepreneurs has gone up more than 30,000 over the last three years [with women] ... often launching business projects shortly after graduation or after returning from maternity leave" (Velinger). The Velinger article notes that these groups plus women in their fifties are at a high risk for unemployment, a further impetus towards business ownership. An example offered was Ema, a young mother who launched a company producing fashion for pregnant women, who said, "When friends learned about our clothes, and how good they looked, they began placing orders. So we designed a website and began to sell our products."

Despite the importance of women-owned businesses (WOBs) in transition economies, there is little research on the gender dynamics affecting CR women business owners (WBOs) or the family businesses of which they are a part (Machek et al.; Petlina and Koráb). Scholarly analyses of entrepreneur motives in other countries have generally focused on identifying push and pull factors involved in start-up decisions—that is, whether individuals are pressured (pushed) out of the labour market or attracted (pulled) into entrepreneurship (Dawson and Henley). Earlier research (e.g., Jurik; Aidis et al.) stressed that women were typically pushed into business ownership because their jobs lacked the flexibility needed to combine paid work with mothering responsibilities, whereas men formed businesses because they recognized an opportunity.

Most entrepreneurship research in transitional countries, such as the CR, has argued that push motives are most salient for WBOs (Aidis et al.). For example, a CR magazine quotes a young woman who said, "The most important motivation for starting business was my children, lack of money and a desire to do something interesting. My husband is my biggest helper" (Casanova). Men's care motives are rarely addressed in any country's research (Dawson and Henley); they are portrayed as pulled into ownership by business opportunities (Cromie). Despite concerns about balancing work with family care, more recent CR studies find that women start businesses for many of the same reasons as do men (Rašticová and Bédiová). Some women choose entrepreneurship for fulfilment or earnings as well as for childcare (Křížková et al., "The Divisions of Labour").

CR mothers of young children have the highest rates of unemployment in Europe. This pattern is associated with the extensive period allowed for paid maternity and parental leave combined with the lack of subsidized care for children under three. Employers are resistant to hiring women of childbearing age, as they know that such leaves may lie ahead. Such issues may push CR women into business ownership (Křížková and Vohlídalová). Still, business ownership is not a perfect solution. CR WBOS face difficulties claiming maternity leave benefits unless they pay into the system well in advance; they are also prohibited from employing others while on maternity leaves (Jurik et al.). Such conditions may push women into family businesses instead of sole proprietorships. This path would enable CR women to continue business operations (i.e.,

under their relative's name) during maternity leave and to have assistance from other family members in balancing business and care duties (Křížková and Vohlídalová; Jurik et al.). We are particularly interested here in the subset of family businesses that are principally operated by romantic partners—copreneurships. For example, a website promoting CR women's entrepreneurship (*podnikavazena.cz*) cites copreneurs Lucie and Ondra who started an online healthy lifestyle consulting firm because they were tired working as employees; Lucie, specifically, was exhausted from combining employment with motherhood. Lucie said, "We nicely complement each other.... Entrepreneurship put us together and returned energy to our life!"

In this chapter, we address entrepreneurial motives among Czech copreneurships. Family businesses have been identified as a key factor in the economic development of transitional countries (Břečková), and copreneurships are a major but underresearched component of family businesses (Machek et al.; Jurik et al.). Copreneurship studies elsewhere highlight the conflicts surrounding business ownership and caring responsibilities present in family businesses (de Bruin and Lewis). John Blenkinsopp and Gill Owens argue that family businesses are a uniquely hybrid organizations that blend economic and caring concerns. Our research question is what are the motives for copreneurship and how are they shaped by the context of the family and CR after state socialism?

Our sample consisted of twelve CR copreneurial couples. We interviewed these partners separately to understand possibly divergent perspectives on matters ranging from women's and men's motivations to start the business, to business operations, and to family responsibilities, especially childcare. In this chapter, we focus on motivations. Our analysis is guided by a structured-agency approach that focuses on how societal norms, the economy, and government policies influence entrepreneurial decisions (Valdez). Our findings reveal how women's caring concerns (e.g., about motherhood and romantic partners) can converge with traditional entrepreneurial motives and the country context to encourage business ownership. The men in our study rarely discussed concerns about parenting duties, and their contextual concerns differed from those of the women. These findings are significant in that they facilitate an understanding of romantic couples' motivations to enter businesses together and of how the entrepreneurial agency converges with social structures in a transitional country, such as the CR. In the

next section, we review the CR context of work, family, gender, and motherhood in the transition from state socialism to a market economy. We then review the literature on gender, entrepreneurial motives, and copreneurships before explaining our conceptual framework. Then, we explain the methods and describe our major findings. We close with a discussion of our study's significance and implications.

Country Context: Motherhood and Economy

The CR's history of state socialism, ownership prohibitions, and mandatory work requirements for all makes it an important site for analysing entrepreneurship and motherhood (Uhde and Hašková). As noted earlier, the CR is a transitional nation because since state socialism ended, it has been changing to a market economy with private ownership. Thus, business ownership is a recent development since it was banned during the Soviet years—from 1949 until the 1989 Velvet Revolution. During the socialist era, women were required to participate in the labour force but experienced job segregation, inferior wages, and a disproportionate burden of household and care-giving responsibilities (Křížková et al., "Working Paths"). In the early years of state socialism (1950s), it was argued that women would be liberated through employment and children would be cared for in state-provided nurseries or collectively established care arrangements. Shortages of care centres and concerns about their quality led many women to rely on their mothers for childcare. Shortages of consumer products and household appliances further lengthened women's double work days. Men's roles in domestic and childcare duties were never addressed (Hašková and Dudová).

Declining fertility rates and the costs of expanding public childcare became a concern to the Soviet government. At the time, some researchers argued that children needed a nurturing mother at home until the age of three, and public health officials raised questions about the health safety of nurseries. These public relations campaigns complemented a shift back towards traditional views of mothering. Between the 1960s and 1980s, the CR policy orientation changed to emphasize what was called "aktivní mateřství" (active mothering)—the view that mothers needed to provide home care for children until the age of at least three. The length of paid maternity leave was extended, and subsidies paid to

parents were increased (Hašková et al.). After the Velvet Revolution, the legacy of state socialism discredited feminist demands for gender equality (Křížková et al., "The Legacy of Equality"; Wagnerová). The transition in the CR caused large-scale structural changes ranging from the nature of jobs to increases in unemployment. Media stories lauded the opportunity for women to devote all of their time to home care and active mothering, thereby furthering the restoration of traditional notions of motherhood in the CR. The situation ushered in an era of refamilialization, including reducing state-supported childcare, especially for children under three, and extending the length of paid parental leaves (Hašková and Saxonberg).

Today, the antipathy towards working women, especially mothers, persists (Hašková). Research suggests that recent generations of CR mothers believe they have many more options than did socialist-era mothers (e.g., regarding breastfeeding, childcare, and working or not working) (Marková Volejníčková). However, they also feel pressured to justify every mothering decision they make so they do not appear to be bad mothers. Surveys report that CR citizens hold gender-traditional attitudes towards working women. A majority of the population believes that women should focus on the domestic sphere of children and household and that men should be the primary breadwinners (Hašková). The CR has the highest gender pay gap (22 per cent in 2016) as well as one of the widest gender employment gaps in the European Union (Jobspin). Job segregation continues to be a significant problem, despite increases in women's educational levels over time. These gaps are the widest between mothers and fathers of small children, reflecting the lack of childcare services for small children (Křížková et al., "Working Paths"). Despite refamilialization policies and attitudes, male breadwinners do not earn enough to support a family alone. Women must continue income-generating activities, such as business ownership, so they can combine paid work and childcare. Most CR survey respondents agree that "women and men should contribute to household income" (Scharle).

As in many countries, the 2008 recession slowed the CR economy. Vulnerable populations (e.g., women under twenty-five with young children and women aged sixty and above) were especially hit by unemployment. These conditions likely contributed to the 22 per cent increase in WOBs as compared to the 6 per cent increase in businesses

started by men. Between the years 2008 and 2011, enterprises started by women between the age of twenty and twenty-four increased by 34 per cent; enterprises started by women between the age of thirty-five and thirty-nine years increased by 74 per cent; those started by women between the age of fifty-five and fifty-nine years increased by 26 per cent; for women sixty and over, the increase in entrepreneurship was 46 per cent (CZSO). These figures reveal how the economic crisis, combined with the refamilialization process, encouraged vulnerable groups to enter entrepreneurship as a survival strategy in the Czech economy. Through this lens, entrepreneurship can be viewed as the best available option for many mothers and other disadvantaged workers, even though most women do not choose this option (Hašková and Dudová).

CR parental leave policies also affect women's role in the labour-market generally and women-owned businesses more specifically. A parent of a newborn child can receive a monthly state allowance (based on prior earnings) until the child four years old. The leave allotment is available to women and men, but only about 2 per cent of men take leaves (MPSV). Yet the parent's job is only required to be secured for three years. Given the difficulty in finding adequate and affordable childcare, only about half of those who take parental leaves return to their former jobs (Hašková). This pattern reflects not only the culturally embedded images of a good mother (i.e., active mothering) but also the relatively higher wages earned by men. Some employers are wary about hiring women who are of a childbearing age because they may have children and take long leaves (Křížková and Vohlídalová). Women returning from lengthy leaves often face hostility as workers and so-called bad mothers. These dynamics reveal the myriad ways that the structure of the labour market, family policies, and cultural norms frame the choices of CR women.

Despite the pressures to find alternative ways to deal with employment problems, CR mothers who are business owners also face obstacles related to family-leave policies. Particularly significant is the requirement that women business owners must cease business operations and are prohibited from employing workers during maternity leave. Since women are the parents who most typically take leaves, this policy delimits their business ownership or necessitates having another business partner formally listed as the sole business owner (Jurik et al.). With copreneurships, the spouse can take over as the formal owner of the

business. This apparent advantage, however, becomes a disadvantage in that it obscures the woman's contribution to the venture; regardless of her actual role in the copreneurship, she has to opt out of formal ownership while on maternity leave. Women copreneurs can also be disadvantaged by tax laws. The CR tax system supports a dual-breadwinner model in households and copreneurships (Sjöberg). The tax system permits a spousal tax deduction when one spouse earns considerably less than the other spouse. Because women employees typically earn less than men, some copreneurial couples decide that the woman should earn a smaller or no salary to take advantage of the spousal tax deduction and reinvest her would-be income into the business (Křížková et al., "Working Paths"). Parental leave and tax policies also affect business start-ups in a variety of ways. They can encourage, discourage, or unintentionally obscure and subordinate women in copreneurships and other family businesses, particularly those who are mothers of young children. These policies also may enhance the man's visibility in the enterprise, thereby facilitating his career advancement (Lewis and Massey; Hamilton). Next, we turn to our review of the literature on gender, entrepreneurial motives, and copreneurships, and detail our conceptual framework.

Literature Review

Although business ownership was prohibited in the CR and other former Soviet-bloc countries, entrepreneurial activities did exist through socialist cooperatives and the underground economy (Hašková and Saxonberg). Some of the research that occurred shortly after the demise of the Soviet Union suggested that push motivations (e.g., job loss and the shift to privatization) explained the rapid increases in business ownership (Scase). More recent empirical evidence suggests that both push and pull motives are important to entrepreneurs in transitional economies (Smallbone and Welter), although there is still some indication that women more often report push motivations and that men are more likely to stress economic independence (Aidis et al.; Manolova et al.). In their comparison of small samples of women entrepreneurs in the CR and Poland, Terri Lituchy and Martha Reavley conclude that push and pull motivations encouraged business start-ups.

They also show that women's motives were similar to those of North American women.

Entrepreneurship research has been dominated by Western perspectives. However, given the global growth of the entrepreneurial ideal, research now considers the phenomenon in countries at different stages of economic development (Welter; Poggesi et al.). Our data come from the CR, a country whose economy is transitioning from state socialism to capitalism. Researchers increasingly stress the importance of regional contextual differences in shaping entrepreneurship. Contextual differences include national history, gender norms, and attitudes (e.g., conflicts between notions of working women versus stay-at-home mothers) (Welter; Welter and Smallbone). Contextual matters also include differences in state laws and policies that can affect business owners generally or WBOs in particular. Notwithstanding the interest in entrepreneurship, the study of small and medium-sized enterprises (SMEs) and family businesses remains underdeveloped in transitional economies like the CR (Křížková et al., "The Divisions of Labour"; Holienka et al.). Indeed, official statistics on these entrepreneurial phenomena are limited (Lituchy and Reavley; Petlina and Koráb; Machek and Hnilica). This information gap is especially problematic because data demonstrate the importance of SMEs and family businesses in the shift from socialism to capitalism in Central and Eastern Europe (Duh et al.; Aidis et al.; Manolova et al.). Estimates suggest that SMEs comprise 98 per cent of all CR enterprises (Petlina and Koráb).

However, as in most Western-oriented studies, CR entrepreneurship research tends to ignore gender issues and concentrate on SMEs' potential for business growth and profitability. Although studies of gender and entrepreneurship have been increasing for several decades (Ahl and Marlow; McAdam and Marlow), most research in advanced market economies (Ahl) and in the CR (Bartoš et al.; Belás et al.; Kozubíková et al.) consists of correlational analyses comparing women and men business owners. Such research often reports that WBOs are less oriented towards growth, risk, aggressiveness, innovativeness, and profitability dimensions. Some of these studies rely heavily on gender stereotypes, such as the attribution of greater emotionality to women business leaders (e.g., Kolouchová and Machek). In the CR, 12 per cent of all working women and 22 per cent of all working men operate businesses (CZSO). Yet when surveyed, CR women perceived that they had fewer

opportunities associated with starting a business than did respondents in many other European countries, and there was a larger difference between CR men's and women's responses than in most other countries (Kelley et al.; Holienka et al.; Křížková et al., "The Divisions of Labour").

Feminist perspectives have argued for gender-aware frameworks that critically deconstruct male-centred definitions of entrepreneurship and business success and examine the influence of societal contexts on start-up motivations and operations strategies. Studies of barriers facing WBOs in transition economies identify credit and work-family balance as chief obstacles (Hisrich and Fülöp; Bliss and Garrat). A few studies have examined the experiences and perceptions of CR WBOs. Comparisons of WBOs in the CR and Poland (Lituchy and Reavley) show that they face obstacles similar to those of North American WBOs. These included a lack of financing as well as a lack of skilled employees and management experience. Bearing responsibility for both business and household duties was also an obstacle (Lituchy and Reavley). In another study, CR WBOs are less likely than Irish WBOs to stress family responsibilities as a major barrier to their business (Treanor and Henry). When compared with WBOs in advanced market economics, WBOs in transition countries appear to more greatly emphasize the support and/or involvement of family members in their business success (Reavley and Lituchy).

The postsocialist political, economic, and normative context has been linked to differences for WBOs in the CR and other transition countries (Rašticová and Bédiová). Several studies find that the postsocialist recession and the extended maternity/parental leave policies have contributed to high unemployment rates for women and have led many CR women to start businesses out of economic necessity (Křížková and Vohlídalová; Treanor and Henry; Rampulová et al.) Alena Křížková finds that CR women start businesses for a variety of motives that include independence, fulfilment, opportunity, and the harmonization of work and family life. Martina Rašticová and Monika Bédiová suggest that CR women are more likely to start businesses for intrinsic reasons (e.g., fulfilment and flexibility) rather than just profitability. Feminist researchers from the CR (Křížková et al., "Women's Entrepreneurial Realities") and elsewhere (Henry et al.) note that the male-centric model of entrepreneurship is not realistic because few entrepreneurs are disembodied business owners who are free of personal responsibilities.

Research on family businesses has been one path for exploring the gendered relationships between economic and caring functions.

Despite acknowledging the importance of family enterprises in transitional economies (Petlina and Koráb), few studies have focused on CR family businesses. Such studies mostly focus on comparisons of the profitability or of the advantages and disadvantages of family businesses, but almost no attention is paid to the gender dynamics or work-life balance (Machek and Hnilica; Petlina and Koráb; Břečková). A lot of research exists on family businesses in Western market economies, and numerous studies focus on the gender dynamics and work-life balance issues involved. This research has explored the hidden, unpaid labour of women and children in family ventures and the gender dynamics of ownership succession in immigrant and nonimmigrant family businesses (Hillman; Webbink et al.; Bhachu). Howard Aldrich and Jennifer Cliff posit a family-embeddedness model that recognizes the connections between business and family. They argue that this characterization applies to any business but is most visible in family enterprises. We suggest that one entrepreneurial form—copreneurship—is especially relevant because it reveals the dynamics of family embeddedness in a visible manner, and copreneurial ventures comprise a growing sector of business forms worldwide (Duh et al.).

Copreneurships consist of romantic couples who are in business together (Blenkinsopp and Owens; Helmle et al.). Research on copreneurs and the gender issues surrounding them is rare in the CR. One exception is Ondřej Machek et al., who focus on comparing the relative profitability of copreneur and noncopreneur CR businesses. Studies focusing on copreneurships in such countries as the United States, the United Kingdom, Australia, and New Zealand (e.g., Cappuyns; Baines and Wheelock, Harris et al.; Bhachu) find that female partners' roles in the business as well as in the home are often gender traditional. Our research reports that women play a range of roles in CR copreneurship, not all traditional, but leadership functions are generally attributed to men (Křížková et al., "The Divisions of Labour"). In this chapter, we focus on the possibly gendered links between social context and CR copreneur motivations.

We employ a more expansive definition of copreneurship than sometimes appears in other research conducted in the CR and US (see Machek et al.; Machek and Hnilica; Helmle et al.). We include partners

who self-report that they are "in business together" even if only one partner is the formal owner so that we can better examine informal participation and be sensitive to potentially hidden roles in copreneurships (Baines and Wheelock; de Bruin and Lewis; Cappuyns). Such inclusion is especially important in contexts where gender norms and state policies discourage formal ownership by women, notwithstanding their contributions (Lewis and Massey; Jurik et al.).

Some scholars who recognize the nuances that affect entrepreneurship in all countries call for new theories and methodologies as frameworks for analyzing the phenomenon (Ahl and Marlow; Poggesi et al.). As a theoretical perspective, we are interested in the utility of the analytic concept of structured agency for analysing women's entrepreneurship in transition countries. In much the same way that push and pull factors were seen as motivational binaries so were notions of structure and agency. In earlier thinking, aspects of social structure were determining constraints opposed to an agency framework emphasizing individual freedom of action (Hays). A more reasoned view, and one that we adopt, is the idea that structure and agency are interdependent forces (Giddens; Valdez). Structure shapes the situations that people confront, but they also make decisions after deliberative, reflexive thought (Archer; Scambler): "Agency, thus involves historically embedded individuals contributing to their own life outcomes based on behaviours, dispositions, preferences and choices" (Hitlin and Johnson 1436). Czech feminist researchers (e.g., Hašková and Dudová) have used similar frameworks to analyze how the refamilialization context shaped CR women's decisions about work and care after the 2008 economic crisis. This perspective can be used to understand how entrepreneurs may perceive opportunities that arise amid structural changes. Thus, we argue in this chapter that CR copreneurs confront situations shaped by the social structure in which they live and that they make decisions about how to confront them, such as launching a business (Valdez; Mizrachi).

Scholars also call for new methodologies for analyzing entrepreneurships. Despite the many benefits of quantitative research, there can be an analytic oversimplification if respondents are forced to answer close-ended survey questions about why they began a business (Dawson and Henley). In contrast, qualitative analyses address the nuanced and potentially shifting rationales that motivate prospective entrepreneurs (Welter; Valdez). In our research, we address this

methodological call, first with a qualitative approach and, more specifically, through an approach wherein we conduct separate interviews with each partner in a copreneurial couple. Research based on interviews with only one partner or with the two partners together may obscure women's perspectives (Hamilton; Pospíšilová et al.). Our separate interviews allow us to be sensitive to potentially different perspectives of the two partners. We detail our methodology in the next section.

Method

We conducted in-depth semi-structured interviews with twelve Czech copreneur couples who were from the Prague area. We used purposive, snowball sampling techniques to generate respondents. Although copreneurships may also include other family members, those in our sample were principally operated by the male and female romantic partners. In three cases, other family members had started or been involved in the business but had already dropped out by the time of our interviews. There are no comprehensive records of CR copreneurs, so we obtained potential respondent names from acquaintances and Internet searches of businesses. We sought to vary respondents' age, business type, family stage, and business age. The partners in each couple were interviewed separately providing a total of twenty-four interviews. This chapter centres the women copreneurs and the ways in which caring narratives converge with traditional entrepreneurial motives to move them into copreneurships. However, we also include male partners' motivation discussions, which provide an interesting comparison and contrast to those of the women.

The couples are listed by pseudonyms in Table 1. To preserve anonymity, identifiable business specifics are not listed; only general demographic information is provided. All of the participants were in heterosexual relationships; they were also all Caucasian and of Czech ancestry. They operated businesses with thirty or fewer employees. The couples were a range of ages, with the youngest couple in their twenties and the oldest couple in their fifties. Approximately two-thirds of the respondents had college degrees. Seven couples had children living with them, and four couples had raised their children to adults while operating their businesses. Only one couple had no children.

The couples we interviewed identified as "being in business together,"

although official ownership arrangements varied considerably. Six copreneurships were officially co-owned. In five copreneurships, the man was the official owner: the female partners were employees (n=three) or informal workers (n=two). A woman was the official owner of one business, and her partner was an employee. We employed this more inclusive definition relying on couples' self-identification because CR laws and policies often directly affect a couple's ownership agreement. All of the participants were active in their businesses.

The copreneurships operated in the service and sales sectors. Examples of these businesses include a language school, jewellery design/repair, toy sales, law, and food/wine production and other sales. For the most part, these businesses were neither stereotypically masculine nor feminine pursuits. Although none of these enterprises would be considered high growth oriented, some were quite successful, offering a comfortable living for the family. Ten businesses were the copreneurs' primary income source; two were part-time ventures, wherein one or both partners also held jobs. Interviews were conducted in Czech and translated into English. They lasted from thirty-five to seventy minutes each and were recorded. Partners were interviewed separately to gather their individual perspectives. Because the interviews were a part of a larger, ongoing research project, they covered matters including start-up motivations, business operations, household and childcare responsibilities, opportunities and barriers, work-life balance, and how contextual factors, such as the changing CR economy and government policies, have affected their lives. We agree with other narrative researchers that interviews are spaces in which the respondents are essentially presenting themselves, their partners, their businesses, their family experiences, and their personal identities (Hamilton). Therefore, we recognize that retelling of motives in interviews may entail retrospective reinterpretations of the past (Dawson and Henley). Regardless, these discussions still provide significant insights into copreneurs' sense of themselves in terms of business and family life.

The transcripts were vetted by our research team and coded in NVivo, according to the research questions, unanticipated themes, commonalities, and points of divergence. This analysis focused on the discussion of motives, including push-pull factors, caring issues, career advancement, self-fulfilment, work-life balance, financial issues, job-loss/unemployment, limited employment mobility, opportunities, government policies,

as well as economic and cultural norms. We were attentive to both what was said and not said and to points of emphasis. Our analysis connected the interviews with the literature, drawing upon both empirical and theoretic connections and locating the responses within the CR context.

Findings

Past research has stressed women's desire to combine paid work and childcare responsibilities as an impetus for the growth of women-owned businesses (Sharafizad and Coetzer; Jurik). Consistent with recent motivation studies (Dawson and Henley; Poggesi et al.), our data revealed a combination of push and pull factors in women's decision to form copreneurships. Forming a copreneurship entailed a two-pronged decision process for respondents: going into their own business and going into business with a male romantic partner. Women arrived at copreneurships through varying trajectories. Some romantic partners formed the copreneurship together. Some women started businesses that male partners joined later; in other cases, the woman joined the male partner's business. Two women entered preexisting family businesses and later were joined by their male partners. Thus, women came to copreneurships in a variety of ways, and their decisions were shaped by a variety of factors, including those identified in traditional entrepreneurship studies and in gender-aware entrepreneurial research. However, our findings also suggest the ways in which copreneur decisions to form businesses are shaped by the economic and normative context, including the CR's transition to a market economy and the corresponding changes in family policies. Our structured agency approach provides a framework through which we can see how our respondents' decisions were influenced by their individual aspirations and situation within the larger CR context (also see Mizrachi). We begin by detailing the motivations that women discussed and then compare these with the motivations described by their male partners. In the findings section, we elaborate upon the ways in which the participants' motives were shaped by CR structural conditions (see Table 2).

Push-Pull Factors and Women Copreneurs

The women we interviewed discussed their motivations in their decision to start copreneurships. Some women identified traditional entrepreneurial pulls, such as a desire for independence or self-fulfilment; others mentioned unique business opportunities. However, for most of the women respondents, an important pull factor also included caring for their family. Most frequently noted was caring for children, but some also stressed helping husbands in a business or taking care of older relatives. Push factors included job loss, discrimination or harassment in the workplace, limited employment opportunities, or, for some, hating their previous job.

Seven women described themselves as needing freedom or not wanting to work with bosses. Five women identified autonomy as an important reason for entering business. For example, Patricie said, "I don't fit into any system; I come into conflict immediately ... so I had to open a business of my own so that I could run things." Vanda said, "We couldn't imagine that we would work for someone else." Nine women said that an opportunity motivated them to start a business. Bohdana said that she had grown tired of the management at her former job and that the time was right for her business. Three women mentioned self-fulfilment. Ester described a combination of fulfilment and earning capacity. She said that copreneurship offered something "that I could like and earn at the same time.... It would be work that ...develops me somehow and gives me self-fulfilment." Most women named multiple motives: in several cases, there were triggering motives that definitively pushed them into business with their partners, but even then, these were usually accompanied by pull factors.

When female copreneurs discussed entrepreneurial motives, most mentioned several types of caring motives. Seven women referenced the needs of their male partners as part of their rationales for copreneurship. Patricie and Bohdana invited male partners into their businesses when the men lost their jobs. Marta described starting a business with her unemployed partner, saying it was because he was unemployed and needed the freedom of self-employment. Marta and Ester described themselves as motivated "by love" to form businesses to "spend more time together" as couples. Johana, Vanda, and Marta joined their partner's businesses to help them out. Some research suggests that preexisting family business may be a pull factor (Dawson and Henley).

Alice exemplified this motive. She wanted to help her father in his business as he moved towards retirement. Her male partner joined that family business later because he was fed up with his management job and wanted more meaningful work.

British and U.S. studies (Loscocco and Bird; Baines and Wheelock) suggest that combining childcare and paid work is a significant motive for women who start a business. Among our female respondents, childcare was important even if not the only motive for copreneurship. Dora and Zina credited the flexibility to combine paid work and childcare as a major rationale for copreneurship. Even women who had started businesses before having children stressed that copreneurship later benefitted them as mothers. Kristýna joined Karel's business when he had employee problems; once they had children, she quit her job and focused on the copreneurship because it gave her freedom to work at home. Of course, past research (Jurik; Křížková et al., "Women's Entrepreneurial Realities") warns that entrepreneurship is no panacea for women with childcare responsibilities. Lada exemplified this concern. She worried that her son was on his own too much while she and her husband were running their copreneurship, but she was glad that her son had become "very responsible at a young age." The copreneurship allowed Lada's family to live comfortably. Regardless of whether it was their sole motivation, the women had lots to say about how copreneurships had facilitated or would facilitate their roles as mothers. Even Ester, who was the only respondent who had no children, said that she looked forward to the flexibility the business provided when she did have them. Concerns about family members, usually children and male partners but also elders, were part of the calculus female respondents described (see also Meliou and Edwards).

Several of the women who discussed the connections of copreneurship to motherhood referenced push pressures. These related to limited employment opportunities, problematic employment experiences, or work childcare conflicts. Often these push factors worked as triggering mechanisms that moved women into copreneurship. Four women (Kristýna, Dora, Johana, and Zina) described a lack of part-time and flexible employment opportunities as part of their decision to become copreneurs. Even though Kristýna had begun working with Karel while she was employed elsewhere and before having children, she said, "When we had children, I didn't want to work fulltime." Her employer

offered her only slightly reduced work hours, so she quit her job in order to work solely in their copreneurship and to care for their children. Dora was driven into business by workplace hostilities she experienced during pregnancy and after the birth of her child. She found another job but experienced problems after declining a supervisor's invitation for a date: "[Afterwards], that man had it in for me." When she took time off to care for her sick daughter, further hostilities ensued. She "repeatedly came home feeling beaten, cried a lot, and became depressed." Then she began her own business: "I simply said to them that I was finished. I quit one day, and the next day got my trade license and formed my first company." She did the accounts for her husband's shop and later joined him working there.

In contrast to surveys that offer limited options for identifying motives, our interviews afforded respondents the space to discuss the complex and interacting array of push and pull factors that motivated their copreneurial ventures. The interviews revealed that their decisions were made by simultaneously assessing past work experiences, work opportunities, as well as caring for partner needs, children, or other family members. Clearly, traditional entrepreneurial aspirations were paramount to some respondents, but notions of motherhood and family figured prominently in every woman's narrative. As scholars Sallie Westwood and Parminder Bhachu have noted, it is possible to analytically distinguish productive from reproductive labour, but these may not be separable in the lives of women. Women spent far more time in interviews than did men discussing caring concerns. Even when flexibility for childcare was not the primary impetus for copreneurship, the welfare of children was mentioned by the women. Helping husbands through copreneurship was mentioned as well. In a later section, we discuss in further detail how the Czech transitional context and state policies were referenced in motivation discussions. Next, however, we discuss how men's motivation discourse compared to that of women.

Push-Pull Factors and Men Copreneurs

Like the women, men respondents stressed multiple entrepreneurial pull motivations, including business opportunities, autonomy, and financial rewards. Seven men noted the attraction of a business opportunity. For example, Libor stumbled upon an attractive product,

bought a large quantity of the item, and opened a shop with his partner, Lada, to sell the items. Borek joined Bohdana's business because he saw its growth potential; their business was successful. Six men stressed autonomy and independence. Viktor said: "I have always been the master of my fate…. I don't want to have some stupid man over me." Four men referenced opportunities for personal fulfilment. Adam wanted to form a sustainability-oriented business. Four men mentioned a good income. Ota said: "The salaries here are such that it is not easy to afford life in Prague … but because my wife and I had skills, we had offers to organize these [sports] activities."

Men also mentioned factors that pushed them into copreneurship. Three men (Borek, Prokop, and Michal) became copreneurs when their own work began failing. Interestingly, however, these men tended to recast copreneurial pushes in pull terms, such as their need for freedom or for seizing a business opportunity. For example, although Michal acknowledged losing his job and being unable to find employment, he described his main motive as not wanting to work for someone else. Borek, who described his own business as being in a slow period, said that he saw an opportunity for expanding Bohdana's business, which he characterized as being in a "hot area." Prokop's business was ending when he and Patricie saw an expansion potential in her business, so he joined her. Prokop described himself as Patricie's boss. Prokop and Borek said their move into their female partner's business made the venture successful. Neither mentioned being helped when their partner included them. Only one man spoke of helping his female partner. Libor said that he felt pressured to find a business opportunity for Lada when she was out of work.

There are, of course, other push factors, but no men spoke about job discrimination or harassment. Several identified workplace politics as driving them from the job and towards business ownership. Adam blamed cronyism on losing a promotion, and David left his job when pressured to join the Communist Party. Interviews allowed the men to offer multiple motives for copreneurship. Many motives they offered paralleled the women's (e.g., traditional pull motivations, such as autonomy or business opportunities, and push factors, such as unemployment or workplace problems). However, men differed from the women on a key dimension. Few men mentioned motives that included care work or love. Two women (Marta and Ester) said they

formed copreneurships out of love—to be with their husbands more—but their male partners never mentioned this. Men rarely discussed childcare responsibilities other than to name women as principally responsible. Men did not credit wives or other family members who took them into business. In contrast, notions of motherhood and family responsibilities permeated women's discussions about motivations and, as we have shown elsewhere, also about how they manage work and family (Jurik et. al.). The women said that they oversaw childcare while their male partners "built their careers." Women's double work days tired and stressed them, but they accepted rather than protest these dual responsibilities (see also Treanor and Henry).

Our interviews also included interesting discussions about the CR's transition to a market economy and the parental leave and taxation policies that were part of these economic and political changes. These shaped the parameters of business, employment, and motherhood in the CR and thereby informed copreneurial decision making. We now turn to these larger contextual matters.

The Importance of Context: CR Transition Economics and Policies

As with the findings by Lituchy and Reavley, copreneurs in our sample mentioned motivations consistent with those found in Western-dominated research. Even so, scholars stress that the situation in different types of countries—for example, in developing or transitional economies—may affect business motives and practices (Smallbone and Welter; Virglerová et al.). We employed the structural-agency approach because it is sensitive to the environment in which decisions, such as forming a copreneurship, are made. Indeed, men and women linked their motivations to conditions in the CR transitional economy. Women also discussed their motivations in relation to CR maternity-family leave and taxation policies.

Business ownership was banned during the Soviet years and was permitted only after 1989. Seven men and three women related their experiences working for state-owned companies or cooperatives as a background for their business motivations. The ways in which these backgrounds informed copreneurships were varied and interesting. In some cases, work experiences under socialism were precursors to

copreneurships. Patricie learned her craft in a state-owned cooperative. Ota and Olga were part of a state-supported sports team, and after the revolution, their experiences facilitated the creation of their sports-related business. During the transition, Karel was involved in privatizing government holdings. He and Kristýna worked in this realm and later developed a related postprivatization business. Jakub learned the business from his father, whose craft had been an informal one because private businesses were prohibited. After the revolution, his father restarted a formal business and Jakub was able to take it over. Bohdana worked at a state-run training school where "there was no problem having freelance clients." This made it easier for her to start a related private school during the transition.

Sometimes work under socialism provided respondents with managerial experiences and contacts that facilitated precopreneurial ventures. Borek worked in state project institutes doing construction work and "jobs on his own," which led him to start a business during the transition era. He joined Bohdana's business but credited his skills to his earlier experiences. Libor also said he gained his management skills from socialist jobs. Prokop said that despite socialism, there were opportunities for entrepreneurship: "We were a state-owned business, but money could be earned ... and we met an unbelievable group of characters, people from abroad, because simply that boom after the revolution was here." Patricie used contacts from a state-owned co-op to develop clients. Prokop added that Patricie's work in her co-op provided training and contacts for what would later become their copreneurship.

In a few cases, the managerial experiences gained in socialist enterprises were described as lessons in how not to run a company. David spoke about almost quitting when he was denied a promotion for refusing to join the Communist party. However, a supervisor recognized the quality of his work and promoted him anyway. David also described rivalries and sabotage between workers and managers from different parts of the country: "I managed eighty people but that work environment, those supervisors, I simply didn't like it. I was not going to suffer because someone would slur my work because I was from the West [region]." His job was to prepare the state-owned company for privatization, and he gained management skills that he later used in copreneurship. For some respondents, the transition led to immediate job displacement: their

state-owned job disappeared. Others lost jobs in the posttransition economic recessions, which caused their new private sector jobs or businesses to fail. Lada worked as a trade union manager but lost her job when the unions were disbanded in the transition. Borek, Prokop, and Michal left their businesses because of slow growth during the recessions. They saw copreneurship as a more viable opportunity. Thus, the transition economy and its aftermath simultaneously pushed and pulled Czech copreneurs—men and women—into their own businesses by ending old job opportunities and opening avenues for new ventures, including copreneurship.

Women discussed how postsocialist changes in employment opportunities converged with changing parental leave policies to inform their decisions to become copreneurs. Reflective of normative views that men were principal breadwinners and not caregivers, none of the men in our sample had taken parental leaves nor was it referenced in their discussions about copreneurship. In contrast, the duties and difficulties of motherhood, past and present, were a constant aspect of the women's discussions. Dora and Kristýna mentioned the limited employment opportunities and the lack of affordable childcare for mothers with young children available to them due to refamilialization policies. Although the state created lengthy parental leaves for parents, usually taken by mothers, women were often met with hostility when they tried to return to jobs (Hašková). The lack of affordable childcare exacerbated the situation for working mothers. This structural condition was reflected in Dora's stories of caring for her sick daughter and then being faced with her supervisors' hostile response. Kristýna's experience with her boss's reluctance to give her part-time work also illustrated the ways in which the rarity of flexible and part-time work opportunities in the CR pushed women into entrepreneurship.

Despite these structural limitations, Kristýna, Zina, and Johana were able to become copreneurs and take paid parental leave. Because she was an employee while becoming a copreneur, Zina was able to take a paid leave and work more, albeit informally, in the copreneurship. She characterized maternity leave as "as a super space to begin or try new things." Kristýna and Johana were also employed at the beginning of their copreneurships. They worked informally in copreneur activities to care for young children and still managed the Internet aspects of their businesses. Patricie, who was in business for some time before having

children, said she was unable to take maternity leave and officially run her business: "The law didn't even allow that I would have a maternity leave. I had to go to work all the time so that I didn't have to fire people." Although the women who were employed at the time of pregnancy could avail themselves of paid parental leave and, thus, might seem advantaged compared to Patricie, maternity leave provisions encourage women to avoid formal roles in copreneurships. Women's informal roles in the business also allowed couples to take advantage of the CR spousal tax deduction. Some women (e.g., Ester) simply took lower or no salary to facilitate reinvestment in the copreneurship and to access the spousal deduction. Accordingly, parental leave and spousal deduction policies reduced the visibility of women's business contributions and may reduce their compensation in the case of divorce or retirement.

The environment in which these copreneurs exist consists of multiple realities that affect mothers with small children the most. Recession and economic downturns make their situation even more precarious (Hašková and Dudová). Mothers face limited and poorly paid part-time employment and potentially hostile employers because of their childcare needs. The government's decision to prioritize leave and allowance policies over available childcare is a further constraint on their decisions. This section has illustrated several ways in which both the CR transitional milieu and the associated refamilialization policies have structured Czech copreneur motivations and decision making. The postsocialist situation necessitated copreneurial ventures for some and provided opportunities for others. Although our respondents exercised agency in overcoming challenges to their parenting and entrepreneurial activities, it is also clear that their entrepreneurial decisions emerged in a particular structural context. This section on transition economics and family policy again illustrates the more intense focus of women copreneurs on caring-related issues, such as parental leave policies and the responsibilities associated with motherhood, even as they often embraced opportunities for entrepreneurship. Men focused much more exclusively on traditional entrepreneurial motives.

Conclusion

At the outset, we noted that there has been a general increase in women-owned businesses. Of note, there also has been an increase in

copreneurships, which are businesses operated by romantic couples. There has been a concomitant increase in research on copreneurial ventures in other countries, but such studies remain scarce in the CR. Copreneurships are of interest because they are hybrid organizations that offer an avenue for explicitly combining earnings and care work. In so doing, they highlight the embeddedness of business in family life and the gendered integration of production and reproduction activities in women's lives. We have focused on the motivations for CR copreneurships and the ways in which they are also embedded in a larger societal context.

Our separate interviews with CR copreneur couples allowed us to learn of perspectives that might have remained unstated in joint interviews. These interviews also allowed space to learn about the complex issues surrounding the creation and operation of a copreneurship and the different emphasis placed on caring responsibilities by male and female partners. Our analysis of these interviews suggests the importance of childcare responsibilities in a woman's decision to join a copreneurship: women respondents discussed these issues far more than the men did. However, we also found that women included other traditional entrepreneurial motivations. Women were pushed from the workforce by a variety of factors, such as limited part-time opportunities, harassment, and a lack of affordable childcare, but they were also pulled by business reasons, such as the desire for autonomy, better income as well as the unique opportunities they recognized during the CR transition. Regardless of their primary motivation to start a copreneurship, the women integrated care and business concerns in the venture. The men, in contrast, focused on business- and career-oriented motivations and did not mention caring concerns. They reframed even push motivations, such as job loss or business decline, into entrepreneurial opportunities, which they have made successful. This dynamic was most striking when their female partners had incorporated men into the businesses that the women had established.

Another significant finding was our elaboration of the ways in which the CR's transition, government policies, and normative regimes shaped copreneur motives in often gendered but not always uniform ways. The structured agency framework offered a window into the nature of copreneurships in the CR. The framework illustrated agency in decision making, but also the ways that decisions are informed by the larger

societal context, including a country's economic structure, governmental policies, and cultural norms (Welter). For example, the end of state socialism caused job loss but, at the same time, created opportunities for copreneurship in the shift to privatization. State socialism provided opportunities for respondents—men and women—to gain entrepreneurial skills that would enhance their businesses at later dates. Similarly, refamilialization policies, including parental leave, blocked but also freed up women to pursue new business opportunities.

Our data agree with CR survey reports (CZSO) in that our female respondents took for granted that they needed to both earn and shoulder primary parenting responsibility. In interviews, they did not question the justness of the mothers' double burden. Their comments reflect a cultural norm to which Czech men and women are held accountable— that is, aktivní mateřství or active mothering. Even though the latest generation of CR mothers (see Marková Volejníčková) perceive that they have more mothering options than their predecessors (e.g., breastfeeding and working), they still feel they must justify every decision so they do not appear to be bad or lazy mothers. For women, reproductive and productive activities are interwoven. Future research should include more explicit comparisons of copreneur dynamics within different national contexts. Coupling in-depth interviews with observations would also enrich the analysis.

The insights from our analysis include, first, the complexity and multiplicity of motivations for copreneurship, for example, the importance of both push and pull explanations and the importance of both individual aspirations and external contexts. Second, transitional economies are an important site for research into copreneurial ventures and one in which structured agency reveals the interplay between contextual factors and individual agency in shaping work and family lives (Pospíšilová). The transitional context provided both barriers and opportunities that were drawn upon by individuals in sometimes unique ways. Third, qualitative methodologies are especially apt for revealing complex and multiple motivations. Fourth, our use of a definition that focused on self-defined copreneurship, regardless of formal ownership status, was essential because government policies can work against women's formal recognition in copreneurships. Regardless of formal designations, the women in our sample described major roles in their copreneurships. Fifth, and finally, notwithstanding the presence of

traditional pull motivations, childcare responsibilities were an important motivation for women in copreneurships, and these concerns typically fell to women in ways that affected their views of their businesses leadership roles.

Table 1. List of Copreneurs and Demographic Characteristics (Pseudonyms Only)*

Female and Male	Age	Business Type*	Years in Business together	Number of Children**	Number of Employees
#1 Ester and Eda	18–34	Service	Less than 5	0	Over 5
#2 Kristýna and Karel	Over 45	Sales	More than 5	4**	1–4
#3 Alice and Adam	Over 45	Sales	Less than 5	2	1–4
#4 Patricie and Prokop	35–44	Creative Product/Sales	More than 5	3**	Over 5
#5 Olga and Ota	Over 45	Service	More than 5	1	1–4
#6 Dora and David	Over 45	Sales	More than 5	1	1–4
#7 Vanda and Viktor	Over 45	Service	More than 5	2**	Over 5
#8 Marta and Michal	35–44	Service	Less than 5	2**	1–4
#9 Johana and Jakub	18–34	Creative Product/Sales	More than 5	1**	1–4
#10 Zina and Zdenek	35–45	Creative Product/Sales	Less than 5	3**	1–4
#11 Lada and Libor	Over 45	Sales	More than 5	2	1–4
#12 Bohdana and Borek	Over 45	Service	More than 5	1**	Over 5

* Because of the small size of our sample and to protect the confidentiality of individual responses, we have coded business type, years in business together, number of children, and employees into very broad categories. In developing this coding scheme, we were guiding by distinguishing classifications that have been stressed in the business literature (e.g., in business together less than five years or five years or more).

** Indicates couples with children under eighteen living with them at the time of the interview.

Table 2. Push and Pull Factors in Women and Men Copreneurs' Narratives

Pull Factors

Traditional Entrepreneurial Pull Factors	Caring for Family	Copreneurship
• desire for independence (freedom, autonomy) • self-fulfilment • business opportunities • financial rewards	• caring for children • housework • caring for other family members • needs of their (male) partners	• helping partners in business • spending more time together with partner • preexisting family business

Push Factors

Problems in Previous Employment	Caring for Family
• job loss, work began failing • discrimination or harassment in the workplace • limited employment opportunities • problematic employment experiences	• lack of adequate and affordable childcare • child or family care emergencies • lack of part-time and flexible jobs • lack of other work-life balance measures

The authors wish to acknowledge funding in support of this research from the following sources: Arizona State University's College of Liberal Arts and Sciences and School of Social Transformation, Technology Agency of the Czech Republic in ETA Programme (TL03000670) and institutional support: Rozvoj Výzkumné Organizace (RVO: 68378025).

Works Cited

Ahl, Helene. *The Scientific Reproduction of Gender Inequality.* CBS Press, 2004.

Ahl, Helene, and Susan Marlow. "Exploring the Dynamics of Gender, Feminism and Entrepreneurship: Advancing Debate to Escape a Dead End?" *Organization,* vol. 19, no. 5, 2012, pp. 543-62.

Aidis, Ruta, et al. "Female Entrepreneurship in Transition Economies: The Case of Lithuania and Ukraine." *Feminist Economics,* vol. 13, no. 2, 2007, pp. 157-83.

Aldrich, Howard E., and Jennifer E. Cliff. "The Pervasive Effects of Family on Entrepreneurship: Toward a Family Embeddedness

Perspective." *Journal of Business Venturing,* vol. 18, no. 5, 2003, pp. 573-96.

Archer, Margaret. *Making Our Way through the World.* Cambridge University Press, 2007.

Baines, Susan, and Jane Wheelock. "Work and Employment in Small Businesses: Perpetuating and Challenging Gender Traditions." *Gender, Work & Organization,* vol. 7, no. 1, 2000, pp. 45-56.

Bartoš, Přemysl, et al. "Are Men More Innovative and Aggressive in Business? Case Study from the Czech Republic." *International Journal of Entrepreneurial Knowledge,* vol. 3, no. 2, 2015, pp. 29-39.

Belás, Jaroslav, et al. "Entrepreneurship in SME Segment: Case Study from the Czech Republic and Slovakia." *Amfiteatru Economic Journal,* vol. 17, no. 38, 2015, pp. 308-26.

Bhachu, Parminder. "Apni Marzi Kardi: Home and Work: Sikh Women in Britain." *Enterprising Women: Ethnicity, Economy and Gender Relations,* edited by Sallie Westwood and Parminder Bhachu, Routledge, 2004, pp. 76-102.

Blenkinsopp, John, and Gill Owens. "At the Heart of Things: The Role of the 'Married' Couple in Entrepreneurship and Family Business." *International Journal of Entrepreneurial Behaviour & Research,* vol. 16, no. 5, 2010, pp. 357-69.

Bliss, Richard T., and Nicole Garratt. "Supporting Women Entrepreneurs in Transition Economies." *Journal of Small Business Management,* vol. 39, no. 4, 2001, pp. 336-44.

Břečková, Pavla. "Family Business in the Czech Republic." *European Research Studies,* vol. 19, no. 4, 2016, pp. 3-16.

Cappuyns, Kristin. "Women behind the Scenes in Family Businesses." *Electronic Journal of Family Business Studies (EJFBS),* vol. 1, no. 1, 2007, pp. 38-61.

Casanova, Petr. "Zkazíš si život, slyšela. Sýčkům nevěřila. Dnes úspěšně podniká při 3 dětech." *FirstClass.cz,* www.firstclass.cz/2015/04/zkazis-si-zivot-slysela-syckum-neverila-dnes-uspesne-podnika-pri-3-detech/. 2015. Accessed 20 Sept. 2018.

Cromie, Stanley. "Motivations of Aspiring Male and Female Entrepreneurs." *Journal of Organizational Behavior,* vol. 8, no. 3, 1987, pp. 251–261.

Czech Statistical Office (CZSO). *Zaostřeno na ženy a muže (Focused on Women and Men)*. czso.cz, https://www.czso.cz/csu/czso/zaostreno-na-zeny-a-muze-2013-j7b2up4uwn. 2013. Accessed 20 Sept. 2018.

Dawson, Christopher, and Andrew Henley. "'Push' Versus 'Pull' Entrepreneurship: An Ambiguous Distinction?" *International Journal of Entrepreneurial Behaviour & Research*, vol. 18, no. 6, 2012, pp. 697-719.

de Bruin, Anne, and Kate Lewis. "Toward Enriching United Career Theory: Familial Entrepreneurship and Copreneurship." *Career Development International*, vol. 9, no. 7, 2004, pp. 638-46.

Duh, Mojca, et al. "The Importance of Family Enterprises in Transition Economies: Is It Overestimated?" *Eastern European Economics*, vol. 47, no. 6, 2009, pp. 22-42.

Giddens, Anthony. *The Constitution of Society: Outline of the Theory of Structuration*. Polity Press, 1984.

Hamilton, Eleanor. "The Discourse of Entrepreneurial Masculinities (and Femininities)." *Entrepreneurship & Regional Development*, vol. 25, no. 1-2, 2013, pp. 90-99.

Harris, Candice, et al. "The Commercial Home Enterprise: Labour with Love." *Turizam: znanstveno-stručni časopis*, vol. 55, no. 4, 2007, pp. 391-402.

Hašková, Hana. "Proměny časování a způsobu návratu matek do zaměstnání (The Changing Timing and Ways of Mothers' Returning to the Workplace)." *Gender, rovné příležitosti, výzkum*, vol. 12, no. 2, 2011, pp. 40-52.

Hašková, Hana, and Radka Dudová. "Precarious Work and Care Responsibilities in the Economic Crisis." *European Journal of Industrial Relations*, vol. 23, no. 1, 2017, pp. 47-63.

Hašková, Hana, and Steven Saxonberg. "The Revenge of History—The Institutional Roots of Post Communist Family Policy in the Czech Republic, Hungary and Poland." *Social Policy & Administration*, vol. 50, no. 5, 2015, pp. 559-79.

Hašková, Hana, et al. "Leaves, Allowances, and Facilities: Childcare Past and Present." *Women and Social Citizenship in Czech Society: Continuity and Change*, edited by Hana Hašková and Zuzana Uhde, Institute of Sociology, Academy of Sciences of the Czech Republic, 2009, pp. 77-128.

Hays, Sharon. "Structure and Agency and the Sticky Problem of Culture." *Sociological Theory*, vol. 12, no. 1, 1994, pp. 57-72.

Helmle, Jill, et al. "Factors that Influence Perceptions of Work-Life Balance in Owners of Copreneurial Firms." *Journal of Family Business Management*, vol. 4, no. 2, 2014, pp. 110-32.

Henry, Colette, et al. "Gender and Entrepreneurship Research: A Review of Methodological Approaches." *International Small Business Journal*, vol. 34, no. 3, 2015, pp. 1-25.

Hillman, Felicitas. "A Look at the 'Hidden Side': Turkish Women in Berlin's Ethnic Labour Market." *International Journal of Urban and Regional Research*, vol. 23, no. 2, 1999, pp. 267-82.

Hisrich, Robert D., and G. Gyala Fülöp. "Women Entrepreneurs in Family Business: The Hungarian Case." *Family Business Review*, vol. 10, no. 3, 1997, pp. 281–302.

Hitlin, Steven, and Monica Kirkpatrick Johnson. "Reconceptualizing Agency within the Life Course: The Power of Looking Ahead." *American Journal of Sociology*, vol. 120, no. 5, 2015, pp. 1429–1472.

Holienka, Marian, et al. "Drivers of Women Entrepreneurship in Visegrad Countries: GEM Evidence." *Procedia-Social and Behavioral Sciences*, vol. 220, 2016, pp. 124-33.

Jobspin. "Gender Pay Gap in the Czech Republic." *Jobspin*, 7 June 2016, www.jobspin.cz/2016/06/gender-pay-gap-in-the-czech-republic/. Accessed 16 June 2016.

Jurik, Nancy C. "Getting Away and Getting by the Experiences of Self-Employed Homeworkers." *Work and Occupations*, vol. 25, no. 1, 1998, pp. 7-35.

Jurik, Nancy, et al. "Czech Copreneur Orientations to Business and Family Responsibilities: A Mixed Embeddedness Perspective." *International Journal of Gender and Entrepreneurship*, vol. 8, no. 3, 2016, pp. 307-26.

Kelley, Donna, et al. "Global Entrepreneurship Monitor (GEM) 2011 Global Report." *GEM Consortium*, 2011, www.gemconsortium.org/report. Accessed 2 March 2018.

Kolouchová, Daniela, and Ondřej Machek. "Ženský leadership v rodinném podnikání: poznatky z kvalitativního výzkumu v České republice." *Trendy v podnikání*, vol. 6, no. 1, 2016, pp. 33-41.

Kozubíková, Ludmila, et al. "The Effect of Business Environment and Entrepreneurs' Gender on Perception of Financial Risk in the SMEs Sector." *Journal of Competitiveness,* vol. 9, no. 1, 2017, pp. 36–50.

Křížková A. "Životní strategie podnikatelek a podnikatelů na přelomu tisíciletí." *Sociologické studie,* vol. 4, no. 8, 2004.

Křížková, Alena, and Marta Vohlídalová. "The Labour Market and Work-Life Balance in the Czech Republic in Historical Perspective." *Women and Social Citizenship: Continuity and Change,* edited by Hana Hašková and Zuzana Uhde, Institute of Sociology, Academy of Sciences of the Czech Republic, 2009, pp. 35-76.

Křížková Alena, et al. *Pracovní dráhy žen v České republice (Working Paths of Women in the Czech Republic).* Praha, Sociologické nakladatelství (SLON), 2011.

Křížková, Alena, et al. "The Divisions of Labour and Responsibilities in Business and Home among Women and Men Copreneurs in the Czech Republic." *Women's Entrepreneurship in the 21st Century: An International Multi-Level Research Analysis,* edited by Kate V. Lewis et al., Edward Elgar, 2014, pp. 258-77.

Křížková, Alena, et al. "The Legacy of Equality and the Weakness of Law: Within-Job Gender Wage Inequality in the Czech Republic." *European Sociological Review,* vol. 26, no. 1, 2010, pp. 83–95.

Křížková, Alena, et al. "Women's Entrepreneurial Realities in the Czech Republic and the United States: Gender Gaps, Racial/Ethnic Disadvantages, and Emancipatory Potential." *Women's Entrepreneurship: Going Beyond the Gender-Neutral Approach,* edited by Shumaila Yousafzai et al., Routledge, 2018, pp. 180-93.

Lewis, Kate, and Claire Massey. "Critical yet Invisible: The 'Good Wife' in the New Zealand Small Firm." *International Journal of Gender and Entrepreneurship,* vol. 3, no. 2, 2011, pp. 105-22.

Lituchy, Terri R., and Martha A. Reavley. "Women Entrepreneurs: A Comparison of International Small Business Owners in Poland and the Czech Republic." *Journal of International Entrepreneurship,* vol. 2, no. 1-2, 2004, pp. 61-87.

Loscocco, Karyn, and Sharon R. Bird. "Gendered Paths: Why Women Lag Behind Men in Small Business Success." *Work and Occupations,* vol. 39, no. 2, 2012, pp. 183-219.

Machek, Ondřej, and Jiří Hnilica. "On the Performance Gaps between Family and Non-Family Firms in the Czech Republic." *Central European Business Review,* vol. 2, no. 4, 2013, pp. 54-55.

Machek, Ondřej, et al. "The Impact of Spousal Relationship on Profitability: A Matched-Pair Investigation of Copreneurial Firms." *Journal of Advanced Management Science,* vol. 63, no. 2, 2016, pp. 162-66.

Manolova, Tatiana S., et al. "The Differential Effect of Men and Women Entrepreneurs' Human Capital and Networking on Growth Expectancies in Bulgaria." *Entrepreneurship Theory and Practice,* vol. 31, no. 3, 2007, pp. 407–426.

Marková Volejníčková, Romana. "Mateřská praxe v příbězích matek tří různých generací. (Maternal Practice in the Narratives of Mothers in Three Different Generations)." *Gender a výzkum,* vol. 19, no. 1, 2018, pp. 105-29.

McAdam, Maura, and Susan Marlow. "Sectoral Segregation or Gendered Practices? A Case Study of Roles and Identities in a Copreneurial Venture." *Global Women's Entrepreneurship Research: Diverse Settings, Questions and Approaches,* vol. 14, no. 3, 2012, pp. 189-203.

Meliou, Elina, and Tim Edwards. "Relational Practices and Reflexivity: Exploring the Responses of Women Entrepreneurs to Changing Household Dynamics." *International Small Business Journal: Researching Entrepreneurship,* vol. 36, no. 2, 2018, pp. 149-68.

Ministry of Labour and Social Affairs (MPSV). "Počet příjemců rodičovského příspěvku podle pohlaví. (Parental Allowance Recipients by Sex)." *MPSV,* 2017, www.mpsv.cz/cs/10543. Accessed 20 Feb. 2018.

Mizrachi, Beverly. "The Henna Maker: A Moroccan Immigrant Woman Entrepreneur in an Ethnic Revival." *Entrepreneurship,* vol. 15, 2005, pp. 257-77.

Petlina, Anastasia, and Vojtěch Koráb. "Family Business in the Czech Republic: Actual Situation." *Trends Economics and Management,* vol. 9, no. 23, 2015, pp. 32–42.

Podnikavazena. "Podnikání nás stmelilo a vrátilo nám energii do života, říkají manželé Ratajští." *Podnikavazena,* www.podnikavazena .cz/rozhovory//podnikani-nas-stmelilo-a-vratilo-nam-energii-do-zivota-rika-lucka-s-ondrou. Accessed 27 Sept. 2018.

Poggesi, Sara, et al. "What's New in Female Entrepreneurship Research? Answers from the Literature." *International Entrepreneurship and Management Journal,* vol. 12, no. 3, 2016, pp. 735-64.

Pospíšilová, Marie. *Partnery v podniku, domácnosti i životě. (Partners in Business, Home and Life).* 2018. Charles University in Prague, PhD dissertation.

Pospíšilová (Dlouhá), Marie, et al. "Genderové inovace v malém podnikání. Institucionální podmínky a dosahování genderové (ne) rovnosti u podnikatelských párů. (Gender Innovations in Small Entrepreneurship: Institutional Conditions and Management of Gender (In)equality in Copreneur Couples)." *Gender, rovné příležitosti, výzkum,* vol. 15, no. 2, 2014, pp. 87-100.

Rampulová, Kateřina, et al. "O podnikatelkách na startovní čáře, jejich motivech, obavách a podnikatelských snech." *Ženy-podnikatelky v minulosti a současnosti,* edited by Pavla Slavíčková, Nakladatelství Lidové noviny, 2016, pp. 209-24.

Rašticová Martina, and Monika Bédiová. "Women's Entrepreneurship in Transition Economies such as the Czech Republic." *Littera Scripta,* vol. 9, no. 2, 2016, pp. 90-103.

Reavley, Martha A., and Terri R. Lituchy. "Successful Women Entrepreneurs: A Six-Country Analysis of Self-Reported Determinants of Success-More than Just Dollars and Cents." *International Journal of Entrepreneurship and Small Business,* vol. 5, no. 3, 2008, pp. 272-96.

Scambler, Graham. "Resistance in Unjust Times: Archer, Structured Agency and the Sociology of Health Inequalities." *Sociology,* vol. 47, no. 1, 2013, pp. 142-56.

Scase, Richard. *Entrepreneurship and Proprietorship in Transition: Policy Implications for the Small- and Medium-Size Enterprise Sector.* United Nations University World Institute for Development Economic Research, 2000.

Scharle, Agota. "Attitudes to Gender Roles in the Czech Republic, Hungary, and Poland." GRINCOH Working Paper, 2015, www.budapestinstitute.eu/grincoh_wp5.09_scharle.pdf. Accessed 20 Feb. 2018.

Sharafizad, Jalleh, and Alan Coetzer. "Women Business Owners' Start-up Motivations and Network Content." *Journal of Small Business and Enterprise Development,* vol. 23, no. 2, 2016, pp. 590-610.

Sjöberg, Ola. "The Role of Family Policy Institutions in Explaining Gender-Role Attitudes: A Comparative Multilevel Analysis of Thirteen Industrialized Countries." *Journal of European Social Policy,* vol. 14, no. 2, 2004, pp. 107-23.

Smallbone, D., and Frederike Welter. "The Distinctiveness of Entrepreneurship in Transition Economies." *Small Business Economics,* vol. 16, no. 2, 2001, pp. 249-62.

Treanor, Lorna, and Colette Henry. "Influences on Women's Entrepreneurship in Ireland and the Czech Republic." *Women Entrepreneurs and the Global Environment for Growth. A Research Perspective,* edited by Candida G. Brush et al., Edward Elgar, 2010, pp. 73-95. Print.

Uhde, Zuzana, and Hana Hašková. "Social Citizenship and Care in Czech Society." *Women and Social Citizenship in Czech Society: Continuity and Change,* edited by Hana Hašková and Zuzana Uhde, Institute of Sociology, Academy of Sciences of the Czech Republic, 2009, pp. 15-33.

Valdez, Zulema. *The New Entrepreneurs: How Race, Class, and Gender Shape American Enterprise.* Stanford University Press, 2011.

Velinger, Jan. "Number of Female Entrepreneurs on Rise, According to Czech Radio." *Radio Praha,* www.radio.cz/en/section/business/number-of-female-entrepreneurs-on-rise-according-to-czech-radio. 2015. Accessed 27 Sept. 2018.

Virglerová, Zuzana et al. "The Perception of the State's Influence on its Business Environment in the SMEs from Czech Republic." *Revista Administratie si Management Public (RAMP),* vol. 26, 2016, pp. 78-96.

Wagnerová, Alena. "Emancipation and Ownership: To the Discussion on the Lack of Conditions for the Rise of Feminism in Czechoslovakia before 1989." *Czech Sociological Review,* vol. 4, no. 1, 1996, pp. 101-08.

Webbink, Ellen, et al. "Hidden Child Labor: Determinants of Housework and Family Business Work of Children in 16 Developing Countries." *World Development,* vol. 40, no. 3, 2012, pp. 631-42.

Welter, Friederike. "Contextualizing Entrepreneurship—Conceptual Challenges and Ways Forward." *Entrepreneurship Theory and Practice,* vol. 35, no. 1, 2011, pp. 165-84.

Welter, Friederike, and David Smallbone. "Institutional Perspectives on Entrepreneurial Behavior in Challenging Environments." *Journal of Small Business Management,* vol. 49, no. 1, 2011, pp. 107-25.

Westwood, Sallie, and Parminder Bhachu. "Introduction." *Enterprising Women: Ethnicity, Economy and Gender Relations,* edited by Sallie Westwood and Parminder Bhachu, Routledge, 2004, pp. 1-19.

SECTION II

Race, Culture, and Market Activity

Chapter Four

Reclaiming Motherhood and Family: How Black Mothers Use Entrepreneurship to Nurture Family and Community

Melanie Knight

This chapter examines the experiences of Black mothers who are business owners. The experiences of these women is set against a multitude of discourses—the varied social constructions of Black motherhood and the construction of the woman entrepreneur as defined in the literature on women's entrepreneurship. In terms of Black motherhood, the super-strong Black mother image now dictates the terms of good mothering for Black women: be strong and be solely responsible. On the opposite end of the spectrum, delinquent in her mothering duties, the image of the welfare queen also predominates. The public, now a space of hypervisibility, is seen as overcrowded, unsafe, and overpopulated by 'public children' from the so-called Black underclass who consume education and social welfare services" (Hill Collins 35), which has now become subject to public scrutiny. Many have written on how Black women counter these motherhood scripts. Meanwhile, the woman entrepreneur in women's entrepreneurship most often represents the experiences of middle-to-upper-class white women understood within a liberal white feminist framework that centres gender. Keeping these discourses into perspective, this chapter

examines how Black women business owners negotiate discourses of entrepreneurship and motherhood. What do both realms teach us about Black women's economic conditions, community ties, and relationship with their families and children? Although many researchers have written about Black women's work and family roles, much less has specifically focused on business activity and its limitations and possibilities in relation to Black family life.

Much of the research on Black women entrepreneurs in Canada is quantitative and somewhat limited in scope. Black women are more likely to have businesses that are smaller, less profitable, and operate in the education and health fields. The reasons for their entry and participation in business somewhat mirror those of other women which include push and pull factors (e.g., discrimination and/or independence). Research on why women choose to become self-employed most often cites the desire to balance work and family as a key reason. Self-employment provides women with the ability to care for and raise their children while also earning an income. Perpetuating the ease or flexibility of self-employment and family balance feeds into, for some, the so-called good mother message—a gendered division of labour that naturally positions women as the ideal caregivers. Challenging this perspective, Tracey Reynolds contends that for Black women, good mothering is not so much defined by "traditional Western ideologies of mothering and employment that present the two as separate, and often incompatible, gendered entities" (1054). For Black women, good mothering is interlocked with wage work and, therefore, presents a "distinctive alternative to the idealized and normative representation of the 'good mother'—the mother who remains at home to care for her children, in particular during the formative years" (1054). In liberal feminist research, when women are defined as the ideal and primary caregivers, the family for these women is often formulated as a "locus of gender conflict" (Glenn, "Racial Ethnic Women's Labor" 103) as well as oppressive in terms of the division of labour and the women's dependence on men. Being attentive to race, for women of colour, the family has also been a source of resistance to oppression and a bulwark against the effects of economic, social, and political forms of oppression.

Researchers are expanding conversations on Black mothering in Canada. In exploring Black families in Canada, Agnes Calliste examines Black family structures in Nova Scotia and Toronto. She argues that

histories of oppression inform gender relations, gender role identities, and the division of labour within Black households. Others have explored the meaning of motherhood and experience of Black mothers, a standpoint that is different from non-Black mothers. Patricia Hill Collins argues that Black mothers, who often do not assume full responsibility of the care of their children, are redefining notions of mothering. Others examine Black mothering as maternal activism that responds to systemic racial oppression and economic exploitation (Lawson). Teaching children resistance, social activism, and giving them a sense of racial pride are essential for Black mothers (O'Reilly). Some Black parents are taking the matter of education both formal and informal into their own hands, choosing to home school or supplement school curriculum (Haddix and Sawyer). The failing of the school system, streaming, low teacher expectations, lack of parental involvement, peer pressure, and lack of role models have all contributed to this practice (James). This chapter builds on the latter and focuses on how Black mothers who are entrepreneurs use the space of entrepreneurship to redefine notions and practices of mothering.

What are the politics of work, entrepreneurship, and family for Black women? How do Black women understand their role as mothers, business women, their sense of self, as well as role in their communities? I argue that Black mothers who are entrepreneurs use the home space and their role as entrepreneurs to nurture their children, families, and themselves. They also use the space of entrepreneurship and work relationships to (re)educate their children on social and economic matters. As business women, their work affords them opportunities for leisure, something of a luxury for workers largely found in precarious types of work. Finally, their business practices challenge traditional business models for more collective economic approaches that support communities. In the following section, I provide a bit of context on Black entrepreneurship research and how this chapter contributes to it.

Black Business Activity: What We Know

Despite claims to the contrary, there is historic evidence of Black business activity in Canada. In the mid-to-late 1700s, the Canadian census revealed that Black Loyalist women in Nova Scotia, due to the scarcity of work, made crafts, which they sold at markets. It was work

that brought in money vital to the survival of the family (Hamilton 33). During the nineteenth century, Black-owned businesses in Toronto included boarding houses, barbershops, physicians, tobacconists, carpenters, dress shop owners, taverns, restaurants, blacksmiths, confectioners, and candy makers (Shadd; Hill, *The Freedom-seekers*). A little known fact, the first ice houses in Toronto were started by two Black entrepreneurs in the late 1840s (Hill, *Black History in Early Toronto*). In the 1920s, Black families in Calgary and Edmonton ran pool halls, barbershops, cafes, horse-drawn delivery services, hotels, boarding houses; some were seamstresses, junk dealers, as well as grocery and candy stores owners (Palmer and Palmer).

More recently, Caribbean people and African entrepreneurs have often been described either as being the least entrepreneurial immigrant group in Canada or as having lower business participation levels than the general population (Henry; Lo et al., *Immigrants' Economic Status*; Lo et al., *Cultural Resources*). When specifically examining Black women's low levels of participation, researchers tend to cite cultural factors, invisibility in family businesses, and the small size of their businesses as explanations. Other researchers attribute low performance to systemic racism, exemplified in Blacks' difficulties in obtaining bank financing (Henry; Lo et al., *Cultural Resources*; Scott; Teixeira) or their lack of experience in family businesses (Uneke). Obtaining financing is the number one barrier for Black business owners (FLG/ACCWG; Henry; Teixeira; Uneke). In Okori Uneke's comparative study of Black and Chinese business owners in Toronto, 47 per cent of Black business owners, compared to 84 per cent of Chinese business owners, were able to obtain bank loans. The reason why Blacks are less successful is due to their lack of collateral and insufficient equity. A much larger percentage (53 per cent) of Blacks, compared to 16 per cent of Chinese, encountered difficulties with banks or had their loan application rejected. Interestingly, 45 per cent of Chinese, compared to 23 per cent of Blacks, reported having friends and ethnic networks in the bank. Other difficulties for potential Black business owners include the lack of access to business information, to government contracts, and to the market for goods and services.

Others attribute Black business success or failure with the ties that a Black business owner has with the Black community. Black business owners often cite the lack of community support as a major hindrance

to running a business (Henry). In a study conducted by Carlos Teixeira in Toronto, 75 per cent of Black entrepreneurs indicated that 50 per cent of their clients were from their own ethnic background. Black businesses are described as being highly dependent on ethnic markets for customers (21). Such a pattern was also observed in Frances Henry's study, in which 85 per cent of the participants provided services to customers of their own ethnicity. The fact that the Black community is not a "unified market" or a coherent community but a fragmented social structure (Lo et al., *Immigrants' Economic Status*) is identified as the main culprit for the lack of success of Black business owners. Reasons such as the lack of cohesion, loyalty, and divisiveness are said to be the result of a history of slavery, indentured labour, and migration. Those who venture outside of the community face even greater challenges. It is important to note that both studies (Henry; Teixeira) conducted research in a specific geographical location and focused mainly on family-owned, restaurant- and service-oriented businesses. Henry did observe that not all industries are directed at an ethnic market; professional service businesses are less directed at ethnic markets than service or retail ones. In Lucia Lo, Carlos Teixeira and Maria Truelove's study of all five groups observed, Caribbean entrepreneurs relied less on ethnic resources. The authors add that "Caribbeans were more heterogeneous as a group and less predisposed to the formation of highly visible ethnic neighborhoods. They were, thus, less involved in networks of kinship and friendship ties" (*Cultural Resources* 69). Despite these claims, Teixeira found that 88.5 per cent of Blacks in his study declared being "somewhat" or "highly" involved in the Black community. Many obtained a great deal of moral support with respect to discrimination and racism.

Studies that are more recent have expanded the conversation on Black female entrepreneurship. I ("Guess Who's Coming") examine the everyday forms of racism that Black women entrepreneurs experience and, more specifically, the politics of cross-racial encounters, the reconstitution of bodily space, and the women's negotiation of how their bodies are read in different encounters. The article addresses a body of research that is based on a narrow understanding of marginalization and gendered forms of racism. Elsewhere, I ("For Us by US") speak to notions of agency and the politicized space of entrepreneurship for Black women. I examine how women in creative industries (such as art, music, and design) use their status as entrepreneurs to (re)define Blackness and

belonging in Canada. Their politicized counter discourse of Blackness is contradictory to what the Canadian nation imagines. Black women describe it in ways that are both local (as rooted in Canada) and global (from the Black diaspora). Employing an interlocking theoretical framework that accounts for processes of gendering, classing, and racialization within structural, disciplinary, hegemonic, and interpersonal domains, I ("Race-in, Classing *and* Gendering") provide a more nuanced and critical understanding of racialized women's participation in enterprise. Moving beyond the focus of identity and categories, the particularities and complexities of racialized women's experiences, struggles, and resistances are demonstrated. This study sheds light on the nuances of power as well as on the creative and subversive ways in which Black women challenge and resist these processes of differentiation.

Research Questions

Despite the importance of the above research, few have focused on Black women entrepreneur, let alone Black mothers who are entrepreneurs. A second limitation to the above studies is there quantitative nature. Historically, census and statistical data left many unanswered questions and underestimated Black women's work. It is difficult to garner from statistical data the pooling of labour as well as the ways women build networks and attempt to sustain their businesses (Bristow; Cooper). Currently, little is known about the business lifecycle progression of Black women entrepreneurs, the barriers they face, their unique assets (social, financial, human, personal, and physical), and the ways in which they develop these assets in an effort to create successful businesses and sustainable livelihoods. Gaps in the literature also exist about women's use of technology and transnational linkages, border-crossing business activities, as well as the use of localized networks across geographic and ethnic boundaries in their creation of diasporic economies. Although much more research is needed concerning the general experiences of Black women entrepreneurs, this chapter fills an important gap—Black mothers who are entrepreneurs.

Methodology

This chapter stems from ethnographic research conducted in 2014 and 2015. In this qualitative study, I interviewed forty Black women in various enterprises in the Greater Toronto Area and a few in Montreal and collected textual data in relation to their businesses (information from blogs, LinkedIn, art, music, as well as video and audio materials). Demographically, participants were more likely to be between the ages of twenty-six and forty (67 per cent), 93 per cent were Canadian citizens, 50 per cent were single, 50 per cent had an undergraduate degree, 48 per cent had children, and 31 per cent had a household income between $20,000 and 40,000. In terms of their individual businesses, four were in professional, technical, scientific, and finance; eleven were in social and personal services; eleven were in culture/ crafts and recreation; ten were in media, publishing, and entertainment; and four were in trade and wholesale distribution. Also, for 75 per cent of the participants, it was their first business; 82 per cent were self-employed, and 50 per cent also worked in paid work. Only half reported making a profit in their business.

Research on Black women entrepreneurs is limited, yet for Black mothers in entrepreneurship, there is even less. For these reasons, this chapter also examines two additional sources of data. First, I examined one of the few publications on Black businesses, *Black to Business,* published quarterly by the Black Business Initiative (BBI), located in Nova Scotia. The magazine updates the community on business development activities, celebrates successes in the Black business community through individual and business profiles, and provides access to a variety of resources.[1] I examined thirty-two issues for narratives of Black businesswomen with the hope of discovering if any were mothers or if any spoke of mothering or children. Second, as I have been researching Black women's entrepreneurship for over fifteen years, I reexamined some of my earlier research for narratives of Black mothers, something that I had not done before.[2] Interview quotes are distinguished by S1 (early study) or S2 (recent study).

In the following sections, I detail the ways Black women negotiate entrepreneurship and Black motherhood scripts. First, in addition to Black mothers' intensive efforts to shield their children from the dangers of living with racism and poverty, they also discussed their desires to raise and care for their children and see the choice of being entrepreneurs

as a way of caring for themselves. Second, entrepreneurship allowed mothers to provide their children with education and experiential tools that Black children may not be exposed to as a result of barriers in the educational system. Third, though not new to Black communities, espousing a collective economic mindset was seen as paramount. Lastly, many used their businesses to challenge stereotypes of Black women. Although there is much more to be said about Black mothers as entrepreneurs, this chapter is starting the conversation.

Entrepreneurship, Self, and Family Care

Concerning the stereotype of the super strong Black mother—the mother who shields from oppression, uplifts, navigates, and empowers children and families—self-care seems impossible. With Black women being vital to the survival of communities, families, and all of its members, self-care seems inconsequential and somewhat selfish in the grand scheme of things. Not taking away from community involvement, what participants reveal is that entrepreneurship in some ways allows them to step back from oppressive wage work environments and take time for themselves. Most likely denied the opportunity to self-care in wage work, this mother described how her work as an artist allows for the expression of her experiences as a Black woman, single mother, and her struggles to be understood, respected and celebrated: "My art became the canvas of my strife, political views, historical reference, and meditative discoveries" (*Black to Business Magazine*, Spring 2009). Others described it in this way:

> I had injured myself a number of years ago, and the stress of my job aggravated the injury [to the] point where I couldn't even drive.... The job of a student support worker is very stressful; you're dealing with systemic racism, so there were a lot of racial issues, low morale among the students, a lack of support from some administrators, low expectations of the students, literature or resources being used that made you feel like you're an inferior race ... a lot of stereotypes on the part of the system as a whole. Don't get me wrong, there was a lot of progress, but there's still a lot of work to be done. And it was taking its toll on me. (*Black to Business Magazine*, Spring 2008)

I've been making people so much money for them over the years that I decided to do something for myself. So it sounds kind of crass, but I just wanted to kind of be more independent. (Interview No. 14, S2)

The entrepreneurship literature often refers to this process as women being pushed into entrepreneurship because of discrimination in wage work and pulled into it because of their need for more independence and freedom. My study participants expanded on why they are pushed out of wage work and what the space of entrepreneurship allows for. Wage work environments were described as creating burnouts, exhaustion, and as requiring the expenditure of a great deal of emotional labour. Within these wage work environments, women came face to face with systemic and individual racism and had little institutional support, which left them overworked or locked in positions that created little meaningful change. The exhaustion felt within these wage work environments left them with little to provide to their own families. Again, one could attribute burnout to any wage worker in precarious work, but Black women's health must be contextualized in relation to systemic racial oppression.

In the pursuit of mind, body and spiritual health, politics "weaves in and out of every major struggle women have ever waged in our quest for social, economic and political emancipation" (Davis 19). Politics permeates our existence and insinuates itself in our private spaces and private lives. Angela Davis goes on to say the following: "While our health is undeniably assaulted by natural forces frequently beyond our control, all too often the enemies of our physical and emotional well-being are social and political. This is why we must strive to understand the *complex politics* of Black women's health" (my emphasis, 9). At the intersection of economic racial injustice, Black women endure higher rates of deaths related to cancer, mental illness, cardiovascular disease, high blood pressure, lupus, and diabetes. Adding to this, Black women face unequal access to health and nutritional programs, psychiatric services, prenatal care; there is also a lack of research pertaining to the illnesses particularly affecting Black women. There have also been massive funding cuts or rather transfers of funds at the expense of social services. In the face of all of this, Black women have little time for self-care. In a powerful piece, Byllye Avery—the founder of the National Black Women's Health Project (NBWHP), which was created in 1983—

recounts conversations with Black health activists. She notes "unless we are able to go inside of ourselves and touch and breathe fire, breathe life into ourselves, that, of course, we couldn't be healthy" (7).[3]

Much like self-care, having the time to nurture family is a privilege. For Black women, social and economic restrictions removed them from their families. During the late nineteenth and mid-twentieth century, poor and working-class women worked in their own homes and for middle-class families, but in the latter half of the nineteenth century, the gap between white and racialized women grew. The low status and low wages of Black men meant that Black women had to work outside of the home (Carby; Glenn, "Racial Ethnic Women's Labor"). In these households women and children were forced into income-earning activities in and out of the home (Glenn, "From Servitude to Service Work" 4-5). The public-private divide—often conceptualized as relegating women to the private realm and men to the public—does not hold up in the case of Black women. bell hooks makes a strong point concerning how white liberal feminism failed to contextualize gender oppression for all women. She contends that "middle class women shaping feminist thought assumed that the most pressing problem for women was the need to get outside the home and work—to cease being 'just' housewives" (95). Meanwhile, Black women struggled to recover from overwork in exploitative and underpaid jobs, as they were often the sole breadwinners in their households (Mama). Again, the entrepreneurship literature defines the process as women being pulled into self-employment as a desire for independence, freedom, and as a way to balance work and family. The idea of balance seems to fall short of explaining its value and essence for Black families. As a Black mother articulated in *Black to Business Magazine*, "I love the flexibility because I can look after my kids and schedule my work for evenings and weekends ... I'm busy—closed four houses last week alone" (Fall 2013). Another, a single mother, went on to say that owning her own business has been a blessing:

> The beauty of owning this business is that I can choose my own hours, and everything is done by appointment.... I don't work weekends. And when Friday rolls around, it's time for me to be home with my family. (*Black to Business Magazine*, Winter 2016)

Many other mothers, both in the more recent study and the earlier one, expressed similar views:

> I can work from home most days. So that was a big thing for me ... I have three young children and that, if I wanted to go on a school trip or if I wanted to leave early to go watch a soccer game or if I wanted to just take off and go away on vacation, I didn't want to have to put in the request and ask for permission.... I can work at my own leisure or my own pace and if wanted to work more, then I can work more. (Interview No. 5, S2)

> I started my business primarily so that I can be consistent and visible in their [children] lives; that is the sole reason, apart from—that's what I mentioned—the cultural aspect of things and my beliefs for community and so on, it's primarily to be here with my children. (Interview 35, S2)

> I want a business and [to] be able to raise my own kids. (Interview No. 26, S2)

> The benefit of working at home [is] I can be close to my baby and still feed him, see him throughout the day, hear him laughing in the next room, and stop and take breaks and play with him. (Interview No. 46, S2)

> Because I was on my own and I had my children, and I wanted more for myself; and I always wanted to do my own thing. (Interview No. 42, S1)

The work-family debate as formulated in contemporary policy arenas fails to address the traditionally low wages and enormously harsh working conditions under which Black women labour on behalf of their families (Harley, "Speaking Up"). Historically, Black women who refused to work during the postemancipation period faced incredible societal pressures from white landowners who felt that Black women staying at home was seen as a desire to be seen as respectable women (Harley, "Working for Nothing"). Regardless of their desire for more freedom, Black families suffered when women did not work for wages, since the male family wage did not apply to Black men. The combination of economic conditions and ideologies of race and gender positioned them

as less suited for the home and better suited for public work. Poor Black women and Latina mothers "were deemed to be 'employable', and not requiring or deserving of charity" (Glenn, *Unequal Freedom* 75).

Experiential Learning within Families

The discourse of good Black mothering conceptualized as one who protects children from the dangers of racism and living in poverty is a heavy burden to carry. Materially, Black women are more likely to occupy feminized and precarious types of work; therefore, the responsibility to shield their family from poverty weighs heavily on them. Education for Black parents and families has often been seen as key to getting ahead in life. In the eyes of many, however, the education system has done a great deal to further marginalize Black youth, including a Eurocentric curriculum, a lack of Black teachers, principals, and faculty, as well as lower expectations, streaming, and harsher punishments for Black students. Similar occurrences are found in the postsecondary setting, including entry barriers (for example, high tuition costs), lack of peer support groups, and lack of guidance and mentorship (Dei and Holmes; BLAC). Research demonstrates how Black parents are frustrated with school boards, authorities, and teachers with their handling of discrimination as well as perceptions of Black youth. There is little research on whether Black parents home school. For those Black parents for whom home schooling is impossible, the alternative is to provide an informal alternate curriculum or a counternarrative within the home. This alternate curriculum includes books that speak about Black achievements and Black history prior to slavery as well as activities that promote positive Black identity and awareness.

Black youth are less likely to frequent postsecondary programs and without a postsecondary education (and some would even say with), the consequences are dire. When Black youth are alienated, this contributes to violence within the family and community, lack of employment, and the difficulty supporting themselves as well as their family and community. This is not to say that entrepreneurship solves all of these issues. For the participants, entrepreneurship allows them to share with their children knowledge that is both financial and business based but also contains an experiential component. Increasingly, the role of

education (beyond the basic curriculum) falls to individual families, which is a huge barrier for Black youth and families with less social and economic capital. The teachings from Black mothers who are entrepreneurs reveal, however, how they use their work roles to enhance their children's learning. In a formalized wage work setting, this may not be possible, aside from, perhaps, the occasional opportunities where employees can bring their children to work for a day. Entrepreneurship provides not only a means for economic survival but also an opportunity to expose children to different labour market contexts, to learn different skills, and to connect with community (e.g. neighbours and community events). Participants described it in this way:

> I'm trying to do this for myself, but most importantly for the children so that when I'm not here, they will have something. So I'm even showing the kids how to run a modelling agency. They will be involved with the business ... they have to kind of learn how it's run properly and how it is for them. (Interview No. 14, S2)

> In terms of my social life, my friends and my children, whatever, I have taken away from some of the things I should have attended to at home ... so much now that I think I have created two monsters. My little one, she is going to be eleven in December. She has already spelt [defined her business] her own little thing on how she wants to organize, where she wants to do different services. You know babysitting, this that I can do, pet sitting, whatever. She already has her lines of business worked out and how she would advertise. She even approaches people now. (Interview No.15, S2)

> You are on display for your child every day. You are all that child's experiences.... They [her children] are home schooled so they are with me 24/7. They see me doing business, my daughter in particular; they see me doing business. (Interview No. 6, S2)

> A proud mother of two, Johnston prides herself on teaching her daughters that "they can do whatever they desire"—they even help out with the business, assisting Johnston with trade shows and working reception over the summer months. (Black to Business Initiative, Winter 2016, Issue 63)

Taken on its own, ensuring children's economic wellbeing beyond their present circumstances is a normal parental desire. Contextualizing the Black experience" from a sociohistorical lens demonstrates not only its difficulty but also its essentiality for Black families. First, the history of slavery and postemancipation destroyed families and communities and denied them access to economic livelihoods for generations (e.g. the inability to own land, denied legal rights, injustices with the criminal justice system, and lack of education). Systemic racism in wage work prevented upward mobility as well as incomes that could provide family stability. Entrepreneurship allows Black mothers to expose children to business dealings and, in some ways, provides them with a bit of financial literacy. There is also the aspect of experiential learning, as children are able to learn about business activities. These practices do not guarantee success, but the realm of entrepreneurship suggests an opportunity that may not be available in wage work.

Collective Economic Efforts

Black economic independence and sustainability are not new as a focus. In the mist of the harshest economic conditions, Blacks have always attempted to find ways to create sustainable livelihoods. Collective networks and processes have been most effective at countering economic inequality. The discourse of enterprise is constructed as a market- and profit-driven, competitive, and individualistic endeavour. Black communities have operated businesses in slightly different forms as political activist centres and spaces, allowing for the networked ties and linkages to benefit the extended family and community as a whole. Examples include Robert Boyd's in-depth analysis of African American women's reliance on entrepreneurship during the Depression. The occupation of boarding and lodging was also a common practice, which at least one third of Black families did in the urban North because of high rental fees. Black women in these positions also played a leadership role, as the go between for Blacks who were looking for work and shelter. Taking in borders became "part of the informal family economy of Black communities" (651). Lynn Hudson focuses on Mary Pleasant, a boarding house owner in nineteenth-century San Francisco. She obtained a great deal of financial success as an entrepreneur but

struggled to challenge the many obstacles placed in her way. The wealth that she acquired from her businesses enabled her to support Black causes, purchase guns for a slave revolt, as well as pay for attorneys to defend falsely accused Blacks. Tiffany Gill examines the political activism of beauty culturists (e.g., hairdressers, salon owners, and beauty product manufacturers) during the mid-twentieth century. She specifically refers to the establishments of these beauty culturists, or beauty activists as she labels them, as political sites. She defines them as activists because of their engagement in social reform as clubwomen. The salons, however, were also a hotbed for political meetings.

In addition to small businesses providing economic, social, and political support, Black communities also have a history of creating collective economic models—cooperatives that respond to market failures and economic marginalization (Perry; Bohn and Grossi; Nembhard). Despite a long, rich history of cooperatives, it is not well documented in the literature, particularly as a way of promoting "a larger economic independence movement" (1). According to Jessica Gordon Nembhard, many of the early collective economic efforts led to the development of more formal cooperatives. She describes these early efforts as pooling of resources to solve personal, family, political, and economic challenge. These efforts consisted of purchasing family members' freedom, supporting health and child development, performing burials, as well as investing in cooperative ventures and employment opportunities.

In the current context, what are the economic barriers for Black women entrepreneurs? The lack of bank financing and low start-up capital is a significant issue facing Black women business owners. Lending institutions also assess women's household finances. George Haynes et al. contend that household financial statements are essential to lenders when deciding whether or not to provide financing. Although women are often asked to produce additional data and information to support their business interest, their household finances are often perceived by lenders as inadequate. Jacqueline Scott shows that Caribbean women are less likely to have even start-up capital. Since Black women are more likely to be located in temporary wage work and more likely to be unemployed for longer periods, they are less likely to have savings to start a business. Additional concerns in obtaining financing for racialized

women is the lack of recognition of foreign credentials or experience, the requirement of having a cosigner, and, finally, lending institutions' ignorance of particular ethnic businesses. The following account makes these concerns clear:

> I walk into a bank, and the business man and I talk about doing natural hair and dreadlocks and they look at me like I'm insane because they can't even begin to relate ... they have no idea what I'm talking about. The credit union I deal with, fortunately the woman in charge of small-business loans was Black, she had a concept of what I was talking about. Every other bank I went to, they were looking at me and saying what is this person talking about, so they have no clue. (Interview No. 28, S1)

Some contend that women face more stringent criteria in terms of interest rate and collateral (Riding and Swift). For those who manage to pass through these stringent criteria and get a loan, they are often faced with higher interest rates, mandatory collateral and, more frequently, require a cosigner on loans and lines of credit. The fact that women are more likely to occupy part-time precarious wage employment makes them more likely to operate businesses from home, which, in turn, makes them less likely to qualify for bank loans. Women's lack of bank financing can lead to a greater likelihood of their operating less profitable, small-scale businesses. Barbara Orser and M.K. Foster assert that perhaps a market approach would generate more success for lending practices. They suggest five criteria that are more subjective: confidence, competence, connections, capital and community.

Other scholars refer to women's difficulties in obtaining financing as being a result of individual issues. Women are perceived as being less prepared than men in terms of a business plan (Buttner), and women's business plans are often reviewed more critically than men's (Gay). Researchers who attribute women's failure to their lack of preparedness reinscribe, according to Tara Fenwick, the notion of a right way of doing business. Women face difficulties in networking. Since they are often excluded from the "old boy networks," they are more likely to rely on close family for information and support (Buttner). Women's networks differ from men's in that they are smaller. Women look for networks that not only provide business information but personal support (Aldrich et al.; Smeltzer and Fann).

Black mothers who are entrepreneurs attempt to circumvent these oppressive banking and financial constraints. These are some of the comments shared regarding women's desires to not only redefine notions of success but also challenge traditional business models.

> We are Rasta people. Okay my family and our livity, our life style has always been alternative as to the norm, you know from home schooling my children to breastfeeding until they were past toddlerhood. Our lifestyle has just always been about people, about humanity, and for me, business, the business model, that is so called traditional business model, is to me not a model based on humanity ... we also believe in, in the Kwanza principals.... Part of it is Ujamaaa and our business ... Ujamaaa means cooperative economics; each one takes care of the other so that they can take care of them. (Interview No. 6, S2)

> I grew up here in Toronto, and I did not receive a lot of cultural training outside of my home.... And so as I got older and I had children of my own, I was seeking things or information to share with them, and so I came across the Rasta culture, and I came across the Kwanzaa principles and so on. And so we started taking those values into our home and my business, not just during that season, but as guiding principles to our life ... we also have a strong connection to the Rastafarian faith as well. Lifestyle, collaborative practices, I should say. (Interview No 15, S2)

> Working together ... making sure that the needs of our community are met, making sure that we start and own businesses and support businesses for ourselves to elevate our status in society and amongst ourselves. And yes, just to ensure that we are all collectively sharing, or using the resources that we have within ourselves first, as a community, or the people, and then broadening that to the mainstream population. (Interview No 16, S1)

In addition to one's business being more collective, some participants stressed the need for business education and development from a community lens. In speaking of a single mother's journey as a model and entrepreneur, BBI explains how this business woman approaches business within the frame of community:

Through the BBI's Role Models on the Road, Bowden has taught students about marketing and business development. Bowden works with many youth and adults who don't have much education and strives to give them the tools to get ahead. "It's about building them up from the inside using their language and putting them in a setting that is non-threatening." (*Black to Business Magazine*, Winter 2016)

Challenging the traditional business model through the collective mindset was not only accomplished through formal cooperatives and education but the pooling of resources. Some participants spoke about bartering as being crucial to their success in starting and maintaining their businesses. Some used bartering as a way to obtain workers and services; others used it for their personal needs or as part of their business dealings. Although I have presented limited data on Black collective economic efforts, more empirical research is needed to highlight how economic marginalization is countered in society.

Black mothers who are entrepreneurs also use entrepreneurship to counter negative society perceptions or stereotypes of Black people and Black mothers. Participants discussed how entrepreneurship enables them to construct professional identities for themselves, which are largely based on respect and dignity otherwise denied to them. Notions of professionalism and independence are alluring, as they have long been denied to Black women. For some, entrepreneurship allows them to escape racist wage work conditions. According to Sharon Harley, studies examining Black female workers have identified the development of what has been described as a work-identity consciousness.

Fighting Negative Perceptions

Since most Black women worked in menial types of employment, they developed a work-identity consciousness based on respectability and professionalization, which served as a form of resistance against subordination. Harley ("Speaking Up") cites Higginbotham's work on the professionalization of domestic servants, who could be defined as self-employed, for example. The professionalization of domestic work, conducted in homes, included wearing a uniform, at the workers' insistence, or refusing to wash and clean on their hands and knees. The development of an identity based on respectability and professionaliza-

tion was adopted by domestic servants in "an effort to re-define and re-present Black women's work identities as skilled workers rather than incompetent menials" (Higginbotham qtd. in Harley, "Speaking Up" 41). The discourse and practice of professionalization were also invoked by my study participants. For example, one participant who owns an online business, *Moms Are Us*, provides advice to mothers who have home-based businesses and advertises their services on her website. She invokes and uses the discourse of professionalism to represent the women business owners and describes her overall business approach or vision as follows:

> The image [of my business] is to help self-employed working moms working from a home-based business, to take away that image that the public has about what self-employed mothers represent, a home-based business represents. So we need to have a professional image in our advertising and on our website and everything that we do ... professionalism means what you expect from those who work out of the home, you can expect from the moms working in the home setting, that they're taking their business seriously with integrity, all that you would expect from larger corporations, that these women understand that and that's what they're offering their clients. (Interview No.45, S1)

This participant attempts to override several messages by using the discourse of professionalism. She challenges three images: the mother, the home-based business, and self-employment. Women who operate these types of businesses are less respected, taken less seriously, and even perhaps overlooked by potential clients. She invokes professionalism to counter these very images:

> I want you [the customer] to definitely know that these ladies [with housecleaning businesses featured on her website] are not women who are running hobbies. They are serious about their business. The lady that is listed under housekeeping, she's actually been featured on *Breakfast Television* several times, like, almost I'd say five times a year. She does housecleaning and professional organizing. So these ladies are very knowledgeable, and they take their business very seriously, most of them are fulltime businesses. (Interview No.45, S1)

The professional image that this participant wishes to convey is an image of seriousness, integrity, and knowledge. The reference to one of her clients' appearance on television is meant to reflect that these women are recognized as doing good work, are well respected, and have been able to generate mass appeal. Aside from invoking the general discourse of professionalism, several participants in this study were more than likely to present themselves into respectable professional subjects by "calling on" more established professions, such as medicine, accounting, and psychology. This identity was developed as a way to escape the traditional work identities of maid, servant, helper, and manual labourer or any association to what Dionne Brand calls "nigger work" (275).

Black Mothers and Their Children created by another Black woman entrepreneur, is a magazine about mothering for Black women. Explaining why she started the magazine, she said, "Where were my beautiful sisters in these magazines? Where were the nappy heads of my children? Where were my issues, my values, the wisdom of my ancestors."[4] Mothering for Black women must defined by Black women. Her message also attempts to subvert dominant racist ideologies and stereotypes of the strong Black woman. She contends that these stereotypes prevent Black women from acknowledging their pain and vulnerabilities, which she seeks to change:

> We recently revised our statement to include women who have previously been pregnant but had lost their child either through miscarriage or still birth and what not. Again that came out of my own experience of having a miscarriage while working on *Black Mothers and Their Children*. Before that, I had never even thought about miscarriage. I said "that never happens to Black women, we're too strong." And that opened up so many sisters saying to me "I had that. And I had two before ..." I was like "what you never told me." We just never talked about it. (Interview No. 27, S1)

This participant was more adamant about recognizing Black history and the various accomplishments of Black Canadians as a way to propel Blacks further in today's society. This space of entrepreneurship that is somewhat outside of the dominant white society allows Black women to challenge dominant racist and sexist representations of Blackness. The owner of the magazine for Black mothers was increasingly using

only advertisers who focused on positive Black messages, which did not include hair relaxers or explicitly offensive sexual ads with Black women or Black families. No longer dependent on white advertisers for financing, she felt more secure in being able to focus on the issues which she felt were important to the community. The magazine fills this gap by providing Black women and Black families with resources on pregnancy and parenting. Her magazine tackles the practical and political side of parenting. The target audience is specifically Black women who plan to become pregnant, are pregnant, or already have children. Professionalization and respectability are used to challenge the racist discourse of Black female inferiority as well as negative stereotypes of Black women.

Conclusion

Entrepreneurship is a perilous space that is filled with many contradictions. It provides some additional income and gives Black women the ability to be with their children and care for their own families on their own terms. The decision to undertake a small business was also described as a form of self-care, shielding them from the burden of emotional labour in wage work. The family is often formulated as a "locus of gender conflict" (Glenn, "Racial Ethnic Women's Labor" 103), oppressive to women in terms of the division of labour and their dependence on men. Evelyn Nakano Glenn, however, challenges this assumption and notes that for women of colour, the family has also been a source of resistance to oppression and has acted as "a bulwark against the atomizing effects of poverty, legal and political constraints" (103). The Black family has often also served as a "strong and central source of social and psychological support for immediate and extended kin members, as a site of socialization and learning, and as a site of resistance" (James et al. 163).

In placing the debate of the care of family and children in a historical context, it is important to note that during postemancipation, Black women were always seen as being suspicious and engaging in "a misguided attempt to imitate middle-class white norms as they applied to women's roles" (Jones 59). Whites often feared Black people not working so that they could have more family autonomy and more time to spend with their children. Opting out of wage work to attend to their

own families and households threatened to subvert gender and racial norms. However, true freedom for Blacks, according to Jacqueline Jones, had very little to do with individual opportunity or independence in the modern sense; rather, freedom "had meaning primarily in a family context" (58).

Participation in entrepreneurship allows Black women to redefine traditional models of business. Excluded from wage work as a result of educational failings, Black youth are left to fend for themselves. Black mothers see their small business lives as opportunities to give their children teachings they have not been exposed to as a result of exclusion form formalized workplace settings. These teachings are by no means meant to replace the role of formalized educational institutions; rather, they attempt to counter these exclusions. Black mothers also challenge traditional business models by espousing and employing collective economic efforts through cooperatives, the pooling of resources, and bartering.

Finally, entrepreneurship allows for a redefinition of dominant negative perceptions of Black women and Black workers. In professionalizing skills and images, Black women are seen with more legitimacy and retain a sense of power over how they are received as workers. As small business owners, they also have an ability to control the messaging regarding Black mothers, Black women, and Black communities. Although entrepreneurship is not the answer to every problem, this chapter attempts to demonstrate the ways in which it allows women to challenge personal, economic, and social marginalization.

Endnotes

1. In 1996, the Government of Canada and the Province of Nova Scotia set up the BBI to address the unique needs confronting the Black business community in Nova Scotia.

2. My early research on Black women business owners took place between 2005 and 2006. I interviewed fifty-three women entrepreneurs of Afro-Caribbean descent in the Greater Toronto Area. Again, I chose a broad criteria of inclusion from different industries and statuses of entrepreneurship (solo versus employer) in order to explore a greater complexity of Black women's participation in entrepreneurship. My specific methods and techniques of data

generation included a survey questionnaire, semistructured interviews, and textual analysis (websites and documents).

3. In 2003, NBWHP became the Black Women's Health Imperative, which is still active today.

4. This quote was featured in the online magazine *Black Mothers and their Children* which is no longer available online.

Works Cited

Aldrich, Howard, et al. "Women on the Verge of a Breakthrough: Networking Among Entrepreneurs in the United States and Italy." *Entrepreneurship and Regional Development,* vol. 1, no. 4, 1989, pp. 339-56.

Avery, Byllye. "Bringing Life into Ourselves: The Evolution of the National Black Women's Health Project." *The Black Women's Health Book: Speaking for Ourselves,* edited by Evelyn White, Seal Press, 1990, pp. 4-10.

Black Learners Advisory Committee (BLAC). *BLAC Report on Education Redressing Inequity-Empowering Black Learners.* CRRF, 1994.

Black to Business Magazine. The Black Business Initiative, Spring, no. 39, 2008, issuu.com/advocateprinting/docs/black_to_business_issue_39_spri?e=27139738/61185882. Accessed 2 Feb. 2019.

Black to Business Magazine. The Black Business Initiative, Spring, no. 42, 2009, issuu.com/advocateprinting/docs/black_to_business_issue_42_spri?e=27139738/61310239. Accessed 2 Feb. 2019.

Black to Business Magazine. The Black Business Initiative, Fall, no. 57, 2013, issuu.com/advocateprinting/docs/black_to_business_issue_57_fall?e=27139738/61311833. Accessed 2 Feb. 2019.

Black to Business Magazine. The Black Business Initiative, Winter, no. 63, 2016, issuu.com/advocateprinting/docs/black_to_business_issue_63_wint?e=27139738/61312336. Accessed 2 Feb. 2019.

Bohn, Simone, and Patricia K. Grossi. "The Quilombolas' Refuge in Brazil: Social Economy, Communal Space, and Shared Identity." *The Black Social Economy in the Americas: Exploring Diverse Community-Based Markets,* edited by Caroline Hossein Shenaz, Palgrave MacMillan, pp. 161-86.

Boyd, Robert L. "Race, Labour Market Disadvantage, and Survivalist Entrepreneurship: Black Women in the Urban North During the Great Depression." *Sociological Forum,* vol. 15, no. 4, 2000, pp. 647-70.

Brand, Dionne. "A Working Paper On Black Women in Toronto: Gender, Race and Class." *Returning the Gaze: Essays on Racism, Feminism and Politics,* edited by H. Bannerji, Ontario, Sister Vision Press, 1993, pp. 270-97.

Bristow, Peggy. "Whatever You Raise in The Ground You Can Sell It in Chatham: Black Women in Bruxton and Chatham, 1850–65." *We're Rooted Here and They Can't Pull Us Up: Essays in African Canadian Women's History,* edited by Peggy Bristow et al., University of Toronto Press, 1994, pp. 69-142.

Buttner, E. Holly. "Female Business Owners: How Far Have They Come?" *Business Horizons,* vol. 18, no. 2, 1993, pp. 59-62.

Calliste, Agnes. "Black Families in Canada: Exploring the Inter-connections of Race, Class, and Gender." *Voices: Essays on Canadian Families,* edited by M. Lynn, Scarborough, Nelson Thomson, 2003, pp. 243-70.

Carby, Hazel V. "Policing the Black Woman's Body in an Urban Context." *Critical Inquiry,* vol. 18, no. 4, 1992, pp. 738-55.

Collins, Patricia Hill. *Black Feminist Thought: Knowledge, Consciousness, and the Politics of Empowerment.* Routledge, 2000.

Cooper, Afua P. "Black Women and Work in Nineteenth Century Canada West: Black Woman Teacher Mary Bibb." *We're Rooted Here and They Can't Pull Us Up: Essays in African Canadian Women's History,* edited by Peggy Bristow et al., University of Toronto Press, 1994, pp. 143-70.

Davis, Angela. "Sick and Tired of Being Sick and Tired: The Politics of Black Women's Health." *The Black Women's Health Book: Speaking for Ourselves,* edited by Evelyn White, Seal Press, 1990, pp. 18-26.

Dei, George, and Leilani Holmes. *Drop Out or Push Out?: The Dynamics of Black Students' Disengagement from School: A Report.* Ontario Institute for Studies in Education, 1995.

Fenwick, Tara. "Lady, Inc. Women, Learning, Negotiating Subjectivity in Entrepreneurial Discourses." International Journal of Lifelong Education, vol. 21, no. 2, 2010, pp. 162-77.

Four-Level Government/African Canadian Community Working Group (FLG/ACCWG). *Towards a New Beginning: The Report and Action Plan of the Four-Level Government/African Canadian Community Working Group.* Four-Level Government/African Canadian Community Working Group, 1992.

Gay, Katherine. *In the Company of Women.* HarperCollins, 1997.

Gill, T. Melissa. "I had my Own Business ... so I Didn't Have to Worry: Beauty Salons, Beauty Culturists, and the Politics of African-American Female Entrepreneurship." *Beauty and Business: Commerce, Gender and Culture in Modern America,* edited by Philip Scranton, Routledge, 2001, pp. 169-94.

Glenn, Evelyn Nakano. "Racial Ethnic Women's Labor: The Intersection of Race, Gender and Class Oppression." *Review of Radical Political Economics,* vol. 17, no. 3, 1985, pp. 86-108.

Glenn, Evelyn Nakano. "From Servitude to Service Work: Historical Continuities in the Racial Division of Paid Reproductive Labour." *Signs: Journal of Women in Culture and Society,* vol. 18, no. 1, 1992, pp. 1-43.

Glenn, Evelyn Nakano. *Unequal Freedom: How Race and Gender Shaped American Citizenship and Labour.* Harvard University Press, 2002.

Haddix, Marcelle and LaToya L. Sawyer. "I Am My Child's First Teacher: Black Motherhood and Homeschooling as Activism." *Laboring Positions: Black Women, Mothering, and the Academy,* edited by Sekile Nzinga-Johnson, Toronto, Demeter Press, 2013, pp. 75-90.

Hamilton, Sylvia. "Naming Names, Naming Ourselves: A Survey of Early Black Women in Nova Scotia." *We're Rooted Here and They Can't Pull Us Up: Essays in African Canadian Women's History,* edited by Peggy Bristow et al., University of Toronto Press, 1994, pp. 13-40.

Harley, Sharon. "Speaking Up: The Politics of Black Women's Labour History." *Women and Work: Exploring Race, Ethnicity and Class,* edited by Elizabeth Higginbotham and Mary Romero, Sage Publications, 1997, pp. 28-51.

Harley, Sharon. "Working for Nothing But for a Living: Black Women in the Underground Economy." *Sister circle: Black Women and Work,* edited by Sharon Harley and The Black Women and Work Collective, Rutgers University Press, 2002, pp. 48-66.

Haynes, George W., et al. "The Differences in Financial Structure Between Women and Men Owned Family Businesses." *Journal of Family and Economic Issues,* vol. 21, no. 3, 2000, pp. 209-26.

Henry, Frances. *A Survey of Black Business in Metropolitan Toronto.* Multicultural and Race Relations Division of Metropolitan Toronto and Black Pages and Black Business and Professional Association, 1993.

Hill Collins, Patricia. "Intersections of Race, Class, Gender and Nation: Some Implications for Black Family Studies." *Journal of Comparative Family Studies,* vol. 29, no. 1, 1998, pp. 27-36.

Hill, Daniel G. *The Freedom-Seekers: Blacks in Early Canada.* The Book Society of Canada Limited, 1981.

Hill, Daniel G. "Black History in Early Toronto." Black History Conference, 18 Feb. 1978, University of Toronto, Ontario. Address. www.archives.gov.on.ca/en/explore/online/dan_hill/papers/big_052_black-historypll.aspx. Accessed 2 Feb. 2019.

hooks, bell. *Feminist Theory: From Margin to Centre.* South End Press, 1984.

Hudson, Lynn. *The Making of Mammy Pleasant: A Black Entrepreneur in Nineteenth-Century San Francisco.* University of Illinois Press, 2003.

James, Carl.E. "Students 'at Risk': Stereotyping and the Schooling of Black Boys." *Urban Education,* vol. 47, no. 2, 2012, pp. 464-94.

James, Carl, et al. *Race and Well-Being: The Lives, Hopes, and Activism of African Canadians.* Fernwood Publishing, 2010.

Jones, Jacqueline. *Labour of Love, Labour of Sorrow: Black Women, Work and the Family from Slavery to the Present.* Basic Books, 1985.

Knight, Melanie. "'Guess Who's Coming to Dinner?': Negotiating Visibility, Encounters and Racism in Entrepreneurship." *Critical Race and Whiteness Studies Journal,* vol. 7, no. 2, 2011, pp. 1-18.

Knight, Melanie. "For Us by Us (FUBU): The Politicized Spaced of Black Women's Entrepreneurship in Canada." *Southern Journal of Canadian Studies,* vol. 5, no. 1-2, 2012, pp. 162-83.

Knight, Melanie. "Race-ing, Classing and Gendering Racialized Women's Participation in Entrepreneurship." *Gender, Work and Organization,* vol. 23, no. 3, 2014. doi:10.1111/gwao.12060. Accessed 2 Feb. 2019.

Lawson, Erica. "Mercy for Their Children: A Feminist Reading of Black Women's Maternal Activism and Leadership Practices." *African-Canadian Leadership: Continuity, Transiition, and Trans-formation*, edited by Tamari Kitossa et al., University of Toronto Press, 2019, pp. 190-210.

Lo, Lucia, et al. "Immigrants' Economic Status in Toronto: Rethinking Settlement and Integration Strategies." (Working Paper no. 15). Joint Centre of Excellence for Research on Immigration and Settlement (CERIS), 2000.

Lo, Lucia. et al. "Cultural Resources, Ethnic Strategies, and Immigrant Entrepreneurship: A Comparative Study of Five Immigrant Groups in the Toronto CMA." (Working Paper no. 21). Joint Centre of Excellence for Research on Immigration and Settlement (CERIS), 2002.

Mama, Amina. *Beyond the Mask: Race, Gender and Subjectivity.* Routledge, 1995.

Nembhard, Jessica Gordon. *Collective Courage: A History of African American Cooperative Economic Thought and Practice.* Penn State University Press, 2014.

O'Reilly, Andrea. "African American Mothering: 'Home Is Where the Revolution Is.'" *Mothers, Mothering and Motherhood across Cultural Differences: A Reader,* edited by Andrea O'Reilly, Demeter Press, 2014, pp. 93-118.

Orser, Barbara J., and M. K. Foster. "Lending Practices and Canadian Women in Micro-Based Businesses." *Women in Management Review,* vol. 9, no. 5, 1994, pp. 11-19.

Palmer, Howard, and Tamara Palmer. *Peoples of Alberta.* Western Producer Prairie Books, 1985.

Perry, Keisha-Khan Y. *Black Women against the Land Grab: The Fight for Racial Justice in Brazil.* University of Minnesota Press, 2013.

Reynolds, Tracey. "Black Mothering, Paid Work and Identity." *Ethnic and Racial Studies,* vol. 24, no. 6, 2001, pp. 1046-64.

Riding, Allan L., and Catherine S. Swift. "Women Business Owners and Terms of Credit: Some Empirical Findings of the Canadian Experience." *Journal of Business Venturing,* vol. 5, no. 5, 1990, pp. 327-40.

Scott, Jacqueline. "Afro-Caribbean Women Entrepreneurs: Barriers to Self-Employment in Toronto." *Canadian Woman Studies/Les Cahiers de la Femme,* vol. 15, no. 1, 1994, pp. 38-41.

Shadd, Adrienne, et al. *The Underground Railroad: Next Stop Toronto!* National Heritage Group, 2005.

Smeltzer, Larry R., and Gail L. Fann. "Gender Differences in External Networks of Small Business." *Journal of Small Business Management,* vol. 27, no. 2, 1989, pp. 25-32.

Teixeira, Carlos. *Black Entrepreneurship in Toronto.* Toronto, Black Pages, 2002.

Uneke, Okori. "Ethnicity and Small Business Ownership: Contracts between Blacks and Chinese in Toronto." *Work, Employment and Society,* vol. 10, no. 3, 1996, pp. 529-48.

Chapter Five

Autohistoria-teoría: Lessons from a Deviant Bar Owner

Marissa Cisneros

Introduction

Easter was a time to be with family and show respect, respect for the family and respect for the holiday. My great grandmother, Ruby, and my grandma, Lilian, had something to say though, and the tradition of respect went out the window.

Ruby did not like my grandmother's shirt, seeing it as too provocative for such an occasion. She also didn't like that my grandmother was drinking. "You chase men the way dogs chase cars," Ruby told her.

Taken aback my grandmother told her, "You? You have the nerve to tell me something?! I chase men, yes, but on the other side of town. What you did, owning that bar, running sex workers, that was in front of our house! I couldn't have any friends, because you owned a bar! I went to Catholic school, and you owned a bar!"

Ruby would not waiver though, "You're going to judge me for supporting my family? I make no excuses. I supported my family."

When this story is told, I always ask my mom who was right. She tells me they were both wrong because they had the argument at another house.

But who was more wrong? "They were both crazy!" My mom exclaims, which I take as code for they both have points. At the end of

the day, right and wrong is really just a lot of grey and depends on who's telling the story.

I have always been fascinated by the women in my family. They have affected every avenue of my life; they have built me into the person I am today and will continue to build who I will become in the future. Thus, when considering the literature on motherhood, particularly motherhood and entrepreneurship, I find it detrimental that the research primarily investigates how the identity of a woman entrepreneur is changed by the experience of motherhood. Although this approach is integral to critically approaching the woman experience, it misses the downward generational impacts these women have on their families, particularly the younger women in their families. This paper seeks to investigate women of colour in the motherhood-entrepreneurship nexus from an upward perspective; in short, through autoethnography, I investigate how my great grandmother owning a bar in 1939 affected my understanding of deviance as well as how she became canonical in my identity construction.

The current literature on the motherhood-entrepreneurship nexus largely ignores the realities of women of colour and instead focusing on how predominately white women negotiate the time constraints of business and motherhood (Lewis et al.; Leung). In order to address these gaps in the literature, I first explain the importance of working from an intersectional framework, and then I contextualize the geohistorical placement of my grandmother's experience and the continual effect it has had on me through explicating the historical timeline of San Antonio, Texas. I then explain the significance of the autoethnographic method of autohistoria-teoría. I use this method to investigate the past narratives of my grandmother as well as my own personal narrative. I show how through tacit and implicit cultural mechanisms of narrative and invocation, I have been given tools of resistance and resilience to the dominant frame.

It is through understanding the intricate ways in which different people, communities, and cultures manoeuvre and work within their understanding of their own sociohistorical placement that we can begin to give voice to those historically erased from the discourse (Lorde; Harris; King). My autoethnographic account provides an example of the complex and often underresearched reality of many in the Latinx community, as the research on such social phenomena is largely missing.

My mother says, "My grandmother, she was a part of the history of

San Antonio. I need you to make sure you say that our ancestors were a part of the Southside for generations, before it was even the U.S. and 'The South Side.'" I assured her I would.

Through a multiplicative intersectional framework, I can identify and explicate the structural frameworks that created such a familial social reality, which not only brings validation and insight to such experiences but also provides a voice and healing to those who have been erased. The more prodigious multiplicative intersectionality becomes, the more voice is given to those often erased and more diverse voices can come together to identify tools of resistance to the oppressor. These tools of resistance are tools of healing and empowerment. These tools were not made by the master. This form of resistance breeds community, and in my research approach, it is micro level grassroots community movements that are most likely to create change.

Autoethnography

As this piece is autoethnographic, it is important to understand my geographical and sociostructural positioning. A facet of my methodology, autohistoria-teoría, is used to decolonize epistemology, which involves bringing to life historical truths that have been erased from the history books. These are truths of our people, told through our mouths. I am a Mexican American living in Texas. Although there are many ways in which I could contextualize Mexican culture and the Mexico histogeographic timeline, I will focus on the State of Coahuila y Tejas and the multiple governments that the people of this land had to navigate. Many scholars focus on the migration of Mexican people to the United States (U.S.) before the Great Depression and the generations of assimilation and racial antagonism that followed. This history is important and needed in the literature, but it often forgets the Mexicans who never moved and who watched the land change between governments often with little say in the process.

There are several reasons why I gravitated towards using autoethnography as a methodological tool to explore entrepreneurship and motherhood. I actively wanted to interrogate how my grandmother's involvement with deviant entrepreneurship affected the construction of my identity. Autoethnography offers a means to interrogate identity; it offers the possibility of unearthing new dimensions of cultural influence

and construction that were previously unknown (Jones et al.). This is done through self-reflection on personal experiences, usually through narratives, to identify how culture facilitates interactions with structure and how different people manoeuvre through culture (Jones et al.; Adams and Manning). This methodological approach is specifically useful when approaching family research, as autoethnography can clarify and chronicle how our lived experiences and social construction of knowledge are coauthored through family development and interactions (Adams and Manning).

Furthermore, autoethnography is particularly important when considering a critical approach to epistemology that considers the complex and colonized situation facing the Latinx community. As the theoretical approach to this article is intersectional, autoethnography offers multiple layers of consciousness (Chavez), as it considers not only the lived experiences of the individual writer but also experiences in relation to community and culture (Chavez). Thus, although autoethnography is centred on the self, it becomes a collective experience (Chavez). Such a methodological understanding becomes imperative in family research such as mine, which considers intergenerational lessons and tools of resistance and resilience. By using autoethnography, specifically autohistoria-teoría, I can investigate narratives heard throughout my life to interrogate how they have affected the construction of my identity.

Beyond Autoethnography: Autohistoria-teoría

In this article, I actively engage in autohistoria-teoría, which is an autoethnographic tool developed by Gloria Anzaldua (Keating), to investigate how having a great grandmother who was an entrepreneur affected not just her life but the identity construction of her lineage. I posit that by owning a business, especially a bar, in a time when this was considered largely immoral for a woman to do, my great grandmother was allowed the freedom to actively construct her own sense of morality instead of accepting one dictated to her. I further investigate how this ability to construct identity and morality directly affected how her daughters viewed dominant moral discourses. I use autohistoria-teoría to construct a theoretical framework that explains how entrepreneurship led to the construction of deviance as resistance to the oppressive dominant frame of my great grandmother's lineage.

Autohistoria-teoría is composed of three dimensions: First, it is composed of critical writings from within the space of the other; by writing from this space, the autoethnographer must be reflective of the onto-epistemology within which they have been indoctrinated (Bhattacharya and Keating; Keating). This critical writing from the space of the other creates a space for decolonized theorizing (Bhattacharya and Keating). Second, autohistoria-teoría is comprised of shadow work, which is conceptualized by Anzaldua as involving internal reflections that lead to the surfacing of repressed, erased, and buried narratives within multiple dimensions of reality (Bhattacharya and Keating). Shadow work includes healing the wounds of both the collective and the individual. The final dimensions is magical thinking, which could involve invoking several different beings, but importantly to this article, it evokes my ancestors who aid in my knowledge creation (Bhattacharya and Keating; Keating).

Anzaldua identifies that the shadow beast is our inner rebel, the being within that refuses to be constrained by cultural tyranny, whether that is the cultural tyranny of Mexicans against our own women or the tyranny of white domination, colonialization, and denigration of our people. It becomes clear in reading *Borderlands: La Frontera* that there is a conceptual overlap between *the shadow beast* and *the Indian woman* that lies within us women of Indigenous decent, including Xicanas. Our culture fears us, women, because we are integrally linked to the supernatural; we are simultaneously divine and undivine (Anzaldua). One of the ways our culture has protected us from ourselves is by making us fear *the Indian woman* that lies within us (Anzaldua). Anzaldua explains the development of this fear and perception through the story of La Malinche, whom some could say is the mother of the mestiza and the original *Indian woman* (Anzaldua; Pinder; Gonzales). So despised is she that her name is used as a slur for "race traitor" (Pinder).

She was an Indigenous slave named Malintzin, who was given as a gift to Cortes and was used to guide his men to the capital of the Aztec nation, Tenochtitlan in the Valley of Anahuac (Pinder, Gonzales). Feminists, including Anzaldua, have begun to reclaim her and interrogate the narrative of La Malinche, the race traitor (Pinder). Overall, she is viewed as the one who guided and translated for Cortes; many believed this made her a traitor to Indigenous people, which led to innumerable destruction in the Americas (Gonzales). But, as Anzaldua notes, it is not

her who betrayed us, but us who betrayed her. Often overlooked is that she was given to Cortes as a slave, by her own people. Choosing to survive, she was left with no other option than to guide Cortes.

Anzaldua describes *the Indian woman* as a spirit of resistance, protest, strength, and magic; they have "silenced, gagged,[and] caged" her; "for 300 years she has been a slave, a force of cheap labour, colonized by the Spaniard, the Anglo, by her own people" (Anzaldua 44, 45).

My Story, Her Story

I remember going to my mom's house the night my grandmother died. My friend drove me to her house; when we turned off the main street, my eyes grew wide. The power was out only in our small neighbourhood. We had been expecting my grandmother to pass, but as we drove down the dark street leading to my mom's house, my heart sank because I knew it meant my grandmother was gone from the physical world.

I walked into the house, and my mother sat at the table staring at a single white burning candle. I stayed up that night listening to the story of my grandmother's life and how she passed. Listening to my mother explain how my grandmother made her the woman that she became. That's how my life is; the ones before are alive within and around me, continually sending me signs of change, of importance. They send guide posts showing me where to follow. There are brujerias coursing through my veins. What Gloria Anzaldua would call, my shadow beast (Anzaldua).

Anzaldua explains that our inner *Indian woman* waits, stoking her hidden flame, invisible, battered and bruised, yet alive: "The spirit of the fire spurs her to fight for her own skin and a piece of ground to stand on, a ground from which to view the world—a perspective, a homeground where she can plumb the rich ancestral roots in her own ample mestiza heart" (45).

For years, I tried to figure out how the women in my family came to be so strong, so tied to their culture, yet so deviant from it at the same time. My great grandmother's identity fit into Anzaldua's conceptualization of "new mestiza"; with one foot in the spiritual realm and one foot in the physical, my great grandmother embodied the freedom needed to build her own cultura and identity regardless of social norms and laws. She claimed her own space. It was she who developed a lineage of strength.

The past women in my family are my shadow beasts; they push me

to rebel, to fight, and to resist. They are my *Indian woman*. I am lucky because I never knew to fear *the Indian woman* within me; instead, I saw her as inner strength I had to unbury and investigate. She was the parts of me that were hidden. My mother's narration gave me hints and clues on how to unlock them and her. I was created from an amazing woman, and although many say that about their mother, I need you, the reader, to understand that my mother is amazing not just from a daughter's perspective but from a feminist academic of colour's perspective. My mother identified the vulnerable place that her daughters were in when my sister and I were growing out of childhood. In general, the early teens are hard on a young woman's self-esteem, but we were isolated from our extended family, living in North Carolina, and being surrounded by whiteness left us feeling like perpetual outsiders even when included. My mother geared battling the impact of this based on the child. My sister was always more athletically inclined than me, and pinning down guys on the wrestling mat suited my sister well. For me, though, I was softer by nature, so books were given to me. It was important to my mother that I constructed my idea of "Latina" identity in my mind as strength, freedom, and perseverance; thus, narratives of strong Latinx like Esmeralda Santiago and Sandra Cisneros were thrust upon me. They walked with me through my young adulthood, consoled me, and pushed me to be more daring. Their stories for me were important ones. My mother provided me stories not just of distant women like Esmeralda Santiago and Sandra Cisneros but the women in my family; she described the blood that coursed through my veins, letting me know that we are not made from weak women.

Autoethnography, specifically autohistoria-teoría, requires me to cut myself open and spill the blood of hundreds of years of colonialization onto paper, hoping to somehow decontextualize the outcome. I never expected to offer my voice as datum, but there are missing elements from the research done through a white lens, of which I hope I can bring a voice to. Reading the stories of strong women as a young teen was identity work; here, writing the stories of the strong women within me and investigating their effect is also identity work. Autohistoria-teoría creates a companionship between reader and writer; as I write myself into existence, I open up decolonized space created for myself to examine my own being and how my identity has been continuously constructed (Bhattacharya and Keating). I invite you, the reader, to engage in

autohistoria-teoría and to add to the literature as well.

One of the major purposes of intersectional work is to make visible the voices often made invisible by the normative feminist framework (Harris). In order to properly do intersectional work, it is important to fully investigate and conceptualize the lived realities of those who the subject matter concerns (King). Autohistoria-teoría has the ability to investigate and develop counternarratives that brings into existence what has often been made invisible in the literature.

Make No Excuses, Apologize to No One

The stories my mother told about my grandmothers occurred organically; something always happened to make her feel I needed to hear a story. More often than not, I was stuck or in a fearful place, and she felt the need to remind me of the strength I am from in order to spur me on. Yet in order to do the work for this chapter, I needed to solicit these stories, so tonight deviated from the norm. I was requesting the stories. I called her on the three-hour drive from my university telling her I wanted to talk about my grandmothers. She agreed, but when I got there, she hesitated.

"You know them all already," my mom said, as she stood over the stove, the magic of her cooking making that perfectly balanced aroma of garlic and cumino fill the air. I love being in the house when she cooks. I sat on the bar stool shaking my head at her, watching as she made the ingredients transform under her skilled hands. As a child, our rule was to be home at dusk, and I remember always pushing my limit on that rule. I would rush home on my bike, panicking as the darkness grew closer. The second my feet touched our yard that smell of garlic and cumino would wash over me, and I knew I was safe and at home. As a doctoral student, I attend a conservative and predominantly white school in Texas that has a habit of not being very nice to critical graduate teachers of colour like me, and often times I long for that smell.

I thought for a second, feeling a little guilty. I had told her this chapter was for my grandmothers and her. However; it was something I needed and something my heart needed too. Yet how do you explain to your mother that you need to tell the world the stories of your grandmothers for some spiritual quest that developed from the colonizing wounds of graduate school? It had been such a long five years, and I still had a long

way to go. I wasn't even completely sure I was there asking my mother these questions for a spiritual quest or if I just really wanted a reason to come home, eat her food, and feel closer to my family. I did know that the university I attended left me with a perpetual feeling of downtrodden exhaustion. My spirit was drained from the endeavour, and I knew I never felt quite as exhausted when my mom told me about my grandmothers. My preliminary examinations were coming up and I knew I really wanted to hear them all again, even if I knew them all already.

"Momma, I want to be sure I get it right. Grandma Ruby did so much, and stories like hers are just missing. People deserve to know what y'all did," I told her.

My mom gave me a look. Where I saw my grandmothers and their work as untold strength, activism and resistance, she saw it as simply surviving and teaching your daughters to survive in a harsh world. She looked down at the stove and said, "You see her as this amazing woman but her stories weren't all good. There's an ugliness to it. But your grandmother, she apologized to no one, and she made no excuses for the things she did. You tell the truth, portray her like she really was, ugliness and all." With full bellies, my mother and I shooed my father away to bed as I pulled out my note book. I wanted to make sure I had all the stories correct before I started this chapter. This was how it always went when she told stories about my grandmothers—late at night, my father asleep, and with a quiet feel to the air as though nothing else existed but my mother, the stories of my grandmothers, and me.

A Force of Nature

I never knew my great Grandmother Ruby, but I grew up on stories of her. Like Esmeralda Santiago and Sandra Cisneros, my mother used narratives of my Grandma Ruby to sculpt an image of strength and perseverance in my head. In a way, she became an ideal to me; she was what I once was and simultaneously what I should aspire to be. Growing up, I was the soft quiet one, but from these narratives, I believed that the same strength and perseverance resided in me. I just had to dig it out. It was as though my great grandmother left reserves of strength and ferocity in my heart that I would somehow instinctively draw on when needed. Although I believe I carry her in my heart, I

also believe she, and all my other grandmothers, watch over me. They will know if I am being weak, if I am doing them wrong.

My great Grandmother Ruby was born on August 31, 1917, the daughter of John C. Treviño and Estefana Vega. She was a child of the Great Depression; she was a young teen when it took hold of the U.S. Her father had owned a washateria on South Flores Street in the Southside of San Antonio, Texas, and my Grandma Estefana was a housewife. My mother tells stories of sitting on the porch swing with my Grandma Estefana as dusk settled over the Southside. She would lean over and tell my mother, as if forewarning my mom not to expect this much freedom in the future: "The only reason I am able to be outside is because my husband is dead." When my mother would tell me this, my eyes would grow wide. My mom would smirk at my shock and explain that this was the times. She would then drive the shock in by explaining to me how Grandpa Treviño would sketch Estefana and her children's feet to buy them shoes because my grandmother was not allowed to leave the house. "That was just how the times were. This was what it was to be a woman then," she said.

Anzaldua explains that for a long time there were only three ways for women to escape the subservience my Grandma Estefana faced: the nunnery, sex work, and, more recently, education and career. What if becoming a nun and getting more education are beyond reach? What if the streets are unappealing? Since I have grown into adulthood, my Grandma Ruby has fascinated me. I was intrigued with how a woman from such a restrictive culture managed to be so autonomous. She had a personality that did not care what society said was acceptable. She was unapologetically a "mujer mala" ("bad woman"), and given the few resources she had, she came to view entrepreneurship as her route to freedom. Much of this was based on her magical thinking and invocation. The following story speaks to this:

I cocked my head to the side, confused I asked my mom, "Mommy what's brujeras?"

My mom leaned over: "It's witchcraft."

"Why did Tita whisper it?"

"Because the Bible says it's so bad, you should never even speak of it," my mom said, her eyes looking down and away.

At nine years old, I still lacked the ability to read social cues. I asked, "But what if you do it for good?"

"She's religious, and it's not supposed to matter. If the Bible says it, you follow it—no matter what."

Then I had been a child, but now, I am an adult and taking examinations that can determine my career. I still wasn't done with this chapter, but that would have to wait. I felt very alone. Studying had isolated me for months, and finally in the middle of my week-long take-home exam, I broke down crying. I had been playing Disney movies in the background, a failed attempt to soothe my nerves while I tried to write. As I cried, I realized *Moana*, a children's movie about a young girl on a journey alone, was playing in the background, her singing periodically pushing past my tears.

"I have journeyed farther. I am everything I learned and more still it calls me." Moana sang.

"Of course this song," I thought, sobbing harder now.

"I didn't mean to let you down," I wailed thinking of my grandmothers who would be thinking "You're crying because you have to write, in your house, in your pajamas?" I wasn't holding my head anymore but had laid it on the desk and I sobbed pulling on my hair.

Moana continued singing, and I continued crying. Sobs waning, I began to tune back in. I looked up at the movie, and Moana sang to her grandmother as she smiled back at her: "I will carry you here in my heart. You remind me that come what may, I know the way." I laughed hard with the sound of a sob just beneath it. Wiping tears from my eyes, which were still flowing but changing in nature, I shook my head and smiled. I looked up and around, and with a teary voice, I called out "Ok! Ok! I hear you grandmas. I hear you!" Their spirits must be here, somewhere, guiding. I watched the scene a time or two more, paced my apartment stopping to smile at my alter: a candle for Jesus the father, a candle of Saint Michael to respect to my father and his line, and Virgen De Guadalupe for my mother and her line. The alter was strewn with articles from them and for them, such as stones, protecting herbs, Grandma Angelita's rosary, and calming dolls. I had also placed a burning white candle and a doughnut for Grandpa Johan because I was sure he was there that day. I laughed to myself and I could feel my grandmothers shaking their head. I could just imagine them saying, "Yeah and who are the ones always comforting you? Watching you? But do we ever get doughnuts?!"

I wiped away the salty tears. I sat down, regrouped, and started writing. A faint worry passed through my mind: "They gave me a week. How am I going to write all of this in three days?" I shook it off thinking, "Well, we shall see what I can do in three days then." I smiled because I know these moments are because of my grandmothers. I told my mother about that particular instance where I felt held and she told me that, at least in that situation, it was most likely her Aunt Annie because she was so sweet and kind hearted. My mom also told me that my Grandma Ruby was probably in the background yelling for me to pick myself up and get it together. I smiled and thought it also could have been Great Grandma Angelita. I always called her simply "Grandma," probably because she raised my dad. I was her baby's baby, so she always wanted to see me smile, and she always spoiled me. I knew her as a gentle and sweet woman, even though that is not how she is described in stories. She was the one who taught me how to drink coffee and helped me outline the flowers on her tablecloth with my hands, as my dad would talk to my grandma (his mother).

Autohistoria-teoría involves the dimension of magical thinking (Bhattacharya and Keating). It also involves antagonizing the onto-epistemological rhetoric I have been indoctrinated into (Bhattacharya and Keating). As a trained quantitative methodologist, I am still not completely a decolonized reflector, who can explicate my magical thinking to the fullest in this Autohistoria-teoría methodology. Future research and investigation are needed to do so clearly. I can say, however, that my great Grandmother Ruby did have a foot in the spiritual and physical realm. She did not fear brujerias despite being Catholic, and she taught my mother not to either. She was and is magical and is constantly invoked by her memory. Ruby was a force of nature, a storm, outside watching me, and the brujerias course through my veins, pushing me to take risks and laugh in the face of the oppressor.

When my mom described my Grandma Ruby's harsh personality, she always explained that Grandma Ruby was the oldest of the children, but only grew to 4'11. For some reason, this combination was used to explain harshness and her ambition. Her spirit was one that was a force of nature, and she would fight a person until they cared about what she cared about.

Figure 1: The building where the Southside Bar stood.

When my Grandpa Treviño passed in 1939, my Grandma Ruby decided to turn the washateria into a bar. We don't really know why my Grandma Ruby decided to do this, other than it seemed like a logical move. My mom told me that grandma saw World War II coming; San Antonio had many military bases, and Grandma Ruby thought it was a good move because military men loved to drink.

During the 1940s, there was a cultural perception that work involving liquor could corrupt a woman, and many communities went to great lengths to keep bars exclusively male (Murdock). Despite these specific barriers, my great grandmother owned and ran her own bar. My mom told a story about watching reruns of a movie called, *The Godfather,* as a young girl and asking Grandma Ruby if she had ever experienced anything like that. My grandmother laughed and gave her a look saying, "if you only knew."

She was a child of the Great Depression, and turning a profit was her top priority. It was known in the family that sex workers worked in the bar and that she took a cut of the profits, which is why many in my family do not speak of my Grandma Ruby fondly. She was mean, harsh, and ambitious in a time when women were supposed to be soft and kind. She had multiple husbands, divorces, and children out of wedlock in a time when this was unacceptable. She upheld sexual deviance in having sex

workers at her bar. Many would read this and wonder why I am so proudly writing about her.

Figure 2: The Southside Bar

During World War II, her bar was in full swing; it also served food and was known to have the best Mexican food on the Southside. This generated economic freedom and my grandmother Ruby made it clear that she made her own decisions no matter the prevailing social rhetoric. One story my mom often told was about the Mexican (Xicana) wife of a Mexican (Xicano) military man. She was pregnant, and the baby was born Black. The husband "beat her to a pulp," my mother would tell, and abandoned her. In the 1940s, San Antonio was heavily segregated, the ramifications of which can still be seen today (Blackwelder; Mason; Walter et al.). San Antonio, while often framed as being relatively civil in terms of how they treated Black Americans, still had strict Black codes and racial tensions, a cultural remnant often attributed to the Spanish caste system (Mason). The Southern culture that influenced San Antonio's development after Spanish occupation contributed to a culture that was intolerant of interracial relations (Gonzales; Mason). In such a cultural climate, a married Mexican (Xicana) woman having a Black child was seen as a dangerous.

Ruby gave the wife a job as a waitress, a place to stay, and support. I have no idea how my grandmother Ruby knew this woman or even if

she knew this woman before she was abandoned. I know because of my grandmother's business she was known, I'm not sure if a friend sent the wife to her or asked for my Grandma Ruby's help. I don't know my grandmother Ruby's full perspective, but I do remember sitting with old photos of the bar and seeing that it was not segregated. I smile when I think of this story, and in my mind I can I see my grandmother Ruby saying: "Well, no one else has the balls to help her, guess I'm going to have to."

Tortillas and Storytelling

For many women, particularly Mexican women, food invokes power and knowledge (Abarca). Although the kitchen can be seen as a place of gender obligation, Meredith Abarca notes that it often becomes a space for women, in which they share instructions not just about food preparation but also about cultural tools, values, and behaviour (Abarca). My Grandma Ruby did this often; she shared knowledge and gave instructions about how to handle difficult life situations in a community that expected subordination.

As my Grandma Ruby aged, she softened, not in demeanour but in her presence. There are stories of how stingy my grandma was with her money, food, and time, since she was a child of the Great Depression. Her life had been about turning profit, and her children were mostly raised by her mother (my Great Great Grandma Estefana) as a result. This was not the grandma my mother knew. She grew up cooking with my Grandma Ruby, and while they cooked together, she would tell her stories and give her life lessons. They would make tortillas, and it would be my mom's job to flip them while on the comal. She would listen to my Grandma Ruby talk in between the rhythmic sound of the rolling pin on the counter. Three rolls on the dough are required, just enough to give you perfect circles, but not so much that dough is overworked.

After that distinctive ding, ding, ding sound of the rolling pin, she would say, "When your father leaves, don't you dare cry. Don't ever cry for any man." "And sure enough," my mom said in between sips of beer, "When my father left, I remember thinking about my grandma and not crying. I just asked him for the pocket knife in his drawer." My mom talks about instances like these in awe: "I don't know if she saw some-thing in me, or if she saw the future, or she knew that with my mom

being how she was I needed her to embed that strength. But she did."

I smile when I think about the lessons she gave my mom because they also helped me grow as a woman. Two of her sayings that have defined my life are "The more you give, the more you have" and "There is always enough food." My passion in life is to feed others.

I consider all this while staring at my writing—the lessons my great grandmother taught my mother, the life my Grandma Lily and Grandma Ruby lived, and how my mom views Grandma Ruby's legacy as independence. Although she had married several times, she always divorced and was known to say: "I don't think I'll ever stay married. I can't stand anyone taking care of me." At the end of the day, my Grandma Ruby sought the freedom to live a life she wanted without being told she couldn't because of rules that were made to subjugate her and other marginalized people.

It is easy to read about Grandma Ruby and view her deviance as negative, as though she was nothing but a harsh woman who broke rules and answered to no one. It is important to understand that sometimes society pushes certain groups of people into subservience and those people have the option to fight against it. When writing about my Grandma Ruby, it becomes apparent that deviance is an act of resistance. Born into a family and time where patriarchal control and subservience were expected, Grandma Ruby deviated from the norms no matter who judged her and despite the risks her life imposed. This meant taking societal and legal risks daily.

I want to note specifically the importance of food and religion in my culture. Culturally, food acts as a point of social and cultural sharing (Julier). Specifically, for Mexican Americans, cooking with family members becomes a narrative and decolonialized space in order to investigate personal historical space and subjectivity (Abarca). Those doing the cooking transform into active agents in their own historias (Abarca). This is an important aspect of how narrative is invoked within my familial space; it can be seen as carrying an important role of facilitating my family's oral history. This relationship between food and invoking oral narratives that act as a decolonized space is culturally logical when considering curanderismo, which is a form of healing through finding a balance between faith, prayer, and the products of the earth. What is cooking if not creating from what is derived from the earth?

Freedom through Deviance
We Didn't Cross the Border. The Border Crossed Us

My throat was tight. I stared at the census record. "Age at last birthday prior to June 1, 1880," read the label, and under it, my great great great great grandmother was marked as forty. We always said we were Mexican despite not being from across the border. The border moved. I didn't realize how much it meant to me; it was as though my identity was validated after all those times I was told I was white and had my culture, the "ness" of my homeland, questioned. No one could take that from me. But marring this happy revelation was a glaring reality, proof the U.S. has always been on a mission to assimilate us. We were here, marked as white, with our last name misspelled. But we were here when the border moved. This was the start of the second colonization, the cultural genocide my family line witnessed and endured.

Grandma Ruby's ability to push against patriarchal control and expectations of subservience can be directly linked back to her entrepreneurial endeavours. The literature on Latina business ventures show that, overall, there is not much monetary benefit comparatively and that Latinas would actually accrue more wealth in wage salary work. Research shows that Latinas are drawn to the entrepreneurial work because of its autonomy and the control they have over economic outcomes (Lofstrom et al.; Lopez and Trevizo). When considering the existing literature and the stories about my Grandma Ruby, entrepreneurial pursuits were based on a quest for freedom, financial or otherwise. Grandma Ruby saw freedom in entrepreneurship, and although her work often led to judgment and being ostracized, it was a sacrifice she was willing to make. Furthermore, the conversations my Grandma Ruby had concerning the patriarchal structure and emotional management showed that she did not intend this quest to stop with her.

In the beginning of this chapter, I noted that my Grandmother Ruby encapsulated what Anzaldua refers to as a new mestiza—a person who through reflection sees that they are multiple beings (Keating). Yet Anzaldua defines "new mestiza" through more of an individualistic approach. I believe my grandmother went beyond that; from the stories, it becomes apparent she was trying to create a new culture within the women in her family. She taught her granddaughter defiance, which was

then handed down to her great granddaughter. Through the uncovering of lost narratives through shadow work, autohistoria-teoría provides healing to collective and individual identities (Bhattacharya and Keating; Keating). Anzaldua created the Coyolxauhqui imperative based on the Aztec story about the lunar goddess, Coyolxauhqui, who was murdered by her brother; he decapitated her and tossed her body down a sacred mountain. When her body was thrown, it fragmented into a thousand pieces. In the Coyolxauhqui imperative Anzaldua creates a narrative and theory of self-healing, Coyolxauhqui becoming her symbol of the fragmenting and rebuilding process of healing. The story explains that you can be whole and broken simultaneously and that the processes of healing can be never ending and imperfect (Bhattacharya and Keating; Keating). The Coyolxauhqui imperative is the process of healing that occurs in autohistoria-teoría, as this writing process involves the fragmenting and rebuilding of a thousand lost narratives.

Through the guidance of my grandmothers, I am forever trying to heal and grow from the pain of fragmentation. My body is the aftermath of patriarchal colonialization—my light skin and blue eyes, which family members comment on almost too excitedly, and the Mexican language, which was stripped from my family by assimilation schools. Yet my family has been here since before the land was stolen, and the *Indian woman* breathes from within me, raped and beaten, fragmented and weakened. Once in graduate school, I feared I'd lose her forever. Yet my Grandma Ruby buried reserves of strength in my blood.

I was raised believing that my grandmothers' blood courses through my veins. There were several occasions presented to me in my graduate career when I realized things would be easier if I just went along with the dominant discourse. The dominant discourse is one that erases the realities and struggles of my people as well as the struggles and realities of others. I couldn't bring myself to do that.

This article is an intersectional piece, and it is important to note when building my theoretical framework that I build heavily from Black feminist writers, since they laid the groundwork of intersectional theory. Yet this magical thinking narrative underscores the importance of reflecting on your own personal frameworks and how they differ from those who come from different backgrounds. Here, I provide a glimpse into the lived experiences of a Xicana, which often go unspoken due to structural fear and generational pain. These concepts are not foreign to

women of colour, but the way in which generational pain affects me is different. Athena Mutua notes that building from different backgrounds strengthens equality and helps to explicate different areas of oppression that may have gone unseen. True intersectionality is not isolating; instead, it brings together different groups to better understand one another and to enhance resilience and resistance.

Conclusion

The dominant narrative may approach this chapter and view it as simply a superstitious narrative. But to do so erases the reality in which I live. I walk with my grandmothers, and they guide me in my life's journey. The dominant frame does not subjugate the normative Christian faith as simply superstition; it is understood that faith is the reality of a Christian's life. This is the reality I live; it is simply deviant from the colonizers' narrative.

I wrote this chapter to explain through autohistoria-teoría how the motherhood-entrepreneurship nexus affects much more than the individual entrepreneur's life. My Grandma Ruby did deviant entrepreneurship as an act of resistance to our culture's subjugation of its women. This helped her children, children's children, and even me achieve freer lives. Because my Grandma Ruby owned a bar, I can draw a direct line to why I've crossed the ocean to cook, why I've hung off the sides of mountains to see, and why I went to graduate school not just to learn but to challenge.

My lineage has dark spots. My grandmothers were rough and deviant out of necessity. But does that mean their hearts were not good? When they were done fighting the world, they showed their kindness. For my Grandma Ruby, she shared the wisdom she had gained. As a sociologist, I know that right and wrong are socially constructed, but some may read this and judge. What is important to know is that my ancestors are my muses: they stay with me. They comfort me, and they calm me when I feel as though I cannot keep my balance on this tight rope any longer. Despite this roughness that deviates from typical female gender norms, there is so much love in it—a love that pushes me to not fear risk, to not fear judgment, and to not be afraid of telling the oppressor that he is wrong and that this will change.

My dad loves to invoke my patriarchal lineage when I struggle, saying

"You are a Cisneros!" Oh, but I am so much more than that. Thanks to my great grandmother's rebellion, and the freedom her entrepreneur endeavour granted her, I am a new mestiza.

Works Cited

Abarca, Meredith E. *Voices in the Kitchen: Views of Food and the World from Working-Class Mexican and Mexican American Women.* Texas A&M University Press, 2006.

Adams, Tony E, and Jimmie Manning. "Autoethnography and Family Research." *Journal of Family Theory & Review,* vol. 7, no. 4, 2015, pp. 350-66.

Anzaldúa, Gloria. *Borderlands: La Frontera.* Aunt Lute, 1987.

Bhattacharya, Kakali, and AnaLouise Keating. "Expanding Beyond Public and Private Realities: Evoking Anzaldúan Autohistoria-teoría in Two Voices." *Qualitative Inquiry,* vol. 24, no. 5, 2018, pp. 345-54.

Blackwelder, Julia Kirk. *Women of the Depression: Caste and Culture in San Antonio, 1929-1939.* Texas A&M University Press, 1999.

Chavez, Minerva S. "Autoethnography, a Chicana's Methodological Research Tool: The Role of Storytelling for Those Who Have No Choice But to Do Critical Race Theory." *Equity & Excellence in Education,* vol. 45, no. 2, 2012, pp. 334-48.

Gonzales, Manuel G. *Mexicanos: A History of Mexicans in the United States.* Indiana University Press, 2009.

Harris, Angela P. "Race and Essentialism in Feminist Legal Theory." *Stanford Law Review,* vol. 42, no. 3, 1990, pp. 581-16.

Hendrickson, Brett. "Restoring The People: Reclaiming Indigenous Spirituality in Contemporary Curanderismo." *Spiritus: A Journal of Christian Spirituality,* vol. 14, no. 1, 2014, pp. 76-83.

Jones, Stacy Holman, et al. *Handbook of Autoethnography.* Routledge, 2016.

Julier, Alice P. *Eating Together: Food, Friendship and Inequality.* University of Illinois Press, 2013.

Keating, AnaLouise. *The Gloria Anzaldua Reader.* Duke University Press, 2009.

King, Deborah K. "Multiple Jeopardy, Multiple Consciousness: The Context of a Black Feminist Ideology." *Race, Gender and Class: Theory and Methods of Analysis*, edited by Bart Landry, Routledge, 2016, pp. 36-57.

Leung, Aegean. "Motherhood and Entrepreneurship: Gender Role Identity as a Resource." *International Journal of Gender and Entrepreneurship*, vol. 3, no. 3, 2011, pp. 254-64.

Lewis, Kate V., et al. "The Entrepreneurship-Motherhood Nexus: A Longitudinal Investigation from a Boundaryless Career Perspective." *Career Development International*, vol. 20, no. 1, 2015, pp. 21-37.

Lofstrom, Magnus, and Timothy Bates. "Latina Entrepreneurship." *Small Business Economics*, vol. 33, no. 4, 2009, p. 427.

Lopez, Mary, and Dolores Trevizo. "Mexican Immigrant Entrepreneurship in Los Angeles: An Analysis of the Determinants of Entrepreneurial Outcomes." *An American Story: Mexican American Entrepreneurship and Wealth Creation*, edited by John Sibley Butler, Alfonso Morales, and David L. Torres, Purdue University Press, 2009, pp. 127-204.

Lorde, Audre. *Sister Outsider: Essays and Speeches*. Crossing Press, 2012. Print.

Mason, Kenneth. *African Americans and Race Relations in San Antonio, Texas, 1867-1937*. Taylor & Francis, 1998.

Murdock, Catherine Gilbert. *Domesticating Drink: Women, Men, and Alcohol in America, 1870-1940*. JHU Press, 2001.

Mutua, Athena D. "Shifting Bottoms and Rotating Centers: Reflections on LatCrit III and the Black/White Paradigm." *University of Miami Law Review*, vol. 53, 1998, pp. 1177-1218.

Pinder, Kymberly N. *Race-ing Art History: Critical Readings in Race and Art History*. Routledge, 2013.

Tafur, Maritza Montiel, et al. "A Review of Curanderismo and Healing Practices among Mexicans and Mexican Americans." *Occupational Therapy International*, vol. 16, no. 1, 2009, pp. 82-88.

Walter, Rebecca J., et al. "Historic Roots of Modern Residential Segregation in A Southwestern Metropolis: San Antonio, Texas in 1910 and 2010." *Urban Science*, vol. 1, no. 2, 2017, pp. 1-19.

SECTION III

Reframing the
Work-Life Interface

Chapter Six

Positionality, Work-Life Interface, and Early-Career Engagement: The Case of Entrepreneurial Mothers in Jamaica

Talia Esnard

Introduction

Although the importance of women entrepreneurs has gained increasing attention across the globe (ILO, "Strategy on Promoting Women's Entrepreneurship"; Martinez and Marlow), much of the scholarship around the topic remains deeply rooted within taken for granted norms of entrepreneurship (Jones and Murtola; Jennings et al.). The broader literature on women's entrepreneurship usually includes studies with large-scale surveys that capture socio-economic trends and build upon deficit models for understanding the entrepreneurial activities of women (Robb and Watson; Coleman). Oftentimes, these studies (framed within an objectivist epistemological framework) are steeped within individualistic assumptions and performance narratives, that are usually framed within the Global North (Minniti and Naude; Jennings and Brush; Marlow and McAdam).

These performance based studies, however, remain silent on the structural forms of inequality (Baker and Welter) and on the gendered notions of entrepreneurship that continue to affect the experiences of women (Ahl; Lewis; Hughes and Jennings; Marlow et al.; Mirchandani; Hughes et al.; Welter et al.). Moreover, existing studies within this performance narrative fail to address in any substantive way the particular ambiguities that entrepreneurial mothers face and the specific circumstances that underpin their strategies for negotiating work and family (Leung; Ekinsmyth, "Changing the Boundaries"; "Managing the Business"). Such limited frameworks and scholarship render invisible the importance of cultural, social, and political factors affecting women's engagement and the processes through which entrepreneurial mothers experience and confront these structures and relations of power.

Research on women entrepreneurs in the Caribbean region faces similar yet more extensive limitations. Thus, although since the 1990s, there has been a continuous push for and an increase in the entrepreneurial engagement of women in the Caribbean (Minniti and Naude; Terjesen and Amorós), an empirical abyss remains. Large scale reports typically identify the push-pull factors for entry into business and profile the challenges for women entrepreneurs in Latin America and the Caribbean (see Ferdinand; Lashley and Smith). What remains fundamentally missing in such reports and related typological assessments of entrepreneurial women are critical interrogations of the underlining archetypes that configure their experiences and challenges within the entrepreneurial space. A related concern is that existing research on women entrepreneurs in the region advances a deficit understanding centred on narratives of underrepresentation and (under)performance (Terjesen and Amorós; Pounder). Moreover, only a few studies have critically interrogated the factors that affect the relative scalability, feasibility, and viability of the ventures for women entrepreneurs in the region (Ferdinand; Minniti and Naude; Lashley and Smith).

In many cases, these research studies and reports decontextualize entrepreneurial engagement. What we begin to see is that these studies emerge as a part of a larger push at the national level for more entrepreneurial participation or engagement across genders. I note here that many of these public policy initiatives remain devoid of a robust empirical foundation and application within the Caribbean region. Therefore, there is an empirical chasm on entrepreneurs in general and,

more specifically, on women entrepreneurs. Little is known, therefore, on the experiences and challenges that women face within the entrepreneurial space and on the ways in which economic and cultural connotations of work and family affect the thinking and practices of entrepreneurial mothers in the Caribbean (Barriteau, "Women Entrepreneurs"; Esnard, "Centering Caribbean Women"; "The Personal Plan"; "Mothering and Entrepreneurship"). The social embeddedness of entrepreneurship and the implications for mothers who engage within the entrepreneurial sphere, therefore, remains wanting.

Shifting the discourse beyond these empirical limitations in the Caribbean region requires asking more direct and critical questions about the meanings, experiences, and routines of women's daily lives (Halford and Leonard). What is needed at this point are more nuanced qualitative research that captures the striking "heterogeneity amongst women entrepreneurs (Jennings and Brush, 695) and that explores how their entrepreneurial thinking and practices are situated within the sociocultural and economic realities of the family (Basco; De Bruin et al.). These lines of investigations around the family and work are particularly important, given the promotion of autonomy and flexibility as central to the promises of entrepreneurship (Manolova et al.) and the mounting concerns for how women are positioned to address the complexities of their work-life interface (Damaske and Gersen; Wattis et al.).

In responding to these research gaps, this chapter pushes for contextual theorizations that consider the cultural and structural complexities that underlie the intersubjective relationships, positions, and confrontations of entrepreneurial mothers. A major contention of the chapter is, therefore, that these cultural and structural facets represent key contextual factors and sites of knowledge that configure the positionalities of entrepreneurial mothers. When these facets of everyday experiences weigh on these early-stage entrepreneurial mothers, their thinking and action become muddled. Although this is by no means a representative study of entrepreneurial mothers in Jamaica, this exploratory work gives voice and visibility to the intricacies of engagement for entrepreneurial mothers.

Positioning Entrepreneurial Mothers

Positionality is "laden with power" (Kezar and Lester 167) but relative to specific social and structural contexts (Alcoff). One major thrust within positionality theory, therefore, is on socially constituted, structured, and stratified landscapes wherein individuals encounter, experience, and react to scripted narratives surrounding their roles and identities. Whether defined by race, gender, class, ability, or an intersection of these, a major proposition remains that of the "situatedness of identity" (Kezar and Lester 166) which is determined by one's relation with, or position to, other persons (Merriam et al.).

Given the constantly changing economic and social relations of power that unfold in a given context, this theoretical perspective also examines the complexities and nuances of these roles and identities as well as how these are (re)defined, or (re)constructed, or (re)configured based on the context, situation, or combination of other factors. In fact, a major argument within this framework is that identity is fluid, dialogical in nature, and "relative to a constantly shifting context" (Alcoff 433). An extension of this line of thinking is that "people have multiple overlapping identities [and that] people make meaning from various aspects of their identity" (Kezar 96). To some extent, this reasoning suggests the following: (i) positionality frames the knowledge that we acquire; (ii) knowledge constructed informs our experiences; and (iii) that we have the capacity to embrace, (re)produce, and/or resist the many forms of subjectivities (based on time-space dynamics). Identity, power relations, context, therefore unfold as key aspects of positionality (Kezar and Lester).

Feminists use this perspective to centre the ways in which social structures and social relations of power both construct and reinforce the lived realities of women (Kezar; Collins; Kezar and Lester). As part of a broader theoretical and political agenda, positionality theory has been employed as analytical lens to underscore the plurality, complexity, and fluidity of women's lived experiences as well as the multiple ways in which women respond. Such theorizations call for deeper explorations of the ways in which these structured experiences alter or reconfigure the standpoint, positionality, and responsivity of those who work within various spaces. More attention is given to the politicization of (inter) subjectivity as a process that is deeply rooted within structures, systems, and relations of power that bear both material and symbolic relevance

within a given context.

Positionality becomes standpoint or what Linda Alcoff refers to as a "positional perspective" of knowledge and for action (324). Acevedo et al for instance contend that "positionality acknowledges complex differentials of power, while simultaneously identifying the value of multiple ways of knowing and being that arise from our multiple identities" (43). This knowledge based on positionality also fits within Floya Anthias's discussion of positionality as the "social position (as a set of effectivities: as outcome) and social positioning (as a set of practices, actions and meanings: as process)". In essence, positionality is the space located at the intersection of structure (social position and ocial stratification) and agency (social positioning/meaning and practice). These intricacies of the theory therefore connect issues of power, knowledge and praxis. Such interpretations of positionality capture how key aspects of knowledge, power, and context inform critical aspects of being and becoming for social groups and/or actors.

This conceptual tool requires further examination of the contextual realities, processes, and specificities that affect the (inter)subjective positionalities, knowledge, and responses of women and mothers. Within entrepreneurial research, such a framework draws on the need to critically address and reflect on the socially embedded complexities of one's position, status, thinking and practice and the extent to which this collective process serves to reproduce and/or transform the entrepreneurial realities of women. Although to some extent this contextual and situational analysis of women's lives has been explored by Caribbean feminists, the innovativeness within this line of inquiry is in its combination of these analytical lenses to interrogate structures of power, identities, positionality, and of the praxes of entrepreneurial mothers.

The application of positionality to entrepreneurial mothers also helps to illuminate the specific ways of knowing, experiencing, and performing the entrepreneurial space. It is my contention that emphasizing the social and structural embeddedness of entrepreneurial mothers offers a unique opportunity to draw on the (inter)subjective experiences, knowledge, and praxes that shape how they become (re)positioned within that space. In the case of this research, the use of positionality theory helps readers to appreciate the complexity and ambiguities inherent within the motherhood-entrepreneurship nexus for entrepreneurial mothers in a developing country like Jamaica.

Socioeconomic Contexts in Jamaica

The socioeconomic realities of a given space and time remain critical to understanding the contextual embeddedness of entrepreneurship (Shane and Venkataraman). In looking at the specific cases of the entrepreneurial women in Jamaica, it is therefore, important that one considers the structures and relationships that (re)produce varying forms and degrees of social inequalities and vulnerabilities (Klak; Mc Elroy and Sanborn; Klak and Conway). This section of the chapter thus captures the socio-economic facets of Jamaica, as contextual realities, which affect position the identities and engagement of entrepreneurial mothers.

Jamaica has one of the largest populations in the Caribbean, estimated to be just over 2.9 million (UNDP). The country also has a formal entrepreneurial policy for the development of micro-, small-, and medium-sized enterprises (GOJ), and, is one of among twenty Latin American and Caribbean countries to push for the entrepreneurial engagement of women (Inter-American Development Bank-IADB). This presents an interesting country for such exploratory work.

I start, therefore, with the premise that Jamaica (like many other Caribbean countries) continues to face many challenges and vulnerabilities as a player within the global economy, albeit to varying degrees (Klak; Klak and Conway; Clair et al.). For many years, the Jamaican economy has been crippled by high levels of public debt, low economic growth rates, fiscal missteps, and external vulnerabilities that stem back to the 1970s (Girvan, "A Perspective"; "Notes form a Retrospective"; Clair et al.). Other regional scholars have also drawn attention to the many contradictions that have emanated from structural adjustment policies in Jamaica and the particular sense of helplessness and socio-economic uncertainties that these have introduced (Clarke and Howard; Handa and King; Barriteau, "Structural Adjustment").

Although the history and contemporary status of the Jamaican economy are beyond the scope of this chapter, it is important to connect the structured facets of the labour market on a more specific level to the social and economic inequalities that differently position women. Thus, despite ongoing economic improvements for Jamaica in the last ten years (Caribbean Development Bank), and its classification as a middle-income and factor-driven economy that is sustained by diverse economic activities (Bailey et al.), many socioeconomic challenges for women remain (Bailey and Ricketts). Even with higher levels of entrepreneurial

activity (Boodraj et al.), we continue to see lower levels of engagement for early-stage or new women entrepreneurs (with more than three months but less than five years in their venture). It is interesting as well that women typically engage in necessity- and improvement-driven activities (Lashley and Smith; Boodraj et al.), that are also informed by the racial and gendered stereotypes of women (Hossein).

On a broader level, Jamaican women continue to experience varying configurations of gender-based vulnerabilities, particularly in areas of economic participation and social empowerment. Related concerns exist around the level of gender-based inequalities (with a gender development index of 0.988), and, the social positioning of women whose employment levels and gross national income in Jamaica remain substantively lower than their male counterparts (STATIN; UNDP). Thus, while Jamaica's human development index (HDI) has been steadily increasing from 0.648 in 1980 to 0.732 in 2017 (UNDP), its HDI rank of 97 for females still remains lower than that of their male counterparts. Other social inequality measures—such as the HDI, the gender development index (GDI), gross national income (GNI), the labour force participation rate (LFPR), and the gender inequality index (GII)—also confirm the marginalized labour market position of women in Jamaica. Although these labour force statistics and gender indices (captured in Table 1.1 below) do not reflect the class differences with and between groups, they still provide a collective picture of the socioeconomic challenges or liabilities that women continue to confront in Jamaica.

Table 1.1: Labour Force Statistics and Gender-Based Indices for Jamaica

Country	Employed	Unemployed	Levels of Education	Self-Employed	LFPR*	HDI	GDI	GII*
Jamaica	44.7% (F) 55.3% (M) (2019)	7.8% (total) 10.2% (F) 5.8% (M) (2019)	Upper-secondary enrollment 89.3% (total) 92.7% (F) 86.1% (M) (2015)	41.0% (total. 2018) 33.0% (F) 46.9% (M) (2017)	64.0% (total) 70.4%(M) 57.9%(F) (2018)	0.732 (2017) (97th rank)	0.988 (2017)	0.412 Ranking 95/188. (2017)

Note: These statistics were compiled from 2018 *Human Development Report*, the Statistical Institute of Jamaica's Labour Force Survey (July 2019), the International Labour Organization's ILOSTAT database (2019), and the Ministry of Education, Jamaica (2015)

Case Study: An Intrinsic Approach

Moving beyond studies of women entrepreneurs that perpetuate the underperformance hypothesis (McAdam) call for new directions within the epistemological and ontological orientations of scholarship that address the experiences and realities of women entrepreneurs (Ahl; Welter et al.; Brush et al.). An important point of departure for this new research is moving away from using sex-based comparisons used for profiling and categorizing entrepreneurial performance to using gender as an analytical lens through which researchers can contextualize some of the specificities surrounding female entrepreneurship (Stevenson; Terjesen and Amoros; McAdam).

Intrinsic case studies are well suited for this kind of conceptual research on women as early-stage or new entrepreneurs. With a focus on how the context or process shapes a given phenomenon (Stake; Yin), a main benefit of such an interpretative approach is that it allows for "one to gain tremendous insight into a case by way of providing rich data on the 'why' and 'how' of a given phenomenon with specific consideration given to the notion of contexts as socially situated" (Baxter and Jack 556). By so doing, the study remains exploratory, with a theoretical application that highlights some of the socially embedded intricacies that affect the lived realities of entrepreneurial mothers. This conceptual focus on the positionalities of women is not meant to be an extensive study of entrepreneurial mothers; rather, it is used to capture the why, what, when, and how of their perceptions, experiences, and coping strategies.

In attempting to connect the dots between positionality and entrepreneurial engagement, this work uses semi-structured interviews to examine the specific case of early-stage or entrepreneurial mothers. In the Entrepreneurial Policy for Jamaica (GOJ), early-stage entrepreneurs are typically classified as persons with between three and forty-two months of experience within a venture. The policy document also specifies an income range of between J$5 and $10 million per annum or between US$36, 954 and $73, 908. I solicited entrepreneurial mothers falling into this category through their registered association with state entities (specific to enterprise development), and I briefed them on the nature and implications of the study and invited them to participate.

The use of purposive sampling in this study allowed for the selection of individuals who could provide "information-rich cases [or] whose story [would] illuminate the questions under study" (Patton 230). Four

early-career entrepreneurial mothers volunteered to participate in the study, who were mostly single parents (except for JD[1] who was living with a partner), with one child or two mostly of African descent (with JD also being the exception here). The participants were involved within microenterprises (that is, they have fewer than five employees,) and between two and five years of experience working within their ventures. Some had a high school education level, whereas others had a university-level education. They also worked within various industries (food and beverage, service, and fashion). Table 1.2 captures the sociodemographic backgrounds of the interviewees.

Table 1.2 Sociodemographic Background of Entrepreneurial Mothers in Jamaica

Inter-viewees	Education	Ethnicity	Marital status	Children	Ages of Children	Industry	YIV*
JA	Secondary	African descent	Single	One boy	Four	Food and beverage	Two years
JB	Secondary	African descent	Single	Two girls	Three and six	Service	Three years
JC	Vocational certificate	African descent	Single	One boy and one girl	Fourteen and sixteen	Service	Three years
JD	Under-graduate degree	Mixed (Caucasian and African)	Living with a partner	One boy	Three	Fashion and beauty	One year

*YIV—years in venture

Audio-taped interviews were transcribed and coded (based on the research questions and emerging issues in the data) to capture areas of convergence and divergence in the experiences and positionalities among and between these entrepreneurial mothers. These descriptive codes were then thematically categorized and theoretically analyzed around issues related to structures of power (gender, race, and ethnicity, for instance), positioning, and strategies for negotiating subcategories used to generated the themes. These codes were also shared with participants to ensure the credibility of the interpretations made (Houghton, et al.; Pandey and Patnaik). This analytical process allowed for a mapping of the data onto that of the objectives and theoretical lens of the study while providing an opportunity to conceptually frame the data within broader theoretical premises that are being explored.

Being at a Crossroad: Between Motherhood and Entrepreneurship

The (in)compatible nature of work and family remains a major source of contention in the entrepreneurship literature (Jennings and Mc Dougald). Central to that discussion are questions surrounding the direction, type, and impact of work or family interference and\or integration. These questions also address notions of boundaries, expectations, and roles related to working within and across work-life domains. However, many empirical gaps and concerns remain. Of note is the lack of attention given to the unbounded nature of work and family domains, the masculinized notion of the entrepreneurial space (Ahl; Mirchandani; Lewis), and, in the case of the Caribbean, the key social and cultural facets of everyday life that affect the entrepreneurial engagement of women and mothers (Barriteau, "Women Entrepreneurs"; Esnard, "The Personal Plan"; "Mothering and Entrepreneurship"). These facets represent important contextual factors and sites of knowledge that configure the identities and engagement of entrepreneurial mothers.

At a collective level, the findings suggest that entrepreneurial mothers within this study were all conscious of, and troubled by, the limitless nature of motherhood and entrepreneurship discourses. This dual consciousness was clearly evident within the simultaneous use of the language of care, servitude, sacrifice, love, and protection (that captures the meanings that they associate with motherhood) and the language of flexibility, autonomy, independence, achievement, and the market (to draw on the promises of their entrepreneurial engagement). This mindfulness around the conflicting narratives of being and becoming mothers and entrepreneurs positioned or, put differently, situated these women at the crossroad of the motherhood-entrepreneurship intersection. Such situatedness introduced particular subjectivities and standpoints or points of view for entrepreneurial mothers.

JA provided some insights into the multiple identities and dichotomies that she faced at this crossroad. On the one hand, she spoke about her concerns for the time and effort needed to sustain her business venture and to the expectations for the survival, growth, and success of her venture. This is particularly important for her, given the competitiveness of the food industry and the scrutiny of new or starting micro-entrepreneurs. On the other hand, she also touched on her own emotional

attachment to her son, to the cultural scripts that exist for mothers, and to expectations for her to sustain that maternal bond. In this sense, she is positioned at the crossroads of motherhood and entrepreneurship, where the expectations and identities associated with these dual roles often collide. Her conundrums, therefore, become those of how she makes sense of the scripted narratives within these maternal and entrepreneurial spaces and how she rationalizes her identity and involvement within the industry and that of her perceived accountability to her son. She noted the following:

> I do not have a nine to five job. This business extends into all odd times. I have customers who call for me to cater for a night event, and although I have two other workers, they also are young women with children, who cannot stay out too late. I too have a child. My son is still very much attached to me, and I always end of leaving work to go attend to him, day or night. So many times I am stuck with having to make a decision of whether to let go of an order [or] take it and work with my son around me ... or find someone else to care for my son while I fulfil that order.... And if when I do that people are so quick to criticize; he is still small you know! But I just can't say no; I need the job ... and I am still trying to get off my feet here ... and, I know that they can go to any other caterer because there are so many already in Jamaica. I just try to provide a really good service to keep my customers ... but I can tell you that it is stressful.

Here, JA shares her concerns and perspectives of what it means to be at the crossroad. She presents her positionality—one that remains muddled within the ideological expectations inherent on either side of the motherhood-entrepreneurial intersection. But her personality also unfolds as a complex interplay of socioeconomic vulnerabilities related to gender, socioeconomic background, parental responsibilities, the stage of her entrepreneurial journey, and the lack of available networks or systems of support within her reach. What surfaces through her conversation, therefore, is a presentation of the social, cultural, and economic factors that preconfigure her positionality—both as a reflection of how she is situated between the two domains and as a stance or perspective through which she begins to make sense of the complexities around this positionality as an entrepreneurial mother. This positionality

remains deeply embedded within the gendered and classed relations of power that pervade within this specific context.

Like JA, JB also adopted a similar sense of positionality and consciousness at this crossroad. JB stated that the following:

> It is hard to be there for my girls all the time.... I cannot always be there to care for them, right? I mean I have a business to see about too! I have to fend for myself and my children. I [am] doing so since they [were] born and since I started this beauty service. At the end of the day, nobody cares about you or your children, but they make sure to talk about you if you don't care for your children. This is so hypocritical! They don't care how you make it; they just want to know whether you make it! At the end of the day, I know it's my responsibility and I will see about my girls and do what I must do to make sure we all survive! It's hard, but something got to give!

JB accentuates how notions of care are positioned between the logics of autonomy, the market, responsibility, and surveillance. Her concerns, therefore, are for the ongoing scrutiny of her maternal role and her responsibility towards her children as well as for the stresses associated with maximizing her own autonomy as a woman, a single mother, and an early-stage micro-entrepreneur. What also emerges through her conversation is that of the ethics of care and responsibility as social principles or values that differently surface through her own understanding of the social, economic, and cultural pressures of being at the motherhood-entrepreneurship nexus. At that intersection, she speaks to the structures and relations of power that position her at that crossroads and that set within her knowledge framework, a necessity for sustaining a positionality and/or perspective that is selfless (subject to sacrifice) but also self-driven (subject to individuality).

Positionality in this sense, therefore, becomes a status, a way of knowing, and an identity, which are shaped by the structures and relationships of power embedded within the motherhood-entrepreneurship nexus. When this system of power collides, positionality is compounded by conflicting constructions and messages related to the two domains. Mary Wrenn and William Waller remind us that "the goal of the neoliberal culture is the restoration of both the caregiver and the cared-for's autonomy. So the need for care is fundamentally a

pathology, to be repaired or overcome" (500). This relegation of care within the neoliberal market, however, produces increased degrees of tensions for entrepreneurial mothers. JB's situation, for instance, demonstrates how that the struggle for autonomy as an independent woman, micro-entrepreneur, and single mother squares directly against that of the morality that underpins the ethic of care associated with the perceived primacy of her children. At the crossroads, therefore, the ambiguous nature of positionality becomes reflective of the norms and expectations implicit within the institutions of the family and the market. This heightened sense of obscurity at the intersection is similarly the case of JC, who claimed the following:

> It is challenging at times to balance being a single mother and businesswoman. You want to mind [care for] your children, but you really have to weigh how you mind [care] your children, how you build your customers ... who you do business with ... how you manage to get the money coming in ... because if you don't, you go [will] find that you are always struggling to cope. It is like being between a rock and a hard place.... They are both similar ... but take different strategies to work it. Different vibes you know ... and you just got to make decisions that are best suited for the time ... because it will always be tough. The children grow, but the challenges will always be there, same as the challenges for how to make money in these hard times!

There are several important aspects of this statement. One is the notion of being caught in the middle and the difficulties associated with navigating various points and spaces of contention. This point draws back to broader concerns within the literature about the unequal impact of austerity measures on women, on their dual responsibilities as mothers and workers, on the need to be more creative as they engage within that sector, and on the particular struggles women face within the entrepreneurial sector (Stevenson). The focus here becomes that of being a hard-working parent—a goal that appears to be devoid of structured analyses related to gender, class, and, perhaps, ethnicity (Dean; Taylor; Demo). It is this weaving of discourses related to motherhood and entrepreneurship that positions JC at the crossroads. Thus, her responsibility to her children and to her venture is individualized in such a way that she adopts a position, stance, or perspective that agonizes over

the difficulties of being and becoming an entrepreneur within a fragile economic environment and being a single mother.

The lack of entrepreneurial capital also has implications for firm performance (Shaw et al.). Even there, it is important to contextualize this lack of access to financial capital within the social categorizations of power, particularly in these cases, along the lines of class and gender. Such intersubjective experiences around work and family problematize the neoliberal promises of free choice, individuality, and autonomy within the market. The tensions related to childcare and work within the neoliberal paradigm (Giles-Vandenbild) have also deepened the significance of social contexts to the complex realities that entrepreneurial mothers confront. In the push for entrepreneurial engagement however, this social context of entrepreneurship however is often overlooked (Lewis; Korsgaard and Anderson). It is this social embeddedness, however, that continues to define, in very nuanced ways, the consciousness, experiences, and choices of entrepreneurial mothers within this study. The following section speaks to this.

Between Resignation and Reconciliation

Positionality theory reinforces the variability of praxis. The findings of this study suggest that being at the crossroads of the motherhood-entrepreneurship nexus can produce states of resignation (in a Gramscian sense, as an acceptance of a maternal identity and perceived responsibility to their children) or reconciliation (as a type of hybridized thinking and practice). Here, the choice of resignation or of reconciliation are informed by their perceptions and assessments of the risk embedded within their positionality as entrepreneurial mothers (whether in the market, in the home, or both).

In the first instance, what materialized through the interviews was a tendency for entrepreneurial mothers to assume a state of submission, and in this case, to the weight of maternal constructions. In such cases, this sense of resignation emerged when entrepreneurial mothers internalized their economic vulnerability—both in terms of how they were positioned in the market (their perceived market share) and in relation to their inability to access the necessary resources and\or systems of support that are required to alter or reconfigure that positionality (their socioeconomic background). JA, for instance, rationalized the

prioritization of her maternal responsibility as a way of coping with market risk and the lack of social support to care for her son at home. This gendered and classed positionality led to a state of resignation, where JA insisted the following:

> There are things that affect my success in this industry. Yes, it is just a little over two years since I started to cater for different events, but it is really a hard thing to deal with, the competition that I [am] seeing here. Clients are asking to upscale events ... they are following foreign [international] trends.... Bigger caterers are advertising using all kinds of outlets. When I think about it, you have to be a big fish with a lot of resources to survive this market. The small fish always has to work harder, with less to manage but more troubles to deal with. When you think it getting better, then things get slow again and you wonder where the dollar go come from[2].... But you have to protect your child's future in all of this. You must do what it takes to see about their survival. So they tell you to take risk, but I have to manage how much I take because my son's future is at stake.... I don't have much friends or family that I can turn to so I have to think about that too.... He is young.... I need to hold back a little.

JA's conservative take on market risk is grounded within her own positionality as a single mother and micro-entrepreneur, with little economic or social resources to tap into. In this case, entrepreneurial risk is constructed as one that has to be managed, tapered, and confronted in ways that protect the social vulnerability of mothers. Her risk taking propensity is directly informed by how she makes sense of her own sociocultural and economic landscapes as well as her positionality within that space. Thus, while this finding confirms that the gendered positionality of women (Mohammed and Perkins; Reddock and Bobb-Smith; Barriteau, "Women Entrepreneurs"), it also underscores the importance of other social, political, and economic shortcomings that affect early-career entrepreneurial mothers, whether at the individual, community, or state level. Such an understanding of that positionality remains critical to that of why and how JA manages perceived entrepreneurial and personal risks. How risk is perceived and evaluated (in this case around the sustainability of her venture and economic security for her son) is important for how it is managed. When knowledge

of these risks are situated within the specific gendered and classed positions of women, then resignation as a choice must be understood within these dynamics.

JB's case reinforces this situatedness of choice. Like JA, she also adopted a state of resignation, a positionality that was linked to her assessment of risk as gendered. In this case, JB spoke about the risks of having young girls and few options for protecting her children or herself (as a woman in a male-dominated entrepreneurial space). She also spoke to the ways in which these limited options and risks of engagement introduced a strong sense of insecurity and bounded notion of choice. A direct outcome in this case was the prioritization of her maternal responsibilities:

> I always say that once you have girls, you must be careful where you leave them. I cannot leave my girl children with anyone. They can be exposed to all kinds of abuse.... I cannot tell you how much that scares me. I know they are young and nothing may ever happen to them, but I constantly think of who is with them ... what they are doing ... and whether people are treating them fairly.... It sometimes distracts me at work. I think of myself too ... my workers ... we have to go to all corners of Kingston ... even on the western side ... to work with customers and different artists ... day or night.... I have two female assistants who work with me ... they thinking about their pickney [children] too ... [and] there are some men who will try to exploit you ... you know what I mean.... So we have to choose who we cater for ... [and] how long we have to stay out there.... Sometimes I feel it is a real problem, especially when I ask my neighbour or my sister and someone trustworthy can help with the girls.... Sometimes it works out.... But whatever comes up, you know, for a job.... I think carefully before I take it.

The gendered positions of mothers and young girls who are (in) directly affected by the logic of the market and from related social vulnerabilities remain major contentions here. This is particularly precarious for entrepreneurial mothers, such as JB, who works within an informal economy, where there are safety concerns, and where there are few opportunities for professional support. The problem of the work-life interface in this case is conditioned by perceived forms of gender-

based violence, vulnerability, and marginalization that affect her sense of personal and financial security. The absence of supportive mechanisms, structures, or resources that protect such mothers and/or cushion institutional, economic, and social susceptibilities inherent within the Jamaican context also adds to this dilemma. Those concerns also informed her positionality or stance that "when you work in rough areas [or communities], you have to protect the things you have control of," which, in her case, is her children. This position also guided her decision to restrict her entrepreneurial engagement.

On the flip side, the findings show that two entrepreneurial mothers also adopted a state of reconciliation—a type of thinking and practice in which they attempt to create some semblance of compatibility across the two domains. This was particularly the case for JC and JD, whose social and economic backgrounds opened the opportunities and options for their engagement across both domains. JC, for instance, shared the following:

> As a medical technician, I train and provide assistants for various hospitals, labs, and clinics. Demand is never an issue, as we have many long-standing clients and getting new ones all the time.... But these jobs no longer interfere with my role as a mother. My children are teenagers now and more independent. They know what I am doing and understand that, at times, I have long nights or days.... But they can come across at any time to see me. The older boy is doing accounting as a subject in school, and when he comes, he tries to learn a thing or two so that's also a good way of making it work for everyone.... My daughter comes at times but usually stays home with my sister or older brother so she is never alone ... that makes me flexible when I need it ... so that I can think about the possibility of extending this service to other areas in Jamaica.

In contrast to JA and JB, JC works from a position of having older children, working within a growing industry for the last three years, and having the time and flexibility to work between both domains. In this case, her family network positions her at point where she can benefit from the support of her family. This system of support, her professional training, and her industry's potential also position JC to integrate her responsibilities and efforts across both the maternal and entrepreneurial

domains. These are strategic choices and/or outcomes for women and mothers who benefit from the instrumental and affective engagement of their family (Brush et al.; Eddleston and Powell; Shelton). When this type of family and firm integration occurs, it enhances the entrepreneurial experiences, options, and outcomes for mothers (Jennings and McDougald). This is clearly evident in the way that JC connects the systems of social support to her plans for growth and for the expansion of her venture in the near future.

Similar to JC, JD talked about how his positionality allowed for the integration of responsibilities across the two domains. She noted the need to strategize around the type of training one possesses, the clients that one selects, and the type of service being offered, when making decisions around how to navigate the motherhood-entrepreneurship nexus. JD said the following:

> I never saw the business and my son as separate. In fact, I have been designing clothes for my son since he was born. When we went on outings, people asked, and I got my first set of clients.... But at that time, I was a registered student in fashion design, so I did it part time. It's been two years since I completed school and returned to Jamaica. It's been one year since I started my designer clothing collection here. It's been more or less good; I have my son in daycare. I work on a children's line, and I have another emerging line for teenagers. I bring different styles and tastes to the Jamaican market, and persons are responding positively to that. So things are picking up, and I am dead set on growing this further. My partner is also very supportive (emotionally and financially) and backing me up on growing this. In the meantime, I use my flexibility to care for my son and to push my designer clothing.

Karin Schwiter notes that neoliberalism pushes people to develop strategic responses within the market. Although JD was conscious of where she was situated as a fashion designer within a local and global space, she also remained mindful of the fusion of tastes and trends across the Global North and South and the impact of these on her own designs. For her, this consciousness and exposure to both markets allowed for a strategic engagement within the sector and the sustainability of her venture within the market. However, her early experience with designing

clothes for her son also served as an impetus to the integration of this passion into a viable venture. The permeability of the two domains in which JC uses her maternal inclinations as well as the sociospatial parameters around childcare forged new ways for her to restructure and reorganize her business in family-friendly ways (Ekinsmyth). In this case, this creative injection of her passion into a venture and her adaptive take on the fashion industry presented an effective reconciliation of the tensions and conflicts associated with work-life interface for entrepreneurial mothers.

Limitations

This research is still in its exploratory stage. Thus, there is a need for some caution in the application of these findings. First, the study does not compare the relative experiences of male entrepreneurs who are also exposed to gendered entrepreneurial and familial spaces. This may be useful in so far as it can give greater insights into the extent of and variations in these gender gaps. Second, the study restricted its analysis to the experiences of early-career entrepreneurial mothers in Jamaica. In most cases, these women fall within a particular socioeconomic categorization; they work from a position of having minimal education, as single parents, and within a small business venture. The study did not compare the experiences and choices of early-stage entrepreneurial mothers across diverse socioeconomic groups and scale of ventures (e.g. small, medium, or large ventures). Additionally, although three of four participants were of African descent, the sample size also limits the ability to infer racialized subjectivities within the entrepreneurial space. Despite the limitations of these self-reports, the study sheds new light on the salience of these early-stage entrepreneurs' positionality to their perceptions, experiences, and responses to the work-life interface. In all of the cases, the challenges and choices of these women extended to their positionalities as women, mothers, and as early-stage entrepreneurs, with limited resources and systems of support. At best, these findings make a credible case for situating notions of performativity and provide much needed advances in the scholarship on entrepreneurial mothers in the Caribbean.

Conclusion

Although examinations of work-life interface provide important points for analyzing the lived experiences of women entrepreneurs (Jennings and McDougald; Damaske and Gerson; Eddleston and Powell), it is important that we question that central axes of power that operate within that matrix and how these configure the perspectives and experiences of diverse groups, such as those of entrepreneurial mothers. Given the embryonic nature of the entrepreneurial field in the Caribbean, I used positionality theory as an analytical tool to explore the thinking, experiences, challenges, and practices of entrepreneurial mothers. The findings confirm not just the significance of structure and relations of power to how entrepreneurial mothers are positioned but also to how risk becomes differently evaluated in defining their own positionality and to how they choose between resignation or reconciliation.

Theoretically, these findings strengthen the need for critical dialogues on difficult issues, such as social relations of power and how entrepreneurial mothers are positioned in the entrepreneurial space. In particular, such findings make visible not only the stratifying effects of gender on the thinking and practices of entrepreneurial mothers but also the interlocking effects of other social categorizations (such as education and socioeconomic and family backgrounds) on how they respond to the intricacies of the work-life interface. Here, the training and the support for entrepreneurial engagement differentiated the mothers' choices around resignation or reconciliation. Given the exploratory nature of the study, the results suggest the need for more eclectic and critical theorizations that can capture the complexities around how and why these mothers are positioned and that explore the factors affecting their ways of being, relating, and doing within specific structural and cultural contexts. This approach requires some rethinking about how entrepreneurship for and among mothers is perceived, evaluated, and enacted.

Unmasking the taken for granted notions of entrepreneurship requires more pointed examinations that trouble the assumptions of women's roles, relationships, and equity within the entrepreneurial and maternal domains (Pitt-Catsouphes and Christensen; Myers and Diener). Such intricacies strengthen the need for future investigations that centre the intersectional axes of power within the entrepreneurial and maternal domains and that offer new epistemological frameworks that can potentially unlock the entrepreneurial (Shaw et al.) and feminine capital

(Orser and Elliott) of entrepreneurial mothers, particularly in challenging economic environments (Welter and Smallbone), such as Jamaica. This type of scholarship, and perhaps related activism, is particularly necessary for how we begin to do the following: (i) make sense of their knowledge and praxes; (ii) assess their existing and potential contribution to the entrepreneurial space; (iii) craft relevant policy agendas, program initiatives, or interventions that positively support early-career entrepreneurial mothers; and (iv) empower entrepreneurial mothers to reposition their being and becoming within the motherhood-entrepreneurship nexus.

Endnotes

1. Pseudonym used in lieu of actual names or initials.
2. The phrase "where the dollar go come from" captures the uncertainty as to the source of funds or the financial sustainability of a particular situation.

Works Cited

Acevedo, S.,et al. "Positionality as knowledge: From pedagogy to praxis". *Integral Review: A Transdisciplinary & Transcultural Journal for New Thought, Research, & Praxis*, vol. 11, no. 1, 2015, pp. 28-46.

Ahl, Helene. "Why Research on Women Entrepreneurs Needs New Directions." *Entrepreneurship Theory and Practice,* vol. 30, no. 5, 2006, pp. 595-621.

Alcoff, Linda. "Cultural Feminism Versus Post-Structuralism: The Identity Crisis in Feminist Theory." *Signs,* vol. 13, no. 3, 1988, pp. 405-436.

Anthias, Floya. "Thinking Through the Lens of Translocational Positionality: An Intersectionality Frame for Understanding Identity and Belonging." *Translocations: Migration and Social Change,* vol. 41, no. 1, 2008. pp. 5-20.

Bailey, Barbara, and Heather Ricketts. "Gender Vulnerabilities in Caribbean Labour Markets and Decent Work Provisions." *Social and Economic Studies,* vol. 52, no. 4, 2003, pp. 49-81.

Bailey, Henry, et al. *Global Entrepreneurship Monitor Trinidad and Tobago 2013 Report.* Arthur Lok Jack Graduate School of Business, 2013.

Baker, Ted, and Friederike Welter. "Come On Out of the Ghetto, Please!—Building the Future of Entrepreneurship Research." *International Journal of Entrepreneurial Behavior & Research*, vol. 23, no. 2, 2017, pp. 170-84.

Barriteau, V. Eudine. "Structural Adjustment Policies in the Caribbean: A Feminist Perspective." *NWSA Journal*, vol. 8, no. 1, 1996, pp. 142-56.

Barriteau, V. Eudine. "Women Entrepreneurs and Economic Marginality: Rethinking Caribbean Women's Economic Relations." *Gendered Realities: Essays in Caribbean Feminist Thought*, edited by Patricia Mohammed, UWI Press, 2002, pp. 221-48.

Basco, Rodrigo. "Epilogue: Multiple Embeddedness Contexts for Entrepreneurship." *Contextualizing Entrepreneurship in Developing and Emerging Economies*, edited by Marcela Ramírez-Pasillas, Ethel Brundin, and Magdalena Markowska, Edward Edgar, 2017, pp. 329-36.

Baxter, Pamela, and Susan Jack. "Qualitative Case Study Methodology: Study Design and Implementation for Novice Researcher." *The Qualitative Report*, vol. 13, no. 4, 2008, pp. 544-59.

Boodraj, Girjanauth, et al. *Global Entrepreneurship Monitor. 2011 Jamaica Report*. University of Technology, 2011.

Brush, Candida G., et al. "A Gender-Aware Framework for Women's Entrepreneurship." *International Journal of Gender and Entrepreneurship*, vol. 1, no. 1, 2009, pp. 8-24.

Caribbean Development Bank (CDB). *Caribbean Economic Review and Outlook for 2015*. CDB, 2014.

Clair, Mathew, et al. "Two Tales of Entrepreneurship: Barbados, Jamaica, and the 1973 Oil Price Shock." *Proceedings of the American Philosophical Society*, vol. 157, no. 1, 2013, pp. 32-57.

Clarke, Colin, and David Howard. "Contradictory Socio-Economic Consequences of Structural Adjustment in Kingston, Jamaica." *The Geographical Journal*, vol. 172, no. 2, 2006, pp. 106-29.

Coleman, Susan. "The Role of Human and Financial Capital in the Profitability and Growth of Women-Owned Small Firms." *Journal of Small Business Management*, vol. 45, no. 3, 2007, pp. 303-319.

Collins, Patricia. "Gender, Black Feminism, and Black Political Economy." *The Annals of the American Academy of Political and Social*

Science, vol. 568, no. 1, 2000, pp. 41-53.

Damaske, Sarah, and Kathleen Gerson. "Viewing 21st Century Motherhood through a Work-Family Lens." *Handbook of Family Work Integration: Research, Theory and Best Practices,* edited by Karen Korabik, Donna S. Lero, and Denise L. Whitehead, Academic Press, 2008, pp. 233-48.

Dean, Hartley. "The Ethical Deficit of the United Kingdom's Proposed Universal Credit: Pimping the Precariat?" *The Political Quarterly* vol. 83, no.2, 2012, pp. 353-59.

De Bruin, Anne, et al. "Advancing a Framework for Coherent Research on Women's Entrepreneurship." *Entrepreneurship Theory and Practice,* vol. 31, no. 3, 2007, pp. 323-39.

Eddleston, Kimberley A., and Gary N. Powell. "Nurturing Entrepreneurs' Work-Family Balance: A Gendered Perspective." *Entrepreneurship: Theory & Practice,* vol. 36, 2012, pp. 513-41.

Ekinsmyth, Carol. "Changing the Boundaries of Entrepreneurship: The Spatialities and Practices of UK Mumpreneurs." *Geoforum,* vol. 42, no. 1, 2011, pp. 104-14.

Ekinsmyth, Carol. "Managing the Business of Everyday Life: The Roles of Space and Place in 'Mumpreneurship.'" *International Journal of Entrepreneurial Behaviour & Research,* vol. 19, no. 5, 2013, pp. 525-46.

Esnard, Talia. "The Personal Plan Is Just as Important as the Business Plan: A Feminist Social Constructivist-Rationalist Choice Approach to Female Entrepreneurship." *The Journal of the Motherhood Initiative for Research and Community Involvement,* vol. 3, no. 1, 2012, pp. 163-81.

Esnard, Talia. "Centering Caribbean Women's Gendered Experiences and Identities: A Comparative Analysis of Female Entrepreneurs in St Lucia and Trinidad and Tobago." *Women's Entrepreneurship in the 21st Century: An International Multi-Level Research Analysis,* edited by Kate V. Lewis et al., Edward Elgar Publishing, 2014, pp. 278-93.

Esnard, Talia. "Mothering and Entrepreneurship: Experiences of Single Women in St. Lucia." *Women, Gender, and Families of Color,* vol. 4, no. 1, 2016, pp. 108-32.

Ferdinand, Carol. *Jobs, Gender and the Small Enterprise in the Caribbean: Lessons from Barbados, Suriname, and Trinidad and Tobago.* International Labour Office, 2001.

Giles-Vandenbild, Melinda V. "An Alternative Mother-Centric Economic Paradigm." *Mothering in the Age of Neoliberalism*, edited by Melinda Vandenbeld Giles, Demeter Press, 2014, pp. 1-30.

Girvan, Norman. "A Perspective from the South." *New Political Economy*, vol. 4, no. 3, 1999, pp. 415-19.

Girvan, Norman. "Notes for a Retrospective on the Theory of Plantation Economy of Lloyd Best and Kari Polanyi Levitt." *Caribbean Economies and Global Restructuring*, edited by Marie-Claude Derne and Keith Nurse, Ian Randle Publishers, 2002, pp. 17-24.

Government of Jamaica (GOJ). *Micro, Small and Medium Enterprise (MSME) and Entrepreneurship Policy.* Ministry of Industry, Investment and Commerce, GOJ, 2013.

Halford, Susan, and Pauline Leonard. *Negotiating Gendered Identities at Work: Place, Space and Time Great Britain.* Palgrave MacMillan, 2006. Print.

Handa, Sudhanshu, and Damien King. "Structrual Adjustment Policies, Income Distribution and Poverty: A Review of the Jamaican Experience." *World Development*, vol. 25, no. 6, pp. 915-930.

Hossein, Caroline Shenaz. "Using a Black Feminist Framework: A Study Comparing Bias Against Female Entrepreneurs in Caribbean Micro-banking." *Intersectionalities: A Global Journal of Social Work Analysis, Research, Polity, and Practice*, vol. 2, 2013, pp. 51-70.

Houghton, Catherine, et al. "Rigor in Qualitative Case-Study Research." *Nurse Researcher*, vol. 20, no. 4, 2013, pp. 12-17.

Hughes, Karen D., and Jennifer E. Jennings. *Global Women's Entrepreneurship Research: Diverse Settings, Questions and Approaches.* Edward Elgar, 2012. Print.

Hughes, Karen D., et al. "Extending Women's Entrepreneurship Research in New Directions." *Entrepreneurship Theory and Practice*, vol. 36, no. 3, 2012, pp. 429-42.

Inter-American Development Bank (IDB). *WEGrow: Unlocking the Growth Potential of Women Entrepreneurs in Latin America and the Caribbean.* Inter-American Development Bank, 2014.

International Labour Organization (ILO). "Labor Force Participation Rate, Total (% of Total Population Ages 15+) (National Estimate)." *ILO*, 2019, ilostat.ilo.org/data/country-profiles/. Accessed 11 Sept. 2020.

International Labour Organization (ILO). *ILO Strategy on Promoting Women's Entrepreneurship Development.* ILO, 2008.

Jennings, Jennifer E., and Candida G. Brush. "Research on Women Entrepreneurs: Challenges to (and from) the Broader Entrepreneurship Literature?" *The Academy of Management Annals,* vol. 7, no. 1, 2013, pp. 663-715.

Jennings, Jennifer E., and Megan S. McDougald. "Work-Family Interface Experiences and Coping Strategies: Implications for Entrepreneurship Research and Practice." *Academy of Management Review,* vol. 32, no. 3, 2007, pp. 747-60.

Jennings, Peter L., et al. "Guest Editors' Introduction: Alternative Perspectives on Entrepreneurship Research." *Entrepreneurship Theory and Practice,* vol. 29, no. 2, 2005, pp. 145-52.

Jones, Campbell, and Anna Maria M. Murtola. "Entrepreneurship and Expropriation." *Organization,* vol. 19, no. 5, 2012, pp. 635-55.

Kezar, Adrianna. "Reconstructing Static Images of Leadership: An Application of Positionality Theory." *Journal of Leadership Studies,* vol. 8, no. 3, 2002, pp. 94-109.

Kezar, Adrianna, and Jaime Lester. "Breaking the Barriers of Essentialism in Leadership Research: Positionality as a Promising Approach." *Feminist Formations,* vol. 22, no. 1, 2010, pp. 163-85.

Klak, Thomas. *Globalization and Neo-Liberalism: The Caribbean Context.* Littlefield Publishers, 1998.

Klak, Thomas, and Dennis Conway. "From Neoliberalism to Sustainable Development?" *Globalization and Neo-Liberalism: The Caribbean Context,* edited by Thomas Klak, Rowman and Littlefield Publishers, 1998, pp. 257-76.

Korsgaard, Steffen, and Alistair R. Anderson. "Enacting Entrepreneurship as Social Value Creation." *International Small Business Journal,* vol. 29, no. 2, 2011, pp. 135-51.

Lashley, Jonathan, and Katrine Smith. *Profiling Caribbean Women Entrepreneurs: Business Environment, Sectoral Constraints and Programming Lessons.* International Bank for Reconstruction and Development/The World Bank, 2015.

Leung, Aegean. "Motherhood and Entrepreneurship: Gender Role Identity as a Resource." *International Journal of Gender and*

Entrepreneurship, vol. 3, no. 3, 2011, pp. 254-64.

Lewis, Patricia. "The Quest for Invisibility: Female Entrepreneurs and the Masculine Norm of Entrepreneurship." *Gender, Work and Organization*, vol. 13, no. 5, 2006, pp. 453-69.

Manolova, Tatiana S., et al. "What Do Women Entrepreneurs Want?" *Strategic Change*, vol. 17, no. 3, 2008, pp. 69-82.

Marlow, Susan, and Maura McAdam. "Gender and Entrepreneurship: Advancing Debate and Challenging Myths-Exploring the Mystery of the Under-Performing Female Entrepreneur." *International Journal of Entrepreneurial Behaviour and Research*, vol. 19, no. 1, 2012, pp. 114-24.

Marlow, Susan, et al. "Exploring the Impact of Gender upon Women's Business Ownership: Introduction." *International Small Business Journal*, vol. 27, no. 2, 2009, pp. 139-48.

Martinez Dy, Angela, and Susan Marlow. "Women Entrepreneurs and their Ventures: Complicating Categories and Contextualising Gender." *The Routledge Companion to Global Female Entrepreneurship*, edited by Colette Henry, Teresa Nelson, and Kate V. Lewis, Routledge, 2017, pp. 15-29.

McAdam, Maura. *Female Entrepreneurship*. Routledge, 2013.

McElroy, Jerome L., and Katherine Sanborn. "The Propensity for Dependence in Small Caribbean and Specific Islands." *Bank of Valletta Review*, vol. spring, no. 31, 2005, pp. 1-16.

Merriam, Sharan B., et al. "Power and Positionality: Negotiating Insider/Outsider Status Within and Across Cultures." *International Journal of Lifelong Education*, vol. 20, no. 5, 2001, pp. 405-16.

Minniti, Maria, and Wim Naude. "What Do We Know about the Patterns and Determinants of Female Entrepreneurship across Countries?" *European Journal of Development Research*, vol. 22, no. 3, 2010, pp. 277-93.

Mirchandani, Kiran. "Feminist Insight on Gendered Work: New Directions in Research on Women and Entrepreneurship." *Gender, Work and Organizations*, vol. 6, no. 4, 1999, pp. 224-35.

Mohammed, Patricia, and Althea Perkins. *Caribbean Women at the Crossroads: The Paradox of Motherhood among Women of Barbados, St. Lucia and Dominica*. Canoe Press, 1999.

Myers, David G., and Ed Diener. "Who Is Happy?" *Psychological Science*, vol. 6, 1995, pp. 10-19.

Orser, Barbara, and Catherine Elliott. *Unlocking the Power of Women Entrepreneurs: Feminine Capital.* Standard Business Books, 2015.

Pandey, Satyendra C., and Srilata Patnaik. "Establishing Reliability and Validity in Qualitative Inquiry: A Critical Examination." *Jharkhand Journal of Development and Management Studies XISS*, vol. 12, no. 1, 2014, pp. 5743-53.

Patton, Michael Quinn. *Qualitative Research & Evaluation Methods.* 3rd ed. Sage, 2002.

Pitt-Catsouphes, Marcie and Kathleen Christensen. "Unmasking the Taken for Granted." *Community, Work and Family*, vol. 7, no. 2, 2004, pp. 123-43.

Planning Institute of Jamaica (PIOJ) and Statistical Institute (STATIN). *Jamaica Survey of Living conditions (JSLC).* Stephen's Litho Press, 2003.

Pounder, Paul. "Entrepreneurship and Gender in Disparity in the Caribbean." *Journal of Research on Women and Gender*, vol. 6, 2016, pp. 4-23.

Reddock, Rhoda, and Yvonne Bobb-Smith. *Reconciling Work and Family: Issues and Policies in Trinidad and Tobago. Conditions of Work and Employment.* International Labour Office, 2008.

Robb, Alicia M., and John Watson. "Gender Differences in Firm Performance: Evidence from New Ventures in the United States." *Journal of Business Venturing*, vol. 27, no. 5, 2012, pp. 544-58.

Schwiter, Karin. "Neoliberal Subjectivity—Difference, Free Choice and Individualised Responsibility in the Life Plans of Young Adults in Switzerland." *Geographica Helvetica*, vol. 68, no. 3, 2013, pp. 153-59.

Shane, Scott, and S. Venkataraman. "The Promise of Entrepreneurship as a Field of Research." *Academy of Management Review*, vol. 25, no. 1, 2000, pp. 217-26.

Shaw, Eleanor, et al. "Gender and Entrepreneurial Capital: Implications for Firm Performance." *International Journal of Gender and Entrepreneurship*, vol. 1, no. 1, 2009, pp. 25-41.

Shelton, Lois M. "Female Entrepreneurs, Work-Family Conflict, and Venture Performance: New Insights in the Work-Family Interface."

Journal of Small Business Management, vol. 44, 2006, pp. 285-97.

Statistical Institute of Jamaica. "Press Brief: Labour Force Survey July 2019." Statistical Institute of Jamaica, statinja.gov.jm/PressReleases. aspx?field1=lfs. Accessed Sept. 11 2020.

Stake, Robert E. *The Art of Case Study Research*. Sage, 1995.

STATIN. "Unemployed Labour Force Statistics by Age." *Statistical Institute of Jamaica*, www.statinja.gov.jm/LabourForce/labourforce AgeGroup.aspx. Accessed Feb. 24 2019.

Stevenson, Lois. "Some Methodological Problems Associated with Researching Women Entrepreneurs." *Journal of Business Ethics*, vol. 9, no. 4-5, 1990, pp. 439-46.

Taylor, Stephanie. "A New Mystique? Working for Yourself in the Neoliberal Economy." *The Sociological Review* vol. 63, no. S1, 2015, pp. 174-87.

Terjesen, Siri, and Jose Ernesto Amoros. "Female Entrepreneurship in Latin America and the Caribbean: Characteristics, Drivers and Relationship to Economic Development." *European Journal of Development Research*, vol. 22, no. 3, 2010, pp. 313-30.

United Nations Development Program (UNDP). *Human Development Indices and Indicators: 2018 Statistical Update. UNDP*, 2018, hdr.undp. org/sites/all/themes/hdr_theme/country-notes/JAM.pdf. Accessed Sept. 11 2020.

Wattis, Louise, et al. "Mothers and Work–Life Balance: Exploring the Contradictions and Complexities Involved in Work-Family Negotiation." *Community, Work, Family*, vol. 16, no. 1, 2013, pp. 1-19.

Welter, Friederike, and David Smallbone. "Perspectives on Entrepreneurial Behavior in Challenging Environments." *Journal of Small Business Management*, vol. 49, no. 1, 2011, pp. 107-25.

Welter, Friederike, et al. "Three Waves and Counting: The Rising Tide of Contextualization in Entrepreneurship Research." *Small Business Economics*, vol. 52, no. 2, 2018, pp. 1-12.

Wrenn, Mary and William Waller. "Care and the Neoliberal Individual". *Journal of Economic Issues*, vol. 51, no. 2, pp. 495-502.

Yin, Robert. *Case Study Research: Design and Methods*. 4th ed. Sage, 2009.

Chapter Seven

Mompreneurship and Quality of Life in Trinidad and Tobago: Capabilities and Constraints

Ayanna Frederick

Introduction

The past few decades have seen a universal upsurge in entrepreneurial engagement levels among women (Minniti et al.). Assumedly, the rising number of women who participate in the sector stems from the numerous benefits associated with entrepreneurial activities. For instance, it is widely accepted that entrepreneurship produces favourable outcomes at the societal level, including, but not limited to, wealth and employment creation (Mueller et al.; Carree and Thurik; Westhead and Wright). Likewise, at the individual level, it serves as a platform for positive change, as it is considered, among other things, an effective strategy for mitigating poverty and improving quality of life (QoL) (Dahalan et al.; Kautonen et al.). Therefore, without a doubt, women continue to play a substantial role in global socioeconomic development (Brush).

While this nexus between entrepreneurship and QoL—defined here as "an individual's perception of their position in life in the context of the culture and value systems in which they live and in relation to their goals, expectations, standards and concerns" (WHOQOL Group

1570)—has received some scholarly attention, studies exploring the said link are still relatively uncommon (Uy et al.). Moreover, of the few studies that do exist, a seemingly large percentage has been conducted by economists, who mostly employ economic indicators, such as income, in their appraisals (Wiklund et al.). These indicators, however, produce stunted representations, as they fail to take into consideration critical, though less tangible, aspects of QoL, such as family life, social wellbeing, and health.

The relationship between entrepreneurship and QoL, however, likely holds real and significant socioeconomic implications. As a case in point, the QoL that individuals derive from their entrepreneurial activities can extend or limit the lifespan of entrepreneurial firms, as individuals tend to continue in activities that they perceive are having a positive impact on their wellbeing. Obviously then, an enhanced QoL, when derived from entrepreneurship, can increase firm survival rates by minimizing entrepreneurial exit, can improve employment sustainability, and can enhance the success of entrepreneurship as an economic diversification strategy. Alternatively, the QoL issues faced by entrepreneurs, if sufficiently understood, can drive the development of strategic, evidence-based policies to mitigate these challenges. Unsurprisingly, given the overall dearth of research in this area, explorations of how entrepreneurial engagement among women impacts on their own QoL and that of their children seem nonexistent. As small-island Caribbean states continue to grapple with social and fiscal challenges, such as poverty and unemployment, there is now a more pressing need to foster entrepreneurial activities across all sectors of the Caribbean population as a means of advancing positive socioeconomic change. Women, naturally, are pivotal to this process, as they comprise a substantial percentage of the regional population. There is, therefore, a definite need to understand whether, and how, entrepreneurship empowers enterprising women—many of whom are also mothers—and their children to have a satisfactory QoL or whether it disables them from achieving this goal. Such understandings can encourage entrepreneurial behaviours among nonparticipating women and, thus, help to maximize the contribution of women-run enterprises to Caribbean growth and development. In addition, taking into account the knowledge gaps that exist on the dynamics of female entrepreneurship in the Caribbean, explorations of this type are a necessity.

In an attempt to address the aforementioned gap, this chapter explores the perceived impacts of small business ownership on QoL for mompreneurs and their children in Trinidad and Tobago, where there is currently a thrust towards diversification as a means of improving economic performance. This need for economic recovery follows diminishing energy sector revenues (the country's main source of income) subsequent to vulnerabilities within the global energy market. Having been identified as a panacea for overcoming these challenges, entrepreneurship is being encouraged among the population at large. Thus, despite the apparent gender-based disparity—where males outnumber females in the sector—female entrepreneurs (mothers included) are set to feature more prominently in the entrepreneurial process.

Contrary to studies that focus solely or mainly on the economic costs or benefits of entrepreneurship, this study takes into consideration both the tangible (economic) aspects of QoL and the less tangible but perhaps equally important ones, such as physical wellbeing, productive wellbeing, family life, and recreation. Semistructured phenomenological interviews with five mompreneurs, therefore, questioned their motivations for engaging in entrepreneurship and the perceived impacts—favourable and unfavourable—of entrepreneurship on their own QoL and that of their offspring. The interviews gathered anecdotal evidence from these women regarding their material comforts, their family life, and their ability to engage in leisure. The findings are discussed through the lens of work-family conflict theory.

The chapter is structured as follows. First, an overview of female labour force participation, both in Trinidad and Tobago and in the context of the wider Caribbean, is given. Second, a review of the literature relevant to this study is undertaken. Third, Sen's theoretical approach to QoL is explained, and its use in this study justified. Fourth, the methodology used for exploring the current issue is detailed. The findings of the study are subsequently presented and discussed. The chapter concludes with a discussion of its implications for future work.

Women at Work in the Caribbean-Historical and Contemporary Trends

Women have always formed part of the Caribbean workforce. Juliana Foster and Rhoda Reddock have traced women's participation in the regional labour force to the early days of slavery and indentureship, in which they typically worked as plantation labourers. Since then, Caribbean states have progressively ventured into new activities, such as manufacturing and tourism, among others. Thus, although the agriculture sector still plays a strategic role in regional growth and sustainability, Caribbean economies have become less dependent on agricultural production for their survival.

Notwithstanding the evolving state of the Caribbean economy, women remain important providers of human capital in the region and, thus, continue to engage in various sectors of employment. However, despite their labour force involvement, women also carry out a wide range of domestic and maternal roles. At least two factors account for this trend. First, societal norms play a major role in shaping women's identities as mothers and employees. In the Caribbean, women are expected to perform this dual function (Freeman). Second, and beyond these gendered expectations, Stephanie Seguino notes the higher percentage of matriarchal households in the Caribbean when compared with other regions. Hence, in the Caribbean, there is a greater reliance on women to engage in paid employment as a means of supporting their families.

The World Bank Group estimates that for the Caribbean, 33 per cent of males engage in entrepreneurship, whereas less than 13 per cent of employed females are entrepreneurs. Of these women, most are microentrepreneurs (Kelley et al.) concentrated in professional fields such as tourism, manufacturing, garment construction, and business services (Foster and Reddock; Pounder). In Trinidad and Tobago, much like the rest of the region, women are less engaged than men in entrepreneurship. This disparity, however, continues to weaken, as women are increasingly engaging in the sector. As such, although the male-to-female gap is broader for older firms (11.19 per cent to 5.86 per cent, respectively), for early-stage entrepreneurial activities it is much narrower (15.68 per cent to 14.31 per cent). Unsurprisingly then, perceptions and attitudes held by women in Trinidad and Tobago about entrepreneurship are less favourable when compared with those of men.

A greater percentage of women (15.3 per cent) than men (11 per cent), for instance, identify "fear of failure" as the factor that precluded their entry into entrepreneurship. In addition, more women in Trinidad and Tobago, as opposed to men, consider themselves unqualified for business ownership (Bailey et al.). There is still a definite need to propel women beyond these fears if they are expected to play a more strategic role in fostering entrepreneurialism, socioeconomic development, and QoL in Trinidad and Tobago.

The QoL Construct

QoL is a complex and contested construct for which there are multiple philosophical approaches. Dan Brock, however, outlines three major approaches to QoL, namely the economic perspective, the sociological perspective, and the psychological perspective. Economists customarily regard tangible measures of wealth as indicative of QoL. This is the basis of the economic view of QoL, which was commonly taken in earlier studies. In contrast, QoL sociologists view, define, and measure QoL within the context of social systems and on the basis of normative ideals, such as religion and philosophy. For the abovementioned approaches, objective measures, such as income and life expectancy, are employed. Such measures are easily quantifiable and require little to no involvement from the individual whose QoL is being evaluated.

The subjective wellbeing (SWB) approach is quite popular among QoL psychologists and is based on the premise that "QoL must be in the eye of the beholder" (Campbell 442). Its underlying argument is that QoL is most accurately assessed by the individual whose life is under scrutiny, since it is a measure of that individual's state in life as experienced by him or her (Diener and Suh; Rapley). Based on the SWB approach, therefore, individuals who perceive their life experiences to be favourable are presumed to have a good QoL; similarly, those who hold negative feelings about their lives are presumed to have a poor QoL. Although researchers from various quarters have made efforts to deconstruct the meaning of QoL and have also attempted to measure it, definitions such as that coined by the World Health Organization Quality of Life (WHOQOL) Group, and the corresponding psychological approach to QoL, are more commonplace. Within the SWB domain, further differentiation is made between two separable, yet interdependent,

components of wellbeing: affective wellbeing and cognitive wellbeing (Schimmack; Busseri and Sadava). Affective wellbeing assesses QoL by observing an individual's emotional disposition—the intensity and frequency of their positive and negative moods and emotions (Luhmann et al.)—through happiness, pride, sadness, depression, and other affective measures (Diener et al.). Cognitive wellbeing, in contrast, relies on a process of self-rationalism, in which QoL is assessed through a person's own evaluation of his/her satisfaction in life (Rejeski and Mihalko). Since personality is shown to have little influence on satisfaction, when compared with affective SWB indicators, it offers a more reliable representation of long-term wellbeing (Schimmack et al.).

Researchers commonly examine cognitive wellbeing via a single question regarding overall life satisfaction or through multiple questions about satisfaction in life, with each question assessing a discrete domain of life (e.g., material wellbeing, family life, or health). The latter approach is more eminent, as QoL is widely perceived as a multidimensional construct (Hagerty et al.; Schalock; Stiglitz et al.). Notwithstanding the broad consensus that QoL is multidimensional, there is still disagreement as to how it should be deconstructed. Consequently, the precise number and names of its dimensions vary in the literature. Still, some dimensions like material wellbeing, family life, social life, productive wellbeing (related to an individual's job), achievement, and health feature more often than others. All of these dimensions have appeared in the writings of one or more prominent authors in the field (e.g., Cummins; Schalock; Hagerty et al.; Stiglitz et al.).

Entrepreneurship and QoL

Past research indicates that the decision to pursue an entrepreneurial career can profoundly influence an individual's QoL (Saarni et al.; Dahalan et al.; Kautonen et al.). Entrepreneurs, for instance, were found to experience more satisfaction overall than paid employees (Saarni et al.; Amorós and Bosma). Although single studies examining the relationship between entrepreneurship and the various elements of QoL are rare, several works have instead focused on the impact of entrepreneurship on life satisfaction in one or more specific domains. One claim emerging out of such studies is that entrepreneurs frequently earn less (Bonetti; Parker), thus ranking lower in the material domain.

Where productive wellbeing is concerned, a popular assertion is that entrepreneurs work longer hours (Blanchflower and Shadforth; Parker); inevitably, this results in less time for family, recreation, and leisure. At the same time, entrepreneurs often enjoy newfound independence, autonomy, and flexibility, which is beneficial to their productive wellbeing (Hamilton; Benz and Frey; Parker). Taken together, the findings of these and similar studies can be used to deduce the overall impact of entrepreneurship on QoL.

Work-Family Conflict and Its Impact on Wellbeing

Work-family conflict is a special type of inter-role conflict that occurs when an individual finds it difficult to balance the demands of work and family. The relationship can be a two-sided one, as work can interfere with family and family can interfere with work (DiRenzo et al.).

Jeffrey Greenhaus and Nicholas Beutell identify three types of work-family conflict. According to these authors, "time-based conflicts" occur when work and family obligations compete for an individual's time. The more time people spend at work, or allocate to job-related activities, the less time they have to fulfill family commitments. The reverse is equally true—the more time allocated to family members and to performing familial roles, the more difficult it is to satisfy one's job requirements. "Strain-based conflicts," in contrast, arise when the burden of one role—either work or family—negatively impacts a person's ability to function in the alternative role (family or work). Consequently, jobs that are energy consuming or mentally taxing, though they may not be overly time consuming, can still interfere with family life. Similarly, a stressful or fatiguing home environment can restrict an individual's capacity to properly execute his/her job-related duties and, thus, impair work performance. According to Greenhaus and Beutell, "behavior-based conflicts" occur when people are expected to display contrasting demeanours in the workplace and at home but find it difficult to adjust their behaviours to complement the current space in which they exist. As a case in point, executives, who are required to assert authority in the workplace, may be expected to display warm, nurturing, and affectionate behaviours at home when interfacing with their families. Such an individual, if unable to display behaviours appropriate for the

context, inevitably experiences conflict.

Literature suggests that the desire for flexibility, the need to avoid work-family conflicts, and the quest to achieve work-life balance are major drivers of female entrepreneurial engagement (Kirkwood and Tootell; Greenhaus et al.; McGowana et al.). Thus, although entrepreneurship has historically been regarded a masculine pursuit (Acs et al.), this trend is currently shifting, and women are now becoming more engaged in the running of entrepreneurial firms (Minniti et al.) as a means of achieving the desired balance. Paradoxically, work-family conflicts remain problematic for enterprising women, as the socially constructed ideas about women's roles in the world continue to emphasize motherhood and household chores as prime responsibilities of females (Kim and Ling; Parasuraman and Simmers). Self-employed women, given their greater levels of job involvement, are more prone to work-family conflicts than are women who engage in paid employment (Greenhaus and Beutell).

Jean Lee Siew Kim and Choo Seow Ling developed a model specific to female entrepreneurs, in which work-family conflict is identified as a multifaceted construct. Its three facets, according to the authors, are "job spouse conflict," "job parent conflict," and "job homemaker conflict." As work-family conflicts stem from issues within the job domain and the home domain, the degree to which female entrepreneurs experience work-family conflicts is contingent, not only on the nature of the job (work characteristics, such as hours devoted, type of business activity, and job location) but also on the family dynamic (marital status, spousal support, number, and ages of children) and household obligations.

Past research suggests that work-family conflicts can adversely affect a person's satisfaction in life (Kim and Ling; Parasuraman and Simmers; Yucel). Likely, the more work-family conflicts individuals face, the less satisfaction they will experience (Allen et al.). Family members, too, can be affected. For instance, the wellbeing of children depends much on the time their parents devote to them (Heinrich). Mompreneurs and their children are no exception; the more work-family conflicts encountered by enterprising mothers, the greater the risk of dissatisfaction, both for themselves and for their children.

Sen's Theoretical View of QoL

The capability approach, pioneered by Amartya Sen and further advanced by Martha Nussbaum, has become a widespread alternative to resource-based approaches in QoL studies (Clark). Sen rejected this latter approach, which he argued was limited in scope and offered an incomplete evaluation of QoL. Sen's, although he did not discredit the importance of commodities and resources when evaluating people's QoL, sought to mitigate the inadequacy of these indicators. By considering other nontangible features of life, Sen provides a better and more intricate framework within which the issue of QoL can be explored.

Critical to the capability approach are its underlying tenets of functionings and capabilities. Functionings are the myriad activities in which individuals tend to engage, such as work or recreation, and the various conditions or states they can achieve in life, such as good health and happiness (Karimi et al.). According to Sen, QoL is the outcome of an individual's ability to attain these functionings—that is, their capabilities—and should, thus, be measured upon this basis. Sen's theory emphasizes, however, that presently acquired functionings or states, in and of themselves, are inadequate indicators of wellbeing. In his opinion, evaluations of wellbeing should also encompass one's ability to access additional or alternative states, if desired (Karimi et al.). In essence, the more people can achieve their desired functionings and alternative states (if they so desire), the better the QoL of that individual.

In the past, the capability approach has been used to elucidate QoL experiences among women (e.g., Greco et al.); these studies are, however, few. This work draws upon Sen's theoretical understanding of QoL. Therefore, the relationship between mompreneurship and QoL is interrogated and discussed on the basis of mompreneurs' capabilities—what it permits mothers and their children to have, to be, and to do and, ultimately, whether entrepreneurial engagement enhances or diminishes their life experiences.

Methodological Approach

In this study, semistructured phenomenological interviews were conducted with five mompreneurs who worked in the formal sector of Trinidad and Tobago to determine whether/how their engagement in entrepreneurship had influenced the satisfaction they had experienced

in various life domains. Each mompreneur was invited to participate in the study after being introduced to the researcher at a local small business expo. Although they were all mothers, they differed along several other variables, including their ages, the number and ages of their children, their marital status, the communities in which they lived and worked, and the products and/or services which they offered. The individual interviews, which lasted approximately forty-five minutes each, allowed for in-depth interrogations of the lived experiences of these mompreneurs and, by extension, those of their children. The semistructured nature of the interviews facilitated open discussions between the researcher and the mompreneurs on matters germane to the study. The women were asked straightforward and open questions, such as "Would you say that entrepreneurship has influenced the quality of your family life?" Affirmative responses, when provided by the interviewees, were followed by the question, "How so?" This pattern of questioning was used for each individually assessed domain. All interviews were audio recorded and transcribed verbatim. The transcribed interviews were then analyzed thematically through a structured and iterative process. Where necessary, a hermeneutic approach was also applied. The forthcoming discussions reveal the findings of these analyses. A brief narrative of each mompreneur preludes the discussions.

Narrative Summaries of Interviewed Mompreneurs

Descriptions of each interviewee are presented below in the form of narratives. Critical to these narratives are details about the respondents' entrepreneurial activities, their paths to entrepreneurial entry, and the demographic information about themselves and their children. In each instance, pseudonyms have been used to protect the respondents' identities.

Amber

At the time of the interviews, Amber was in her thirties, married, and had one child, a son just under the age of ten. Interestingly, she had been an entrepreneur for roughly the same amount of time. Amber operates an event management firm from the comfort of her home. In addition to managing corporate events, she occasionally provides

rapporteuring and transcription services. Amber's decision to launch her firm resulted from myriad factors. She was once a paid employee and had performed various jobs. One such job was at a local bank. According to Amber, while she competently performed her duties and produced work of impeccable standard, her naturally ebullient personality was not well received. As a result, she constantly felt like an outcast. Upon leaving the financial sector, Amber found work as a rapporteur and as a transcriber, but these jobs were equally dissatisfying. She noted the following:

> I did so many transcriptions and [so much] rapporteuring and I did it for next to nothing [very little money]. They would give me a CD of about an hour and a half long to transcribe and would pay me 600 TTD [approximately 89 USD or 115 CAD]. You know how much is the real price for that? Ten hours of typing multiplied by about 150 TTD [22 USD or 29 CAD]. That's how much I was supposed to be getting for every CD. At times, I went home with nine CDs, and I got paid, for the most, 1500 TTD [220 USD or 290 CAD].

This perceived exploitation led to deep frustration.

Altogether, her negative experiences as a paid employee engendered within her a strong desire for independence. With some encouragement from a friend, she was suddenly determined to become her own boss. It began with a single project: "I fell into it ... a friend of mine knows that I'm really good with reports and that sort of thing, and one of her colleagues needed someone to do up a report." She eventually expanded her service offerings to the management of corporate events; she now earns the bulk of her income from this activity. She no longer considers rapporteuring a lucrative trade: "The reason I branched out [diversified my business] is because I realized the rapporteuring field is dying."

Sapphire

Sapphire runs a family business with her husband, her mother-in-law, and her father-in-law, at an office away from home. At the time of her interview, the main business venture, a transportation company launched by her father-in-law, had already been in existence for forty-five years. Sapphire, who was between forty and fifty years old at the time, had been involved in the business for approximately twenty-one years

and had two teenage children, an older boy and a younger girl.

Sapphire's path to entrepreneurship was a less turbulent one. Like Amber, she had a deep desire for independence. However, the source of her desire varied. Independence was all she ever knew. She stressed, "I cannot work for anybody ... my father has his own business, so it's only him I had to answer to." Through her exposure to entrepreneurship and her experience in the transportation industry, gained while working with her father, she acquired competencies, which now allowed her to assist in the management of her family's firm. She pointed out:

> When I got married I came into the business ... because my father also has a transport company ... when I came, it was just my father-in-law, my mother-in-law and my husband with all of our [50] employees here, so obviously when I got married I had to come into the business and start helping, you know? So I ended up being an entrepreneur because of marriage.

Through her vision, though, the family since launched a second firm: "I opened another company.... I opened that company about three years ago. We do wholesaling of toys, household items, stationery, that kind of thing. So together with this transport business, we also have that other business." The transportation company has also become more diversified in its operations: "Over the past couple of years, the industry has gotten a little slow for us, so we have diversified a little. We now also do construction." As an entrepreneur, Sapphire is, therefore, actively involved in several diverse activities.

Pearl

Pearl, along with her husband, oversees the sale, maintenance, and repair of marine engines. She mostly operates this business at an office away from home, though she occasionally conducts some of her activities at home. Pearl's venture was merely two years old when she was interviewed. At that time, she was in the twenty-nine to thirty-nine age group, and had two children, a teenaged boy and a preteen girl, whom she hopes will someday assume leadership of the firm.

Like Amber, Pearl was formerly a paid employee who worked numerous jobs: "I've worked in all kinds of jobs. I've worked in gas stations, pumping gas. I've worked in stores. I've worked in administration." Although she did not necessarily believe that she had

been exploited during her time in paid employment, as did Amber, she lamented the fact that she did not earn much as a paid employee: "I was stressed getting up early and going to work for small salaries...that was really hard.... My husband got a promotion. It [the salary] was equal to what we were both getting before." She, therefore, opted to remain at home in order to take care of her children. However, the additional hours, which her husband was now required to work, had disrupted their family life. This, she stated, was her impetus for starting a firm: "I told him [my husband], 'Listen, the kids are not seeing you, and I'm not seeing you. It's better for us to open a business, register a company, and in doing that you could see your clients based on appointments. And that's how we came about doing this.'" Notably, Pearl was the only mompreneur who stated explicitly that she entered entrepreneurship for the sake of her children's wellbeing. However, as will be seen in the forthcoming discussions, she was not the lone interviewee to perceive that entrepreneurship had an impact on her wellbeing and that of her children.

Jade

Jade's business is all about garments. She mostly outfits professional women by providing a range of industrial uniforms, such as aprons, scrubs, laboratory coats, chef coats, and chef hats, among others. Although she designs and constructs customized clothing, she also imports garments to satisfy those with a preference for foreign apparel.

Prior to engaging in microenterprise, Jade was employed at several fast food restaurants and at a local garment factory. The latter allowed her to pursue her true passion, garment construction, which she had been involved in for many years. Jade's passion also led her to pursue a fabric design class. The following statement describes, in her own words, why she ultimately chose to engage in entrepreneurship: "I decided that the whole idea of putting the fabric design together with the garment construction would be good." She viewed entrepreneurship as a unique opportunity to commercialize on her skillset—a combination of old and new skills that she had acquired formally and informally over the years. She initially ran her business from home but soon saw the need to operate from elsewhere: "Home wasn't really giving me the accommodation that I wanted, especially when customers came to do their fittings.... I wanted the professional experience of doing business away from home.... I

couldn't really sell my garments from home." At the time of the interviews, Jade's business was ten years old. With respect to her family dynamic, she was unmarried and had two children, one boy and one girl, one who was a young adult and the other who was a teenager. She was in the forty to fifty age group when she was interviewed.

Crystal

When Crystal was interviewed, she was a soon-to-be married mother of one in the twenty-nine to thirty-nine age group. Prior to engaging in entrepreneurship, she was employed at a local energy company. Her story is one of frustration coupled with determination. She explained:

> I was getting a good salary. I just left school and was working on contract. Things were looking good. I thought I would secure a permanent job. From a contract position, they sent me back to work on a temporary basis; then they decided to rotate the position. So, I would work for one month and the next month I would be off [not working] ... it was sort of emotional to deal with that.

A project manager and an engineer by profession, her desire was to work in the areas of her expertise: "It was a dream. My desire was to do engineering, so that's why I decided to register the business." Her next few words, though, prove that her path to business ownership was a less intentional one when compared with the other women in the sample: "One day I said, 'Wait! I could do business!'" Admittedly, therefore, Crystal was pushed into entrepreneurship. Despite her very humble beginnings, she now leads a group of companies of very diverse activities—construction (the first activity in which she was engaged), maintenance, janitorial, and food catering services, as well as agricultural products which she grows herself. Diversification of her business also came by force, at a time when she felt she could no longer survive doing construction alone: "Because of the downturn in the economy and because of the political influence with construction projects, we had to diversify." Crystal operates her company from home, from an office space specifically built for that purpose. At the time of her interview, her only child was a daughter, just under ten years old. Her firm, a limited liability company that she directs alongside other family members, was also less than ten years in operation—nine to be exact.

QoL Changes from Entrepreneurship

Prior to probing the mompreneurs about the perceived impacts of entrepreneurship on their own QoL and that of their children, they were asked to identify the factors which they felt were important for having an ideal QoL. Altogether, they identified six domains which were consistent with those commonly found in theory: 1) material wellbeing (standard of living), 2) family life, 3) social life/recreation/ leisure, 4) productive wellbeing (wellbeing at work), 5) achieving in life, and 6) health. The following discussions describe those changes observed by the interviewees in these six domains as a result of their entrepreneurial engagement.

Material Wellbeing (Standard of Living)

Two of the mompreneurs felt that entrepreneurship made them some "profits at the end of the day" (Sapphire) and, therefore, allowed them to provide for their children "a lot better" materially (Pearl). The others, though, noticed a decline in their standard of living and sometimes that of their children. They spoke at length about the diverse financial challenges they encountered. Crystal, who once earned a competitive salary in the energy sector, noted the following: "You are being paid less than if you were out in the workplace." Jade, even after ten years of being an entrepreneur, also lamented, "My business just pays my bills for now, bills that I need to pay for my kids and for my home ... my money pays more for things that I need and not [for] the things that I want. With my kids, I try to make sure they have all their wants, but for me I will leave out what I want and just pay for what is needed." She added: "You could make money this month, and next month make none. It's a struggle and it's a fight, but you have to keep going." Amber discussed this issue in greater depth. She emphasized the specific source of her lowered standard of living as well as the predicaments she faced in extremely difficult seasons. She revealed: "The hardest thing is to get jobs [contracts]. That's very difficult. Last year was very bad, very bad. I asked myself 'Should I go back to work?'... It gets difficult because you'll get a job in January, then for February, March, April, May, June, July you get nothing. Then you might get something in August." She confessed that had it not been for her husband things would have been much worse: "My husband has a

stable job, but if that were not the case, then we would be having some problems. Because you can't tell me you got a job in January and the next one's in August. What's going on with your children between then?" She further commented on how a poor standard of living could affect other important aspects of life, both for a mompreneur and for her children:

> Bad QoL to me is not providing or not being able to provide for your children.... They come and ask you for something to eat, and you look in your cupboard and have nothing.... All these things lead to unhappiness. You're going to be stressed when your child comes and asks you for something to eat, and you're going to cry because you know you can't give them anything.

Although she mentioned in a general sense that mompreneurship improved her material wellbeing, Pearl also acknowledged the financial challenges she suffered from time to time. She pointed out the following: "There are times where money is a little low, especially when things are slow. It puts a strain on us."

Ivan Light and Carolyn Rosenstein attempt to correct the widespread myth that entrepreneurs are all affluent. According to them, most are not. They usually earn less income than their counterparts in paid employment (Parker). This was clearly the reality of most mompreneurs in this study. Alina Sorgner et al. pose the question: "Why do individuals remain self-employed if they could earn more in paid employment?" For these mompreneurs, who would face fewer financial challenges and who could better provide for themselves and for their children in alternative employment, this question seems reasonable. Enterprising mothers, however, are generally less concerned with profit maximization (Nel et al.). In the case of these women, for whom "getting rich" was not a major factor, the nonpecuniary benefits they gain from entrepreneurship may compensate for the challenges that they experience in this domain. These benefits, along with other challenges faced by the mompreneurs, are explored in the discussions which follow.

Physical Wellbeing

Some authors (e.g. Stephan and Roesler) have discussed the positive implications of entrepreneurship to the physical health of entrepreneurs. However, the mompreneurs in this study offered a different account. None felt that their physical health had been directly affected in a positive way by entrepreneurship. At the same time, when the negative impacts of entrepreneurship on health were identified, these effects were not necessarily linear. For example, as previously pointed out by Amber, being financially constrained could lead to unhappiness and stress. These negative affective states if prolonged and left unchecked could have deleterious effects on health in the long run. These negative effects alluded to by Amber counter the findings of Ute Stephan and Ulrike Roesler, who assert that, for the most part, entrepreneurship favourably affects the psychological health of business owners. However, they support another aspect of these authors' findings, which suggest that, when present, negative affective states among entrepreneurs, such as described by Amber, most often result from financial issues.

Beyond Amber's case, there was no evidence to suggest that any of the mompreneurs in this study, or their children, experienced positive or negative health changes due to entrepreneurship. They spoke, though, of having more flexibility to recover when ill or to attend to the needs of their sick children, if necessary. Pearl noted: "I manage my time based on my needs. If I get sick today and I'm feeling better at night, then I'd work in the night." Similarly, Amber articulated, "If someone [a child or other family member] gets ill, you're able to see about that person comfortably and not have to wonder, 'Lord, where am I finding the money for this?'" The one dissenting view was from Jade who expressed the following: "There is nothing like holidays, time off, or sick [leave]. If you're sick you still have to fight and get yourself to work." Despite her reluctance to take "time off" to recover if she became ill, she was willing to do so to attend to her children's health needs if necessary.

Productive Wellbeing

In the domain of work and productivity, a number of issues emerged. The mompreneurs discussed both positive and negative changes to their work life which resulted from their entrepreneurial engagement.

Extended but Flexible Workdays

As anticipated, they worked for very long hours. Crystal said: "You have to go the extra long hours." Sapphire agreed that "You have to work twenty-four hours a day.... We work from Sunday to Sunday.... It's very difficult. On Sundays when you think you could take a five [-minute break], you can't do that because you have to see about the vehicles for Monday morning ... in order to have a business running, you have to be there all the time." Pearl shared similar sentiments: "If you're working for someone else, when you go home you could lock off the work. When you are the business owner, when you go home you don't lock off the work, the work is still with you." Despite her previous claims that there are no holidays, Jade, alike the others, acknowledged that entrepreneurship gave her a level of flexibility that could not be obtained in paid employment: "If they [my children] are really sick, I don't have to ask a boss' permission to go and see about my kids. I can just close up [my shop] and go and see about them." Amber, likewise, felt that entrepreneurship offered her a degree of flexibility that was not possible with paid employment. It allowed her to work whenever and wherever convenient to her, thus maximizing her productivity. She told of the freedom to work while "on vacation" with her family: "Even if you're on vacation, you can have your laptop, and you could still do what you need to do; take a little hour, do it, and then go back to the beach." Women with younger children, like Amber, usually engage in enterprise to satisfy this need for flexibility, which, subsequently, allows them to fulfil their maternal obligations and effectively navigate other aspects of work and family life as described in the above anecdotes (Lombard; Wellington). For these women, the flexibility accrued from entrepreneurship may be a nontangible benefit, which offsets the financial challenges associated with their business ownership.

Added Credentials

Given the multifaceted nature of entrepreneurship, some respondents were also forced to acquire new training (formally or informally) in diverse areas, which enhanced their professional development and, at times, reduced or eliminated specialized labour costs. This was best articulated by Pearl:

I studied supervisory management, and I just recently finished a two-year psychology course. When I came into this business, I didn't have specific education, so I had to hire people to help me understand it ... the people that I hired taught me things.... Normally, I wouldn't have gotten that training before but, being in this business, I had no choice but to ensure that I got the training.... Even the accountant I hired to come and do my finances said, "You could do that for yourself," and he sat down and showed me so I didn't have to hire him [again].

Sapphire and Jade shared their own unique stories. The latter noted, "Right now I'm doing a course.... You need to improve every time there is a different style....You always need to improve your skills, and you always need to be at the top of your game. You always need to move to a higher level." Sapphire, too, felt this need to constantly further her knowledge in order to "keep up" with evolving industrial trends. Doing so, in addition to enhancing her skillset, allowed her to remain relevant in a competitive business environment.

In different ways, the broadening of their competencies has the potential to improve their own QoL and that of their children. Likely, the more capable they are of performing essential business-related tasks, the smaller the wage bill. Especially for those mothers who struggled in the area of their finances, lower wage bills could improve profits, enhance their standard of living, and minimize financial stress. In addition, it is expected that greater feelings of achievement, self-actualization, self-efficacy, and autonomy will accompany their new credentials. This, in turn, can have positive psychological implications for mompreneurs.

Personal Achievement

There was a great deal of consensus among the mompreneurs that entrepreneurship, in one way or another, engendered within them strong feelings of achievement. For Crystal and Pearl, it was the ability to see their visions materialize into something tangible that affected them most profoundly. Hence, Crystal identified "seeing the dream come to pass" as the fundamental source of her accomplishment. For Pearl, it was her ability to elevate her status from one of poverty to one of financial security: "It gives a sense of accomplishment, especially

because growing up we didn't have anything. We were poor. Now I could afford some more things." Being able to provide for her children more than what her parents could provide for her and her siblings added to her sense of achievement as well. Another mompreneur who experienced a heightened sense of achievement was Sapphire, although hers was not necessarily due to improved financial status. Rather, for her, "whenever you succeed in something," there come more feelings of achievement. Amber's sense of achievement was also more deeply rooted in her completion of job-related tasks: "The quality of work that people get [from me] they don't get it anywhere else.... When I finish something, I finish it perfectly." In a study of Irish women conducted by Pauric McGowan et al., the ability to provide good quality service, as mentioned by Amber, was found to be the commonest source of achievement, which, for decades, has been linked to entrepreneurial success (McClelland). Amber also asserted: "When I look at myself, from where I was to where I am now, I have this extra drive and this motivation to succeed." Jade shared comparable sentiments: "It has created a passion and a drive to climb higher."

Family and Social Life, Recreation and Leisure

Given similarities in their experiences in these two dimensions (family life and leisure), discussions on these two areas were consolidated. Questions about changes in these domains solicited rich information. As with the other dimensions, the mompreneurs supplied mixed responses about the impact of mompreneurship. Those for whom entrepreneurship created a favourable outcome gained more time at home with their children or earned more money, thus giving them more options for recreation, or they could adjust their schedules to attend to their children's needs. Pearl, reflecting on the present state of her family life, found that she now "like[d] it a bit more," since she was now able to spend more time with her family. Apart from the time factor, she explained: "One of my favourite restaurants right now is Ruby Tuesday.... When we [my husband and I] were working [as paid employees], we didn't have the time, and we didn't have the finances. The income wasn't much, so we couldn't do it as often as we could now." Amber also gave a positive critique of the impact of entrepreneurship on her family life. As previously mentioned,

becoming a mompreneur had given her the flexibility to work whenever and wherever necessary. One may argue, however, that working while spending time on the beach with one's family (as she had previously discussed) defeats the purpose of a vacation. It also calls into question the quality (versus quantity) of the time she is actually afforded with her son. Still, she insists, "My focus is family.... If I were not an entrepreneur, I would not be able to spend much time with my son, because I would have to get up early to go to some God-forsaken eight to four job. Entrepreneurship has given me more time with my family ... that is why I'll remain as a business owner."

Those who cited the negative implications of entrepreneurship in these areas of their lives discussed the opposite. Based on Jade's statements, she lacked quality time with her children: "When I started at first, I was working at home, and they would see me a lot.... Now, I come to work from eight o'clock [a.m.], and if nobody calls to say it's time to come [home], I will stay until midnight.... My only free day is Sunday, and that's to do housework [chores]." The same was true for Sapphire: "That [time with my children] has been affected a lot.... You cannot sit down to actually have dinner or anything together ... but they understand. They see what it is like. It's not like I'm making excuses, or simply going to lime[1], and just leaving them at home." These women, who scarcely had time for their own children, were similarly disadvantaged in the area of their social lives. Crystal also confessed that entrepreneurship had affected both her family and social life in a negative way. She, however, took a different slant in discussing the changes she observed in her family life. In addition to having less time for her family, she identified behaviour-based conflicts at play in her interactions with her fiancé: "As an independent female, I'm accustomed doing things on my own.... In a typical relationship, a normal traditional relationship, you find that the man would lead. So with respect to things like houses and other acquisitions, you'll find that I can deal with those things on my own. Right now, I'm trying to figure out where I should strike a balance, if I should just hold back and allow him to take the lead. It's something I'm working on." Thus, despite the flexibility they enjoyed as mompreneurs, these women also experienced severe time-based work-family conflicts, as characterized by Greenhaus and Beutell.

Notwithstanding the bidirectional nature of work-family conflicts, the conflicts experienced by these mompreneurs were largely unidir-

ectional. Thus, although they admitted that entrepreneurship had interfered with different aspects of their family and social lives, they did not allude to the opposite. Time-based conflict was the predominant type, but behaviour-based conflict was also evident; strain-based conflicts did not appear to affect these mompreneurs.

One may think that home-based mompreneurs who are more physically present at home will face less work-family conflicts than mompreneurs who work away from home. One may also be tempted to assume that the mompreneurs with fewer children will suffer less work-family conflicts. In this study, however, Crystal, a mother of one who operates from home, seems to experience more work-family conflicts than Pearl, a mother of two who operates her business away from home. Crystal's management of multiple firms, and her status as a single mother who lacks spousal support, can perhaps explain the extent of her conflict. Similarly, the potentially broad scope of her parental obligations, given the young age of her daughter and/or her subliminal intent to quiet skeptics who questioned her ability to succeed as a young woman in entrepreneurship, may inadvertently influence her ability to balance her work and home demands.

Entrepreneurial Engagement in Relation to Capabilities among Mompreneurs

The objective of this study was to explore both the positive and negative impacts of mompreneurship on QoL, as experienced by enterprising mothers and their children. This chapter presented key insights gained from in-depth interviews conducted with five mompreneurs in Trinidad and Tobago.

Sen's theoretical view of QoL, when added to these discussions, can offer a greater appreciation of the interconnection between mom-preneurship and QoL. As previously mentioned, Sen's approach is based on the premise that QoL should be assessed on the basis of one's capabilities or power to achieve desired functionings (states of having, doing, and being). Based on Sen's theoretical view of QoL, mompreneurship diminished, albeit indirectly, the physical capabilities (physical wellbeing) of these mothers in different ways. The reverse was found to be true for their children who, given the flexible nature of their mothers' work, were able to enjoy the benefit of having their mothers

nurse them back to health in times of illness. In contrast, it was found that for their ability to achieve in life, mompreneurs were unanimous in the sentiment that entrepreneurial engagement had enhanced their capabilities.

Regarding all other areas explored—namely material wellbeing, productive wellbeing, leisure, and family life—their responses were more divided. In these specific domains, therefore, amid the consensus that mompreneurship had an impact on their QoL, entrepreneurial engagement affected the capabilities of different women and their children in different ways. In the material wellbeing domain, some women felt that their capabilities (ability to elevate their financial status) had increased; others experienced a diminishing effect. Similar trends were observed in their productive wellbeing and in their family life, social life, recreation, and leisure. Based on the accounts of these women, mompreneurship was typically found to improve their capabilities. However, it also constrained, oftentimes based on work-family conflicts, the ability to achieve some desired functionings. In scrutinizing these women's experiences, it appears, somewhat, that their capabilities in the discrete domains were predicated on the degree to which they valued specific states or activities subsumed within those domains. As a case in point, Amber, who stressed "My focus is family," found that her capabilities in this area of life had been enhanced, in contradiction to the realities she faced in the material domain. In stark contrast, Jade's family life had suffered despite her favourable experiences in the area of her material wellbeing.

Conclusions

This study, through Sen's capability approach, examined the perceived effects of mompreneurship on QoL for female entrepreneurs and for their children. Data obtained from these women, based on their own testimonies of their experiences, provided mixed results. Hence, while their entrepreneurial engagement improved some aspects of QoL for themselves and for their children, it also constrained, oftentimes based on work-family conflicts, their overall capabilities (that is, what it allowed them and their children to have, to be, and to do) and, therefore, their QoL. The diversity of the sample—together with the variation in interview responses and, at times, their tendency to defy

the expected—signals that the relationship between mompreneurship and perceived QoL is undeniably one of a complex nature. It is quite possible that this relationship is moderated by factors such as mompreneurs' motivations for entrepreneurial entry, their values and priorities, the products and services they provide, the age and stage of their firms, the number and ages of their children, their marital status, and the level of spousal support they enjoy. However, given the small sample of mompreneurs featured in this study, definite conclusions regarding the moderating role of those factors are impossible to make solely on the basis of these interviews. Similarly, it would be injudicious to extrapolate the data from this study to predict how entrepreneurial engagement impacts QoL for mompreneurs and their children in general. Thus, while this work adds to a growing body of literature on female entrepreneurship in the Caribbean, as well as to the limited knowledge available on the issue of mompreneurship and QoL, there is need for a deeper interrogation of this relationship, preferably through the use of larger samples and quantitative (statistical) assessments. Studies drawing comparisons between mothers who engage in entrepreneurship and those who do not may also offer interesting insights.

In addition to its theoretical implications, the research holds potential significance for entrepreneurial policy and practice as it pertains to women entrepreneurs. With respect to practice, the findings of this study can offer a clear understanding of success rates among mompreneurs. It is expected that the QoL boost or deficit that mompreneurs and their children derive from entrepreneurship will extend or limit, respectively, the lifespan of the entrepreneurial firms operated by mothers. Thus, enterprising mothers who perceive their business engagement as having a net positive impact on their own QoL and on the QoL of their children will likely continue to engage in entrepreneurship, hence producing more sustainable entrepreneurial efforts with more long-term contributions to socioeconomic progress. With regards to policy, the QoL issues faced specifically by mompreneurs, if supported by evidence, can encourage more data-driven policy interventions which mitigate these challenges and which create entrepreneurial opportunities and foster entrepreneurial behaviours among potential mompreneurs.

Endnotes

1. "Lime," a colloquial term which is widely used in Trinidad and Tobago, means "to socialize" or "to hang out." The term is also popular in some other parts of the Caribbean.

Works Cited

Acs, Z. J., et al. *Global Entrepreneurship Monitor: 2004 Executive Report.* Babson College and London Business School, 2005.

Allen, Tammy D., et al. "Consequences Associated with Work-to-Family Conflict: A Review and Agenda for Future Research." *Journal of Occupational Health Psychology,* vol. 5, no. 2, 2000, pp. 278-308.

Amorós, Jose Ernesto, and Niels Bosma. *Global Entrepreneurship Monitor 2013 Global Report: Fifteen Years of Assessing Entrepreneurship Across the Globe.* Global Entrepreneurship Research Association (GERA), 2014.

Bailey, Henry, et al. *Global Entrepreneurship Monitor Trinidad and Tobago 2013 Report.* Arthur Lok Jack Graduate School of Business, 2013.

Benz, Matthias, and Bruno S. Frey. "Being Independent Raises Happiness at Work." *Swedish Economic Policy Review,* vol. 11, 2004, pp. 95-134.

Blanchflower, David G., and Chris Shadforth. "Entrepreneurship in the UK." *Foundations and Trends in Entrepreneurship,* vol. 3, no. 4, 2007, pp. 257-64.

Bonetti, Benjamin. *Entrepreneurs Always Drive on Empty.* Benjamin Bonetti Limited, 2010.

Brock, Dan. "Quality of Life Measures in Health Care and Medical Ethics." *The Quality of Life,* edited by Martha Nussbuam and Amartya Sen, Clarendon Press, 1993, pp. 95-132.

Brush, Candida G. "Women Entrepreneurs: A Research Overview." *The Oxford Handbook of Entrepreneurship,* edited by Anuradha Basu et al., Oxford University Press, 2006, pp. 611-28.

Busseri, Michael A., and Stan W. Sadava. "A Review of the Tripartite Structure of Subjective Well-Being: Implications for Concept-ualization, Operationalization, Analysis, and Synthesis." *Personality and Social Psychology Review,* vol. 15, no. 3, 2001, pp. 290-314.

Campbell, Angus. "Aspiration, Satisfaction and Fulfilment." *The Human Meaning of Social Change*, edited by Angus Campbell and Philip E. Converse, Russell Sage Foundation, 1972, pp. 441-46.

Carree, Martin, and A. Roy Thurik. "The Impact of Entrepreneurship on Economic Growth." *Handbook of Entrepreneurship Research*, edited by Z. J. Acs and D. B. Audretsch, Springer, 2010, pp. 557-94.

Clark, David A. "Sen's Capability Approach and the Many Spaces of Human Well-Being." *The Journal of Development Studies,* vol. 41, no. 8, 2005, pp. 1339-68.

Cummins, Robert A. "Assessing Quality of Life." *Quality of Life for People with Disabilities: Models, Research and Practice*, edited by Roy I. Brown, Stanley Thornes, 1997, pp. 116-50.

Dahalan, Norziani, et al. "Local Community Readiness in Entrepreneurship: Do Gender Differ in Searching Business Opportunity." *Procedia-Social and Behavioral Sciences*, vol. 91, 2013, pp. 403-10.

Diener, Ed, and Eunkook Suh. "Measuring Quality of Life: Economic, Social, and Subjective Indicators." *Social Indicators Research,* vol. 40, no. 1-2, 1997, pp. 189-216.

Diener, Ed, et al. "Subjective Well-Being: Three Decades of Progress: 1967 to 1997." *Psychological Bulletin,* vol. 125, no. 2, 1999, pp. 276-302.

DiRenzo, Marco S., et al. "Job Level, Demands, and Resources as Antecedents of Work–Family Conflict." *Journal of Vocational Behavior,* vol. 78, no. 2, 2011, pp. 305-14.

Foster, Juliana, and Rhoda Reddock. "The Global Financial Crisis and Caribbean Women: A Gender Analysis of Regional Policy Responses." *Social and Economic Studies,* vol. 60, no. 3-4, 2011, pp. 67-99

Freeman, Carla. *High Tech and High Heels in the Global Economy: Women, Work, and Pink-Collar Identities in the Caribbean.* Duke University Press, 2000.

Greco, Giulia, et al. "Development, Validity, and Reliability of the Women's Capabilities Index." *Journal of Human Development and Capabilities,* vol. 19, no. 3, 2018, pp. 271-88.

Greenhaus, Jeffrey H., and Nicholas J. Beutell. "Sources of Conflict Between Work and Family Roles." *Academy of Management Review,* vol. 10, no. 1, 1985, pp. 76-88.

Greenhaus, Jeffrey H., et al. *Career Management.* Sage, 2010.

Hagerty, Michael R., et al. "Quality of Life Indexes for National Policy: Review and Agenda for Research." *Social Indicators Research,* vol. 55, no. 1, 2001, pp. 1-96.

Hamilton, Barton H. "Does Entrepreneurship Pay? An Empirical Analysis of the Returns to Self-Employment." *Journal of Political Economy,* vol. 108, no. 3, 2000, pp. 604-31.

Heinrich, Carolyn J. "Parents' Employment and Children's Wellbeing." *The Future of Children,* vol. 24, no. 1, 2014, pp. 121-46.

Karimi, Milad, et al. "The Capability Approach: A Critical Review of Its Application in Health Economics." *Value in Health,* vol. 19, no. 6, 2016, pp. 795-99.

Kautonen, Teemu, et al. "Late-Career Entrepreneurship, Income and Quality of Life." *Journal of Business Venturing,* vol. 32, no. 3, 2017, pp. 318-33.

Kelley, Donna J., et al. *Global Entrepreneurship Monitor 2012 Women's Report.* Global Entrepreneurship Research Association, 2013.

Kim, Jean Lee Siew, and Choo Seow Ling. "Work family Conflict of Women Entrepreneurs in Singapore." *Women in Management Review,* vol. 16, no. 5, 2001, pp. 204-21.

Kirkwood, Jodyanne, and Beth Tootell. "Is Entrepreneurship the Answer to Achieving Work–Family Balance?" *Journal of Management & Organization,* vol. 14, no. 3, 2008, pp. 285-302.

Light, Ivan Hubert, and Carolyn Nancy Rosenstein. *Race, Ethnicity and Entrepreneurship in Urban America.* Aldine de Gruyter, 1995.

Lombard, K. V. "Female Self-Employment and Demand for Flexible, Nonstandard Work Schedules." *Economic Inquiry,* vol. 39, no. 2, 2001, pp. 214-37.

Luhmann, Maike, et al. "Time Frames and the Distinction Between Affective and Cognitive Well-Being." *Journal of Research in Personality,* vol. 46, no. 4, 2012, pp. 431-41.

McClelland, David C. *The Achieving Society.* Free Press, 1967.

McGowan, Pauric, et al. "Female Entrepreneurship and the Management of Business and Domestic Roles: Motivations, Expectations and Realities." *Entrepreneurship & Regional Development,* vol. 24, no. 1-2, 2012, pp. 53-72.

Minniti, Maria, et al. *Global Entrepreneurship Monitor: 2004 Report on Women and Entrepreneurship.* Babson College and London Business School, 2005.

Mueller, Pamela, et al. "The Effects of New Firm Formation on Regional Development Over Time: The Case of Great Britain." *Small Business Economics,* vol. 30, no. 1, 2007, pp. 59-71.

Nel, P., et al. "Motherhood and Entrepreneurship: The Mompreneurship Phenomenon." *The International Journal of Organizational Innovation,* vol. 3, no. 1, 2010, pp. 5-34.

Parasuraman, Saroj, and Claire A. Simmers. "Type of Employment, Work–Family Conflict and Well-Being: A Comparative Study." *Journal of Organizational Behavior,* vol. 22, no. 5, 2001, pp. 551-68.

Parker, Simon C. *The Economics of Entrepreneurship.* Cambridge University Press, 2018.

Pounder, Paul. "Entrepreneurship and Gender Disparity in the Caribbean." *Journal of Research on Women and Gender,* vol. 6, 2015, pp. 4-23.

Rapley, Mark. *Quality of Life Research: A Critical Introduction.* Sage, 2003.

Rejeski, W. Jack, and Shannon L. Mihalko. "Physical Activity and Quality of Life in Older Adults." *The Journal of Gerontology, Series A: Biological Sciences and Medical Sciences,* vol. 56, no. 2, 2001, pp. 23-35.

Saarni, S. I., et al. "Quality of Life, Work Ability, and Self-Employment: A Population Survey of Entrepreneurs, Farmers, and Salary Earners." *Occupational and Environmental Medicine,* vol. 65, no. 2, 2008, pp. 98-103.

Schalock, R. L. "The Concept of Quality of Life: What We Know and Do Not Know." *Journal of Intellectual Disability Research,* vol. 48, no. 3, 2004, pp. 203-16.

Schimmack, Ulrich. "The Structure of Subjective Well-Being." *The Science of Subjective Well-Being,* edited by Michael Eid and Randy J. Larsen, Guilford Press, 2008, pp. 97-123.

Schimmack, Ulrich, et al. "The Influence of Environment and Personality on the Affective and Cognitive Component of Subjective Well-Being." *Social Indicators Research,* vol. 89, no. 1, 2008, pp. 41-60.

Seguino, Stephanie. "Why Are Women in the Caribbean so Much More Likely than Men to Be Unemployed?" *Social and Economic Studies,* vol. 52, no. 4, 2003, pp. 83-120.

Sen, Amartya. "Capability and Well-Being." *The Quality of Life,* edited by Martha Nussbuam and Amartya Sen, Clarendon Press, 1993, pp. 62-67.

Sorgner, Alina, et al. "Do Entrepreneurs Really Earn Less?" *Small Business Economics,* vol. 49, no. 2, 2017, pp. 251-272.

Stephan, Ute, and Ulrike Roesler. "Health of Entrepreneurs Versus Employees in a National Representative Sample." *Journal of Occupational and Organisational Psychology,* no. 83, no. 3, 2010, pp. 717-738.

Stiglitz, J., et al. *Report by the Commission on the Measurement of Economic Performance and Social Progress.* Europa, 2009, files.harmonywith-natureun.org/uploads/upload112.pdf. Accessed 16 Sep. 2020.

Uy, Marilyn A., et al. "Joint Effects of Prior Start-Up Experience and Coping Strategies on Entrepreneurs' Psychological Well-Being." *Journal of Business Venturing,* vol. 28, no. 5, 2013, pp. 583-97.

Wellington, Alison J. "Self-Employment: The New Solution for Balancing Family and Career?" *Labour Economics,* vol. 13, no. 3, 2006, pp. 357-86.

Westhead, Paul, and Mike Wright. *Entrepreneurship: A Very Short Introduction.* Oxford University Press, 2013.

WHOQOL Group. "The World Health Organization Quality of Life Assessment (WHOQOL): Development and General Psychometric Properties." *Social Science & Medicine,* vol. 46, no. 12, 1998, pp. 1569-85.

Wiklund, J. C., et al. "Entrepreneurship and Wellbeing." *Elsevier,* www.journals.elsevier.com/journal-of-business-venturing/call-for-papers/entrepreneurship-wellbeing. Accessed 12 Sept. 2020.

World Bank Group. *Profiling Caribbean Women Entrepreneurs: Business Environment, Sectoral Constraints and Programming Lessons.* International Bank for Reconstruction and Development, 2015.

Yucel, Deniz. "Work-To-Family Conflict and Life Satisfaction: The Moderating Role of Type of Employment." *Applied Research in Quality of Life,* vol. 12, no. 3, 2017, pp. 577-91.

Chapter Eight

Doing All That Matters: A Relational Career Psychology Perspective on Mother-Entrepreneurship Career Success

Rebecca Hudson Breen and Silvia Vilches

Women's entrepreneurship has increased dramatically over the past decades (Hughes et al.), but entrepreneurship, particularly for women who are mothers, is often described with a balancing metaphor, which positions mothering and business work on two sides of a scale. Yet this is not necessarily how entrepreneurship is experienced by women who are managing the life roles of entrepreneur and mother. Understanding the career-life development of women entrepreneurs from their perspectives is an important step forwards in career counselling and vocational psychology in order to support the continued growth and success of women-led businesses. A relational perspective of the psychology of work takes into account all of an individual's life roles, including moving beyond the dichotomy of paid and unpaid work and highlighting how their work lives are shaped by relationships and culture (Blustein et al.; Richardson; Schultheiss, "The Emergence"). Relational perspectives view "working as a relational act" in the context of all of a person's life, not merely as an isolated job or paid work (Blustein 1). Broadening the lens to include all of a woman's life is central to feminist perspectives. In career-life

theories, understandings of career as an interaction with relational contexts are still developing (Blustein). In this chapter, we apply a relational career psychology perspective—which supports an inter-disciplinary approach and enables a fuller understanding of the mother-entrepreneurship nexus as a relational context—to suggest new directions for research.

Women's entrepreneurship research has its roots in both feminist and career (specifically, gender and occupations) literature (Jennings and Brush). Early research on women's career-life development was influenced by important developments in women's psychology, such as the work done by Carol Gilligan and Jean Miller, which brought awareness of the importance of relationships and connectedness in women's development. Research on women's career development has examined the experiences of women who have left paid employment to raise their children as well as the experiences of women who continued to engage in paid employment while mothering. Little research, though, has focused on mother entrepreneurs specifically. Furthermore, although the majority of women's entrepreneurship literature focuses on the differences between male and female entrepreneurship, as well as the constraints experienced by women, the experiences of mother entrepreneurs have been neglected. Within all of this research, the work of mothering seems to have been marginalized (Schultheiss, "To Mother or Matter"). Matricentric feminism (O'Reilly), calls for feminist approaches to consider the unique experiences of women who are mothering. Andrea O'Reilly's work draws attention to the absence of a mother-centred perspective in career theories. Our discussion in this chapter presents a view of mother entrepreneurship as embedded in and shaped by the mothering role.

The term "mompreneur" captures how mothering and entrep-reneurship roles may evolve in mutually enhancing ways, as mother entrepreneurs make choices that are beneficial for both family and business venture. However, the concept of the "mompreneur" is also highly contentious; various definitions of "mompreneurship" have been proposed, which highlights the complexity and diversity within women's entrepreneurship and mothering identities (Ekinsmyth; Richomme-Huet et al.). We argue that mother entrepreneur's success may not be captured by traditional metrics of business success. In contrast to traditional male-centric, individualistic models of career development

and entrepreneurship success, a relational perspective of career-life development anticipates an evaluation of business success based on how well the business meets the needs of the woman and her multiple life roles and relationships. This perspective contrasts also with the ideology of intensive mothering, however, which Sharon Hays describes as "a gendered model that advises mothers to expend a tremendous amount of time, energy, and money in raising their children" (x). We explore the ways in which these tensions co-exist as mother entrepreneurs find a middle ground between what Hays terms the "opposing logics" (9) of mothering and income generation.

We begin by revisiting how traditional theories of entrepreneurship and career-life development situate female entrepreneurship, and then we describe the value and benefits of the relational lens—as described by David Blustein and colleagues, Donna Schultheiss ("A Relational Approach"), and others—for understanding mother entrepreneurship. We will present brief vignettes from interviews with mother entrepreneurs to illustrate the importance of autonomy, relationships, choice, and values for mother entrepreneurs. Data of mother entrepreneur experiences, derived from two separate grounded theory qualitative research studies, provide a range of examples to illustrate the relational perspective of mother entrepreneurs' career development.

Theorizing from Lived Experiences

The stories and quotations of mother entrepreneurs' experiences that are discussed in this chapter are drawn from two studies. The first study ("How Self-Employed Women Manage Multiple Life Roles"— SEW-MMLR) is a grounded theory study of mother entrepreneurs (Hudson Breen; Hudson Breen et al.). Grounded theory is a method-ology originally developed as an alternative to research approaches that exclusively built from gaps in prior research (Glaser and Strauss). Barney Glaser and Anselm Strauss, and many since, prioritized people's own socially mediated perceptions of their experiences to theorize social processes and problems, with the purpose of developing new grounded theories to explain human behaviour and phenomena. The SEW-MMLR focused on how eighteen individuals who self-identified as mothers and entrepreneurs balanced their multiple life roles. The grounded theory developed with this data—called "Keeping

Going"—described "the basic social process" by which mother entrepreneurs resolved the social problem (or problematic process) of balancing the life roles of mother and entrepreneur (Hudson Breen 194).

The initial question of the SEW-MMLR study was of how mother entrepreneurs balanced mothering and entrepreneurial work. It soon became clear that being a mother and an entrepreneur was a process women embarked on to resolve the tug-of-war between mothering and other work. However, the concept of "balance" was rejected by participants. Mother entrepreneurs intentionally shaped their work and life roles to allow space for mothering work and their business—an ongoing, evolving process motivated by personal values, which included considerations of both family and mothering, of self-fulfillment and challenges, and of integrity and meaning. The process was contingent on the availability of supports (both instrumental and relational), and facilitated by the autonomy to make choices and adapt creatively to the ongoing demands of their career-lives through their roles as mothers and entrepreneurs. The grounded theory of Keeping Going highlighted the role of values and relationships, while the concept of "managing" as opposed to "balance" better described the active process of negotiating the multiple life roles that mother entrepreneurs engage in. This relational aspect, which is the basic social process of being a mother entrepreneur, points to the importance of taking a relational career-life psychology perspective. Furthermore, the relational process illustrated here intersects with and adds to the critique of intensive mothering (Hays).

In the SEW-MMLR study, the sample was comprised of a fairly homogenous group of primarily well-educated, white, and middle-class women with partners. This makeup is typical of average women entrepreneurs as described in the entrepreneurship literature (Greene et al.), but this leaves a gap in the research, as women with some level of means are almost exclusively focused on. In particular, the grounded theory of Keeping Going highlighted the way women were able to begin their entrepreneurial initiatives because they had access to government benefits or a spouse with paid employment. Having steady, even if small, income allowed several women the opportunity to start their business. For example, government policy in Canada allows people to draw employment insurance payments for one year after the birth of a child, generating the necessary funds to cover family expenses. Spousal salaries

during the start-up period provided other women with sustained financial support. The importance of these supports suggests the need for further critique and exploration of barriers to entrepreneurship for lone mothers, women of colour, and immigrant women. As a result, we draw on another study to illustrate how a low-income entrepreneur employed similar principles in developing her own business. This second study (Study Two, IA3.1[1]) was a three-year longitudinal study of the experiences of impoverished lone mothers with young children who were receiving income support. A grounded theory analysis of this data, demonstrated how women were motivated by their dreams to create a better future for themselves, rather than just focusing on getting a job. The case of Julia,[2] who became an entrepreneur, illustrates many of the same characteristics of the grounded theory that emerged in the SEW-MMLR study and helps us see how the concept of keeping going also fits for someone who is a new Canadian, a single mother, and a woman of colour. In the next two sections, we review traditional approaches to entrepreneurship and career development and discuss how a relational, career-life psychology provides theoretical support for viewing mother entrepreneurship as a site of empowered mothering and work-life achievement, before introducing data from the two studies.

Traditional Theoretical Approaches: Male-Centric Frames on Women's Business

Although women entrepreneurs today are a rapidly expanding group in economies around the world, prior to 1980, the majority of entrepreneurial businesses were started by men (Brush et al., "Growth Oriented"; Hughes et al.). As Susan Lewis points out, however, women have historically run a broader variety of businesses than are acknowledged. Early research on entrepreneurship largely failed to take into account the gendered nature of work (Ahl; Bird and Brush; Mirchandani); the concept, role, and identity of entrepreneur were masculine in expected behaviour and image (Bird and Brush). As a result, early research on women's entrepreneurship tended to focus on the growth and performance of women's enterprises against so-called universal norms (Ahl; Hughes et al.) or factors influencing women's entry into entrepreneurship, such as family considerations and a desire for work-life balance (e.g., Collins-Dodd et al.; Schindehutte et al.).

One of the critiques of early approaches to entrepreneurship is that traditional theories of entrepreneurship tended to measure business success in a purely individualistic or organizational sense, reflecting a decontextualized masculine norm. According to this conceptualization, venture creation is comprised of three basic aspects—access to markets, money, and management—the "3Ms" (Brush et al., "A Gender Aware Framework" 9). On the basis of these 3Ms, women's ventures were often deemed less successful due to smaller growth, measured in terms of capitalization, number of employees, and geographic scale (e.g. Ahl; Lewis; Mirchandani). Helene Ahl notes, however, that this early research only focused on financial performance and growth. The bias in these research foci is compounded by empirical statistical methodologies in which gender is treated as a variable, rather than as a lens through which to understand trends in women's entrepreneurship (Brush et al., "A Gender Aware Framework" 16).

Recent growth in research on women in entrepreneurship has revealed unique characteristics of female-led enterprise and has responded to earlier calls for more constructionist and contextual questions in women's entrepreneurship research (Hughes et al. 429). There is a further need, however, to understand the unique experiences of women who combine mothering work and entrepreneurship, especially because existing research on women's entrepreneurship has often combined women with and without children (e.g., Kirkwood and Tootell; McKay; Winn). Candida Brush et al. propose a "5M" framework that emphasizes the importance of understanding unique aspects of the experiences of mother entrepreneurs, such as the unequal division of labour and access to household resources ("A Gender Aware Framework" 11). This model adds two new M's to the traditional 3M framework: motherhood is added as "a metaphor representing the household and family context of female entrepreneurs, which might have a larger impact on women than men," whereas the meso/macro environment lens highlights the role of social contextual factors (8). Although this gender-aware framework introduces a novel way of understanding unique elements of women's entrepreneurship, the focus remains on how women's entrepreneurship is constrained by these two additional "M" factors, and the authors stop short of advocating for a specific theory of women's entrepreneurship (16).

Despite some advances in the area of women's entrepreneurship

research and the growth of women-owned businesses, there continues to be a widely held, though implicit, assumption that entrepreneurship is a gender-neutral activity, yet entrepreneurship research continues to focus predominantly on male samples (Jennings and Brush). Jennifer Jennings and Candida Brush also note that the proportion of recent research that focuses on female entrepreneurship published in top entrepreneurship journals is only between 8 per cent and 11 per cent. In addition, the differences within groups of women entrepreneurs, such as those between women with children and those without, are largely missing (De Bruin et al.). Such issues as the timing of the business start-up, business and family composition, and the diversity of criteria on what constitutes a mumpreneur within the subgroup of women entrepreneurs require further study (Richomme-Huet et al.). Furthermore, there is a call for a shift from a focus on entrepreneurial success as an economic activity, with possible social change outcomes, to entrepreneurship as a social change activity, with a variety of possible outcomes (Calás et al.).

In addition to adding a feminist lens to what constitutes successful outcomes, scholars have cited the need to expand the gendered framework around entrepreneurship in the career development literature, which has not focused on the role of mothering work in women's career-lives (Schultheiss, "To Mother or Matter"). Mother entrepreneurs have many constraints that would suggest limits on the capacity for business growth and success; however, the alternative view taken here addresses the complexity involved in mother entrepreneurs' multiple life roles and investigates the values behind the choices women make. O'Reilly's call for a matricentric feminism, which considers the specific issues women face as mothers (198-199), offers an alternative entry point, directing us to focus first on mothering and then on entrepreneurship. The relational lens used in career development also supports a women-centric approach, which sheds light on the mutually influencing roles and experiences of mother entrepreneurs as well as highlights the importance of understanding the unique characteristics of this diverse group.

Redefining Mother Entrepreneurship from a Relational, Work-Life Perspective

A relational career psychology perspective offers an alternative lens for understanding the motherhood-entrepreneurship nexus. In contrast to traditional theories and models of career development—which hold several cultural assumptions, including those of individualism and autonomy, affluence and opportunity, linearity, and the centrality of career (work) as a source of identity in people's lives (Gysbers et al.)— contemporary relational approaches in career development acknowledge the embeddedness of an individual within their social contexts and the multiple roles that individuals engage in (Blustein et al.). The terms "career-life" or "life-career" are often employed in this perspective to emphasize the interconnectedness of an individual's roles and the idea that career encompasses all types of work—both paid and unpaid. Furthermore, a lifespan view is also useful because it introduces the concept of change over time, and potentially changing criteria of success, in the career-life development of mother entrepreneurs because career decisions are not a single point event (Blustein; Super et al.). Viewing career-life more holistically, and as a continually evolving relational process, offers alternative foci to investigate the careers of mother entrepreneurs by taking into account how individuals may modify expectations as their perceptions of the structure of opportunity change.

A relational understanding of career development helps to explain the unique aspects of gender and parenting-related differences in women's entrepreneurship. Feminist psychologists, for example, have long critiqued individualistic perspectives. Miller's work on women's psychological development first presented the idea that women's development centres around connections with others. Gilligan's work delved into how women's psychological development might differ from the normative but male-centric processes presented in traditional models, which valued independence and autonomy. These feminist psychological approaches provoke consideration of alternative pathways from the progressive, linear approaches to career, which assume that career choice is an autonomous (not relational) endeavour and (paid) work the most significant life role (Crozier). The outcome of this theorizing over the past twenty years has been a continued appreciation of women's different ways of constructing knowledge and identity—a more connected,

relational process, as opposed to individualistic meaning-making process (Belenky et al. qtd. in Crozier). Whereas early work on women's career development focused on factors influencing women's educational achievement and career choices (Betz and Fitzgerald), relational perspectives of career development take into account beneficial qualities of relatedness and interconnectivity. This encourages consideration of the embeddedness of individuals within systems of family, cultural communities, and romantic relationships (Blustein; Farber; Richardson; Schultheiss "The Emergence"). Blustein stresses the importance of viewing work and relational functioning as integrated aspects of life, with vocational behaviour itself as "an inherently relational act" (1).

Schultheiss further emphasizes the significance of culture in relationships. Her relational cultural lens highlights the role of ethnicity, sexuality, class, and other variables of diversity important for understanding the career-life paths of all self-employed women with children. This metatheory offers four tenets of the relational cultural paradigm including:

(a) the influence of the family as critical to understanding the complexities of vocational development
(b) the psychological experience of work as embedded within relational contexts (e.g., social, familial, and cultural)
(c) the interface of work and family life, and
(d) relational discourse as a challenge to the cultural script of individualism.

(Schultheiss, "The Emergence" 192-193)

The relational-cultural lens focuses on the interconnectedness of family and culture and how culture is expressed through relationships, acknowledging the ways in which social contexts are experienced differently by different individuals. Specifically, this approach incorporates the fact that women and members of nondominant groups experience barriers in their career-lives due to the locations of power and the differing availability of opportunities, a crucial element to the development of an entrepreneurial career-life. Schulthiess's approach is particularly useful for understanding not only the diversity of culture but also the multiple contexts and roles that self-employed women with children experience throughout their career-life development. For example, the relational-cultural model explains how mothers' ventures

may be intrinsically linked to their mothering work as well as illustrate how the multiple social constructions of mothering work, expressed through interpersonal relationships and economic opportunities, may intersect and influence their choice to become self-employed. The relational cultural paradigm of career psychology complements the understanding of women's entrepreneurship from a gender-aware framework, which moves away from the concept of constraint to examine the ways that entrepreneurship and mothering work may support and enhance each other.

Beyond Ideas of Balance

Notwithstanding the grounded theories that were developed by both studies, here, we take a closer look at relational theories and how these studies both support a more contextualized investigation into mothers' career-life paths. As we discuss the theory of Keeping Going, developed in the SEW-MMLR study (Hudson Breen et al.) and discuss data from the SEW-MMLR study and low-income entrepreneurship in the IA3.1 study, we review how contextualizing women's lives creates a picture of sustainable entrepreneurship for them and their families. Then we turn to relational understandings of how women make choices and refute ideas of balance, and how mothering enhances their business skills and success. We look at the benefits mother entrepreneurs see for their families and how staying consistent with their values is empowering and provides a new model of mothering to their children. Lastly, we discuss what this means for relational theory as a feminist career counselling approach.

Many of the women who were interviewed for the SEW-MMLR study described how their initial plan in starting a business was to be able to spend more time with their children while also earning an income, consistent with a dual-aim focus. For example, Ann initially had a home-based and online business, which allowed her to be at home with her child. She shared that "When I first started doing it, it was so I could stay home with [my daughter]."

This dual aim was expressed very clearly by Courtney, the mother of a young child, in the IA3.1 study. Courtney was reflecting on the way entrepreneurship is not an approved employment path for women with young children, like her, who receive government income support.

However, from her point of view, it makes sense to combine parenting and entrepreneurship, in this case, family:

> For the people that want to do [childcare] and excel at doing it, I think they should be given the chance to do it because…. We don't stay home and raise our kids anymore, and I think, a lot of people don't want to and I understand why. But then for the people that do, like some of the moms in this neighbourhood, of course [they] are bright enough to know, "Alright, I want to be at home and raise my kids so I'm going to start up a daycare and raise a couple of others. What the heck, you know … I'm staying home anyway."

Although it is beyond this chapter to discuss the complexity of the regulatory system of income support, the IA3.1 study did uncover entrepreneurship. The case of Julia, who began a home handicraft business to sustain herself while she worked to build an e-commerce business, provides the clearest example, as we discuss below. However, Ann's story illustrates many of the challenges that must be managed, as she describes adapting as her business quickly outgrew her home. "Now that we opened the store, it's been a little bit more challenging because I can't actually have her here with me even though I thought I was going to be able to." The growth did not represent failure; it meant adapting to the needs of attending to children while also attending to clients or increasing business demands. This choice is always difficult; and it was the main reason women needed to find additional support through paying for or hiring employees for their business.

Determining business success in both these cases means considering the context of the entrepreneur, as the relational approach to career-life does. Through this perspective, choosing to keep ventures small and manageable was a deliberate strategy identified for maintaining business and other life roles (e.g., Lee-Gosselin and Grise; Morris et al.). The historical review by Lewis of nineteenth-century female entrepreneurs showed this as well; women chose to keep capitalization small because, it appeared, they were interested in the goal of sustaining their family, including by engaging them in their own business. A widowed woman, for example, could employ her daughters in a millinery shop, as well as a niece or two, thus sustaining the family and maintaining oversight over the young adult women in her care, so as to maintain respectability.

This illustrates how, even historically, women's businesses were shaped by relational influences.

In the SEW-MMRL study, Cheryl, a mother of two young children and owner of a successful events production company, spoke of both intentionally limiting the expansion of her business while also curbing cultural and internal messages regarding intensive mothering:

> I really benefitted from my mom being a stay-at-home mom, and I think it's awesome if families can have one person staying at home. That being said ... that's just not the case, families today, most of them can't really do that anymore, so what I do is try to create a version of that where I am available to them, you know, and flexible with my schedule so that I can be available to do those things and really be a part of my kids life. That's important to me. Because time goes by so fast, and I want to be a real part of my kids' life.... I struggle with wanting to spend more time and trying to create more time out of my schedule, and I miss some opportunities, you know, work wise out there in the community ... different opportunities that have been presented to me because I choose to not make work my main focus.

It may be argued that the choice to limit business growth is not in fact a choice, or that mother entrepreneurs experience constraints inherent to the motherhood role. An alternative view acknowledges the complexity as well as relational influences involved in embodying these multiple life roles. Cheryl went on to speak about her plans to grow the business further when her two young children were older, an example of the ways she considered relationships and the ways these relationships can shape career-life across the lifespan:

> I might make different choices down the line, but right now ... my daughter is just starting kindergarten. I want to be able to be there in the morning and in the afternoon when she's done, right now. So that's a big thing for me. So I guess to clarify I do feel a twinge of "Oh I could be making so much more money if I took on this opportunity." But then it's, you're balancing, you know, you're trying to figure out what makes sense with your values.

Although past research on women's entrepreneurship has suggested that women's ventures are constrained by socialization processes

affecting women's identification and exploitation of opportunities, Brush et al. acknowledge that women's experiences also offer unique perspectives that allow for the identification of different types of opportunities that are related to their mothering work and social contexts (16-17). As Lewis found, sustainability was the key to success, at least as measured in consistent appearance over years and decades, of female-led business in nineteenth-century tax rolls of Albany, New York. The experiences of women in these two studies similarly suggest that for at least some women entrepreneurs, their businesses are also successful because they work in complementarity with the various life roles that the mother entrepreneurs are living. Women are able to achieve autonomy and an opportunity to live their career-life in accordance with their values. In this perspective, these businesses served the needs of the women who started them, rather than women "balancing" or forcing a choice of one role over the other.

Rejecting Either/Or to Create a Sustainable Work-Life

The assumptions and challenges of intensive mothering affect our thinking about mother entrepreneurs as well as their thinking about their experiences. Intensive mothering, described by Hays, is an ideology of childrearing that is *"child-centered, expert-guided, emotionally absorbing, labour-intensive,* and *financially expensive"* (8); it includes expectations that parents, particularly the devoted parent, will focus on nurturing children to support their brain development (see Shonkoff and Phillips). As O'Reilly points out (146-47), this approach does not specify the gender of the nurturer, but because of societal divides around the division of labour, this work tends to fall to women. O'Reilly further speculates that for middle class women, intensive mothering may also be an outcome of later childbearing, which continues the "type A" behaviour of the busy career woman.

In the career and entrepreneurship literature, the concept of intensive mothering lurks behind the concepts of work-life balance and work-family conflict. First, the concept of work-life balance does not adequately accommodate the room needed for maternal thinking or the mental load involved in running a household (Rich) or the demands that squeeze out personal time (Kershaw). The work-life balance concept also bypasses issues of unpaid labour in the form of childcare and household tasks, which disproportionately fall to women (Jung and O'Brien 2-3). In terms

of entrepreneurship, the work-life balance concept implies that home and mothering duties would not be a problem if a person was not employed. Thus, the concept of "balance" ignores ideological and social expectations, such as those described by intensive mothering. At an individual level, the activities enacted in one domain of the work-home dichotomy require the energy of communication and negotiation to cross the borders between different life spheres (e.g. Clark).

The concept of matricentric feminism offers a means to think beyond the false dichotomies generated by the gendered trip of intensive mothering to legitimize concepts that acknowledge both the mothering and the entrepreneurial experience. Mother entrepreneurs challenge the cultural contradictions of intensive mothering described by Hays, as the self-interest involved in the pursuit of a business venture may seem at odds with the proposed selflessness of mothering work. However, conceptualizing mothering as selfless work creates a false dichotomy of mothering. Linda Ennis, for example, looks more deeply into "whether the unselfish nurturance of intensive mothering is a form of self-interested gain and how it is related to the economic needs of a patriarchal society" (2).

An intersectional lens highlights additional considerations in understanding minority mothers' entrepreneurship. While not always visible in the entrepreneurship literature, there is a long and legitimate history of Black women running businesses (Lewis). Adia Harvey describes how Black women she interviewed who owned hair salons, found business ownership to be a resolution to the intersecting oppressions of class, race and motherhood. More than that, though, Harvey describes how the women in her study created a place of pride that was self-affirming and supportive, similar to how Colleen Collins-Dodd describes the way Black women intentionally create positive spaces. Although Harvey uses the concept of work-life balance to describe the way these women "have it all," she explains how these examples illustrate that these women found time for both in a context of intersecting racial and gendered injustices, affirming the relevance of the "keeping going" model.

Mother entrepreneurs who start and maintain businesses that allow for both mothering and income generation (rather than focusing on business growth) may be seen to resist the economic pressures of stratified reproduction, enacted through patriarchal or racialized

neoliberalism. Significantly, all the mother entrepreneurs cited here, low income and middle income, created their own definitions of successful mothering and rejected the guilt imposed by societal concepts of intensive mothering; they very much valued their mothering work. For many, this meant reconciling their decision to access childcare, despite initially not intending to, and adjusting their own expectations for themselves regarding their availability for their children. These choices were made in the context of often conflicting negative stereotypes around intensive mothering, which include both the "helicopter parents," who are critiqued as unable to let go of their children, and the subtler critique that the parent who does not do enough is betraying their child's developmental potential (Kershaw and Long; O'Reilly). The same intensive parenting that causes problems for middle-class women causes problems for-low income women in a different way; intensive parenting is not allowed because public income supports focus on employability. Parenting is a personal responsibility, which Julia reconciled in her basement workshop, since her industrious activities were not legitimate employment according to income support regulation (Gurstein and Vilches). Her entrepreneurship reconciled it so that her daughter could be with her:

> And you have to buy some stuff, like I [bought] the VCR, because I make [handicrafts], so I [can] sell [them] and save some money. So if I do five, I'm going to have this, and I can buy this, and I can make the plans. So I buy the VCR for her [child] because in Christmas, they gave me videotapes, and I didn't have VCR.... Because when I am doing the [handicraft], I cannot be all, paying attention to her, so she wants to watch TV, the Winnie the Pooh, whatever, but [even though] I don't like her to be just watching TV all the time, so yeah, it's kind of difficult.

Although Julia is conflicted about using video as a helper, using the VCR allows this low-income mother to make handicrafts that she can sell for a little supplemental money, thus providing her with the start-up funds she needs for longer term sustainability. The trade-off is not between being a mother and being an entrepreneur. The trade-off is between being home and being out of the house because if not for this work, she would need to find childcare, which would be expensive, and also leave the house. As an entrepreneur, she can control her environment

with her business and be both mother and provider.

Cheryl also resolved the problem of childcare to support her overall endeavour despite social and ideological expectations:

> I thought that I'd never ever need to use childcare. I don't know why.... I grew up never being in childcare. My mom was a stay at home mom. So that was a challenge for me, the guilt of, you know, putting my kids in childcare and feeling like somebody else is raising them.... And now I don't really feel like that anymore. I see that things are balanced quite well ... it's really worked for us to make use of some childcare.

Although it was not what her mother had done, she felt satisfied in being able to work on her business with a single focus, return to her children, and be present in her relationships with them. Making these choices allowed these women to shape their own version of motherhood. Similarly, Lucy, a financial consultant, whose children were teens at the time of our interview for the SEW-MMLR study, stated the following:

> It's getting over the fact that you can't always be there 24/7 when you're self-employed, for your kids, and getting over the guilt of that. And looking back now, I see they wouldn't have needed me anymore ... Looking back now, that was my thing, not my kids going "mom, you [missed] that" ... They were fine with that.

Even though Lucy moved between being with her children and not, choice, control, and autonomy were key aspects of the experience that made being a mother entrepreneur tenable. In rejecting the idea of "balance," both the needs of the business and those of the family were acknowledged as important and required ongoing evaluation and attention. It was even noted that the business is, in some ways, "like a baby," (as Judi stated), requiring constant care or an extension of oneself. For example, Cheryl said, "I think that when you work for yourself, you can't have someone fill in for you necessarily. You can have people help you, but in the end, you're responsible for making things the way they need to be and to keep up the quality and things like that." The responsibility fit with the autonomy afforded by entrepreneurship, and women saw themselves as serving both. The work and relational nature of mothering was pieced together with the integral nature of business ownership, which

made it difficult to step away but also provided new opportunities to encompass both sides of the whole set of contextual relations.

Choosing and Creating through Entrepreneurship

Many of the businesses—as integral extensions of the entrepreneur herself—also had a relational component—a finding that supported earlier research, which noted women's businesses often include more of a focus on relationships and social connections (Bird and Brush; Harvey; Lewis). Values around wanting to contribute to one's community and to support other mothers and families were important. Eva, an owner of a business that included both a family-oriented retail component as well as services such as pre- and postnatal classes, spoke of this in terms of creating a feeling in the physical space that her business occupied: "The idea of having a place where you can create your own feeling, where there can be a mood, where people are welcomed to come and find help and where I'm able to help people, that's very very attractive to me." This theme is also reflected in studies of African American women's entrepreneurship. According to Black women interviewed by Harvey, part of the rationale for entrepreneurship included non-business goals, such as being able to create a way to sidestep the underemployment and barriers to capitalization that Black women often experience. In the SEW-MMLR study, the path into entrepreneurship that Cheryl spoke about was interconnected with her journey into mothering, which she experienced as a new level of accomplishment and independence:

> It was when I was pregnant with my daughter that I took the training to be a breastfeeding counsellor. And that was when I started, got a first taste of working for myself, and I realized I like this. I like being my own boss. I love doing the work. I loved helping families a lot, and I just wanted to kind of do something that sort of made me feel like I was making a difference, a real difference in people's lives you know.

Later, Cheryl spoke about how being in charge of her time allowed her the opportunity to schedule mothering into her work day: "I went and [volunteered for a school activity] because I can, because I'm my own boss, so I was able to schedule that into my day. That's cool. That's the

cool stuff about, you know, working for yourself."

The element of choice—being in charge of the business decisions and one's own time management—made for a feeling of empowerment, as mother entrepreneurs forged their own career-life paths in line with their values and based on creative adaptations in the face of systemic limitations. Many of the women in the SEW-MMLR study valued this element of choice and contrasted it with not having choice while working in traditional paid employment. Eva noted, "Although you know employers may make your life difficult by requiring difficult hours or expecting a lot of work from you, if you're self-employed you expect that from yourself and your clients expect that from you. So I don't know that it's that different. The only difference is that it is my choice." The autonomy to make choices about how they would structure their lives and time in order to attend to their various roles was a key theme that emerged throughout the research.

Working for oneself also provided opportunities to overcome the limitations experienced within paid employment and to satisfy personal aspirations. For example, Ginger, an engineer and mother of one, experienced limitations in terms of career advancement and flexibility during her tenure as a paid employee. Choosing to start her own business represented both an opportunity to wisely chart her own career course while also carving out time to attend to mothering work. Although some may argue that the choice to enter entrepreneurship was based on traditional push-pull dynamics of entry to entrepreneurship and that there was in fact little choice involved, given that her original choice was paid employment, a relational view of career-life development emphasizes the validity of other roles and relationships in the making of career choices.

Moving beyond a push-pull balance, Ginger experienced her choice as an empowering opportunity to blend work roles in an intentional way to meet the needs of her family and herself. Ginger noted that as her own boss, the use of technology (her smartphone) enabled her to preserve traditional business hours—something important in her industry— while also being present for her child:

> I have an engineering business, which is a little tricky, because it's a very male-dominated field, but as far as my clients are concerned, they don't know when I work. I'm very good at kind of masking the hours, and with technology today, you know, you

always have your smartphone or whatever so no matter if I'm walking to school I can be corresponding with clients, so it's having that front of still the old-school nine to five, Monday to Friday job.

Although research on work-family balance has highlighted the issue of role conflict and its negative effect on role satisfaction (e.g. Cardenas et al.; McElwain et al.), these entrepreneurial examples support the idea that some women do not always experience conflict—that is, a negative or competing sense of tension between paid employment and home-motherhood identities. Indeed, although there were experiences of role overlap, the majority of the women interviewed indicated that they were satisfied with how their roles averaged out over time, which echoed earlier findings that although enacting multiple roles can be demanding, these multiple roles are integral to women's health and wellbeing (Barnett; Betz), and, in fact, women exercise personal agency in negotiating these roles (Bailey). Rather than focusing on the potentially unattainable "holy grail" of balance (Belkin, as cited in Mainiero and Sullivan), these mother entrepreneurs described a process of working to live in alignment with their life values, which produces a sense of satisfaction despite fluctuating experiences of balance.

This combining of roles does not come without stress however, and the blurring of roles can be a double chain for women who work from home, in particular (Gurstein). Katrina, in the SEW-MMLR study, noted that being the head of her company meant she sometimes had less flexibility—business hours needed to be maintained, clients expected answers to their calls, and children needed to be picked up at childcare closing times regardless of what important work needed completing. For entrepreneurs who had children after starting their business, the gendered demands of the childbearing year also presented some challenges. As Emily, a musician and mother of two noted:

At the same time, it's also ... perhaps been more stressful than say if I'd had the opportunity to take the maternity leave, where I could just kind of not think about work or mostly not think about work for a year or so. Because I did find that was quite tricky at first, dealing with a new baby and then figuring out not only like childcare, even just how to schedule things like nursing, and all those kinds of things, how to make it all fit.

In addition to the realities of attending to infant and childcare, there was a necessity to remain active with the business, so as to not lose momentum that had been built. As Emily explained, "It's like the moment you step out of the game, you're gone; they've come up with somebody else." Canadian law provides fifteen weeks of Employment Insurance payments for women who take maternity leave after the birth of a child and a further thirty-five weeks of parental leave, which can be taken by either parent. However, as various feminist critiques of policy regimes find, policy expectations fit a particular kind of two-parent, stay-at-home mother-parent figure (Syltevik). Entrepreneurs may opt in to these benefits in Canada, but for many, it may not be feasible to leave the business. Managing the need to maintain the business while also attending to mothering work is a unique reality for mother entrepreneurs, who may not be able to take a maternity leave in the same way that women in paid employment can. Nevertheless, the women described here met both types of needs, creating and choosing configurations that helped them evolve the life they chose.

Mothering as a Business Resource

Beyond the idea of the mothering role not acting as a constraint, mothering can actually enhance the business, as many women in the SEW-MMLR study attested, which occurred in several ways. Through a set of transferrable skills that were honed though the mothering role—self-management, time efficiency, self-regulation and empathy—women became more successful as entrepreneurs. These transferable skills are not exclusive to the mothering role, but the women in the SEW-MMLR study spoke of how they honed or realized these skills through the mothering role and transferred them to the entrepreneurial role. Anna, for example, spoke about how being a mother enhanced her focus, as she was often limited to her child's nap times in order to accomplish important business tasks: "You get really good at being efficient with small chunks of time." Katrina also spoke about how becoming a mother enhanced her business self by inviting her to be more clear in her direction: "Having to, forcing myself to really, really articulate what I wanted to become, because, dear God, now I'm a mom and all this stuff. Before [her child] was born I didn't have a really clear idea of what I wanted my life to become, so it's kind of been a gift,

you know. I think I can say that." Part of the skill that was learned and exercised included the exercising of responsibility experienced through mothering, which created a new sense of focus and enhanced their performance as entrepreneurs.

In addition to skills, women gained motivation through the experience of mothering. For example, Eva spoke about how, having managed her life as an at-home mother to her young children, she realized that she could no longer work for someone else. As she described, her experiences as a mother enabled her to identify needed services and products for families in her community. The skills she honed and sense of empowerment she gained from being in charge of her own time gave her the push to pursue entrepreneurship:

> I stayed home, and after two years of staying at home, I realized that it was going to be difficult to work for anybody else. Somehow the experience of having run my own life, and I guess that was the first time I'd ever done that, right? I'd been in school where somebody else runs your life and then I'd worked for a big company where somebody else runs your life and then I'd been really self-employed as a mother and run my own life and made my own schedule and set my own priorities and decided what I would do when and not have to answer to anyone other than me."

Thus, the concept of work-life balance also meets its match in thinking that the two spheres are separate; here, we see examples not only of how business enriches mothering responsibilities but also of how mothering contributes to business motivation, satisfaction, and success. The findings here break down the idea of a dichotomy of skills and/or the suggestion that parenting is always the burdensome role.

Full Circle: Relational Benefits of Entrepreneurship

Although mothering could enrich entrepreneurship, being an entrepreneur also enriched the family by modelling behaviours and values for children and creating a venture with a family, which they could be proud of. Eva, whose children were in their late teens and early twenties at the time of our interview, said the following: "I hadn't thought about that part. I hadn't realized that [the business] would be

of value to my kids, but it actually is, they really like it. They're very proud of it and [daughter has been] particularly involved." Katrina spoke about her hopes for what her son would learn:

> My biggest value is just kind of to embrace opportunity and not to hold back from things, to say I want that I'm going to go get it and nothing or no one is going to stop me from getting it. So these are things that I hope being a parent and working the way I'm doing. I'm hoping [her child] will get this. I'm hoping it will be a role model for him, that he learns that anyone, and maybe women in particular, have any right in the world to go for what they want and nobody should try and stop them or say you can't do that, or it's too hard, or it's been done before, or that's never been done before.

Katrina is specifically speaking about lessons of empowerment and the values around being self-reliant, which is modelled on her own success and then will be transmitted to her son. This suggests that mother entrepreneurs are enacting the type of feminist mothering that O'Reilly describes, which includes a focus on antisexist childrearing or self-enhancement for the purposes of being a better mother (180). There is both the valuing of how the business enriches the mother entrepreneur's life and how this, in turn, influences her mothering. Because of the interconnectedness of the mother entrepreneur's roles, it is difficult to separate her personal empowerment from the benefit this brings to her children. As Katrina further elaborated, "So the experience of motherhood, although it was really wacky for two years, it hasn't changed me fundamentally, hasn't put a dent in my ambition. I'm still me."

For Julia, from the IA3.1 study, entrepreneurship was also part of how she modelled success for her young daughter: "I said, no, but that's not what I want. I was like, 'I'm going to have to go and look for a job in the [store]' ... I definitely was sure that I wasn't going to do it ... like that's not what I want my daughter ever to see me doing. I want her to see me like an example ... I want to get better than that." For Julia, developing her own business was not only her way out of a trap but also a way to walk in her father's footsteps as a business owner while also providing for her new family.

While referring to the way she accommodated and managed her child's needs in her work plan, Julia also saw entrepreneurship as a valid

new identity and a strong start for herself and her daughter. She framed tension, though, in terms of cultural expectations. In her home country, it is commonly viewed that unwed mothers have forfeited their future: "I don't want to live like that. In my country if you get pregnant people think oh, your life is ruined, that's it for you.... So that's like, 'No!' I know people are cleaning houses and everything and I will do it if I really, really need to do it, but I really, really wanted to keep going in the right direction that I was looking for." She explicitly rejected that vision of her future and stated that she wanted her daughter to see that her mother was working in a positive manner, not accepting pregnancy as the end of her aspirations or capability. Although she arrived in Canada as a refugee, her circumstances afforded her the opportunity to create a new future with herself as an empowered woman model, something she intentionally put into action.

Being an entrepreneur and a mother also became a site of empowerment for Anna, and she reflected on her own journey as one in which she served both her family and self and benefited from it:

> I think that through the whole process, I've been making a lot of choices that come from family, definitely, but are also about me. And it's the first time in a lot of years that I've been making choices about me, and so putting myself back on the priority list has been huge. And through that, I think that I've been more patient and I've been better able to give something back to my family and to the community because I've been in a better place in myself.

Her comments illustrate how it is not an either/or situation—her roles are mutually enhancing, and, in turn, these influence her relational contexts. She further explained: "To be excited about doing something ... that resounds [with] the boys, like they can see that I'm passionate about it and that I'm excited about it, and they get to come to [event]. It's fun, and mommy put this together. They're proud of me, and that's huge." Her entrepreneurial achievements combat some of the social stereotypes around mothering, which generate a false image of service only, and create a new image of impactful achievements that she sees being passed on to the next generation.

Another example of relational influences is in the entrepreneurship of women who choose to operate home-based childcare businesses.

Whether regulated or not, home-based childcare, or family childcare as it is termed in Canada, is a much ignored area of entrepreneurship, perhaps because it is a field dominated by women, who often have young children themselves. However, the home-based childcare provided Dana, a teacher by training, was a way to generate financial support for her family while also being at home with her young child: "I figured out that if I went back to work and put [her child] in daycare, by the time I had paid for daycare, gas, I would have hardly anything left. So why not help out a couple of other families, and be able to be with [her child] too, which is what I want, I want to be there for him." These examples highlight the ways in which values shape the mother-entrepreneur nexus. Specifically, mother entrepreneurs noted valuing their mothering work and their relationships with their children, expressed through their ability to be present for their children, which was facilitated by their entrepreneurship role.

As can be seen in these examples, not only did women feel empowered by being a good role model, they also did so by valuing themselves. O'Reilly has observed that mothers "are accorded agency to effect social change through childrearing or activism, but little attention is paid to what this agency does or means for the mother herself in the context of *her own life*" (180). For mother entrepreneurs, their business was an important aspect of their career-lives, created by them, which became a source of empowerment that enhanced their lives and, by extension, that of their families. Julia, an income assistance recipient, also expressed this sense of empowerment, which is an important finding, since such recipients often battle public stigma (Cassiman). For the women in the SEW-MMLR study, the realization of personal ambition and desire for accomplishment, as well as the desire to model that women can succeed in business for their children, made it possible to combine mothering and other career roles. They also modelled such values as independence, perseverance, and ambition.

Discussion

Two particular tensions provided a point of entry for the SEW-MMLR study inquiry and frame this discussion concerning the need for a relational and feminist approach in vocational psychology. First, entrepreneurship research has focused on the factors involved in

entering entrepreneurship and has discussed them in terms of push and pulls factors—that is, elements that force an exit from traditional paid employment (push) or attract an individual to entrepreneurship (pull). As Jodyanne Kirkwood and Beth Tootell found, although men and women are both motivated by a complex combination of factors, women entrepreneurs consider their children as motivators to a greater extent and are also more strongly motivated by a desire for independence. These findings were amply demonstrated in both the SEW-MMLR and the IA3.1 data. Outcomes, such as empowerment, helped mother entrepreneurs to redefine the push-pull factors; entrepreneurship became an opportunity to pursue their family and business ambitions, to generate income, and to honour the relational nature of their career-life. Women in these studies also felt good about being role models; they felt they gave to themselves, their children, and their community, even if they faced time pressures.

The second tension, the focus on work-life balance, frames parenting as an additional duty and suggests that mothers have to choose between attending to work or to parenting, but not both at the same time (Kirkwood and Tootell). As discussed, this situation gives rise to a focus on the work-family conflict, which orients us to the potential negative impacts on women's businesses. This tension was particularly evident for participants in the IA3.1 study, as the income assistance policy focuses on employment created conditions, which forced a choice between either employment or a lack of support and was resisted by the entrepreneurs in the study. As discussed, the nature entrepreneurship means that women do have a feeling of always being "on" and not truly feeling able to step away from their business, yet they also enjoy the autonomy afforded through entrepreneurship. This autonomy was used by mother entrepreneurs to negotiate their multiple roles through a process of making choices and creative compromises. Although the role overlap may be seen as conflictual, based in the concept of work and life as separate roles, the concept of "work-life balance" was rejected as problematic and unrealistic by many of the women interviewed in the SEW-MMLR study (Hudson Breen) and as unworkable by the low-income women in the IA3.1 study (Vilches 2011). Instead, the women pointed to multiple and simultaneous "wins," which incorporated all of their lived contexts.

Rather than refer to work-life balance, Lisa Mainiero and Sherry

Sullivan employ the image of a kaleidoscope to illustrate their relational model of women's entrepreneurship. They suggest that women in particular appreciate how changes in one part of a person's life create changes within others and that "women shift the pattern of their careers by rotating different aspects of their lives to arrange their roles and relationships in new ways" (111). The kaleidoscope metaphor helps to understand the ways that shifts in one aspect of the career-life creates ripples throughout the career-life space, with these patterns continually shifting over the lifespan. This model highlights how relationships shape women's career-lives, as women balance and manage their multiple roles through the evolution of their business and the growth and changes in their families. The kaleidoscope pattern invokes the image of the mother entrepreneur at the centre of an interconnected and fluid set of responsibilities.

Implications and Conclusion

Whereas previous work has addressed the myth that multiple roles are inherently stressful, (Barnett), we suggest a view of the phenomena of mother entrepreneurship as inherently relational. As demonstrated through interviews with these Canadian mother entrepreneurs, a relational theory of career-life offers a holistic perspective of how women's career-lives are shaped within the context of their interpersonal relationships. In contrast to both traditional theories of career development and traditional entrepreneurship research, which tend to privilege an individualistic, male-centric orientation, a relational view of mother entrepreneurship highlights the complexity of mother entrepreneur's career-lives, in which mother and entrepreneur roles evolve reciprocally within relational, contextual systems.

Given this relational lens, several implications for policy and future research present themselves. First, the SEW-MMLR study highlights the role of supports and resources (including financial and practical, such as childcare) in enabling mother entrepreneurs to begin a venture or continue managing their career-life roles. As the case of Julia (IA study) highlights, further research is required regarding the barriers experienced by sole mothers, mothers who receive income assistance, and newcomers, who may not have access to the same supports and resources as middle-class women in the first study. An intersectional

approach to understanding how issues of race, ethnicity, class, and gender affect entrepreneurship opportunities and experiences is essential to understanding the barriers and constraints to entrepreneurial activity (Harvey), particularly perhaps for women who are also mothers. Second, many mother entrepreneurs require childcare in order to continue to run their businesses, and the high cost and lack of part-time or flexible childcare present challenges to managing the roles of entrepreneur and mother. Furthermore, the childcare needs of mother entrepreneurs may not fit into the schedule of traditional group daycares, which typically require fulltime registration and are open during typical business hours. Mother entrepreneurs may need or desire more flexibility—for example part-time or occasional care, or care during evening or weekend hours. Although mother entrepreneurs in both studies employed creative means for juggling the work of mothering with that of running a business, these efforts serve to highlight the need for systemic change that supports and values the performance and provision of carework, which is largely unpaid and performed by women. Finally, a relational psychology of working highlights the reciprocally influencing nature of mothering and entrepreneurship work and offers an alternative perspective on defining features of success for mother entrepreneurs.

Moving beyond concepts of balance and intensive mothering, the stories of these mother entrepreneurs highlight the embeddedness of individuals within family, social, and cultural relational contexts, which influence how career-lives develop (Schultheiss, "The Emergence" 192) as well as the influence of the gendered role of mothering in shaping choices, experiences, and identities of mother entrepreneurship. These women challenge societal messages about career, mothering, and entrepreneurship while shaping their career-life paths with an intentionality that honours their personal values and life roles, which creates space for personal empowerment.

Endnotes

1. *Government Responses to Poverty and Income Inequality and Their Effects on Children and Families (the Income Assistance Project (IA3.1).* The IA3.1 study, from which the data are drawn, was one of ten projects within the Consortium for Health Intervention, Learning, and Development (CHILD), funded through a Social Science and Human-

ities Research Council (SSHRC) Major Collaborative Research Initiative (MCRI) project. Principal Investigator (PI) was P. Gurstein and Co-Principal Investigator was J. Pulkingham, whereas PI of the CHILD consortium was H. Goelman.

2. All participant names are pseudonyms.

Works Cited

Ahl, Helene. "Why Research on Women Entrepreneurs Needs New Directions." *Entrepreneurship: Theory and Practice*, vol. 30, no. 5, 2006, pp. 595-621.

Bailey, Lucy. "Bridging Home and Work in the Transition to Motherhood." *European Journal of Women›s Studies*, vol. 7, no. 1, 2000, pp. 53-70.

Barnett, Rosalind C. "Women and Multiple Roles: Myths and Reality." *Harvard Review of Psychiatry*, vol. 12, no. 3, 2004, pp. 158-64.

Bird, Barbara, and Candida Brush. "A Gendered Perspective on Organizational Creation." *Entrepreneurship: Theory & Practice*, vol. 26, no. 3, 2002, pp. 41-65.

Betz, Nancy E., and Louise F. Fitzgerald. *The Career Psychology of Women.* Academic Press, 1987.

Blustein, David L. "A Relational Theory of Working." *Journal of Vocational Behavior*, vol. 79, no. 1, 2011, pp. 1-17.

Blustein, David L., et al. "Toward a Relational Perspective of the Psychology of Careers and Working: A Social Constructionist Analysis." *Journal of Vocational Behavior*, vol. 64, no. 3, 2004, pp. 423-40.

Brush, Candida G., et al. *Growth-Oriented Women Entrepreneurs and their Businesses: A Global Research Perspective.* Edward Elgar, 2006.

Brush, Candida G., et al. "A Gender-Aware Framework for Women's Entrepreneurship." *International Journal of Gender and Entrepreneurship*, vol. 1, no. 1, 2009, pp. 8-24.

Calás, Marta B., et al. "Extending the Boundaries: Reframing 'Entrepreneurship as Social Change' through Feminist Perspectives." *The Academy of Management Review*, vol. 34, no. 3, 2009, pp. 552-69.

Cardenas, Rebekah A., et al. "Exploring Work and Family Distractions: Antecedents and Outcomes." *International Journal of Stress Management*, vol. 11, no. 4, 2004, pp. 346-65.

Cassiman, Shawn A. "Resisting the Neo Liberal Poverty Discourse: On Constructing Deadbeat Dads and Welfare Queens." *Sociology Compass,* vol. 2, no. 5, 2008, pp. 1690-1700.

Clark, Sue Campbell. "Communicating Across the Work/Home Border." *Community, Work & Family,* vol. 5, no. 1, 2002, pp. 23-48.

Collins-Dodd, Colleen, et al. "Further Evidence on the Role of Gender in Financial Performance." *Journal of Small Business Management*, vol. 42, no. 4, 2004, pp. 395-417.

Crozier, Sharon D. "Women's Career Development in a 'Relational Context'." *International Journal for the Advancement of Counselling*, vol. 21, no. 3, 1999, pp. 231-47.

De Bruin, A., et al. "Introduction to the Special Issue: Towards Building Cumulative Knowledge on Women's Entrepreneurship." *Entrepreneurship Theory and Practice*, vol. 30, no. 5, 2006, pp. 585-93.

Ennis, Linda R. *Intensive Mothering: The Cultural Contradictions of Modern Motherhood.* Demeter Press, 2014.

Ekinsmyth, Carol. "Mothers' Business, Work/life and the Politics of 'Mumpreneurship.'" *Gender, Place & Culture,* vol. 21, no. 10, 2014, pp. 1230-48.

Farber, Ruth S. "An Integrated Perspective on Women's Career Development within a Family." *American Journal of Family Therapy*, vol. 24, no. 4, 1996, pp. 329-42.

Gilligan, Carol. *In a Different Voice: Psychological Theory and Women's Development.* Harvard University Press, 1982.

Glaser, Barney G., and Anselm L. Strauss. *Discovery of Grounded Theory: Strategies for Qualitative Research.* Routledge, 1999.

Greene, Patricia G., et al. "Women Entrepreneurs: Moving Front and Center: An Overview of Research and Theory." *Coleman White Paper Series,* vol. 3, no. 1, 2003, pp. 1-47.

Gurstein, Penny. *Wired to the World, Chained to the Home: Telework in Daily Life.* University of British Columbia Press, 2002.

Gurstein, Penny, and Silvia Vilches. "The Just City for Whom? Re-Conceiving Active Citizenship for Lone Mothers in Canada."

Gender, Place & Culture, vol. 17, no. 4, 2010, pp. 421-36.

Gysbers, Norman C.,et al. *Career Counseling: Contexts, Processes, and Techniques.* Amer Counseling Assn, 2009.

Harvey, Adia M. "Becoming Entrepreneurs: Intersections of Race, Class, and Gender at the Black Beauty Salon." *Gender and Society,* vol. 19, no. 6, 2005, pp. 789-808.

Hays, Sharon. *The Cultural Contradictions of Motherhood.* Yale University Press, 1996.

Hudson Breen, Rebecca E. *Meet the "Mompreneurs:" How Self-Employed Women with Children Manage Multiple Life Roles.* University of Victoria Press, 2014.

Hudson Breen, Rebecca, et al. "How Self-Employed Women with Children Manage Multiple Life Roles." *Canadian Journal of Counselling & Psychotherapy,* vol. 51, no. 3, 2017, pp. 187-206.

Hughes, Karen D., et al. "Extending Women's Entrepreneurship Research in New Directions." *Entrepreneurship: Theory & Practice,* vol. 36, no. 3, 2012, pp. 429-42.

Jennings, Jennifer E., and Candida G. Brush. "Research on Women Entrepreneurs: Challenges to (and from) the Broader Entrepreneurship Literature?" *The Academy of Management Annals,* vol. 7, no. 1, 2013, pp. 663-715.

Jung, Ae-Kyung, and Karen M. O'Brien. "The Profound Influence of Unpaid Work on Women's Lives: An Overview and Future Directions." *Journal of Career Development,* 2017.

Kershaw, Paul W. *Carefair: Rethinking the Responsibilities and Rights of Citizenship.* University British Columbia Press, 2005.

Kershaw, Paul W., and Andrea Long. "The Risk of 'Making Children First.'" *Social Planning and Research Council BC,* vol. 20, no. 1, 2003, pp. 9-11.

Kirkwood, Jodyanne, and Beth Tootell. "Is Entrepreneurship the Answer to Achieving Work-Family Balance?" *Journal of Management & Organization,* vol. 14, no. 3, 2008, pp. 285-302.

Lee-Gosselin, Hélène, and Jacques Grisé. "Are Women Owner-Managers Challenging Our Definitions of Entrepreneurship? An In-Depth Survey." *Journal of Business Ethics,* vol. 9, no. 4, 1990, pp. 423-33.

Lewis, Susan Ingalls. *Unexceptional Women: Female Proprietors in Mid-Nineteenth-Century Albany, New York, 1830-1885.* Ohio State University Press, 2009.

Mainiero, Lisa A., and Sherry E. Sullivan. *The Opt-Out Revolt: Why People Are Leaving Companies to Create Kaleidoscope Careers.* Davies-Black, 2006.

McElwain, Allyson K., et al. "An Examination of Gender Differences in Work-Family Conflict." *Canadian Journal of Behavioural Science,* vol. 37, no. 4, 2005, pp. 283-98.

McKay, Ruth. "Women Entrepreneurs: Moving Beyond Family and Flexibility." *International Journal of Entrepreneurial Behaviour & Research,* vol. 7, no. 4, 2001, pp. 148-65.

Miller, Jean B. *Toward a New Psychology of Women.* Beacon Press, 1977.

Mirchandani, Kiran. "Feminist Insight on Gendered Work: New Directions in Research on Women and Entrepreneurship." *Gender, Work & Organization,* vol. 6, no. 4, 1999, pp. 224-35.

Morris, Michael H., et al. "The Dilemma of Growth: Understanding Venture Size Choices of Women Entrepreneurs." *Journal of Small Business Management,* vol. 44, no. 2, 2006, pp. 221-44.

O'Reilly, Andrea. *Matricentric Feminism: Theory, Activism, and Practice.* Demeter Press, 2016.

Rich, Adrienne. *Of Woman Born: Motherhood as Experience and Institution.* W.W. Norton, 1976.

Richardson, Mary Sue. "Counseling for Work and Relationship." *The Counseling Psychologist,* vol. 40, no. 2, 2012, pp. 190-242.

Richomme-Huet, Katia, et al. "Mumpreneurship: A New Concept for an Old Phenomenon?" *International Journal of Entrepreneurship and Small Business,* vol. 19, no. 2, 2013, pp. 251-75.

Schindehutte, Minet, et al. "Entrepreneurs and Motherhood: Impacts on their Children in South Africa and the United States." *Journal of Small Business Management,* vol. 41, no. 1, 2003, pp. 94-107.

Schultheiss, Donna, E.P. "A Relational Approach to Career Counseling: Theoretical Integration and Practical Application." *Journal of Counseling & Development,* vol. 81, no. 3, 2003, pp. 301-10.

Schultheiss, Donna E.P. "To Mother or Matter: Can Women Do both?" *Journal of Career Development,* vol. 36, no. 1, 2009, pp. 25-48.

Schultheiss, Donna E P. "The Emergence of a Relational Cultural Paradigm for Vocational Psychology." *International Journal for Educational & Vocational Guidance*, vol. 7, no. 3, 2007, pp. 191-201.

Shonkoff, Jack P., and Deborah A. Phillips. *From Neurons to Neighborhoods: The Science of Early Childhood Development.* National Academy Press, 2000.

Super, D. E., et al. "The Life-Span, Life Space Approach to Careers." *Career Choice and Development,* edited by D. Brown and L. Brooks, Jossey-Bass, 1996, pp. 121-78.

Syltevik, Liv J. "Taking Control of One's Own Life? Norwegian Lone Mothers Experiencing the New Employment Strategy." *Community, Work and Family,* vol. 9, no. 1, 2006, pp. 75-94.

Vilches, Silvia L. *Dreaming a Way Out: Social Planning Responses to the Agency of Lone Mothers Experiencing Neo-Liberal Welfare Reform in Western Canada.* University of British Columbia Press, 2011.

Winn, Joan. "Entrepreneurship: Not an Easy Path to Top Management for Women." *Women in Management Review,* vol. 19, no. 3, 2004, pp. 143-53.

Chapter Nine

Shifting the Lens: The Complexity of Space and Practice for Entrepreneurial Mothers

Talia Esnard and Melanie Knight

Whereas entrepreneurship has often been typically assessed within economic frameworks that measure success and growth (Cooper et al.; Naudé; Volkmann et al.), we reconceptualized entrepreneurship so as to explore the social aspects of the phenomenon (Steyaert and Katz). This social thrust allowed for an assessment of entrepreneurial agendas across diverse contexts as well as notions of enterprising cultures and how these are grounded within ideological and material expressions of neoliberal structures. The focus on the social aspects of entrepreneurship also advanced considerations on the relative impact of these collective dimensions on the thinking and practices of diverse groups in society, particularly entrepreneurial mothers.

We initiated these discussions through the examination of the contextual embeddedness of entrepreneurial mothers. In so doing, we particularly disentangled the environmental aspects (such as economic, social, cultural, and institutional) that structure the lives of mothers as entrepreneurs. We started this volume, therefore, by examining the diverse ways in which worker subjectivities are continuously being (re) defined and (re)configured within the neoliberal economy. This focus underscores (i) the changing patterns of work and social relations; (ii)

the regulatory and legislative frameworks that underpin these changes; (iii) the deep-seated sociocultural and ideological frameworks that shape existing expectations; (iv) the vulnerabilities that emerge for entrepreneurial mothers; and (v) how these workers attempt to confront the realities of working within that space across the globe.

We acknowledge, however, the need to deepen our analyses of this social dimension of entrepreneurship. We, thereby embrace Chris Steyaert and Jerome Katz's challenge to reclaim the geographical, discursive, and cultural aspects of entrepreneurship. Given such, we support the need for greater explorations that focus on the sociospatial, historical, and temporal dimensions of different contexts (see the work of Korsgaard, Müller, and Tanvig; Lippmann and Aldrich; Wadhwani). If we are to shift the analytical lens to capture the complexity of entrepreneurial and maternal space, then we must ask more pertinent and pointed questions that both scrutinize and problematize the discursive, institutional, and relational constructions that intersect to frame the lived realities and trajectories of entrepreneurial mothers. Extending existing investigations of space and practice require that we push for new questions and theoretical applications that probe the following: the discursive and spatial dimensions of communities, neighbourhoods, and countries; how these contexts have been constructed; and the diverse thinking and practices of entrepreneurial mothers who operate within such contexts.

Deconstructing the Neoliberal Political Worker

A necessary aspect of advancing this interrogation of space and prac-tice is critically examining political economy. Thus, we premised the volume on observed patterns of commodification and rationalization (Mirowski), which continue to lure, construct, and affect women and mothers, who already face particular challenges related to formal em-ployment (Lewis et al.). Through the chapters, we point to the ways in which mothers, as entrepreneurs, continuously work through and re-spond to unfolding configurations of the neoliberal market. In Weidhaas's chapter, she centres the legitimacy and authenticity of the practices and the outcomes of mothers who engage in the entrepre-neurial sphere. While scrutinizing the notion of mompreneurship, Moore and Anderson's chapter, for instance, focuses on the lived real-

ities of entrepreneurial mothers to interrupt the (mis)representations and promises of the enterprising individual. This point of examination is particularly significant given mounting campaigns and digitized marketspaces that promote and commodify the productive and reproductive potentials of women.

This popularization of mompreneurship, however, is even more troubling given the extent to which such neoliberal enterprising notions are deeply rooted within patriarchal notions of motherhood and the economy. To some extent, the chapters in this volume address these issues. Thus, in Jurik et al's treatment of copreneurs in the Czech Republic, we learn of how mothers use this entrepreneurial arrangement as a way to negotiate the tensions associated with actively operating within an emerging market economy and that of contending with the cultural scripts of motherhood that persist. In some ways, this chapter sets the tone for how we make sense of the complex parameters that define the space for entrepreneurial mothers. In other ways, the chapter also brings visibility to the creative ways in which entrepreneurial mothers within the Czech Republic recraft and redefine entrepreneurial engagement to suit the peculiarities of that context. This type of boundary shifting and alternative methods for engaging within the neoliberal economy are critical for how we begin to recognize the specific elucidations and contributions for diverse mothers. This is similarly the case for Knight and Cisneros, who connect systemic methods of oppression to the particular realities of Black and Mexican mothers in Canada and the United States, respectively. In both cases, the authors challenge notions of choice and autonomy to introduce more hybridized forms of thinking and practices that remain deeply rooted in the cultural inklings and communal practices of these women. In many ways, therefore, these unfold as agentic expressions and representations of cultural and\or communal practice.

We acknowledge, however, the need for further analysis of the discursive, cultural, and institutional frameworks wherein these entrepreneurial and maternal practices are situated. We support, therefore, new historizations and theorizations that deepen our scrutiny of the many contradictions, innovations, and ambiguities that surface through the coexistence of institutionalized market mechanisms (such as private property and free market) with those of the structured realities and cultural proclivities for diverse groups. This is particularly timely

given the many debates and contentions related to the promises of entrepreneurial freedoms (see Harvey) and the permeability of market fundamentalism that continues to promote state surveillance and control (see Dean; Lemke; Rose; Rose et al.; Walkerdine). The social injustices and discontents across contexts also strengthen the need for this kind of work. These global and local rigidities also raise more pointed quest- ions, not just on the hybridization and commercialization of culture, but, equally important, on the aesthetic, expressive, and human value of culture for human kind (Gilroy).Although Paul Gilroy, for instance, remains optimistic about how people across contexts can deconstruct boundaries and transcend oppressive practices, we must also consider how the specific vulnerabilities for unique groups, such as entrepreneurial mothers, are both positioned and affected by the relations of power that operate within their entrepreneurial and maternal spaces. In fact, Lynne Layton speaks to the need for new theories that demonstrate the intricate web of social and relational experience (steeped within classed, racialized, and gendered contexts) and the psychosocial effects that these produce for individuals. To some extent, the volume explores this concern. In the last section of the book, Esnard, for instance grounds her treatment of the entrepreneurial subjectivities within the cultural, economic, and social landscapes of Jamaica.

Examining neoliberal subjectivity is particularly important given the contending ideologies that pervade the maternal worker (see Bauman) as well as effect these have for mothers involved in entrepreneurial activities. The work-life interface must be treated as a broader issue through which we can tease out the fluidities and ambiguities of the self-enterprising mother. In so doing, it is also important that we acknowledge what Jim McGuigan refers to as "a self-condemn [ation] to freedoms, [and] responsibility... [how this is] self-cultivated by neoliberalism, [and how this feeds into notions of] freewheeling consumer sovereignty with enterprising business acumen" (34). Whereas the promise of freedom and individualism emerge as key facets of the neoliberal environment, the call is also for critical assessments of the structures and processes through which the rationalities of the market interface with the sensibilities for human rights and choice. Attention to these susceptibilities is particularly important given the sporadic and inconsistent institutional support to protect vulnerable groups within the neoliberal economy (Binkley; Lemke; Rose et al.).

Frederick's treatment of Sen's social capacity framework challenges us to think of how these capacities are developed, how freedoms are defined, how vulnerabilities are imposed, and whether these capacities are necessary for operating within the neoliberal economy. On a broader basis, Frederick's chapter stimulates deeper thinking on issues related to constructions of security, self-advancement, and self-fulfillment and the impact of these, whether imagined or lived, on the wellbeing of mompreneurs. Questions, therefore, emerge about freedoms and regulations are represented and reimagined within the neoliberal area.

Such findings also connect to the contributions of Breen and Vilches, who push for a relational examination of the career and life trajectories of entrepreneurial mothers. They show how entrepreneurial mothers constantly resist and reconstruct the relations of power to enact creative expressions of their voice and choices. As a way of deepening this conversation, we must also explore globalized forms and meanings of entrepreneurship (Freeman); notions of the democratized, rationalized, and self-disciplined social actor (Popkewitz); the (in)visible normative thinking around individualism within the practice of self-entrepreneurialism (Du Gay); and how these affect the lived realities of globalization (Sassen). Such analyses call for new theories concerning the contextual embeddedness. We speak to two potential lines of inquiry below.

Advancing Theorizations on Spatial Dimensions

The entrepreneurial space is multifaceted and fluid (Korsgaard; Ekinsmyth). Space is embedded within a society's ability to "regulate [social] behaviour," (Prieto, 13), and place becomes the physical boundaries, locations, or positions, wherein social actors confront and negotiate existing notions of the space. As Edward Casey reminds us, spatial realities are not neutral; they are also cultural, with "implacement [emerging] as an ongoing cultural process [that] acculturates whatever ingredients it borrows from the natural world (31)." Making sense of such complexities therefore, call for the deliberate study of the ideological, relational, social, and material aspects of space, whether on a local or global scale (Tuan; Massey).

Such attention to the multidimensionality and complexity of space and place is increasingly important given the changing nature of global

and social relations and the implications of these for how entrepreneurial mothers enter, experience, and negotiate the space-place continuum. In exploring the fluidity of these spaces and practices, we are encouraged by the work of Susan Halford and Pauline Leonard, who argue that argue that "as individual negotiate their identities, they do so in the context of their everyday lives: as they move between the *spaces* of their work, between the *places* of their work and home and through the different *times* of the day and night" (our emphasis, 10). The point of departure here is that of the continuous yet unsolidified representations, rescreenings, and renegotiations that happen within the everyday learning of one's place (as a socially constructed notion) within the specific localities, contexts, or space that one enters. As part of dissolving the assumed boundaries between work and family, Carol Ekinsmyth argues for theories that examine spatial dimensions and centre the importance of relationships across different time spans:

> We have seen that the spaces and places of motherhood; the families, homes, neighbourhoods, communities, and the social relationships, identities and performances played out within them are the key factors framing the entrepreneurial activities of these women. In short, places and their associated assemblages of people and social infrastructure matter, and to people working at home, building ideas and businesses from the inner sanctums of family spaces, they perhaps matter more, than to those people operating a working day in a corporate or solely business environment. ("Challenging the Boundaries" 113)

Ekinsmyth stresses the social and cultural importance of how place is spatialized and performed. This performative take on place, therefore, presupposes some attention to spatialized meanings and their enactment, both through the thinking and practices of entrepreneurial mothers. Such a spatial analysis calls for deeper considerations of the institutional, relational, and cultural aspects of place but, as we show in this volume, across diverse contexts or spaces. To do this, we call for more critical reviews of emerging representations of entrepreneurial mothers as well as examinations of how these are connected to neoliberal subjectivities and how these unfold across contexts. Mixed research designs that employ the use of more comparative lens are also needed, as is interdisciplinary research to better understand of the contextual

embeddedness of the motherhood-entrepreneurship nexus. We also support a turn to cultural studies as a "way to counterbalance the economic and managerial foundation of entrepreneurship with enough connection to the social sciences and the humanities" (Steyaert and Katz, 193). The potential here is for deepening our insights on the tractability of entrepreneurial mothers.

Pushing Intersectional Inquiries

The motherhood-entrepreneurship nexus is inherently complex with multiple layers and intricacies that define this phenomenon. A useful point for further interrogation of these difficulties is that of intersectional analyses. As a growing framework used to study marginalized groups, intersectional analysis sets a critical framework to challenge oppressive systems and relations of power (Crenshaw; Hill Collins). An important aspect of such inquiry is that of intersecting axes of power (for instance gender, class, and race) that oppress and marginalize specific groups of women (Crenshaw, Hill Collins; Essers et al.). Intersectional analyses centre conversations on the socially constituted but mutually constituting categories of difference that reproduce social inequality while affecting the identities, positionalities, and realities of women within the broader society (Anthias; Mc Call; Healy et al., Choo and Feree).

Such theoretical examinations are also important for how we begin to make sense of the complex web of social influences that affects entrepreneurial thinking and practice (see, for instance, the work of Essers et al; Knight) and the effects of these on the psychosocial wellbeing of minority entrepreneurial groups (Bell and Nokomo). Studies have provided critical points of examination that centre the importance of gender, race and ethnicity for how migrant women of colour experience and navigate the entrepreneurial terrain. For example, Caroline Shenaz Hossein also employs intersectional analysis to underscore the importance of race, class, and gender to the lending infractions and financial injustices that are imposed on Afro-Guyanese clients. In her study of Black beauty salons in mid-Atlantic United States, Adia Harvey also contends that class remains an important factor for why Black women enter into entrepreneurship. In this case, the findings suggest that unlike middle- and upper-class women who attempt to evade the

glass ceiling within their work spaces, these Black women enter to secure some measure of financial stability. Intersectionality can analyze the oppressive structures, interactions, and the implications of these power structures for the entrepreneurial identities and practices of women.

Further examination is needed concerning the oppressive structures that affect the positionality, precarity, marginality, and hypervisibility of entrepreneurial mothers as well as questions relating to women, mothers, entrepreneurship, and citizenship. An important aspect of this examination requires that we explore social networks, power relations, and social axes of difference (such as queerness, ableism, racism, ethnocentrism, and classism) and how these affect the identities, choices, and practices of entrepreneurial mothers. Methodologically, one suggestion is to use a comparative intersectional framework (Esnard and Cobb-Roberts) that examines the nuances of these lived experiences within and between specific geographic sites and contexts. Even there, a case can be made for more discursive treatment of entrepreneurial mothers, which embraces comparative methodologies that seek a more complex sense of how neoliberal subjectivities are both constructed and enacted.

Conclusion

Neoliberal principles of the market economy remain central to the development of women's entrepreneurship (Bushell). For more than forty years, researchers have conducted a large number of empirical and theoretical studies that use diverse theoretical frameworks to examine the growing number and unique experiences of women within the entrepreneurial sphere (Hughes et al.; Lewis et al.). However, the growth of entrepreneurial mothers who "start their own new ventures besides taking a role of being a mother ... adds a new dimension to entrepreneurship" (Nel, Maritz, and Thongprovati 9-10). Although women are increasingly entering the entrepreneurial space, their entrepreneurial engagement is often "punctuated by transitions; often women's employment fluctuates between full-time work, part-time work, leave arrangements and inactivity (Kelley, Brush, Greene and Litovsky). Despite the tendency to homogenize women's motivations and participation in entrepreneurship, we are reminded of the situated nature of women's entrepreneurial engagement (see Brush

et al.; Hughes and Jennings), and, more particularly, that motherhood (as a life stage event) profoundly influences how women navigate between work and family (Lewis et al).

It is here that the participation of mothers within entrepreneurial space offers a rich site for analyzing the contextual nature of maternal identity, work-life relationships, and entrepreneurial identities. The volume offers this insight. In fact, the contributions in this edited volume offer a sociological and psychological account of entrepreneurial mothers as neoliberal workers. In so doing, the chapters addressed the different histories of oppression, movement of people, socioeconomic conditions that underpin that experience, as well as the various axes of power that affect the precariousness of work and citizenship on a global scale. Existing studies also centre the notion of a work-life "balance" or a "right blend" for coping with the challenges of working within and between different spheres, and such scrutiny highlights the complexities and ambiguities of working within these two boundaries. Such scrutiny also demonstrates how women have adopted strategies that are materially, culturally, socially, and politically empowering. This scrutiny is presented as a way of reframing not just the work-life interface but also how the interface affects the specific practices, choices, and responses of entrepreneurial mothers within specific localities and positionalities. No doubt, these insights provide important foundations for advancing theorizations on entrepreneurial mothers.

However, we also acknowledge the need for more critical investigations examining the complexity of space and practice. In so doing, we push for more multidisciplinary and integrated theoretical approaches that treat with the many points of intricacy around the work-life interface that unfold for entrepreneurial mothers. Of note are the issues related to the ideological and discursive contradictions embedded within constructions, representations, and expectations of the embodied neoliberal worker. Another issue is the inherent complications that surface within specific communities or sociogeographic spaces (as in communities, type of establishments, or institutions) as well as the processes through which these (mis)align mothers as entrepreneurial workers and their responses to them. Finally, there is a need for intersectional analyses that are centred on mothers and on the multiple ways in which they both experience and resist oppressive structures and social relations. The hope, therefore, is to advance scholarship that

pushes for the specific concerns and circumstances of entrepreneurial mothers while securing needed forms of institutional and social support that are contextually relevant and liberating.

Works Cited

Anthias, Floya. "The Material and the Symbolic in Theorizing Social Stratification: Issues of Gender, Ethnicity and Class." *British Journal of Sociology*, vol. 52, no. 3, 2001, pp. 367-90.

Bauman, Zygmunt. *Liquid Modernity*. Polity Press, 2000.

Bell, Ella J., and Stella Nokomo. *Our Separate Ways: Black and White Women and the Struggle for Professional Identity*. Harvard Business School, 2001.

Binkley, Sam. "Happiness, Positive Psychology and the Program of Neoliberal Governmentality." *Subjectivity*, vol. 4, 2011, pp. 71-94.

Browne, Irene, and Ivy Kennelly. "Stereotypes and Realities: Images of African American Women in the Labor Market." *Latinas and African American Women at Work*, edited by Irene Browne, Russell Sage, 1999, pp. 185-208.

Brush, Candida G., et al. "Introduction: Women Entrepreneurs and Growth." *Women Entrepreneurs and the Global Environment for Growth: A Research Perspective*, edited by Candida G. Brush et al., Edward Elgar Publishing, 2010, pp. 1-16.

Bushell, Brenda. "Women Entrepreneurs in Negal: What Prevents them from Leading the Sector?" *Gender and Development*, vol. 16, no. 3, 2008, pp. 549-64.

Casey, Edward S. *Getting Back into Place: Toward a Renewed Understanding of the Place-World*. Indiana University Press, 1993.

Choo, Yoen Hae, and Myra Marx Ferree. "Practicing Intersectionality in Sociological Research: A Critical Analysis of Inclusions, Interactions, and Institutions in the Study of Inequalities." *Sociological Theory*, vol. 28, no. 2, 2000, pp. 129-49.

Collins, Patricia Hill. *Black Feminist Thought: Knowledge, Consciousness, and the Politics of Empowerment*. 10th ed. Routledge, 2000.

Cooper, Arnold C., et al. "Initial Human and Financial Capital as Predictors of New Venture Performance." *Journal of Business Venturing*, vol. 9, no. 5, 1994, pp. 371-95.

Crenshaw, Kimberle. "Mapping the Margins: Intersectionality, Identity Politics, and Violence against Women of Color." *Stanford Law Review*, vol. 43, no. 6, 1991, pp. 124-29.

Dean, Jodi. "Nothing Personal." *Rethinking Neoliberalism*, edited by Sanford F. Schram and Marianna Pavlovskaya, Routledge, 2017, pp. 3-22.

Dean, Mitchell. *Governmentality: Power and Rule in Modern Society.* 2nd ed. Sage, 2010.

Du Gay, Paul. "Organizing Identity: Entrepreneurial Governance and Public Management." *Questions of Cultural Identity,* edited by Stuart Hall and Paul Du Gay, Sage Publications, 1996, pp. 151-169. Print.

Ekinsmyth, Carol. "Challenging the Boundaries of Entrepreneurship: The Spatialities and Practices of UK 'Mumpreneurs.'" *Geoforum,* vol. 42, no. 1, 2011, pp. 104-14.

Ekinsmyth, Carol. "Managing the Business of Everyday Life: The Roles of Space and Place in 'Mumpreneurship.'" *International Journal of Entrepreneurial Behaviour & Research,* vol. 19, no. 5, 2013, pp. 525-46.

Esnard, Talia, and Deirdre Cobb-Roberts. "Black Women in Higher Education: Towards Comparative Intersectionality." *Black Women, Academe, and the Tenure Process in the United States and the Caribbean,* edited by Talia Esnard and Deirdre Cobb-Roberts, Palgrave, 2018, pp. 99-133.

Essers, Caroline, et al. "Female Ethnicity: Understanding Muslim Immigrant Businesswomen in the Netherlands." *Gender, Work and Organization,* vol. 17, no. 3, 2010, pp. 320-39.

Freeman, Carla. "The 'Reputation' of Neo-liberalism." *American Ethnologist,* vol. 34, no. 2, 2007, pp. 252-67.

Gershon, Ilana. "Neoliberal Agency." *Current Anthropology,* vol. 52, no. 4, 2011, pp. 537-55.

Gilroy, Paul. *Against Race.* Harvard University Press, 2000.

Halford, Susan, and Pauline Leonard. *Negotiating Gendered Identities at Work: Place, Space and Time.* Palgrave MacMillan, 2006.

Harvey, Adia. "Becoming Entrepreneurs: Intersections of Race, Class, and Gender at the Black Beauty Salon." *Gender and Society,* vol. 19, no. 6, 2005, pp. 789-808.

Harvey, David. *A Brief History of Neoliberalism*. Oxford University Press, 2005.

Healy, Geraldine, et al. "Intersectional Sensibilities in Analysing Inequality Regimes in Public Sector Organizations." *Gender, Work & Organization*, vol. 18, no. 5, 2011, pp. 467-87.

Hossein, Shenaz Caroline. "The Exclusion of Afro-Guyanese Hucksters in Micro-Banking." *European Review of Latin American and Caribbean Studies*, vol. 96, 2014, pp. 75-98.

Hughes, Karen D., and Jennifer E. Jennings. "Introduction: Showcasing the Diversity of Women's Entrepreneurship Research." *Global Women's Entrepreneurship Research: Diverse Settings, Questions and Approaches*, edited by Karen D. Hughes and Jennifer E. Jennings, Edward Elgar Publishing, 2012, pp. 1-11.

Hughes, Karen D., et al. "Extending Women's Entrepreneurship Research in New Directions." *Entrepreneurship Theory and Practice*, vol. 36, no. 3, 2012, pp. 429-42.

Kelley, Donna J., et al. *Global Entrepreneurship Monitor 2012 Women's Report*. Babson, 2012.

Knight, Melanie. "Race ing, Classing and Gendering Racialized Women's Participation in Entrepreneurship." *Gender, Work & Organization*, vol. 23, no. 3, 2014, pp. 310-17.

Korsgaard, Steffen. "Mompreneurship as a Challenge to the Growth Ideology of Entrepreneurship." *Kontur*, vol. 16, no. 1, 2007, pp. 42-45.

Korsgaard, Steffen, et al. "Rural Entrepreneurship or Entrepreneurship in the Rural–between Place and Space." *International Journal of Entrepreneurial Behavior & Research*, vol. 21, no. 1, 2015, pp. 5-26.

Layton, Lynne. "Irrational Exuberance: Neoliberal Subjectivity and the Perversion of Truth." *Subjectivity*, vol. 3, no. 3, 2010, pp. 303-22.

Lemke, Thomas. "'The Birth of Bio-Politics': Michel Foucault's Lecture at the College de France on Neo-Liberal Governmentality." *Economy and Society*, vol. 30, no. 2, 2001, pp. 190-207.

Lewis, V. Kate, et al. "The Entrepreneurship-Motherhood Nexus: A Longitudinal Investigation from a Boundaryless Career Perspective." *Career Development International*, vol. 20, no. 1, 2014, pp. 21-37.

Lippmann, Stephen, and Howard E. Aldrich. "A Rolling Stone Gathers Momentum: Generational Units, Collective Memory, and Entrepreneurship." *Academy of Management Review*, vol. 41, no. 4, 2016, pp. 658-75.

Massey, Doreen. *For Space*. Sage, 2005.

McCall, Leslie. "The Complexity of Intersectionality." *Signs*, vol. 30, no. 3, 2005, pp. 1771-1880.

McGuigan, Jim. "The Neoliberal Self." *Culture Unbound*, vol. 6, no. 1, 2014, pp. 223-240.

Mirowski, Philip. *Never Let a Serious Crisis Go to Waste: How Neoliberalism Survived the Financial Meltdown*. Verso, 2014.

Naudé, Wim. *Promoting Entrepreneurship in Developing Countries: Policy Challenges*. United Nations University, 2010.

Nel, P., et al. "Motherhood and Entrepreneurship." *International Journal of Organizational Innovation*, vol. 3, no. 1, 2010, pp. 6-34.

Pieterse, Jan Nederveen. "After Post-Development." *Third World Quarterly*, vol. 21, no. 2, 2000, pp. 175-91.

Popkewitz, Thomas S. "A Social Epistemology of Educational Research." *Critical Theories in Education: Changing Terrains of Knowledge and Politics*, edited by Thomas Popkewitz and Lynn Feudler, Routledge, 1999, pp. 17-42.

Prieto, Eric. *Literature, Geography, and the Postmodern Poetics of Place*. Palgrave Macmillan, 2013.

Rose, Nikolas. *Powers of Freedom*. Cambridge University Press, 1999.

Rose, Nikolas, et al. "Governmentality." *Annual Review of Law and Social Science*, vol. 2, 2006, pp. 83-104.

Sassen, Saskia. "The Global Inside the National: A Research Agenda for Sociology." *Sociopedia.isa*, 2010, www.saskiasassen.com/PDFs/publications/the-global-inside-the-national.pdf. Accessed 20 Feb. 2019.

Springer, Simon. "Neoliberalism as Discourse: Between Foucauldian Political Economy and Marxian Poststructuralism." *Critical Discourse Studies*, vol. 9, no. 2, 2012, pp. 133-47.

Steyaert, Chris, and Jerome Katz. "Reclaiming the Space of Entrepreneurship in Society: Geographical, Discursive and Social Dimen-

sions." *Entrepreneurship & Regional Development: An International Journal*, vol. 16, no. 3, 2004, pp. 179-96.

Tuan, Yi-Fu. *Space and Place: The Perspective of Experience.* University of Minnesota Press, 1977.

Volkmann, Christine K., et al. "Background, Characteristics and Context of Social Entrepreneurship." *Social Entrepreneurship and Social Business: An Introduction and Discussion with Case Studies,* edited by Christine K. Volkmann, Kim O. Tokarski, and Kati Ernst, Springer Gabler, 2012, pp. 3-30.

Wadhwani, R. Daniel. "Entrepreneurship in Historical Context: Using History to Develop Theory and Understand Process." *A Research Agenda for Entrepreneurship and Context*, edited by Friederike Welter and William B. Gartner, Edward Elgar, 2016, pp. 65-78.

Walkerdine, Valerie. "Workers in the New Economy: Transformation as Border Crossing." *Ethos,* vol. 34, no. 1, 2006, pp. 10-41.

Notes on Contributors

Gillian Anderson is a mother, professor, and chair of the Sociology Department, Vancouver Island University. Her research and teaching focus on gender and familial relations, mothering, motherwork, and the sociology of home. Recently, she coedited *Sociology of Home: Belonging, Community and Place in the Canadian Context* (2016), published by CSPI.

Gray Cavender is a professor emeritus in the School of Social Transformation, Arizona State University, whose focus is media studies. His books include *Corporate Crime under Attack: The Fight to Criminalize Business Violence* (Anderson), *and Provocateur for Justice: Jane Tennison and Policing in "Prime Suspect"* (University of Illinois Press).

Marissa Cisneros is a sociology doctoral student at Texas A & M University focusing on critical approaches to race, class, and gender in the food industry. A first generation nontraditional Latin@, she recently began to interrogate the unique Southside of San Antonio Latinx community's structural and cultural background using autoethnography and narrative analysis.

Talia Esnard is a lecturer (sociology) and head/chair of the Department of Behavioural Sciences, at the University of the West Indies, St. Augustine campus, Trinidad and Tobago. Her research centres on issues related to women's experiences in the entrepreneurial and educational spheres. Some of her work has been published in *Journal of the Motherhood Initiative, Women, Gender and Families of Color, Journal of Cases in Educational Leadership, Mentoring and Tutoring: Partnership in Learning,* and (v) *NASPA Journal about Women in Higher Education*. Dr. Esnard is also a co-author of *Black Women, Academe, and the Tenure Process in the United States and the Caribbean*. She was also a recipient of

Taiwan Research Fellowship (2012) and Canada-CARICOM Faculty Leadership Program (Brock University-2015 and Ryerson University-2018).

Ayanna Frederick holds a PhD in entrepreneurship and commercial studies. Her research centres mainly on small business management, entrepreneurship and wellbeing, and female entrepreneurship. She has shared segments of her work at conferences in the Caribbean, the United States, and Australia. She is also an educational entrepreneur by profession.

Rebecca Hudson Breen is an assistant professor of counselling psychology at the University of Alberta and a practicing therapist. Her research interests include the career-life development of mothers and mother entrepreneurs more specifically, as well as the intersections of addiction, recovery, and career/work.

Nancy Jurik is a professor emerita of justice and social inquiry in the School of Social Transformation, Arizona State University. Her interests focus on gender, occupations, work organizations, and entrepreneurship. She is the author of *Bootstrap Dreams: U.S. Microenterprise Development in an Era of Welfare Reform* (Cornell University Press).

Melanie Knight is an associate professor in the Department of Sociology at Ryerson University in Toronto. Her research interests are grounded in Black activism/organizing, Black collective economic initiatives, Black women business owners, and the subtext of race and gender in the discourse of enterprise. Her work has been published in the *Journal of Critical Race and Whiteness Studies*, *Gender, Work & Organization*, and the *Canadian Journal of History/Annales canadiennes d'histoire*. Outside of her work in the academy, she collaborates with a number of community organizations that deliver programs and advocate for the health and wellbeing of Black Canadians. She also supports organizations that promote Black history and heritage. In 2018, she was awarded the Viola Desmond faculty award.

Alena Křížková is a senior researcher and head of the Gender & Sociology Department at the Institute of Sociology of the Czech Academy of Sciences. She conducts research on economic justice, gender discrimination, and gender in entrepreneurship. She is a country expert for the European Commission in the Network of Experts on Gender Equality.

Joseph (Joey) Moore is an instructor of sociology at Douglas College in New Westminster, BC. He holds a PhD from McMaster University and is a coeditor of the recently published *Sociology of Home* (CSPI 2016). His current interests include urban sociology, homemaking in public spaces, as well as labour and environmental movements.

Marie Pospíšilová is postdoctoral researcher at the Gender & Sociology Department at the Institute of Sociology of the Czech Academy of Sciences. She is interested in gender and entrepreneurship, copreneurship and work-life balance.

Silvia L. Vilches (she) is an assistant professor in human development and family studies at Auburn University, Alabama, and an extension specialist for early childhood. She is interested in gender and family issues, and her work often involves studying community capacity development, especially with impoverished communities. She has participated in Women on the EDGE (WEDGE), contributed to Canadian Public Policy for Women, and written on *Dreaming a Way Out* about the lives of lone mothers who receive public support.

Allison Weidhaas, PhD, is an associate professor at Rider University in Lawrenceville, NJ., and researches gender issues. She has published a book titled *Female Business Owners in Public Relations: Constructing Identity at Home and at Work*. Weidhaas is also the director of Rider's two graduate degrees in business communication and health communication.

Deepest appreciation to
Demeter's monthly Donors

DEMETER

Daughters
Christine Peets
Myrel Chernick
Summer Cunningham
Rebecca Bromwich
Tatjana Takseva
Debbie Byrd
Fionna Green
Tanya Cassidy
Vicki Noble
Bridget Boland

Sisters
Amber Kinser
Nicole Willey